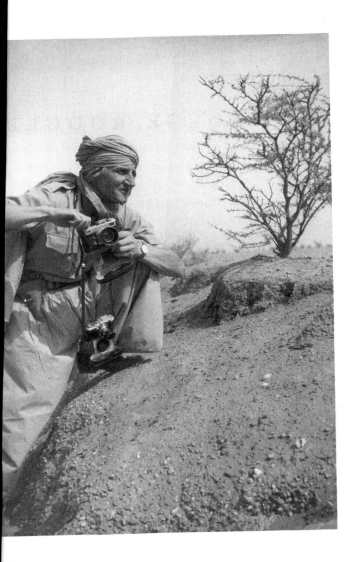

GEORG

Geor
Ingr

GEORGE RODGER

AN ADVENTURE IN PHOTOGRAPHY, 1908–1995

Carole Naggar

SYRACUSE UNIVERSITY PRESS

Library of Congress Cataloging-in-Publication Data

Naggar, Carole, 1951–
 George Rodger : an adventure in photography, 1908–1995 /
Carole Naggar.— 1st ed.
 p. cm.
 Includes index.
1. Rodger, George. 2. News photographers—Great
Britain—Biography. 3. Magnum Photos, inc. I. Title.
TR140.R64 N34 2003
070.4'9'092—dc21 2003012602

Manufactured in the United States of America ·

This book is for Jinx Rodger,
who opened all the doors,
and for Fred,
who lived with me through it all.

Born in Cairo, Egypt, **Carole Naggar** moved to New York from Paris in 1987. A writer, painter, and cofounder of PixelPress, she lives in Riverdale with her husband, Fred Ritchin, and their two sons, Ariel and Ezra. Her books include *Eikoh Hosoe: Luna Rossa, Algerian Women 1960; Light Readings: Women On Photography, 1850–1990; John Berger: Drawings; George Rodger en Afrique;* and *Dictionnaire des Photographes.* She is the recipient of several awards, among them the Samuel Rubin Foundation Grant (1994), an award from the Bronx Council for the Arts (1994), and the Golden Light Award (1993) for "Best Book in History of Photography" (with Fred Ritchin).

Contents

Illustrations

Acknowledgments

During the almost seven years it took for this book to be completed, many people gave generously of their time. My warmest thanks go to Jinx Rodger for her amazing research, her hospitality, and her generosity. She authorized this biography and granted me unlimited access to the Rodger archives in Smarden. She also let me read all his correspondence and diaries as well as some of her own journals and letters, and consult his contact prints and his library. She helped most generously with picture research; she guided me through Scotland and Cheshire to see Rodger's childhood landscapes; she helped me trace many friends and colleagues of Rodger's in Europe and the United States. I also thank Jenni, Jonathan, and Peter Rodger for sharing their memories of their father.

I thank my husband, Fred Ritchin, for his moral support through this adventure, for his help in juggling work and family, and for his discerning eye in the final edit of this book's illustrations. A special thank you to my children Ariel and Ezra for their patience while I was researching and writing. Diana Stoll speedily and cheerfully edited down my thousand pages to a readable length. I thank the teams of Magnum Photos in London, Paris, and New York, especially Diane Auberger and Raymond Depardon for their efforts in securing a French publisher; Brigitte Lardinois, who is circulating George Rodger's exhibits in Europe and in the United States; Melissa Harris of Aperture for referring me to Diana Stoll, a superb editor; Peter Marlow for his editing of Rodger's contact sheets for the Phaidon monograph, and for his psychological insights; Elko Wolf for believing in Rodger and in the project; and Guy Mandery, then my editor at Photo Magazine in Paris, for sending me on assignment to Smarden in 1977 to meet George Rodger for Magnum Photos' thirtieth anniversary.

I owe gratitude to my friends at PixelPress, especially Alison Beckett, Zohar

Nir-Amitin, and Shalu Rozario for their technical help with scans and disks; Ambreen Qureshi for the generous gift of her time; and Aviva Michaelov for her calm in the face of the computer crash that engulfed part of this book.

Eve Arnold provided a sensitive and enthusiastic reading of the manuscript. I thank Cornell Capa for his early encouragement and Henri Cartier-Bresson for his sharp memories of Capa, Chim, and Rodger. Françoise Davoine's work on World War I soldiers' trauma was influential, and Pascale Hassoun-Lestienne arranged our meeting. Raymond Depardon's desert and Africa travels had led him to some of the places Rodger had visited. James Fox wrote a wonderful piece after Rodger's death. Tom Drysdale knows all about darkslides and Kodak Vest Pocket cameras. Neil Burgess wrote a beautiful memoir of Rodger in the 1980s. Marjolane Guisan, archivist at Vevey's communal archives, discovered some of Rodger's Swiss ancestors. Pierre Gassmann reminisced about Rodger's Blitz and Nuba photographs. Arthur Howes, whose films were an inspiration, carefully read my chapter on the Nuba and made many helpful suggestions. Hilary Johnston at TimePix provided permissions for Rodger's Time-Life pictures. MaryAnn Kornely and Marthe Smith, when working at Time-Life, helped with research on Rodger's postwar reportage. So did Robert Stevens, who verified the file numbers and titles of World War II stories and introduced me to Carl Mydans and Shelley Smith-Mydans, colleagues of himself and Rodger, whom I also thank for their fond recollections of Rodger.

Linda Morgan gave an interview with an open and unprejudiced mind and contacted her mother, Dorothy Bye Parmalee, Cicely Hussey-Freke's sister. Barbara Michie told me about her husband Allan's war journals. John Morris generously shared his files, memos, memories, and Xerox machine.

The librarians of the Department of Special Collections at Boston University's Mugar Memorial Library, especially Charles Niles, who opened their archives to allow me access to Allan Michie's unpublished war diaries. Luke McKernan, of B.U. Film and Video Council in England, gave me information from the B.U. newsreel project database about Rodger's war colleague in Burma, Alec Tozer. Peggy Rodger, since deceased, had vivid memories of her brother and her childhood. Dick Stratford, Rodger's driver throughout World War II Europe, evoked his painful memories of Bergen-Belsen for the first time in more than forty years. Anita Summer must be thanked for her precise memories of Fleet Street, Black Star, and Muriel Segal.

I also wish to thank Chris Boot, then photography editor at Phaidon, for his attempts to save my contract; Arthur Chapman, for letting me reproduce extracts of his correspondence with Rodger; Dorothy Bye-Parmalee for talking about her sister's death and Rodger's mourning; and Jean Gaumy, Sebastião Sal-

gado, and Lélia Wanick Salgado for sharing their memories of a "founding father": all have been helpful at understanding Rodger.

I wish to thank Rodger and Jinx's friends and neighbors in Smarden and their friends from England and Scotland: Dr. and Mrs. Robert Hardwick, Michael Randolph, Josephine O'Conner-Howe, and Jill and David Eddison.

My agent, Jean V. Naggar, was an early enthusiast of the project and strove to find an American publisher. Her partner, Ann Engel, bravely skimmed the unedited thousand pages of the manuscript and made many helpful suggestions. The editorial staff at Syracuse and Matthew Kudelka, a freelance editor, did a superb job on the manuscript. Jennifer Weltz at the J. V. Naggar Literary Agency brought her enthusiasm, energy, and sense of humor, sorely needed by the end of a seven-year project. Mark Bussell was an enthusiastic "on the phone" listener.

My dear friend and next-door neighbor, novelist Béatrice Shalit, listened with patience in Paris as the book took shape. So too, with a smile, did Gail S. Reed in New York. I thank all the team at Syracuse University Press—Amy Farranto, Theresa Litz, and Mary Selden-Evans—for their professionalism and interest. And a special thank you to Ezra for finding a title!

I interviewed eighty people for this book, some in the early 1980s, some between 1995 and 2001. Two among them—both unfortunately recently deceased—provided special insight into Rodger's complex personality: his Magnum colleague, photographer and writer Inge Morath, of New York; and my friend Dr. Jacques Hassoun, a witness to this project. I wish they could enjoy this volume of Rodger's adventures.

To those I may have forgotten, pardon me and accept my warmest thanks.

GEORGE RODGER

Prologue

Wahr spricht, wer Schatten spricht.
One who tells the truth tells the shadows.
 —Paul Celan

In May 1977, I arrived in Smarden, Kent, a charming English village founded in the eighth century. The town boasts a Norman church, St. Michael, with an adjoining cemetery. Smarden's impeccable streets, lined with freshly painted houses and flower beds, have garnered awards for "the best-kept village in Kent."

I was coming to interview British photographer George Rodger. Thirty years earlier, in 1947, he and three other photographers—Henri Cartier-Bresson, Robert Capa, and David Seymour (known as "Chim")—had founded Magnum Photos. In 1977 only Rodger and Cartier-Bresson were alive to celebrate the anniversary of the agency, which now had three offices worldwide and more than sixty members.

As a young journalist based in Paris, I wanted to meet Rodger for many reasons. It intrigued me that he had chosen not to live in London or Paris. I admired his photographs and was surprised that he was still so little known outside photojournalism circles. Many people knew his most famous photographs—images of the Nuba and the Masai in Africa, images from Bergen-Belsen, from Haiti, from Bali—yet they did not know their author.

Rodger at seventy was still striking in appearance: a six-foot-tall Englishman with blue eyes, a mane of white hair, and the ruddy cheeks of an outdoorsman. He wore a well-used beige cardigan with patched elbows, and he looked more like a gentleman farmer than a worldly photojournalist. He seemed more eager

1

to show off his fruit trees and rose garden and to tell me about his home, Waterside House, than to look at or talk about his work. He was reserved, unassuming, and thoughtful—rather undecipherable. He sized me up, but in the most discreet way.

Rodger had begun renovating the family home in 1958, joining three workers' cottages from the Tudor era. They had very low ceilings, and he told me that while working on lowering the floors he had worn rubber padding under his cap so he wouldn't knock himself out on the ceiling beams when he stood up. The remodeling had taken seven years, most of them without water or heating. He had had to halt often because of lack of funds. When he started the project, Jinx Rodger had been pregnant with their first child, Jenni. By the time the house was finished, their second child, Jonathan, had been born.

Rodger and I talked a lot that weekend, at first about Magnum and his friends Capa, "Chim," and Cartier-Bresson, all of whom had received more recognition. I assumed at the time that this was because he tended to shy away from the spotlight.

In our conversations, Rodger displayed a dry and sometimes wicked sense of humor that I instantly liked. Though only six months older than Cartier-Bresson, he called him "my little one." He dubbed himself "M'zee Rodger"—"respected elder" in Swahili—because he had spent a large part of his life in Africa. The name perfectly suited the Victorian side of his personality. Capa called George "old goat"; when they met as war photographers near Naples in 1943, shower opportunities were not as frequent as photo opportunities.

Quite taken by this first meeting, I returned several times, with no specific assignment. We also exchanged letters. Rodger's only request to me, as to all his visitors, was that I stay at least two days. I was only too happy to comply. There was no "Chunnel" at the time, so from Paris I would take an early morning train from the dark, sooty Gare du Nord, then the ferry from Calais to Dover. When I had more money on hand, I would take the Hovercraft. Rodger would come pick me up in his car and drive me to Smarden.

In time I learned to love the Kentish landscape in all seasons: the winding roads, the oaks and clipped hedges under snow or in bloom. I met Rodger's wife Jinx, a one-time Time-Life researcher, and their children, Jenni, Jonathan, and Peter. The Rodgers made me feel very much part of the family.

At midday we often went out for a ploughman's lunch at one of the local pubs, The Chequers or The Bell. On the way back, Rodger would sometimes bring the car to a screeching halt if he noticed a sign for a sale on eggs. He attributed his parsimony to his Scots ancestors: he was always keen on scraping pennies. Other times we might stop by a local dump, where he would scavenge

for an old window, a piece of beam, a pipe, or an appliance needed for Waterside House, which had become his life's project.

On the second floor of the house he kept a huge stash of contact sheets and prints. His lab—he still did his own printing—was downstairs. Jinx had traveled with him throughout the 1950s, writing texts for his reportage; now she was working as a researcher and, in concert with Magnum, filling orders for prints from book publishers, magazines, and (starting in the 1980s) galleries as well. At the time, Rodger still had an agreement with the agency that granted him a large measure of independence.

Rodger had always been an incorrigible wanderer. He had dropped out of school early and by the age of eighteen had sailed twice around the world on a British steamer. He had arrived in the United States in the middle of the depression of the 1930s and had worked at hard, unforgiving jobs in factories and on construction sites. He had sorted fleeces in a tannery, picked fruit, and sold cherries on the street to survive. All the while he had held on to his dream of becoming a writer and photographer.

Soon after World War II broke out, *Life* stumbled onto his photographs. The magazine offered him a four-week assignment; it grew into two years, during which he traveled to no fewer than sixty-one countries. He escaped from the Japanese army into India; he was pursued by head hunters through the Burma jungle; in April 1945 he was the first photographer to record the liberation of Bergen-Belsen concentration camp. For his courage he earned seventeen medals, which he never mentioned (he had hidden them in a drawer somewhere). Later he became the supreme chronicler of the lives of African tribal people. Between the 1940s and 1981 he made fifteen trips to Africa. He had explored the Sahara, Haiti, Bali, and the Middle East.

In 1981, Rodger traveled to Africa, funded by a grant from the British Council. It was to be his last visit to that continent. On that journey he witnessed an event until then unseen by any white man: the circumcision ceremony of an adolescent Masai warrior. His new photographs were stunning.

Since the 1955 publication of his groundbreaking 1949 reportage *Village of the Nubas*, none of Rodger's African pictures had been published in book form. A new book about Africa, drawing on his extensive African archive, seemed a natural project, so we decided to undertake it. Rodger and I edited down several thousand pictures and collaborated on the book's design. I found venues for the African work in several French galleries and then convinced a French publisher specializing in Africana to take on the book. I wrote a text inspired by Rodger's

travel diaries and notebooks. The resulting book, *George Rodger en Afrique*, was published in 1984.

By then we were friends. Rodger gave me a photograph that I hung on my bedroom wall in Paris—the first thing I saw when I woke each day. It shows a group of adolescents from the Masai tribe walking. They wear robes of bark and headdresses of ostrich feathers. Their hair is tightly braided. The boy in front seems somewhat diffident: his eyes are averted, his left hand is raised shyly near his mouth, his lips are half-open in a smile. The quiet magic of that image welcomed me each morning.

Rodger and I were friends, and I was always learning more about his extraordinary life, yet he remained somewhat obscure to me as a person. He rarely talked about himself, and never about his emotions. He was always unflappable.

As I got to know his work better, I was amazed by its quality and scope. Each contact sheet was sparse, even ruthless in its choices. Complex, in-depth stories unfolded from frame to frame, and blossomed not through single images—Rodger was not given to the single, spectacular shot, as his colleagues Capa and Cartier-Bresson tended to be—but rather in discrete, nonlinear narratives that built up through ramifications and connections.

The inventor of the "package story"—a combination of text and pictures—Rodger always wrote captions for his pictures (in the field, sight unseen), as well as most of the accompanying texts. Like Walker Evans—another reticent perfectionist—Rodger had first wanted to become a writer, and his photographic method seemed almost literary in its scope and depth. Yet so little of the work was known and published! Why had Rodger not been given the recognition he deserved?

The narrow windows of Rodger's studio overlooked the church of St. Michael. The room felt like a ship's cabin, with oil portraits of his somber Scots ancestors hanging from the slanted walls. Humorless and very solemn, from their high vantage point they seemed to be keeping a sharp eye on us.

The studio walls were lined with diaries; since he was a sailor on the SS *Matra*, Rodger had been a keen letter writer and an exact, almost obsessive chronicler of his own life. Barely a day had gone by without the ritual of writing in his diary. I was keeping a diary myself at the time and could not help wondering whether the diaries held clues to Rodger's personality, whether he let down his guard on those pages and opened his most secret, vulnerable self.

My relationship with Rodger became looser after 1987, when I moved to

New York City. I settled into a new place, got married, and started a family of my own. We wrote to each other, though, and I was happy to know that many miles away lived someone who had been essential to my life. The Masai photograph Rodger had given me was hanging on the bedroom wall of our house.

Somehow, I must have thought that like all heroes, Rodger would live forever. But on July 25, 1995, without warning, the photograph fell off the bedroom wall and the glass shattered. I began to weep: I knew what it meant. After a long illness, Rodger had died of cancer, though not before attending the opening of his retrospective at London's Barbican Galleries.

I flew to England to attend the funeral. I slept that night in Rodger's studio with the Scots ancestors and his diaries. When I woke up, I had decided to write this book. I had to crack open the mystery and understand who George Rodger really was.

Eighteen months later, Jinx Rodger agreed to the project.

At first the diaries were daunting: how could I write the biography of someone who every day had recounted his own life? How could I position myself as the *narrator* of such a life, and find my own version?

I immersed myself in his writings, reading page after page and trying to make sense of them. But the more I learned about Rodger's circumstances and daily routines, the less I understood him. The pages were like a Venetian mask: they fit his face and made it into a type, while leaving the person hidden. His letters to colleagues and friends were funny, smart, detailed, and informative—but rarely illuminating. The mountain of facts, dates, and details held in the archive was becoming an obstacle, blocking my view instead of opening vistas.

Rodger had banished almost all emotion from his writings. I knew which kind of feathers any African tribe wore on their headdress, what the Rodgers ate for breakfast every day, how much had been spent on each photo story, and how many "pinky" gins they drank in the evening. Yet it seemed that I knew nothing. For instance, in 1954, according to friends, Rodger was profoundly depressed after his friend Robert Capa's death. He couldn't work, and saw a doctor who gave him daily injections in the hope of curing his "nervous condition." Rodger kept on writing about physical symptoms such as migraines and muscle aches, but he never explored his feelings of loss.

I was losing heart, until one day I picked up Homer's *Iliad*, which I hadn't read since high school. While I was reading Book 18, I had an uncanny feeling of familiarity. If I replaced Achilles with Rodger, Patrocles with Capa, the Trojan War with World War II . . . I was developing the blueprint of a key, traumatic episode in Rodger's life: the death of Capa. When Achilles learned of his friend's

death, "a mist of black grief enveloped him. . . . Let me die now. I was no help /
To him when he was killed out there. He died / Far from home, and he needed
me to protect him."[1]

Homer's words accurately describe the emotions of many modern photo-
journalists: grief when a colleague is killed at war and the wish to join the fallen
friend in death. Homer goes on to describe the two things a survivor can do to as-
suage his grief and his guilt: either avenge his friend, or wish for the end of all
wars: "When it comes to war . . . / I wish all strife could stop, among gods / And
among men, and anger too."[2]

But in modern wars, killing has become anonymous. There is no obvious
culprit: the survivor cannot avenge the dead. Capa was killed by stepping on a
landmine. Achilles was able to unleash his emotions by killing his friend's killer;
Rodger, a modern survivor, would have to live with his grief and guilt.

Grief and guilt had started piling on Rodger as early as 1945: he had wit-
nessed World War II massacres and seen and photographed Bergen-Belsen; his
first wife, Cicely, died in childbirth in 1949, and he would always believe he could
have done something to prevent that death; his companion and mentor, Capa,
died in 1954, and his friend Chim two years later.

So Rodger, too, wished that "all strife could stop, among gods and among
humans." He tried to avoid war and conflict altogether—a moral but unrealistic
choice that would cause even more conflict. He escaped into what he thought
was a paradise on earth, "untouched by our Western ways": Africa. After 1949 he
chose to never again photograph war.[3]

To write about Rodger's life, I had to remember what the poet Paul Celan
wrote: "One who tells the truth tells the shadows." I had to give up my early no-
tions of Rodger as a hero to understand what had wounded him—*why* he did
things, as much as what and how. What drove him? Beyond images, what was he
after?

Slowly, by patching together pieces, diagnosing symptoms, seeing his child-
hood landscapes, meeting his friends, letting myself be guided by Jinx—whose
intuition often led to the truth—I started to understand who Rodger was.

Then facts started to crystalize on the branches of surmise. One day I was
talking to one of Rodger's colleagues, who like so many people had tried to get
close to him but remained on the edge, baffled and unable to get in. And I real-
ized that I knew more about Rodger than they could tell me.

I was ready to write this book.

1

Big Boys Don't Cry

It was the summer of 1914, a beautiful summer. World War I had just started.

"Boy!" called Auntie Nut-Nut, "You must join the others on the lawn."

George fled through the lavender, toward the hedges, cursing his tight blue-striped shirt and the sailor's tie that made him choke. Once beyond the lime trees, he would be safe: he could roam the hills with his pet dog, watch the birds, go fishing with a makeshift cane in the nearby River Ettrick. He would bring his catch to Hardy, the handyman, in the lodge behind the house.

Hardy was George's hero. He smelled of tobacco, sweat, and the tar he used to cure rot in sheep. The potting shed was their kingdom.

The Bridgelands was where George spent all his summer holidays with his two sisters, Margaret Agnes (Peggy), four years his senior, and Janet Elizabeth (Betty), three years his junior. The two-story house was built of light-gray stone. George's grandmother, Blanche Rodger (née Eck) and his three maiden great-aunts, Carlotta, Janet, and Agnes, resided there the year round. The house had been in the family for five generations.

On March 22, 1908, a few days after Rodger was born, his great-aunt Carlotta—known in the family as "Auntie Nut-Nut"—received a letter from her cousin, Augustus Eck, together with a large scroll delineating the family's Swiss heritage:

> My Dear Carlotta,
> *Tout vient à point à qui sait attendre.* Herewith, I send you the extract from the pedigree of the Eck family, according to my promise. . . . You will be able to trace your descent from Bernard Eck, that you are my first cousin once removed. You will notice that Bernard Eck was admitted to the bourgeoisie of

Vevey in 1667. . . . I felt tempted to put in the name of the brother of your great-great grandfather who emigrated in England and settled at Northampton somewhat before 1760. . . . He started in business as a watch and clock maker and it was he who made the grandfather clock in my room.[1]

According to the family tree, George Rodger's ancestors were all Protestants, a mix of Swiss Calvinists and Scottish Presbyterians. The scroll's corner has a reproduction of the family crest: "Gulls with silver fish swimming on azure waves, accompanied on the top with two silver optical squares worn crosswise."[2] George Rodger's ancestor on his mother's side, Bernard Eck d'Anerlingen, whose family came from Saxony, was made "Bourgeois de Vevey" (Burgher of Vevey, Switzerland) in 1667, together with his son, Francis David. Eck paid £300 for the privilege.[3]

Vevey's location on the border with France made it an important transportation center. The town was also famous for its tanneries, cobblers, and cabinet makers, and for the printing of fine books and lithographs.

For the Veveysans, Protestantism was more than a religion: it was a code of ethics and a way of life. Calvinism placed great stock in austerity and self-discipline. Life was about praising God with prayer. Religion ruled everything, including behavior and clothing. The rich were not to squander their goods but spend them wisely for the community's good and for the care of the sick and the poor.

Imagine this: in 1666, on a beautiful Sunday morning, Augustus Eck and his wife, both dressed severely in black, stroll the main street of Vevey with their young son Francis David. They walk toward Place du Temple, not far from the arcades where the local peasants are peddling their milk, cheese, vegetables, and wool; the butchers their meat and live poultry; the bakers their black bread and pies. Several Italian laborers are grinding cacao by hand, and the cloying smell saturates the spring air. Gawkers have gathered around a vendor selling novelties: cheap watches from nearby la Chaux-de-Fonds and Le Locle, copied from English models, and music boxes from the Jura.

"Boy!" says Madame Eck to Francis David, who is listening with delight to the dance tunes wafting from the boxes. "Time to go to service." In his black cloak and trousers, his white stockings and copper-buckled shoes, Francis David runs out of sight. His hat has fallen off. His parents will have to enter Sainte Claire without him, as Madame Eck will not miss a sermon by Pastor Josué Chevalier for the world.

But Francis David will nevertheless become a bourgeois like his father. He grows up and marries Elizabeth Daun from Vevey, and their son Abraham Au-

gustus becomes a glove maker. Augustus marries Marguerite Charnaud, and that couple's second son, René Eck, becomes a clock maker and marries a woman from Geneva, Renée Archinbaud, in 1721. They have eleven children, and one of their sons in turn has nine children, some of whom immigrate to Northampton around 1760, thus starting the English branch of the Eck Rodger family.

In 1804, George Rodger's ancestor Louisa Sarah Du Mont marries Francis Vincent Eck. Louisa has six siblings, one of whom, François Frédéric, marries one Janet Alexander. Their daughter, Elizabeth Charlotte Eck (born in Valparaíso in April 1847), marries George Eck Rodger, procurator fiscal of Selkirkshire, in 1872; their son George—our hero's father—is born in 1873. Another son, Peter Robertson, is involved in trade in India; he dies at Kamptee in 1905.

Rodger was born on March 19, 1908, in Hale, Cheshire, to Hilda (née Sebourne) and George Rodger, Sr. His parents met on a bicycling trip in Scotland in the mid-1890s, and married in 1903. His father's ancestors were Scots who had traded in the Middle East, South America, and China.

Rodger's mother Hilda (born in 1874) was an attractive woman with brown eyes and fair hair that she kept in a bun. She had a soft, sad smile, and those who remember her say she was often depressed. In one of the family photographs—most of them taken by George Rodger, Sr.—George is seated on his mother's lap in the big kitchen at the Bridestones, their main residence. Mother and son hold each other tight. Hilda was an affectionate and tender mother, sensitive but somewhat sad and withdrawn. From her letters to her son—probably her favorite child—we know of her love for nature and her gift for poetry.

George Rodger, Sr., never smiles in the photographs. "He was a difficult man, 'dour' as they say in Scotland, and certainly 'a man with no cuddles.' "[4] Severe and extremely reserved, he was very judgmental and seems to have inspired little except awe in his children; he would never become close to them. A level-headed and stolid businessman, Rodger, Sr., had nevertheless spent a rather adventurous youth traveling abroad on cotton business to the Middle and Far East. He had a gift for languages and succeeded in learning Arabic, Spanish, French, and German.

After marrying Hilda, George Rodger, Sr., entered the wine business with his father-in-law and a partner. This was near Manchester, which at the time was the second-largest city in England. After a few years, however, his partner brought troubles to the business; Rodger, Sr., scrupulously paid all of his partner's debts, losing a lot of money. He then bought the farm and estate that would be the family home: the Bridestones.

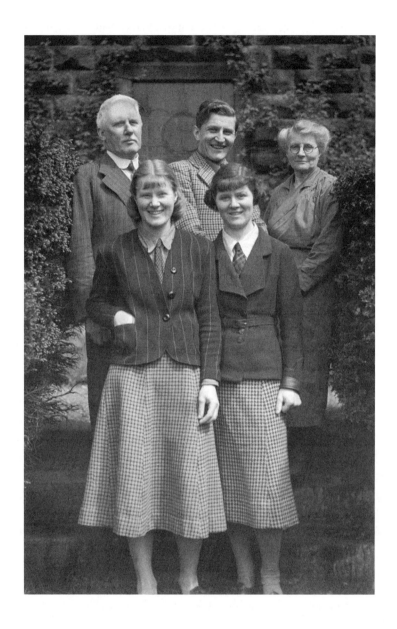

The Rodger family at the Bridestones in 1925. *Back row:* George Frederick Eck Rodger, George Rodger, his mother Hilda. *Front row:* Rodger's sisters Peggy and Betty. © *Rodger Archive.*

Today it is an English spring: rare rays of sunshine take turns with stormy rains. The trees glisten, and ribbons of mist circle the fir plantations. The Bridestones with its whitewashed walls and deep-slanted roof is an isolated house three miles east of Congleton, at the top of a high hill known as "the Cloud."

Congleton's landscape is special. The Pennines rise sharply where the plains of western Cheshire meet eastern Derbyshire. The hills reach their greatest height at Congleton Edge and Mow Cops. And the highest peak, at nine hundred feet, is the Cloud.

To a child, the Cloud must have seemed like the top of the world. From its heights, one can see Staffordshire and Derbyshire to one side and the plains of Cheshire to the other. The Derbyshire side, bleak and rough (think of *Wuthering Heights*), is all moors and broom stretching out to the horizon. The Cheshire plains are much more cheerful, with lush vegetation fed by hundreds of springs. The landscape is punctuated by quarries, abandoned salt mines, and dairy farms. A road, the Earle Waie, slips through from the Cheshire plains into Derbyshire; it was the old salt road of the Earl of Cheshire. Now, as then, sheep and Holstein cows graze in yellow fields divided by low hedges and wooden fences.

It is easy to imagine young George at the top of the hill, looking down at these three counties. From here, three different worlds converged to feed his dreams of faraway places.

In front of the Bridestones stands a Neolithic chamber tomb dating from B.C.E. 2500. It is a series of large stone slabs surrounding a taller, vertical stone. Two or three smaller stones form a circle as high as a child—all that is left of the original crescent-shaped façade that enclosed the tomb's forecourt. The stones look much like an ancient circle of bridesmaids surrounding a bride—hence the name of the house where Rodger lived for the first sixteen years of his life: "the Bridestones." The chamber and the massive upright stone at its east end, "the Pinnacle," must have been a powerful magnet for Rodger's imagination. As a young man he would often come here to reflect or to make important decisions.

Rodger's older sister Peggy was ninety and still in good health when I began working on this book. She was a no-nonsense, independent woman with blue eyes and straight white hair combed back behind her ears. Peggy never married, and lived most of her life in a house a few stones' throw from the Bridestones. She recalled:

> The Bridestones was quite a big house, with four bedrooms. It used to have araucarias in front and a huge lawn that we children had to mow, bordered by clipped low hedges that are gone now. There were 173 acres of land. We loved exploring the grounds. There was a bit of wood with lots of bluebells, we ran to

the stone wall that was limiting the property, and sometimes even further. On Sundays we used to go to the little Methodist church on the side of the Cloud, the oldest in use in England. In August the Cloud was covered with purple heather, and we climbed those old steps that go all the way to the top and had picnics.[5]

Peggy recalled her father's distance when she and her siblings were children:

Father—"Fazzy," as we called him—we saw very little of. He left at seven from home with the pony and trap, to the station and then to Manchester. Fazzy wasn't much of a farmer, really—he left it all to the bailiff. Mother ruled the house, and we had a score of governesses looking after us. . . .

George and I, we were always in trouble, always getting into mischief. Betty was never in on those escapes, she was much younger. [We used to] climb along the wall to go play with the animals on the farm. We used to go down to the river, catching eels. We had nails on a stick and we stabbed them. We took them to the cook and she had to cook them, and she cursed us. We ate them, though, and they were lovely.[6]

The children grew up in a deeply religious environment. According to Sue Dale, a neighbor of the Rodgers, "George did go to the Cloud chapel occasionally. However, they enjoyed most the annual outdoor service that kept up the Primitive Methodist tradition of the 'ranters,' as the locals called them. It was held on Drummer's Knob.[7] There were prayers, a sermon by the preacher, Mr. Beard, and hymn-singing."[8]

When he was six, Rodger was shipped off to "short-pants" school. After that he attended prep school in Altrincham, an upper-class suburb southwest of Manchester. Rodger never really enjoyed school, much preferring the farm at the Bridestones and his outdoor life, and even more his summers at the Bridgelands.

Early on, Rodger felt that he had little in common with his father: "My father was a chip off the old Scottish block—granite, of course."[9] Rodger, Sr., was preoccupied with his wine business and unable or unwilling to communicate with his children. At home, he retreated behind his *Manchester Guardian.*

In his wartime letters to his first wife, Cicely, Rodger expressed some bitterness toward his father. He felt that Rodger, Sr., had never helped him with any business connections and that he had been left to make his own way alone in the world. At home, his father constantly put down his mother, extinguishing her gaiety, spontaneity, and gentleness with constant reproaches and accusations. He was, Rodger, Jr., wrote, a total misanthrope. His repeated failures in business had nothing to do with his intelligence or ability, but came from his profound inabil-

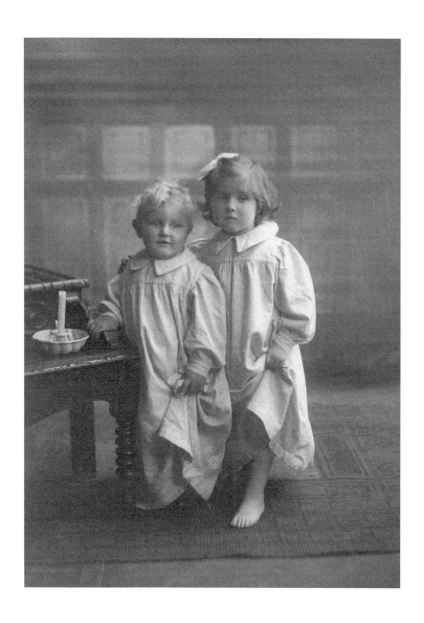

George and sister Peggy in nightgowns, 1909. © *George Frederick Eck Rodger.*

ity to get along with his fellow man. Furthermore, Rodger, Sr., was jealous of his wife's friends and made no effort to relate to them when she invited them to dinner, so that in the end they stopped visiting. In one letter to Cicely, Rodger swore that if ever he had a family of his own, he would make every effort to be different.

Early on, Rodger the son tended to idealize and identify with his mother. Yet both were guarded, and awkward at showing emotions directly or having physical contact. Their feelings flowed more freely in written form than in real life—a pattern that would be fairly constant in Rodger's life. Hilda's generally sad life may well have accounted for his later tendency to "keep his chin up"—he was reluctant to add to her worries.

An important part of Hilda's life was her large, well-equipped kitchen. On weekdays she made the menus and worked with the cook, contributing fresh vegetables from her garden and even baking bread. Peggy later recalled: "Mother was a grand cook. We ate in the dining room, roast and apple pie. Meat was beef or lamb. We only shopped once a week, with the pony and trap. We had a wonderful cellar, nice and cold. We grew our own vegetables. We had our own cows and made our own butter in a milk churn. . . . In the springs I remember picking bilberries . . . for her pies."[10]

Hilda seems to have been a keen and talented gardener. Her garden was her pride—perhaps she gave to it all the unspent affection of her frustrating married life. After it became clear that farming life was a failure, the Rodgers left the Bridestones for a smaller house in Congleton.

After 1914, George, Jr.'s life took on a pattern. The school semesters were spent in Cheshire. Then each summer he and his sisters traveled to Scotland by rail, accompanied by two young women, Ann and Flora, who looked after them. They changed trains at Galashiels for Selkirk. This next train followed a single-track line along two steep-banked rivers, the Ettrick and then the Tweed. From the windows the children could see salmon leaping from the cool, green waters. At Selkirk they were met by a coachman named Graham, who wore a tall silk hat and carried a long whip; he was "a heraldic figure," according to Rodger.[11] Down the cobbled road to the Bridgelands they went at a noisy trot. It was the same road that Sir Walter Scott had taken for many years, on his way to church or to the station.

As they passed through the town square of Selkirk, the trap would slow down and George would take rapt note of the monument to three explorers, sons of the region, who had journeyed to Africa and disappeared there: Alexander Amberson, George Scott, and Thomas Park, "son of Mungo Park, [who] died in

Aqumboo, West Africa, in 1827, while endeavouring to obtain trace of his distinguished father."[12] On each side of the stone monument were four larger-than-life bronzes of African men and women with elaborate hair and long tunics. It was these that commanded Rodger's interest. The figures' cheeks were marked with scars, and they were holding drums.

Soon after, Graham would tug the reins and stop in front of the Bridgelands. Under the portico, Grandmother Elizabeth Charlotte and Grandfather George would be waiting to give the children a formal greeting. Their grandmother was a rather austere-looking woman with dark hair parted down the center, a straight, sulking mouth, and sunken eyes; she was given to dark gowns with high, clerical-style collars. Elizabeth Charlotte did have a sense of humor, but she delivered most of her puns without a smile. Throughout his early years, George was certain that it was her portrait engraved on the pennies she gave him for church collection; indeed, photographs of the time confirm her striking (and unfortunate) resemblance to Queen Victoria.

Grandfather George was a portly man with clear eyes and a bushy white mustache. He often wore a beret and a three-piece gray suit; he could barely close his waistcoat buttons over his stomach. His cheeks glowed a healthy red. In a rare gesture of generosity—true to every cliché, this Scots family prided itself on its frugality—he would treat the children, on their arrival, to a bowl of strawberries and cream.

The three maiden aunts, Janet, Carlotta, and Agnes, would also appear to greet the children. Peggy recalled that their grandmother "reigned supreme" and that the three aunts were "prim and proper. . . . They had been missionaries in India and had never married." She continued: "Mother and Father . . . never went to the Bridgelands; they never went away for the holidays. We never seemed to be together."[13] This was true enough: Hilda and George never visited the Bridgelands. A formal photograph of a family picnic, where twenty-four people are assembled on the front lawn, shows no trace of them.

With such a "prim and proper" environment, not to mention his parents' conspicuous absence, it is no wonder that little George could not wait to escape the house. He recalled that "life-sized ancestors looked down from gilded frames around the walls. Their sharp, discerning eyes followed me everywhere and I was terrified."[14]

Indeed, when I first encountered these same paintings at Rodger's house in Smarden, I too found them disquieting: they seemed to be in an eternal state of disapproval. Now, I wonder why Rodger—who professed so much dislike for them—nevertheless spent all of his working life typing letters, stories, and diaries under their unflinching gaze.

Since the Reformation, the Rodgers had been Scottish Presbyterians, stiff, unyielding, quite certain of the correctness of their moral rules. For them, the line between right and wrong was clear and sharp: "Any little sin that ventured across [it] attracted immediate and unabated fury."[15]

The Bridgelands house was also rather austere. Like most Scottish houses in that region, as a protection against winter's bitter wind and cold it had no windows on its eastern side. Set in a pocket surrounded by rolling hills, it seemed to turn its back on the beautiful landscape of hills, woods, and rivers. Long, sinuous walls built of small, sharp, gray stones flowed over each hill like a mane. These fences would have been striking to Rodger, both as a child and later as a photographer. On these reddish hills covered with purple heather, the racing clouds create shifting patterns of light and shadow. In later years, Roger would make annual visits to the house and reminisce with the new owners about his time there.

The Bridgelands garden has changed little. Today I am walking the path Rodger would have walked, toward the old pond and the orchard with its crabapple, pear, and Damson plum trees. Jinx, his second wife, recalls Roger's story of stealing some apples, almost as big as his head, and how Carlotta caught him and pulled him by the ear all the way from the garden into the house. On another occasion, Rodger cut his finger and came running into the house, blood dripping on the hallway's white marble. Surely he would have been reprimanded for making such a mess, even while his finger was being dressed.

Rodger would have seen these peacocks strutting back and forth, scraping the gravel; he would have walked under the chestnut and umbrella birch trees and admired the azalea and the deep red of this rhododendron hedge. Already in his time, the small, white-and-green garden cottage would have been used for picnics and for hide-and-seek. I stand, as Rodger must have stood, on the echo stone at the very back of the garden, and shout my name, and the rolling hills send it back to my feet.

Rodger remembered his childhood as rather solitary. But he never dwelt on his isolation, or on the pain he felt at being so often and so long separated from his parents, especially his mother. Very early on, he learned to project onto nature, his pets, and his pony most of his emotions: "I formed a close rapport with nature which left no room for loneliness and boredom."[16]

Except for occasional visits from cousins or neighbors, George had few friends before he started school. His two sisters were encouraged to behave like "ladies" and to participate in the house chores. But Peggy was as independent-

minded as George. The two of them often ganged together, leaving behind Betty, the tender "baby" of the family.

A letter from 1915 by the seven-year-old George gives some idea of his antics:

Dear Mother and Father.

I hope you are very well. I am writing in bead and I have had two doses of caster-oil and lemon juice. And both of us have scene a weasel. Peggys weasel was by the hay-stack and mine was by a holly bush. Peggy was going up to the hay over the stable and put her hand into some hayseads oup jumped a mouce and ran bhinde the bin. There was a camp and Anty Gee and Anty Carlotta go there to feed the Tommys and ones we went with her into the tent and bought some biscuits and three of sweetis.

love from George[17]

In another letter written later that summer he inquired: "How is my garden getting on? Have the beens got beens on them and how fat are my turnips? We have had our photograph taken last Thursday. It was hard work to keep from giggling."[18]

A letter dated July 11 of the same year is oddly free of spelling mistakes (perhaps it was corrected by Peggy or one of his great-aunts). It is marked "aged 7 years," and ends "Love from Boy to everybody."[19] From this point on, George—who perhaps now fancied himself the man of the family—always signed his letters "Boy." Also, he began sometimes adding drawings—of a horse, or of a wasp that had stung him. Still later, instead of writing letters only on Sundays, he would begin casting them as diaries written over successive days. In one of these, addressed to "Muzzy and Fazzy," he noted poignantly: "I hope you will like your birthday present."[20]

George must have missed his parents terribly, although he never said so in his letters. Why did his parents behave as if they were continents apart when they could easily have visited the Bridgelands, only a few hours by train from the Bridestones?

In fact, a painful family rift had occurred in 1908, before George's birth, between Hilda and the great-aunts. On January 19, 1908, the second child of Hilda and George, Sr., Marie Rodger, died at age two in unknown circumstances. George was born two months after that death. How the young mother must have felt, torn between her grief and her sense that she must "pull herself together" for her coming child. According to Jinx Rodger, "the aunts in Scotland always

blamed Hilda for Marie's death. She never quite recovered from that. . . . She never got on too well with the straight-laced aunts."[21]

We can only guess at the impact of Marie's death on Peggy and of course on George, who entered the world so soon after his mother had lost a child. Marie's spectral presence must have cast a shadow over his childhood and Peggy's, making them feel profoundly inadequate. They could never make up for her death; they could never make their mother truly happy. Hilda in turn could not give them her undivided attention and love, for she was still grieving. Moreover, both George and Peggy must have felt conflicting loyalties between their mother on the one hand and their aunts, whom they also loved, on the other.

George Rodger, Jr., was raised in a strict and religious world in which his mother was in mourning. For him, being sent away to the Bridgelands had to have felt like a deserved punishment, a confirmation that he was unworthy of his parents.

Perhaps the aunts made disparaging remarks about Hilda, or perhaps they simply neglected to mention her at all. In this way George learned that emotions were volatile things and best kept hidden.

On one visit to George and Jinx's friends in Scotland, I heard a few rather telling Scottish jokes, such as this one: "How do you recognize a Scot at the train station?" "He is the only one who does not kiss his wife goodbye." Rodger never greeted or said farewell with a kiss, except for a perfunctory brush on the cheek. He followed his aunts' dictum: "Big boys don't cry." He stored his emotions away in some deep well, where they would later become unrecognizable even to himself.

Yet on the outside, he was constantly busy, exploring his world. Hardy, the Bridgelands' handyman, taught him the basics of carpentry. He also taught him how to observe and identify birds and their nests. Soon enough, Rodger could tell a lark or a finch from a corncrake. As soon as he could read, he acquired field guides to plants and animals and begged his uncles for a pair of binoculars.

By the time he was six, he was "hunting" rabbits and pheasants with a wooden rifle—basically, an excuse for expeditions: "I felt an affinity with those wild things. . . . I was hemmed in physically by the woodlands which surrounded [the property], and aesthetically by the seclusion, my own tender age and my love of nature."[22]

It was a very special birthday when George was given a Scotland pony, Gollywag. Holding tight to her black mane, George was soon out all morning, galloping up and down hills. From their heights, he could keep a lookout for rabbits, pheasants, and the occasional partridge.

Only when the bell rang for lunch would he return, reluctantly, to the adults and their rules. Of course, the rule that "children should be seen and not heard" suited him perfectly—he always preferred daydreaming to talking.

Sundays were unbearable: He had to dress up and attend mass. Doctor Lawson's preaching went on forever, with endless talk of Hell and damnation. One day, George got so bored that he could not help himself: he caught a maggot that had ventured into the mink stole of a lady in the front pew. The woman was not amused. George was pulled out of church and scolded severely for disturbing the dignity of God's house.

2

The End of Paradise

1 9 2 1 – 2 6

Separation from his parents had given George a precocious independence. It had also strengthened his love of nature and his sense of observation. Much of the time, when adults were not around, he felt free.

Serious schooling marked the end of his halcyon days. Peggy and Betty were sent off to Blencathra School for Girls in Ryle, North Wales; George was packed off to preparatory school at Alderley Edge, then to St. Bees College from 1921 to 1926.

At St. Bees he made two close friends, Morris Davenport and Arthur Chapman. Rodger and Chapman lost track of each other after their studies, but later reconnected when Rodger appeared on a BBC program in 1990. Afterward they corresponded until Rodger's death in 1995. Their memories of St. Bees widely diverged: "You speak of the enjoyable days [at school]," Rodger wrote. "But I am afraid I don't look back on it with such respect. . . . It was so regimented, so restrictive and I just rebelled."[1] Elsewhere, he recalled: "Nothing really sank in and it was only in the rifle range that I excelled over all others."[2]

Chapman kept a rare photograph of the young Rodger. Though somewhat blurred, it reveals a happy and intent-looking boy of about ten. He is wearing a gray tweed school uniform and a striped tie. His blond hair is a bit disheveled, and he is holding a gun.

Over the school holidays, Rodger invited Chapman and Davenport on bicycle explorations of the moors and dales of Cheshire. One summer, when they were about fourteen, they rode all the way from St. Bees to Selkirk. Chapman re-

members: "We were best friends who walked many miles together, rode our bikes even further. We were each free spirits. . . . We had no intention of following the usual track of boys of the age we were . . . George was an excellent marksman and horseback rider. Where his interests lay he always excelled."[3]

The only honor Rodger received while at St. Bees was a medal for shooting at the school's Bisley competition. He and his two friends spent their time in heated debate over the things that mattered most: rugby, cricket, hunting grouse, trapping and skinning rabbits and other small game. George also acquired a banjo; he strummed chords and at one point fixed the instrument himself. Peggy recalls that he never bothered to buy sheets of music, preferring improvisation to sight reading.

One of the very few gifts from his father was a Kodak Vest Pocket camera. Rodger packed it on many of his outings. He made a portrait of Chapman standing in a field, his arms folded behind his back, smiling. He gave the photo to Chapman, who years later sent it back, along with his own portrait of the young gunman. Rodger's response: "Thank you so much for the photographs. . . . The picture of me is blurred, indecisive, out of focus. That is how I was. Coming events cast their shadows before."[4]

Rodger had a very strong connection to the landscape of his youth. In 1930, when the Bridgelands had to be sold after his grandmother's death, he took it very hard. He felt as if his memories were being erased. As he expressed it to Chapman in 1990: "All that is gone now. One by one the relations up there left for happier hunting grounds and property after property was sold. Now there is nothing left at all except the names on the tombstones. It is a pity. I loved that part of the world."[5]

Rodger always emphasized his independence from institutions. In his correspondence with Chapman he declared that nothing had really sunk in from his classical education. In fact, one subject would stay with him all his life: poetry, in English, Greek, and Latin. Like all students at St. Bees, Rodger was required to memorize long passages of verse. He had an excellent memory and a distinctly literary mind. In his diaries he would refer over and over to poets, from the Ancient Greeks (Homer's *Iliad* in particular) to the English Romantics. The passages he memorized at St. Bees would stay with him all his life. Two decades later, as he stood in the mire of a bloody battle in Italy, the sight of a broken bust of Mussolini brought back to him lines from Shelley's "Ozymandias," which he quoted verbatim in his diaries.

But literature also had another, more subtle effect on Rodger. He was a rather lonely child who did not get from the adults around him any affectionate, day-to-day guidance, but mostly rules and principles. So he sought in books what

real life did not provide. Early on he decided that he did not want to grow up to be like the adults around him. The books he read were more than escapes and pleasures (as they would have been for a happier child): they were his guides and mentors. It's as if Rodger wanted his life to be like a story, an adventure book, a book of romantic poetry. In that he succeeded very well, perhaps too well.

One adventure from that time brought Rodger and his friend Morris Davenport instant notoriety, not to say infamy. At the end of the 1926 summer term, public figures were invited to address the students, and the two of them concocted a prank. Rodger described it in his memoir: "In our determination to make the summer speech day more interesting, we resorted to gunpowder. We made a loud-sounding firework which we screwed under the speakers' platform in the big marquee where long tedious speeches were made before Governors and doting parents. . . . We controlled it by means of a time fuse set for half-past three. It did not go off. It was not until the following day that repercussions started."[6]

A special team of explosives experts transported the "bomb" to their depot, where they set it off—and determined that it was no more than a firework. Even so, the reaction to their prank was certainly strong—far stronger than they had anticipated. It warranted the first mention of Rodger's name in the national press. One of the figures scheduled to speak at St. Bees that day was statesman and former British prime minister David Lloyd George.

The next day's headline in the *Manchester Guardian*—Rodger's father's favorite newspaper—was ATTEMPTED ASSASSINATION OF LORD LLOYD. Rodger, Sr., must have been appalled at his son's growing fame as other articles followed in the *Daily Express*, the *Daily Mail*, and the *Daily Dispatch*. Rodger, Sr., had been publicly embarrassed and was not at all amused. A practical man whose understanding of adolescents was nil, he decided then and there that he would not keep paying school fees for such a rebellious son. He immediately pulled George out of school.

Writers—biographers in particular—are always telling themselves that how a life actually takes shape is only one among infinite possibilities.

I wonder if Rodger, Sr., was correct in thinking that he had wasted his money? What would have happened had he reacted differently to the boys' mischief? After all, their scheme seems so typical, no more than an expression of adolescent anger and humor, besides a clear attempt to attract their parents' attention. What would have happened if the two Georges had been able to talk frankly and try to figure out what the younger one really wanted? If the father

had not been such a "chip of granite," if had they gotten along better, could they have struck a deal that included a few years of university for the son?

But none of that happened, so George, Jr.'s life took a sharp turn. His father decided that it was time for his son to learn what "real life" was about, and that this lesson could be learned as a farmhand. So the next fall, after a brief grace period over the summer at the Bridestones, Rodger said goodbye to Davenport and Chapman, who were headed back to St. Bees, and went off to a farm in Yorkshire owned by a cousin of his mother.

Although the Bridestones was technically a farm, Rodger had never helped run it. In Yorkshire, he lived in a cottage on the farm property, about a mile from the main buildings. The farmer assigned him several unsavory tasks, including mucking out bullpens and (worst of all) castrating piglets. He could not bear the way farm animals were treated, and waking at dawn to perform endless chores made him feel like a slave.

Rodger soon determined that farm life was even worse than school. But with the resourcefulness of a seventeen-year-old, he managed to find ways to amuse himself. One morning, while he was milking his assigned cow, he discovered that by directing the warm stream of milk onto the side of the galvanized pail beneath, he could produce a variety of musical notes. He informed his fellow slave in the next stall of this scientific fact, and the two practiced until they could strike the first notes of Rachmaninoff's Prelude in C Sharp Minor: George was in charge of striking the A's, G sharp, and C sharp; his friend played E sharp and D sharp: "Because I had the brindle cow with big teats I couldn't hit the highest notes. I had to teach the fellow with the young heifer in the stall next to me to do them for me, but he was tone deaf, so it took weeks of practice. One day, just when we'd got it to perfection, the foreman came in and caught us. He went purple, and asked if we were farmers or a bloody orchestra? . . . I was terribly bored, you see."[7]

The foreman had no sense of humor: George had to pack his bags and head back home, where once more he faced his father's fury.

After the initial relief from leaving the farm, Rodger began to feel restless. But he still had no idea what he wanted to do with his life. The atmosphere at home was strained, to say the least: all lines of communication with his father seemed permanently cut. The family's dinner conversations were halted and uncomfortable, heavy with ominous silences. George longed to escape.

He recalled in his memoirs: "I wanted to go out and conquer something, but I didn't know what and I could only soothe my frustration by riding my father's horses faster and faster into the far horizon."[8] As his tastes ran to unbroken horses, the inevitable result was three broken ribs. Rodger's father never learned about the accident, and Peggy and his mother helped him keep it a secret.

Growing up seemed to involve growing even more distant from a father whom he already deeply resented. This resentment would have a strong effect on Rodger's life choices.

After his accident, no longer in any shape to ride a horse, Rodger spent a lot of time reading adventure novels, which fueled his imagination:

"I was fascinated by Conrad and Stevenson, then [Henry Horton] Stanley, [John Hanning] Speke and [Richard] Burton though I must admit I found Rider Haggard more gripping reading . . . The world was wide then for exploration and I wasted many an hour in wishful thinking, looking over the magnificent but unresponsive distant views of Derbyshire and the Cheshire plains. . . . It was fashionable for the young in those days to 'run away to sea,' and I contemplated this very seriously from my vantage point in the heather moors with the curlews wheeling overhead and the black grouse calling." [9]

In 1926, Rodger was eighteen years old. There was one thing he was certain he did *not* want: a nine-to-five job. His few stints at working had not lasted long. He had no personal money, very few social connections, no plans, no prospects. He had no clear notion of what he wanted, although he knew he had a general liking for physical activity in the open air.

"Running away to sea" seemed the obvious thing to do.

3

Wanderings

1 9 2 6 – 3 5

In November 1926 Rodger left the Bridestones for an interview in Liverpool at the Cunard offices. The meeting had been arranged through an associate of his father's (Rodger later found this hard to admit). He had decided to join the steamship company of Anchor Brockelbank, whose ships traveled around the world. In no time he had signed as an apprentice deck officer on the SS *Matra*. It was a year's commitment, but Rodger had made up his mind not to turn back.

Before the ship left, Rodger's thoughts were mainly of his mother, to whom he was still close. Although he had enjoyed a warm relationship with his sisters in his childhood, the siblings had grown apart and he knew by now that their lives were moving in different directions from his own.

In some ways, though, it was not people but environments that Rodger found hardest to leave behind. He had so loved his summers at the Bridgelands, and the landscapes surrounding the Bridestones. The rolling hills would linger vividly in his mind. In August the heather-covered slopes turned a deep purple, a hue he had seen only one other time, in a postcard he owned of Cézanne's *Montagne Sainte-Victoire*. There was the Pinnacle, the druidic stone that had so fascinated him. There were the hunting expeditions with his white dog. There was the cool, blue lake nested between hills where he had taken so many early-morning swims, even in the gray English drizzle.

But school? He would not miss that, except for his friends Davenport and Chapman. He would remember their visits to Scotland, or Dryburgh Abbey, and their weekends in Southampton, where they raced their motorcycles on the

sand. In his wallet Rodger kept a picture of himself riding an Austin H.R.D., and another of Davenport on a 120 M.A.H. Zenith.

As for girls, there had been one, his first girlfriend, Beatrice Little, whom he had met the summer before. He had introduced her to Davenport and Chapman but usually kept her to himself. They had exchanged poems and taken long walks on the moors, passionately holding hands. Often they had ridden together on his motorcycle, nicknamed "Boaninges" ("son of thunder" in Gaelic mythology) after the one owned by T. E. Lawrence. While they were riding she would clutch his waist, the wind blowing their hair. Beatrice had given Rodger his first taste of intimacy and provided one reason for homesickness.

Ten days after signing on, Rodger boarded the *Matra* with his brand-new navy greatcoat and his backpack. The first thing he pulled out of it was his diary: "The day of sorrow," he wrote.[1] To the young adventurer, the *Matra* had lost a good deal of its romance: "The cargo sheds, the giant cranes and the ship itself seemed somehow menacing, [a feeling] accentuated by the arc lamps high on the ship's masthead that threw a weird macabre light reflected in puddles on the quay." On board, things were even worse: "The noise was tremendous—the rattle of winches as cargo was slung aboard dangling dizzily from clashing derricks; chain slings crashing onto steel deck plates."[2]

Rodger longed for faraway shores, but in a strange way he also felt forsaken by his family. He resented his departure, as he had every summer when his parents sent him to the Bridgelands. Long into his adult life he would hold a bitter grudge against his father. Thirteen years after his voyage on the *Matra*, he wrote: "I attribute [my father's] failure in business entirely to his inability to fraternize with people, and also my strange launch into life. When the time came for me to leave school and face the world, he had no friends in other businesses who could advise me or give me a start, and the result was that I had to jump from pillar to post just finding things out for myself."[3]

In his first month at sea, Rodger grew accustomed to life on the *Matra*. The ship edged slowly toward the Middle East. He wrote home once a week; his letters to his mother and sisters paint a much more optimistic picture than his diaries. He spent many nights on watch, but he rather enjoyed the solitude. He passed the time trying to identify the new constellations.

Shipboard life had its drawbacks, of course: when he stumbled back to his cabin just before dawn, the sea was often so rough he had to sleep on the floor. And the food was atrocious: "The sausage rolls! Bags of mystery I call them."[4]

Sometimes the boat pitched wildly and the rain poured down relentlessly in heavy sheets. The intense darkness fueled his nostalgia for home and his dreams of the family hearth: "A little yellow flame . . . [lighting] up a circle of faces . . .

Mother, Father, Sister, Brother, Sweetheart maybe, and all happy in each other's company."[5] That family picture was of course something of a fantasy: Rodger never had a brother; Beatrice had rarely if ever joined in family evenings; and the atmosphere between his parents had never been so serene.

Rodger's loneliness was somewhat abated when the *Matra*'s Captain Cornish, a chain-smoking, weather-beaten, but kindly man, took him under his wing. He also found a friend in the quartermaster, "Big Mac," a towering man in his sixties with tufts of gray hair growing out of his ears and nostrils. Though his conversation consisted mainly of monosyllables and grunts, Big Mac taught the young apprentice how to read a compass, navigate by the stars, tie complicated knots, and splice and interweave rope.

As they approached Port Said, the *Matra*'s first stop, the sea became calmer. The temperature rose and so did the spirits of those on board. "In spite of being on duty all night my excitement denied me sleep and I awaited the dawn to record the mysteries of the Orient. Soon there was sufficient light, and I grabbed my camera.[6] Egypt on one side, the Sinai on the other: it was Rodger's first sight of the desert, and he fell in love with it instantly.

The ship continued down the Red Sea into the Indian Ocean. By the time it made landfall at Ceylon (now Sri Lanka), Rodger's homesickness was gone. "At last my expected world was opening up before me. There were things unheard of at Bridgelands or the Bridestones—flying fish, porpoises, the occasional triangle fin of a shark, jellyfish on the surface of the smooth sea . . . and a spicy fragrance that wafted 50 meters across the water from the cinnamon gardens of Ceylon."[7]

At the village of Kidderpore, near Calcutta, the crew had their first shore leave of the voyage. A guide led them to some local prostitutes. Rodger, still an innocent, was appalled. "Six little people, hardly more than children, trooped in, wearing nothing more than ghastly frozen smiles. They sat in a row, knees well apart to show their little clap-traps. I fled . . . I was learning that my new world was not necessarily all sunshine and roses."[8]

In the nearby village of Chowringhi, Rodger visited clubs, attended dances, and explored the local bazaar for gifts to send home. For himself he acquired what must have been his first (and surely most memorable) suit: "a dashing silk suit made in canary yellow."[9] He also roamed with his camera, making black-and-white photographs of the harbor and the town streets. Still rather shy, he worked from a distance.

His father had given him a small allowance for the journey, and Rodger had asked him, half naïve, half provocateur: "As you are providing the wherewithal, would you rather have long letters at sixpence or shorter ones for tuppence-halfpenny?"[10]

Too soon it was time to go back on board. As the ship neared the Ganges Delta, Rodger fell seriously ill with a raging fever. Delirious, he was taken to Kidderpore Hospital, where he was diagnosed with diphtheria. The *Matra* sailed on without him.

Rodger had never before been so ill. He was far from home and did not know if he would be able to rejoin his ship. The Kidderpore Hospital was a two-story shack. When Rodger's fever subsided, he realized with horror that the nurses got rid of the dead simply by throwing them out the window. "When I came out of my delirium, I felt awful and there were three black crows sitting in line at the foot of the bed. . . . I did not want to die in that place with those three harbingers looking on."[11]

After ten days in the hospital, Rodger's youth and good looks caught the attention of a young nurse, who smuggled him into her apartment near the town's bazaar. Under her care, Rodger was soon regaining his strength.

It was with this young woman that Rodger had what was most likely his first sexual experience. He described it in his memoir, with characteristic discretion. "She smiled, and while her sari dropped over her head, I saw that she was incredibly young, little more than a child."[12] Through the absence of explicit description here, Rodger gives us a beautiful and almost photographic image: the sari going over the head, the imagined body where the emblems of femininity are sketched. It is interesting that he describes this young woman with almost the same words he used to describe the young Kidderpore prostitutes: "little more than a child . . . hardly more than children." The two episodes, which took place just two weeks apart, stand as parallel stories with opposite meanings: the first a mercenary transaction that struck Rodger as distinctly evil; the second, one on one, the experience initiated by the woman. Making love with her was the culmination of a relationship, one that coincided with the end of illness and the beginning of manhood.

When he was more fully recovered, Rodger began exploring the neighborhood while the young nurse was at work. He struck up conversations with the tailor whose shop was under her apartment. He visited the bazaar and met with silversmiths, tinsmiths, and jewelers. He was not taking photographs; rather, he was trying to relate to people, and finding that he had a gift with them. Although he didn't know their language or circumstances, he felt completely at ease, and so did they.

When Rodger rejoined the *Matra* in Calcutta three weeks later, he was in several ways a different person: he had had his first brush with death and his first sexual experience. But perhaps most crucially, he had become aware that he had the gift of empathy, and that would serve him well throughout his working life.

The *Matra* was docked in Calcutta for two weeks, loading up for its "long run" to America, Australia, South Africa, and back to India. During the wait, Rodger went to visit a distant cousin, a tea planter in Upper Assam. Traveling by slow train, river steamer, and mountain railway, he caught his first glimpse of the jungle and of green, geometrical rice paddies. Ox-carts plowed the fields, women walked about in colorful saris. "At one point, a fellow passenger with a large, white turban pointed through the window and said, briefly: 'Tiger.' And there it was, sitting like a big tabby cat in a clearing."[13] During this journey to Hattikhira, where he met his cousin and visited the tea plantations, he came to realize that if he made the sea his life, he would never see such scenes.

Rodger enjoyed being at sea, yet he already knew he would not be taking the four-year officer's training course—the expected path for someone of his background. Instead, he intended to arrange his discharge after just two years.

That winter, alone in his cabin with the rain roaring down, Rodger decided he wanted to be a writer. He had no experience, but he was confident that it would not be any more difficult to be a journalist than to write his diaries and letters. He spent much of his time rewriting his account of his trip to Assam. Then in January 1927, when the *Matra* docked in Boston, he mailed it to several American magazines.

Civilization! Rodger very much enjoyed his time in Boston. There, the British Army Lounge seemed like a corner of heaven. For the first time in his life he danced to live jazz—"The Black Bottom," "Thanks for the Buggy Ride," "Ain't She Sweet?" and "Cheek to Cheek." In Boston, he met Catherine Mayo, author of the best-selling book *Mother India*, who ran the BCA in New York. Impressed—if not by Rodger's conversation, then by his six-foot frame, wavy blond hair, and thoughtful blue eyes—Mayo invited him to her house in Mount Kisco, New York, to discuss India. Their conversations made Rodger feel as if he had entered a select club of explorers. While in New York, he also made excursions into midtown Manhattan and the Broadway theaters: the Roxy, the Strand, the Capitol, the Keith Albee.

After all of that, he must have found it hard to return to the ship and to the freezing cold that made his trousers stand on end. Not long after, however, the *Matra* passed through the Panama Canal, which impressed the young traveler deeply: "I stood . . . overawed by the beauty of the tropical forest, the jungle-covered islands and the wildlife, exotic birds in the forest, a galaxy of multi-coloured fish in the crystal clear water and wanted to record it all on paper."[14]

The Pacific crossing was smooth, and Rodger became rather restless until

the next landfall, which was Australia. The young man was charmed by Sydney: "All was more basic, closer to earth, and I soon learned to prefer the palm-fringed streets of Sydney to the gaudy lights of Broadway, and sun-tanned girls striding in cotton frocks to their fragile counterparts in leopard skin coats."[15] On another stop in Australia, Rodger enjoyed a brief fling with Elsie McDonald, a Scottish girl with "a drop of Maori blood."[16] One of Rodger's first self-portraits dates from this time. In it he is aboard the *Matra*, dressed in a sharply creased white uniform.

The ship finished out its voyage by way of South Africa and the South Atlantic. This time was uneventful for Rodger, except for an attack of quinsy that he suffered in Gibraltar.

In January 1928 Rodger arrived back in England. His mother was waiting for him on the dock in Avonmouth. He soon learned that his first story, sent from Boston, had been picked up by the *Baltimore Sun*. "They paid $25 for it and I thought that proved my travel stories were saleable."[17] When he saw his first piece in print, he was both thrilled and disappointed. "They had some local artist that illustrated it and [in that picture I was shown] hacking my way through jungles with a machete and snakes with their mouths open. . . . I thought this was just so much overdone that I . . . had to take pictures to show what it was really like, and that's what started me. . . . [I wanted] to get integrity into the things I was writing about and not [have] it glamourised by somebody else who had never been there."[18] In his unpublished memoir, *20,000 Days*, he recalled: "There and then I decided my text pieces must be illustrated with my own photographs. . . . I bought my first camera, a small Kodak that fitted comfortably into my pocket."[19]

In fact Rodger had been taking photographs since he was fifteen, at the Bridgelands and at St. Bees, as well as during his voyage on the *Matra*: at the tea plantation in Hattikhira, in Ceylon, South Africa, and Naples.[20] Perhaps he preferred the romantic notion of a sudden revelation to the more organic reality: his interest in photography had been building up for years.

After only a few days back home at the Bridestones, Rodger felt oppressed by the family atmosphere and the unchanging routine. He now saw himself as a man of the world. He took a job at the Austin motor factory in Longbridge, Birmingham, working on automatic lathes, and began saving money at the rate of £5 a week. On weekends he tinkered with his Austin motorcycle, pushing the engine and cross-country racing with Davenport. Peggy Rodger recalls: "Fazzy did not know that George was racing up those hills and dales. . . . One weekend

George had a terrible accident, he had a scar on his leg all his life from it. But he hid it from Fazzy, never told him about it."[21]

Before Rodger had £30 in the bank, and even before his scar had healed completely, he had again signed on for the *Matra*. By February 22, he was gone.

This new voyage began with another bout of homesickness, with him writing six or seven letters home every day. But by early March he was cheerful. He went ashore in Port Saïd and strolled happily through the cosmopolitan crowd of Maltese, Venetians, and Sudanese. In his diary he sang praises of the moonlit desert. His letters of this period have an epic, Conradian tone:

> The ship would lift her bows clear of the water and then, with an almighty thud, plunge into the middle of the next wave which would be some forty feet high, sending the water out on either side like two solid green walls and throwing spray a hundred yards on either beam. Then, as she heaved herself out of the water again, water poured off her deck in sheets, foaming and churning round the hatches, thrown from side to side as it endeavoured to get back through the scuppers. As the spray was thrown into the air the wind caught it and sent it with terrific force right up and over the ridge . . . where we were suitably arrayed in sea boots and oilskins to receive it.[22]

When the weather had turned foul, Rodger found himself with plenty of free time. With the mate's help he improved his rope and carpentry skills. He used them to craft a secret panel in his cabin, behind which he hid some small treasures he had purchased: silk, perfume, and cigars. He read Raphael Sabatini's *St. Martin's Summer* and tried (with some difficulty) to read books by Alphonse Daudet and Pierre Loti in the original French.

The *Matra* arrived in the Bay of Bengal on March 19, 1928—Rodger's twentieth birthday. "Well I do feel a heavy-headed old antique," he wrote. "Here I am twenty years old today, not a penny to bless my name with and haven't even started to make a place for myself in the world yet. I really must put an end to this pleasure-making stint and start and earn my living."[23]

In late March, Captain Cornish encouraged Rodger to take another trip to Assam, Once again, he was impressed by the "tiger-infested jungle of India."[24] Nonetheless, he was coming to realize that he did not want to be a tea planter any more than he wanted to be an officer. Around this date, his diaries begin to note the onset of strong headaches—a signal of conflicts he was not ready to express in words.

Back aboard the *Matra*, Rodger continued to ruminate about his future. How could he reconcile his longing to travel with the need to earn a living? As it

turned out, making money would always be a struggle for Rodger. Except for rare periods, he never succeeded in reconciling the need for money with the yearning for contentment. He invariably chose adventure and personal happiness over material comfort—a choice that was feasible while he was young and unattached, but that would bring him much conflict in later years.

In May an event occurred aboard the *Matra* that reveals an important facet of Rodger's character. An eagle landed on the ship's deck, and a crowd of sailors circled the lost bird, jeering and tormenting it. Rodger was outraged. As he described it: "To be on the safe side, rather than touch it they preferred to batter it with a bag and poke it with sticks. The look in its eyes as I touched it was simply fine—majestic, regal, unconquerable, defiant—the look of a captured Rusham Bey, beaten in body, but not in spirit." [25] Repelled by his companions' cruelty, Rodger carried the eagle to a sheltered spot where it could recover, and cared for it until it could fly off.

Charles Baudelaire, in his poem "The Albatross," [26] describes a majestic wounded bird floundering on the deck of a ship, taunted by sailors. The similarity of the two scenes is striking. Baudelaire used the albatross as a metaphor for the poet himself—a "captive king" dragged down by the weight of his own giant wings. This romantic vision of the artist—alone against the crowd, misunderstood—is not unlike young Rodger's view of himself: he, too, was an isolated idealist and, like the poet, he would always feel deeply for the dispossessed. And like the poet, he would try to set the world right through his art.

On May 11, after six weeks at sea, the *Matra* docked at Marseilles before sailing on to London, where Rodger had arranged a rendezvous with Beatrice. The ship arrived in London on May 21, and Rodger was elated to find ten letters from home. He and Beatrice met at his cousin Marion's house in London and packed as many activities as they could into their brief time together: walks in the Buna gardens, an outing to the Holborne Empire Theatre, concerts.

The *Matra* sailed again soon after, reaching Antwerp by the end of May. Rodger had his camera with him and spent an afternoon making views of the cathedral and the streets. Antwerp was a clamoring harbor that never slept, and he drank in all the excitement. With awe, he noted the "fights at every corner" and "women tearing at each other's hair on the pavement . . . whines and shrieks from dogs, and the melodious raucous rhythm of an electric piano without which no tavern is complete." [27]

After a few more stops at European ports, the *Matra* arrived on June 8, 1928, in Middleborough, their final destination. Rodger packed his trunk and got

ready to return home. He had been at sea for nearly two years and had grown to love it deeply. "I must say there is something very fine about the open sea though I can't exactly define it," he wrote.[28] "I shall miss the sound of the sea, the roar of the waves as they beat up against the sides of the vessel. Maybe I shall lie awake at night and hear the pulsing of imaginary engines, the howl of a wind that does not exist and the lashing of angry seas that are not."[29]

Fifty years later, when I spoke with him, Rodger tried to understand his fascination for the sea, which had remained a constant throughout his life as an adventurer and a photographer. He associated the sea with another infinite landscape he loved: the desert. In the desert, too, he observed, the mind is lifted from everyday anxieties and preoccupations, left free to meditate and contemplate minute and telling differences: animal tracks, the colors and textures of sands, the height and shape of dunes. The changes of light in the desert are much like the shifting tides. In both, colors and surfaces change endlessly; life is hidden but teeming. "Why do some men develop a tremendous liking for the sea? Why do some cross the Atlantic in a boat while others have agoraphobia? This love for vast, empty space is individual, and it's hard to explain."[30]

Rodger often used words just like these to describe his photographs: to him, the small, contained space of a picture was actually immense, packed as it was with a distillation of experience. When a picture truly succeeded, part of it remained a mystery, something he could not explain.

Rodger had been idealizing England from a distance. Back ashore, however, he was disappointed. "There is certainly no cause to doubt the fact that we are once more in England. It is bitter cold. There is a typical British drizzle. Everything looks dull and murky. . . . Nothing could be more dismal than these wet, cold, uninteresting docks with no prospects of change."[31]

His description echoes that of two years earlier, just before he set sail for the first time. Since then, he had been twice around the world, yet it seemed to him that nothing had changed. Was it because he himself had not really changed?

The sea's foamy waves had brought to the surface of his soul those peculiar qualities that would prove essential to his life and his photography: a powerful capacity to love mixed with intense nostalgia, a longing for untouched spaces. For Rodger, it seems, happiness was always somewhere else, never here, never now. At sea or ashore, he could not help living in the past or the future. His unfulfilled longing for freedom—from himself, from his sense of having been abandoned—never left him. This longing manifested itself in a lifelong restlessness; Rodger's constant travels and explorations became his means of expressing his ideal of freedom. Only constant action and constant displacement could disguise

his intractable sadness. Only when the outside was reduced to its barest traits was he free of himself and of his sense of abandonment.

It could be said that Rodger became a photographer not by chance, as he later claimed, but because photography suited him so perfectly. In photography, time is never present.

When Rodger and I talked, about his trips or about anything, I often had the impression that he wasn't completely there. However friendly he was, the live wires of his feelings were kept away from the person he was talking to. His deepest emotions were linked more tightly to the people in his photographs than to his immediate family or closest friends. While writing this book, I had to question witnesses and colleagues about Rodger. Yes, they all said, he was a gentleman, I liked him and admired him—but you see, I never really *knew* Rodger.

Presumably Rodger found Beatrice waiting for him on his return. We do not know for certain, because he stopped keeping a diary during the next months in England. We do know that by early 1929 he had decided to immigrate to America. He had, after all, sold his first story to the *Baltimore Sun*. Surely America was his land of promise.

He obtained a visa, bought a third-class passage with the Cunard Line from Liverpool to Boston, and sailed for America with little more in his pockets than a few pounds and Catherine Mayo's address. His hopes were high: when he returned to England it would be in triumph. Perhaps he would even be in a position to marry Beatrice.

His timing was unfortunate. "As I soon found out, 1929 was not the best time to go to America. The Depression was just starting and very soon I had no money at all. But I was not insolvent alone. Everybody's money had run out in 1929. Rotund bankers and respected executives in horn-rimmed spectacles sold red apples on the street." [32]

But he did not turn back. He remained in the land of promise for six years, doggedly going from job to job, just barely surviving—first in Boston, then wherever he could find work. He stopped writing in his diary at this point, so we know little about these years of his life, except that most of the time he collapsed into bed early, exhausted after long hours working in a factory or on a farm.

Rodger himself was always reticent about those years. He was not generally a complainer, but from hearing the stories of many of his contemporaries—Americans or immigrants—who lived through the Depression, it is easy to imagine what he went through. They must have been difficult, lonely years, wayward years—like the ones he had experienced on the *Matra*, but without the protec-

tion of a community or the pretense of adventure. In America, for the first time in his life, Rodger was completely alone.

His first job in Boston was sorting wool. He found it relatively easily because the work was so distasteful that even in those desperate times, no one else wanted it. He had to grade fleece in an unventilated shack, in the powerful stench of sheep. His cohorts were mostly poor blacks and immigrants (Polish, German, Czech). His home in Boston was a one-room apartment on Joy Street in a run-down neighborhood. It had a cellar, and that is where he spent his evenings and weekends, developing and printing whatever pictures he had been able to shoot after work. In defiance of Prohibition, he bought a still and manufactured "truly vicious gin, while the enlarger produced only a few pictures of dubious quality."[33]

For two long years he graded fleece. Then the company went bankrupt, and he found work on a construction site. It was dangerous work: his first day on the job, his boss was killed by a steel girder. But at least it was outdoors, and Rodger was interested in learning how to build houses. He was sure those skills would be useful someday. So he spent the next two years in construction, until that company also closed, in 1933.

Rodger had saved enough money to acquire a second-hand car, a Ford he nicknamed "Boanerges" (again borrowing from the Gaelic). As it seemed there were no more jobs to be had in Boston, he decided to get in the car and take his first vacation in four years. So, armed with maps, he drove three hundred miles to the Finger Lakes in upstate New York. He had to sleep in his car during this trip, but for the first time in years he felt alive. He resumed his diary-writing habit, and used his Kodak Vest Pocket camera every day. His journal from this period contains a large number of 3-by-4.5-inch captioned pictures, affixed to the pages by adhesive corners.

The inside cover of Rodger's diary—a large, black accounting ledger—holds a map of his trip and a picture of his car: "Boanerges and I are faithful friends . . . His four pneumatic tyres eat up the miles at my bidding, and the soft purr of his well-lined engine is music on the road."[34] This was Rodger's first attempt at combining text and pictures, and he was consciously seeking a relationship between the two. In this private "reportage," he was using parts of a running text as captions. Throughout this trip into the Adirondacks, to Blue Mountain, and on to the Finger Lakes, he was fascinated by the natural landscape. With his experience on the *Matra* still fresh in his mind, he described the Blue Mountain: "range upon range of rugged hills surged upwards like a vast storm-tossed sea that, at a word of its maker, had been turned to stone."[35]

Rodger was also interested in the culture and history of Native Americans, in particular the Iroquois tribes, whose names he listed in his diary. He felt a deep

empathy for them because, in many ways, he also was among the dispossessed: poor, exiled, with few prospects. Most likely, he did not count himself among the "whites" when he wrote: "Once red men roamed where cities stand today, and all that remains of their proud dominion is a small reservation inhabited by half-breeds, and here and there an Indian cemetery—a grim memorial to the passing of the red man and his supercedure by the whites."[36]

Rodger drove Boanerges past lush landscapes—roads lined with pear and apple trees and fields of cabbage, beans, beets, and squash. It brought to his mind the Iroquois myth of creation. "The traditional lore of the Iroquois says the hand of the Great Spirit was placed on the land in blessing, and now in its imprint live the five sapphire lakes of Owasco, Cayuga, Seneca, Keuka, and Canandaigua."[37]

Before his funds ran out altogether, Rodger rounded out his trip with the obligatory visit to Niagara Falls. Then he shot a few more black-and-white pictures in Saughannock and Montour.

In Geneva, New York, he took a job as a mechanic working on automatic lathes at the American Can Company. Once again, he was working alongside men who were barely literate. He felt sympathy for them but could not make friends of them. He sometimes thought bitterly that he had had just enough of an education to feel a complete outcast. Would that be his fate? Would his dreams of being a writer and a photographer never come true? He saw clearly that without any connections he would never make it into the world of newspapers and magazines. The few stories he had managed to write since his debut piece in the *Baltimore Sun* had all been rejected: "I still wrote my stories . . . but they never saw the light of day. Sadly, I packed away my little Vest Pocket Kodak. Traveling, writing, photography, all had to be shelved while I concentrated on earning sufficient to keep body and soul under one roof."[38]

A rare picture from 1934 has survived: an official company photograph from the Geneva plant. Though made with a large-format camera, it has almost the look of a Farm Security Administration image by Walker Evans or Ben Shahn. In it, Rodger is sitting on a bench in a yard, one of a group of forty-two men in work clothes and one in a dark suit. He is twenty-five but looks older and distinctly discouraged, a man on the verge of renouncing all hope. The Stars and Stripes float in the background. So far, the "Land of Hope and Glory" (as he called America in his *Matra* diaries) had not in any way lived up to his dream.

Rodger was getting more edgy and his loneliness was becoming unbearable. He lasted only a few months at American Can, and then left to take a job just outside Geneva as a manual laborer on the Jacket Fruit Farm.

His new situation was a great improvement. The farm was owned by the family of Fred Brown Lee, who, he wrote, "accepted me as their own son."[39] He

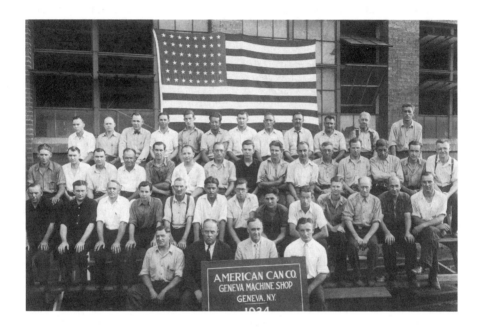

American Can Company machine shop, Geneva, New York, 1934.
George Rodger is in third row, right of center, with crossed arms. ©
Rodger Archive.

stayed on the farm from spring through late fall of 1934. In winter, when there was not enough work for the family to keep him on, he took a job grinding lenses for the Shuron Optical Company in Geneva. But the following spring he was back selling cherries for Fred Brown Lee from a roadside fruit stand: "I built up a roaring trade . . . Fred Brown Lee could not understand that it was not popular demand for his cherries, and feigned anger when he learnt it was not his cherries that swelled the market but my British accent." [40]

Rodger's spirits were much improved, and he even began to experiment with his camera again: "There was no one around me to tell me what to do, so I had to teach myself by making mistakes and learning from them. I developed and printed in the bathroom, saw what had gone wrong and tried to get it right the next time. I got some help, too, from [technical] articles in magazines." [41]

In late 1935, Rodger took stock of his six years in America and decided he would leave in the spring. He perceived his stay as a failure: he had not been able to fulfill his dream or even to make friends among professionals. He had no savings. He had barely survived, and his rough look and ragged clothes were proof of it. He had just enough money for a third-class passage back to England.

Meanwhile, in 1936 in New York City, barely ninety miles from the Brown Lee farm, Henry Luce was launching the first issue of *Life* magazine—the publication that would one day make George Rodger famous. The entire first press run of 466,000 copies sold out in four hours. Across the ocean, Robert Capa was taking the most famous war photograph of all time, in the Spanish Civil War. In the French countryside, Henri Cartier-Bresson, who had already traveled to Africa and Mexico, was assisting filmmaker Jean Renoir, while in Paris Chim was covering the strikes of the Front Populaire.

Rodger knew nothing about these things. Instead, he asked himself whether he was eternally condemned to wander "from pillar to post" throughout the world.

4

From Studio to Street

THE MAKING OF A PROFESSIONAL, 1936–40

This was hardly the homecoming Rodger had hoped for. A gaunt twenty-eight-year-old, he now looked far older than his age, and his tan from working on the farm with Fred Brown Lee was fading quickly. He had just one suit and one shirt left, and three pounds and change in his pocket.[1] In Liverpool it was raining—inevitable that it would, he thought wryly as he set foot on the dock—just when his only pair of shoes had worn through.[2] He immediately headed home.

His father's reception was icy. "When the only son goes away to make his living," Rodger later reflected, "the rest of the world is expecting him to make good somewhere, which I failed to do. So I left home . . . right away and came down to London."[3]

Rodger had circled the globe twice on a tramp steamer and traveled all over America, but in his heart he was still a country boy. He had never seen London before, and he hated it from the first moment: on the street, in the Tube, in shops, people never talked to one another. He hated crowds, and he hated his damp, dingy room where he had to feed the gas radiator with his few pennies. At night he scrubbed his shirt, underwear, and socks in the sink and hung them out to dry near the window.

"In England the depression was as impressive as in America," he would later write, "and the column of 'situations vacant' in the *Daily Telegraph* was only two-and-a-half inches long. . . . Then one of the *Daily Telegraph*'s 'situations' called for a photographer. The British Broadcasting Corporation needed someone to

take portraits for their [in-house] magazine, *The Listener.* The job was in London but even if it did mean stopping in one place for a while, I felt I should apply."[4]

Rodger's portfolio consisted of no more than six black-and-white prints of the Adirondacks, the Blue Mountains, the Finger Lakes, and Niagara Falls. But he had nothing to lose, so he got ready to bluff his way through the interview—in America, he had become good at bluffing. And it worked: "In no time at all, judgement had been passed and rather to my amazement I emerged a professional photographer."[5] He would later remark: "It was probably the luckiest stroke I ever had!"[6]

He was elated at the prospect of a weekly £5 check (roughly $75)—more money in his pocket than he had seen in ten years. But he was also panic-stricken: he had absolutely no experience with studio equipment. "A studio was provided with backdrops, floods and spots, and a huge half-plate camera on a heavy tripod. I knew nothing of these things. The camera took glass plates in wooden darkslides. But I had never before seen a darkslide, [and had no idea] how to load one."[7]

Rodger's second stroke of luck was his newly hired assistant. A little younger than Rodger, Esmeralda was pretty with a mass of auburn hair, a heart-shaped face, and arched eyebrows. She also had an advantage over her new boss: she had studied photography at the Bloomsbury School and her technical training was impeccable. She needed the work as much as Rodger did, so they struck a deal: she would train him after hours and teach him everything she knew. From that point on they worked late at night, photographing each other with the huge Speed Graphic half-plate camera. Esmeralda showed Rodger how to vary lighting, bracket exposures, and process plates.

Rodger was learning every day, and not only professional techniques: his social skills were improving as well. He began to assemble a personal life. He had arrived in London knowing no one but his cousin Marion. Now Esmeralda introduced him to her fellow students from Bloomsbury and to the pubs and cafés of Fleet Street. Rodger always felt that without her, he would never have made a life as a photographer. From 1937 until her death in the early 1990s, the two of them stayed in touch.

Very few of Rodger's early studio efforts survived World War II. Those which did—some formal portraits of Esmeralda and of another young friend, a few romantic nudes, and a still life of roses—have the contrived look of exercises. Plainly, Rodger was not cut out to be a studio photographer; even so, the knowledge of lighting that he was slowly acquiring would serve him well later on, when the lighting conditions were difficult: in the billowing smoke of the London Blitz, in Sahara sandstorms, in the hazy light of Africa. He later commented: "I

could never have got my Masai pictures if handling a camera hadn't become second nature to me, a matter of reflexes as instinctive as opening one's mouth to bite an apple."[8]

The student-photographer and his teacher worked out a system for portrait assignments. When someone was due to come in the next day for a sitting, the two of them stayed late in the studio to "get everything standardised—lights, exposure, time, temperature and so on."[9] When the model arrived, Esmeralda guided the person to the chair, which was set up in a prearranged spot. Any variation in the sitter's position would throw off the whole setup.

Rodger's success as a BBC photographer thus depended on a tenuous process. One day disaster struck: His Royal Highness the Prince of Wales—later Edward VIII—walked in. "I was confident in our preset lighting and Esmeralda [was] ready," Rodger recalled. "But His Royal Highness took the chair and turned it *the other way round*." Shyly but in a panic, Rodger asked him if he would mind turning the chair back as it was. The prince replied regally, "I don't see why I should."[10]

A year went by, and Rodger slowly acquired enough technical knowledge to get by. He began to feel restless. This was the first year he had spent in one place since he was seventeen. Then he had another break: "The course of the next twelve months saw many changes. Television was launched, and I was appointed to Alexandra Palace [which housed a number of television studios] to document the early productions." Until then, for Rodger, photography had been "merely a way of making a living."[11] But after he got a job and an office in the tower of "Ally Pally" (as Londoners called the large, domed brick building), photography began to seem rather exciting to him. Rodger started to think of himself as a photographer. Around this time a chance encounter took place that would change his life.

In *20,000 Days*, he would later recount: "Working on the captions to my pictures I was in need of carbon paper. So I phoned the typing pool next door asking if someone could bring me a couple of sheets. Someone did. She handed me two sheets of carbon paper and my destiny."[12] Cicely Joan Hussey-Freke, who had just walked into Rodger's life, was a shyly beautiful young woman of twenty-three. She wore a chic turban that showed off her shoulder-length dark hair. Her face was thoughtful, with a graceful nose and slightly drooping eyebrows that she lifted quizzically as she asked him a question. Rodger immediately fell head over heels for her: "Her dark eyes were deep and unwavering, and I knew there and then some vital seed was sown. She was the loveliest thing I had ever seen."[13]

Cicely had led a much more sheltered life than Rodger. A surviving photograph shows her with her classmates at St. George, a posh boarding school in

Clarens, near Montreux in Switzerland. In family pictures she can be seen in front of Hannington Hall, her family's impressive estate in Wiltshire. In other photographs—Sweden in 1937 and 1938, Montana-Crans in 1939—she is posing with her skis. During vacations she and her family traveled to the mountains of the Black Forest (1933) and Grenoble (1934), as well as to Nice and Corsica.

Now well recovered from his years of misery in America, Rodger was again a study in British good looks: tall, with blue eyes, a straight nose, and wavy hair over a high forehead. He ate frugally and spent much of his salary on clothes. In terms of the British class system, he was a middle-class working man with no trust fund or inheritance. He could not afford a car, nor could he afford the expensive sports—tennis, polo, skiing—that Cicely was used to playing. He was a good shot and could ride a horse, but now that his parents were in Cheshire he could only go hunting at the Bridestones.

Still, George and Cicely fell deeply in love. From the very start they clung desperately to each other. Cicely had just lost her beloved but distant father. Frederick Hussey-Freke had lived most of his life in Tientsin, China, where his five children—Cicely, Dorothy, Ambrose, and the twins Helen and Peggy—were all born. He had held several posts there, including Associate Chief Inspector of Salt Revenue in Shanghai and North China (1926 to 1931) and administrator to the Fu-Chung Corporation in Kaifengfu (1932 to 1935). When his family returned to England, he stayed in China with his Chinese mistress. "He only came to England every two years," recalled Cicely's niece, Linda Morgan. "He was like Santa Claus when he showed up, bringing gold bracelets engraved with Chinese characters for his daughters."[14]

When he died, Hussey-Freke had just retired and was settling down again with his family in England. His long-awaited return, followed so soon by his death, was a shattering event for Cicely and her siblings. The family had to sell the Wiltshire estate and move to Devonshire. (The Hussey-Frekes would eventually return to it, but not until 1950 when Ambrose, Cicely's older brother, was successful enough to buy the house back.)

Frederick Hussey-Freke had been a "tall, rosy-cheeked, white-haired and blue-eyed man; the bright colouring, as he once pointed out, of his national flag."[15] Charming and well liked, he enjoyed entertaining friends from all over the world and was an excellent raconteur. He loved sports and outdoor activities and was physically gifted; he also had a gift of empathy and was an excellent communicator. In those ways he resembled Rodger. He even looked like him, or rather, like the man Rodger was to become. To Cicely, Rodger's entry into her life at this moment must have felt like a miracle.

Shortly after their first meeting, Cicely and Rodger borrowed a car to visit

her new home in Devonshire, which looked over Taddisport and the River Tor-ridge. Together they strolled the deserted beaches and picked primroses. Rodger was both enchanted by the experience and unnerved by the realization that he was not making enough money for a potential bride used to a better daily fare than fish and chips.

When Rodger returned to the Alexandra Palace after his vacation, he learned that his friend Esmeralda was leaving to get married. Fortunately, by then he was able to maneuver the "cruelly critical" Speed Graphic by himself. But there were glitches:

> In the hush of the studio during transmission the shutter clanged like a full blast of the Hallelujah Chorus. . . . I strove to synchronise the shutter with a drum beat or a fanfare of trumpets so it would pass unnoticed. I was on the point of banishment from the studio when, in the nick of time, my request for a Leica was granted. . . . That first Leica created a new concept, a technique that was revolutionary and I quickly realised that its "candid" potential would be very helpful if ever I started travelling again but, for the time being, there was no al-ternative to my 5 pounds a week job in the television studios.[16]

Rodger's job brought him not only contacts but also an enormous amount of ex-pertise in rapidly developing photographic technologies. When he started using his new Leica in 1937, both Rolleiflex and Leica had been on the European mar-ket for only eight years. In response, Agfa and Kodak had immediately begun manufacturing special 35-millimeter film with such a fine grain that a full con-tact sheet could be used as a cover picture for an issue of *Berliner Illustrierte*, one of the pioneering German illustrated magazines.

In his spare time, Rodger began looking at illustrated magazines and seeking out the work of photojournalists. Photographers all over Europe were beginning to use the new cameras as if they were extensions of their eyes. "I was particularly interested in the work of Kurt Hutton and Felix Man in *Weekly Illustrated* under Stefan Lorant, who had come to England from Nazi Germany. Then Stefan Lo-rant left *Weekly Illustrated* to pioneer *Picture Post*—bigger and better."[17] By chance, Rodger had stumbled onto the BBC job. And another stroke of luck had landed him in the realm of television. Now, his recently acquired Leica would be his passport to a community of professionals that was beginning to form all over Europe and the United States. The new medium of *photojournalism*—made pos-sible by the Leica—was generating a quiet revolution. In France, Hungarian-born André Kertész, a pioneer of "candid" photography, had begun shooting night scenes, street scenes, and intimate portraits of avant-garde artists such as

Piet Mondrian, Alexander Calder, and the writer Colette. One of Rodger's future Magnum colleagues, Henri Cartier-Bresson, had been traveling in Africa and Spain, and during a sojourn in Mexico had produced some surrealistic street pictures—extraordinary, groundbreaking work. Another future colleague, David Szymin (later called David Seymour and nicknamed Chim), had come a long way from his birthplace in Poland's Otwock ghetto to settle in France and was now reporting for the new French magazine *Regards* on the mass demonstrations held by Leon Blum's Front Populaire (the French version of Roosevelt's New Deal). Robert Capa had thrown himself into the heat of the Spanish Civil War. His 1936 picture of a Loyalist militiaman collapsing in death on the Córdoba front was already a legend: no one until then had ever seen a war picture taken at such close range. He had taken it with the 35-millimeter Leica, which was greatly increasing photographers' mobility and making it possible to work inconspicuously.

In the United States, Henry Luce had launched *Life* magazine in 1936, modeling it after the French magazine *Vu*. Most of the American photographers on staff at *Life* had begun carrying a Leica on assignments, following the lead of their European counterparts. Soon, *Life* opened its gates to a flood of refugees from Nazi Germany and Eastern Europe. Luce—who never liked Jews very much, although he hired plenty of them—commented rather insensitively that in 1939, he just had to sit in New York and wait for the best photojournalists to land.

Twelve years earlier, when Rodger had been working on the *Matra* as an apprentice seaman, he had dreamed of becoming a writer-photographer, of publishing stories taken directly from his own experiences. Now he discovered that this dream was not so far out of reach: picture essays that told real and important stories of the world, stories with a point of view, were being published. Just perhaps, he might one day be able to quit his job, where he felt so uneasy—charity balls, galas, the ballet, and other formal occasions had never been to his liking—and join that new "community of photographers."

They called themselves "photojournalists." The rise of that new profession in Europe and the United States coincided with the social misery of the Depression era—misery that Rodger had experienced first-hand. In those years of heavy political, economic, and social turmoil, people felt desperate, yet they also felt hope for a better future based on political, economic, and social liberation.

While living in the United States, Rodger had been mired in a hand-to-mouth existence. Although he had fantasized about writing and publishing stories, he had not yet resolved to become a professional photographer. Had he known where to look, he would have found some who shared his emerging vi-

sion. The U.S. Farm Security Administration, headed by Roy Stryker, was employing photographers like Walker Evans, Dorothea Lange, and Ben Shahn, all of whom believed deeply that photography could help change the world.

Rodger's time in America had not been wasted, though; his casual jobs in factories and on farms and construction sites had given him a perspective on the working-class world that his own middle-class, provincial background would never have provided. Along the way, he had learned how to communicate with people. The time had now come for him to put all his lessons to use.

On the European side, the photojournalists Rodger now admired—Erich Solomon, Kurt Hutton, and Felix Man of *Picture Post*, as well as the contributors to *Vu* and *Regards* in France—were working not in groups but as individuals. Their images were changing the medium. Under Stefan Lorant's influence, posed photographs were going out of style. By the end of the 1920s Berlin had become, with Paris, a center for artistic and intellectual movements. Illustrated magazines such as *Berliner Illustrierte* and *Münchner Illustrierte Presse* were drawing a huge public: more than two million readers, at 25 pfenning (roughly 10 cents) a copy. With television still in its early stages, illustrated magazines had suddenly become the main source of information for a growing public.

The main difference between photojournalism in those early years and the business as we know it today, is that freelance photojournalists enjoyed enormous independence. Typically, the photographer approached the magazine's editor-in-chief with a completed story. Instead of shooting single photographs to illustrate text, the photojournalist developed themes through sequences of pictures. This approach allowed a broadening of perspective; it also made the pictures more precise, more articulate, and of equal weight to the text. All of this meant that photographers were beginning to be seen as authors in their own right.

In professional terms, 1937 was a sideways year for Rodger: he now understood what he wanted, but he didn't yet know how to start. On a personal level, his relationship with Cicely was becoming serious. Rodger lacked confidence, and he needed a woman in his life to establish his personal and professional identity. In a sense, he did not really exist when he did not have a witness to whom he could relate the circumstances of his life. Both of them were looking for compensation for what they felt their family life had lacked: warmth and empathy.

The short, handwritten letters they exchanged while Rodger was away on assignments soon blossomed into a veritable letter-mania. Three or even four times a week they exchanged detailed, typed accounts of their lives that ran several pages long. Cicely often complained of his long hours. She felt lonely and depressed—as she must have felt as a child whose father was away and whose

mother did not understand her. Writing from the Hussey-Frekes' family home on May 14, 1937, she told George—then visiting his grandparents and aunts in Scotland: "Rude interruption last night by Mother, who apparently does not approve of writing letters in bed."[18] Cicely's mother was rather erratic in her sense of propriety: on the one hand, she disapproved of love letters written in bed; on the other, she seemed to find no problem in letting Cicely go away for weekends or vacations with George.

From Rodger's replies, it is clear that the relationship had lifted his melancholy. He recovered his old taste for whimsy and poetry, and he often included some of his own in his letters, such as this one, written for Cicely's sister Dorothy:

> O give not your heart to a Frenchman
> O live not your life in La France.
> Are you blasée or bored
> that you must go abroad
> and not even give us a chance?[19]

In August, George and Cicely took their first long vacation together. In Cheshire, he introduced her to his parents, who for once both approved of his choice. He spent evenings telling her about his childhood. Before they left, he took her picture by the Pinnacle, the druidic rock on his parents' property.

In September, Rodger decided to leave his BBC job and pursue his long-held ambition of becoming a freelance photojournalist. "With Cicely in the offing, I had for the first time reason to better myself."[20] Rodger's notes date this move to September 17; however, it has been suggested that he actually lost his job a year later, when World War II began and the BBC closed its photography department.[21]

He had decided to contact Black Star, a very small but active photo agency with offices at Clifford's Inn, off Fleet Street. It represented both English and American photographers—among them Ralph Crane, Philippe Halsman, Constance Bannister, Baron, and Zoltan Glas—and dealt in everything from illustrations to features, from babies to sports, from fashion to stock pictures. The agency's owner, Muriel Segal, would find stories and check in with picture editors, then send out photographers and writers on assignments. Black Star's clients included newspapers and serious illustrated magazines of the sort that Rodger admired, but also fan magazines such as *PhotoPlay* and *Everybody*, both of which bought pictures of movie stars.

Anita Summer (née Gottlieb), a secretary at Black Star in the late 1940s, described the setting:

Fleet Street, where all the newspapers were concentrated—*News Chronicle, Evening Standard, News of the World, Daily Express, Daily Herald* . . . was very narrow: when the double-decker buses rolled through, the passers-by could almost touch the driver. There were lots of pubs and tea-rooms where the journalists hung out. Our quarters were cramped, and had a musty smell from all the pictures. There were always piles and piles of them waiting to be refiled.[22]

Rodger walked into the Black Star office without an appointment and leaned over the counter toward Muriel Segal. "She was tiny—maybe four feet eight inches—and her injured hip gave her a limp," Summer recollected. "Her short reddish hair was curly. She had brown eyes with a twinkle, a great sense of humor. Everyone—employees and photographers—would call her 'Miss Segal.' She was a powerhouse! She knew every editor at every magazine and when she called they were always there for her. They knew she would not waste their time."[23]

As for Rodger, he later noted: "It was a good move but I made the fatal mistake of not being either Felix Man or Kurt Hutton and starved very successfully for the ensuing year, which made a poor impression on Cicely's mother in far away Devonshire. And I was not surprised when Cicely told me she had to leave Alexandra Palace and go to Sweden. Even lovely girls of twenty-one did what they were told back in 1938."[24]

There were rumors of impending war, and Cicely's family only rarely allowed her to visit London. In professional terms, the same year was also a struggle for Rodger, and it was only his letters from Cicely that kept him going. He was making barely enough to eat a single meal a day and pay his monthly rent of five pounds, but this time he did not put his camera away. By the spring of 1939 his dogged obstinacy was beginning to pay: his name was in print and his work was being published in an important picture magazine. On April 13 he wrote to Cicely: "Did you see this week's *Bystander*? I have quite a nice page in it, but I wish they had made a little more of it, as they had 18 photographs and only used 6. It is useful though as they have given me credit . . . mentioned that I took the pictures."[25]

As summer approached, the two grew more and more excited: they would be able to spend their vacation together in Germany. This was Cicely's idea. She had spent a summer there in 1933, and on this journey they retraced the routes

she had hiked six years earlier: Freisburg in Breisgrau, Glottertal, Zaringen—villages seen in her old albums that reappear in the 1939 photographs taken by Rodger. She was introducing him to her world in the form of favorite landscapes, as he had done with her in Scotland the summer before.

> Certainly Cicely and I saw no suspicious writing on the wall and went off happily on a carefree holiday right into Germany itself. We walked mile after mile in the vast pine forest of the Schwarzwald; we climbed the Schlossberg for Pfirsich on a sun-lit terrace of the Inn; and we walked through the woods to the Glottertaland, drank the amber wine of the valley that was cooled in the stream behind the Engel Inn. . . . We drank from heavy goblets beneath the linden trees and all was peace and tranquility."[26]

Rodger and Cicely were young and politically inexperienced; they wanted above all else to be happy. In full denial, they succeeded in persuading themselves that the Hitler Youth they watched parading "seemed excessively arrogant but not necessarily sinister."[27] Meanwhile, observers in both Europe and the United States had been growing more and more alarmed at the rise of Hitler's National Socialist movement. One of these Cassandras, Allan Michie, would soon play an pivotal role in Rodger's life as both a colleague and a friend.

Michie had been born in Scotland but immigrated with his parents to Wisconsin when he was nine. A clarinet player since high school, he had eventually formed a small orchestra of his own. In 1936 he persuaded the captain of the SS *Hamburg* to let him and his friends play their passage across to Europe and back. In the three months between passages, Michie biked through Europe, staying at youth hostels, one of them in Heidelberg. At the time, Michie was only twenty-three, with little journalistic experience. Yet he understood immediately what the Hitler Youth were about. "In my conversations with them," he wrote, "I found no one thought for himself—they all repeated parrot-like phrases that they had learned from their propaganda books. . . . Everyone of them defended Italy's actions in Ethiopia, condemned the Jews for having all the money."[28]

Three years later, in the spring of 1939, Michie was working at *Time* and begging the foreign desk editor to assign him to Europe. Exasperated by their refusal, he resigned and boarded a freighter to Germany, his pockets full of letters of introduction to everyone, including Joseph Goebbels. Disembarking on September 3, the day World War II was declared, he was immediately detained as an enemy alien. He was saved by a phone call to a friend at *Fortune* magazine. In the spring of 1940, Michie got himself hired by *Life*[29]

After traveling with George in Germany, Cicely dutifully returned to Stock-

holm. She was still there when war was declared. Back in London, Rodger was seized by patriotic fever and wanted to enlist immediately as a rear gunner in the Royal Air Force. But on September 11 he noted in a letter to Cicely: "Father writes to me that he has seen a list of reserved occupations, and I am on the reserved list. That means to say that I am not allowed to join any National Service scheme, and also will not be conscripted, as my work is of national importance."[30]

The period from September 1939 to April 1940 is sometimes referred to as the "phony war." During those months, panic set in among the German émigrés in London, most of whom were either Jewish or politically opposed to Hitler and had been forced to flee their homeland. A number of these people were working at illustrated magazines as picture editors or photojournalists.

Sir Tom Hopkinson, an Englishman who worked at *Picture Post* under the editorship of Stefan Lorant, remembered realizing that his boss intended to emigrate:

> Stefan Lorant became convinced that the democracies intended to do a deal with Hitler: "You British citizens will be alright. But what about us bloody foreigners? We shall be handed back." . . . One day in late June he called me into his office: "Hitler is coming: he caught up with me once, I'm not waiting to be caught again." I was still negotiating with people in the Government to try to secure immediate naturalization for him when I learned that he had left on the *Britannic* for New York. At almost the same time, our two German photographers [Felix Man, whose real name was Hans Bauman, and Kurt Hutton, whose real name was Kurt Hubschmann] were imprisoned in the Isle of Man as enemy aliens, and very soon the only writers I had managed to recruit—Lionel Birch and Richard Bennett—were in the Army. Within weeks, we were down to five people trying to produce the magazine.[31]

In a letter to Cicely dated September 12, 1939, Rodger commented with satisfaction—and some understatement—on his own comparative good fortune. "All the refugee photographers, who had practically all the business in their hands, have now had their cameras taken away, and I don't suppose there are more than about six of us still doing it in the whole of London. *Picture Post* and *Illustrated* have both only one man left each, and nearly all the agencies have lost their staff too. So it does look like a heaven-sent opportunity to make a name for myself."[32]

Rodger's luck was to be one of the only British photographers in the field. Undoubtedly his admiration for Man, Hutton, and Lorant was tinged with the budding professional's envy of more established photojournalists. In his enthusiasm he played down his colleagues' situation: the German photographers had

not simply had their cameras taken away, they had been imprisoned as enemy aliens.

London was gearing up to resist the first German air raids. Curfews were being set, and children were being sent out of town. All of this worked in Rodger's favor; he was now one of only a handful of photographers who could work in England, at a time when daily scoops were possible. Beginning in the summer of 1939, his assignments became more frequent, his press book more impressive. In fact, he had barely enough time to catch a night's sleep.

Not surprisingly, he did not become rich: he still had to give a 40 percent commission to Black Star, and some of his assigned stories were no more interesting than those he had done for the BBC: society pictures ranging from "Televising the Sleeping Princess" to "Planning a Charity Gala." But to the good, his story list for 1939 included no fewer than seven publications: *Photoworld, Bystander, Leader, Life* ("Blackout Fashions"), *Pearson's, Click,* and a book, *Photograms of the Year.* And he managed to hold on to his sense of humor. "I am going to do a series of pictures on making a 'Blackout Coat' for their black dog," he wrote to Cicely. "A coat with white stripes on it so it can be seen in the dark!!! Crazy idea, but it will sell like hotcakes." Later he noted wryly: "Could not find a black dog around here as they have been evacuated."[33]

Rodger used work to stave off depression: whenever he had free time he started feeling melancholy. In a letter to Cicely that November he waxed nostalgic for their summer; now that a war was on, it seemed a faraway dream. "All sorts of little things crop up in my mind—the wild raspberries, and that glorious glass of beer we had going down the Afptal, where I took your pictures sitting at the table, then that other picture I took of you at Mathisleweir, when you stood up against the sky, more beautiful than any man-made statue."[34]

Most of the pictures, good or not so good, that Rodger was sweating to take were being published badly by editors. Most of them were being "cut to size" and used indiscriminately to illustrate whatever point the writer had decided to highlight in the text. In publications such as *Click* and the *Leader,* even his serious photo stories—among them "Secret Studios at the BBC,"[35] which was about home service transmissions and demonstrated the BBC's crucial role in the war effort—were cut up into puzzle pieces in order to fill the rectangle of the page. In the *Leader's* 1939 report "There is a War On,"[36] Rodger's pictures, cut up and collaged, were used literally as recommendations for dos and don'ts in wartime: do not waste fuel, do not send money abroad, do not hold long telephone conversations as the line might be needed, and so on.

One of Rodger's Blitz pictures, which would later become classic, shows two boys, the younger in a pram being pushed by the elder, who is wearing a tin hel-

met. The caption: "What are these kiddies doing? . . . These kids aren't carrying their gas masks, they're playing with official equipment (in this case, a tin hat)—and in any event, they should have been evacuated." At the time, this layout technique was often being used even in well-respected illustrated magazines such as *Vu*. For instance, many of Capa's photographs of the Spanish Civil War had been run with geometric patterns cut into them and with captions superimposed on pictures. The integrity of pictures was not an editorial consideration at the time, though it would become one later in the 1940s.

Rodger's photographs were treated better in *Bystander, Picture Post*, and the *Illustrated London News*. For example, sometimes they were spread out around a central text, as in "Planning a Charity Gala" (*Bystander*, July 5, 1939), or they had individual captions under each image, as in "Animal ARP" (*Bystander*, January 17, 1940).

In 1990, Pierre Gassmann looked through and reedited George Rodger's pictures for a fiftieth-anniversary exhibition on the Blitz.[37] While examining these images in a new context, Gassmann—a Paris-based printer who had participated in the launch of Magnum—discovered the true quality and scope of Rodger's photographs. As Gassmann explained: "In the 1940s George had been the victim of editors who chose 'what the public wanted to see'; only a small portion of his work had been used by magazines. In his own editing, he was also a victim of his desire to be useful." It seems that Rodger himself experienced the photographs afresh by working on them with Gassman, who recounted:

Walking through the exhibition, he discovered some of his pictures that I had printed differently, others that had never been printed. We had tried to be his interpreters, to find again the impressions that had pushed his fingers to the shutter. . . . George was not at all like Henri [Cartier-Bresson]: he did not give much room to his ego. But he was grateful when others "recognized" him. In our editing he saw his vision. We had followed intuitively the reason why he had made certain pictures.

Photographers are burdened with too much memory. They forget. To print means releasing their memory back to them, giving them back the details that they have not seen consciously, but that their eyes and brain have captured.[38]

In 1940, though, editors were more interested in news and propaganda than in picture quality. Nonetheless, little by little, they began to trust Rodger and to assign him more intriguing stories.

At the end of October, Rodger and Cicely took a weekend break in the Epping Forest and at the Burnham beaches. Rodger had been in joyful anticipation

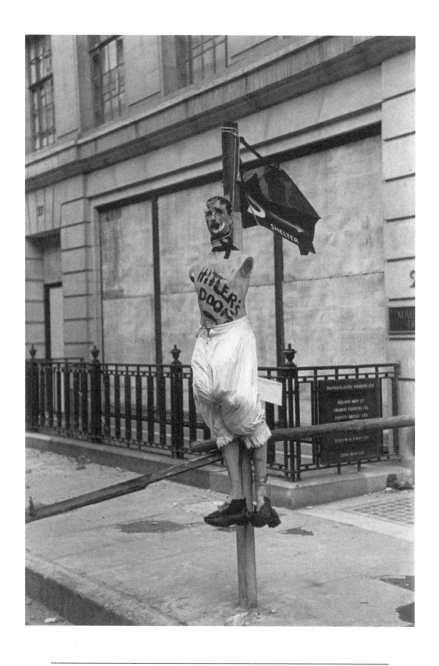

An effigy of Adolf Hitler appeared overnight in London after an early bombing raid hit the city, London, 1940. © *George Rodger.*

for weeks, and he painted for Cicely a lyrical picture of one of his favorite spots: "It will be lovely out there, with the smell of the damp leaves on the ground; and the air is brisk and frosty too. There is a lovely eggshell blue sky, and the hundreds of little balloons look so peaceful and reassuring."[39]

But two weeks later, on November 6, his good spirits were dashed after a weekend visit to his parents. He vented his longstanding bitterness and anger toward his father, who, he felt, had always treated his mother cruelly and kept her in social isolation. Rodger wrote to Cicely: "He can never see any wrong in himself, and all the faults he has, he endows Mother with. His statement about Mother's friends is a gross inexactitude, for she had many friends before her marriage but lost them through his inhospitality. . . . The fact is, he himself has had hardly any friends at all throughout his life, simply because I suppose he was too self-contained."[40]

As Rodger's thirty-second birthday approached, he was still struggling to establish himself professionally; success was not coming easily. When a few days after his birthday he learned of the sinking of the *Matra*, the ship on which he had voyaged for two years around the world, he grieved for the ship and for the sailors: "I feel very sad tonight for the SS *Matra*, my old home is now at the bottom of the sea. I spent two years on her, and it felt as though I had lost an old friend when I read of her loss in the evening papers today. She struck a mine in the North Sea last night. There were two killed and 22 injured."[41] But he also grieved for himself: he sensed that his youth had come to an end with the ship.

Early in March 1940, Rodger asked his mother to send him a solitaire that had been her own mother's engagement ring. Hilda Rodger was at first reluctant, telling him that this particular stone had not brought any good luck, but later she gave in.[42] Rodger sent the ring to Cicely, who proudly wore it on her next visit to her family. But her mother and relatives were neither impressed nor happy, and Rodger was furious and bitter when he found out—once more he felt rejected. As a freelancer who did not make a good living and was not considered suitable, he also felt vulnerable. In a March 11 letter his emotions surfaced as black and violent humor and as loathing for social conventions:

Oh blast those scandal-mongering cats in Torrington. Why the hell can't they leave you alone? Must we, just because they are old, pander to their desire for one more little thrill of sensationalism before they dodder over the verge of senility? Is it for us to titillate their long dead sense; to . . . provide in their hopelessness, a mental compensation for their dried up dugs and lost virility? Oh damn the old cows. . . . Your Mother of course is different, for, naturally, her thoughts are genuinely for your welfare. But why this sudden interest?—Why

didn't she begin six or seven years ago when you were most in need of her guidance and advice? Now, she wants to hold to the conventions of her youth, when an engagement was the occasion of family rejoicing, of feasting, of bowing and scraping and flaunting of family escutcheons. But, she should have started earlier. . . . You were sent out into the world with absolutely nothing but your bare hands to defend yourself against spears of your own rising desires and the barbed arrows of desire thrown at you by your fellow men. . . . NOW you are expected to conform to the conventions of 50 years ago. You know I'll stand by you.[43]

Cicely and Rodger shared a dream of living their life together on a different, less conventional plane, away from both their families and the rules and limitations they imposed. However, Cicely's visit of April 1940 would be the couple's last quiet time together for a long while.

She had returned to Sweden when Hitler invaded first Austria, then Czechoslovakia, Poland, Belgium, Holland, and France. The Germans dropped their first bombs on London on the night of August 24 and 25. Children were evacuated, civilians fled into shelters. RAF fighters fought back against the German Stukas that were raining bombs all over London. At this point, Rodger's career as a photographer began to soar.

In early September 1940, just a few days after the Luftwaffe's first bombing raid on London, Rodger was on Shakespeare Cliff near Dover behind a barricade of sandbags. He and a crew of reporters and photographers had been waiting a whole week for Germany to invade Britain. The sky remained very blue and very empty. Rodger took a picture of his colleagues grinning next to a sign that read: "R.I.P.—HERE LIE 3 PRESSMEN. DIED WAITING." As it turned out, they had not waited in vain. On September 7, four hundred German bombers roared overhead toward London, making the cliffs tremble under the newsmen's feet. The casualties in London were high that day, but the Germans paid heavily themselves: RAF fighters shot down 175 German bombers. From then on, the Germans would be making sorties only by night.

In 1940, *Life* had just opened a London bureau, and Allan Michie was working there as a writer and editor. He had come there from *Fortune* after a brief stint at *Time*. Either he or David Ritchie (*Life*'s assistant editor for Europe) spotted in the *Illustrated London News* Rodger's report on the Thames. They liked the understated, relaxed spirit of his pictures, so they bought the piece. On August 17, *Life* republished it across four full pages under the title "*Life* Spends a Wartime Weekend on the Thames."

By November, Rodger had published a few more pictures in *Life*. Michie

suggested that he become a stringer for them, pointing out that he was giving up 40 percent of his fees to Black Star. Rodger indeed thought that 40 percent of almost nothing was much too much, so he quickly accepted their offer.

Being a stringer meant that the magazine was entitled to a first look at what he shot but that he could still sell his stories to other magazines. "I just couldn't believe it," he would remember. "I'd been making five or six pounds a week on commission, and now my first week's cheque [for the Thames story] was for seventy-five!"[44] After that, Michie and Rodger often worked together on *Life* stories.

Rodger was now meeting the great *Life* staff photographers, among them Hans Wild and the tall, imposing Bill Vandivert, whom Rodger had never dreamed he could befriend. Seven years later, Vandivert would help found Magnum Photos, along with Rodger, Cartier-Bresson, Capa, and Chim. Rodger had just become a colleague of these men on the most prestigious illustrated magazine in the world, and his pictures had the potential to reach millions every week.

Over the next nine months, 48,000 Londoners would be killed by the Blitz, and thousands more made homeless. As the Blitz began, the response to Hitler was defiant: "We can take it."

For the first time, Rodger was feeling at ease in a city that he had until then disliked—a city under siege. Still a young man, perhaps he enjoyed this challenge to his courage and resilience, the new edge that life took on when it lost its varnish and was reduced to its essentials. He could feel the pulse of a vulnerable, quotidian life: routines were lost, and there was the sense that at any moment people could become homeless, bereaved, injured, or killed. But what Rodger most enjoyed about that time was the new warmth and spontaneity of human contacts. He thought of himself proudly as a chosen man, a man with a mission:

London underwent a cleaning process. All lesser mortals fled, and those who remained behind formed a huge and courageous family with a deeply caring allegiance towards one another. For the first time, people spoke to each other on their way to work. There were new things to talk about, things that had happened unexpectedly in the night—the house that had disappeared after a direct hit; the deep crater in the roadway; windows broken by blast. And also less sensational things such as food rationing and the shortage of petrol. It all added to a complete and immediate change in lifestyle; a lifestyle dominated by ever present danger and the continuous thunder of gunfire. I felt a compulsion to document it all in photographs. I worked at night when firebombs were dropped, at dawn and during the daylight rounds when planes came over, floating slowly

like silver fish against the deep blue sky and we watched them lay their lethal eggs when the bomb bays opened. Each bomb that fell left horror, tragedy and grief in its wake but I left these emotions to the Press Boys of Fleet Street. I was concerned more with the ordinary people of London and how they coped with their new lifestyle—just a record of a courageous, unflappable public.[45]

Under terrible duress, Londoners did show enormous courage, but to call them "unflappable" is wishful hindsight, a case of memory taking forty years to reconstruct and idealize the facts. Rodger's on-the-spot impressions of the Blitz were rawer than this. He wasn't ready for the sheer violence of war, which he was witnessing for the first time, and he would have had to try hard to keep up his own "unflappable" façade in his working hours.

On September 10, after covering an air-raid story, Rodger joined a group of colleagues for dinner at the St. Regis Hotel, followed by dancing to the music of a Cuban band. At dawn the group drove directly to shoot a story for *Picture Post* in an area of London that had been bombed while they were dancing.[46] He wrote to Cicely:

> It was pitiful Darling. Very poor class houses were just littered all over the place and the streets were heaps of debris. Some of the blocks of flats which had withstood the blast were simply wrecked inside. All windows were shattered and their frames torn from the walls. Furniture was all mashed up, all doors were torn from their hinges. A piano had been knocked clean through the wall of the house and was lying on a pile of debris outside. Inside, plaster off the walls and ceilings had come off and covered everything. . . . In one room, a little old lady of 77 was digging around for some cherished possession. She found a tin box among the wreckage—it had apples in it. She held it towards me and asked quietly if I would like one—I could have cried. Her hands were shaking, but her eyes were dry. She had lost all she had in the world. It was pitiful, and pathetic too, especially so somehow, as all the things she cherished and held so dear would, to our mind, be just worthless junk. . . . I have never disliked a story as much as I did this one.[47]

On a personal level, the war was striking fast and close. The same week, Cicely lost her best friend, Kay Garland, who had been attending Matins with her fiancé at the Guard's Chapel when it was bombed.[48] The Bridestones was also hit, and Rodger's family was narrowly missed. "Would you believe it, Darling . . . There are now two huge craters close to the little reservoir where we used to sit up and wait for the fox."[49]

Put to the test of unrelenting daily violence and under constant pressure to

produce stories, Rodger held up with resilience and courage. But he also realized quickly that he was not a classic "war photographer." Witnessing violence did not give him pleasure, and unlike some of his more hardened colleagues, he did not thrive on transforming human suffering into hard news. Instead, he took a step back and began to form his own theory about what his pictures should really be about: "My job with *Life* was not the ultimate fulfillment of my photographic ambition. Not by any means. It was too close to the news of the day. Ideally I wanted to cover the background to the news and, rather smugly perhaps, apply my own interpretation."[50]

Rodger was not always able to pick his own subjects or choose his favorite pictures, but he did publish many stories that year. On August 24, *Life* ran "Running The Gauntlet," publishing his pictures in conjunction with a story told by Captain John M. Dawson, a veteran of World War I and master of an English coasting vessel, who recounted an attack on his convoy and its successful defense by British Spitfires. The story was meant to counter Germany's claims that it controlled the English Channel. Other *Life* stories shot by Rodger around this time included "The Balloon Goes Up," "Night Raids Over England," and "Dover In Wartime." All of them covered various aspects of the Blitz, from everyday life to the courage of the RAF pilots.

The editors at *Life* always demanded very sharp images, so Rodger often used both his Leica and the medium-format Rolleiflex; the latter produced photos with a finer grain. For the European publications *Picture Post* and the *Illustrated*, he could rely mostly on the faster Leica. Almost always, he avoided spectacular settings and wide, dramatic angles. His images had a quiet, modest feeling, and their interpretive quality was constantly improving. His *Life* stories, and those in *Picture Post* and the *Illustrated*, ran as many as fifteen photographs, some of them full-page.[51] Rodger's picture of a submarine returning from a North Sea patrol made a striking opening spread in *Picture Post*. Other extraordinary opening pictures from this period include an image of a station commander sleeping while he waits at base for the bombers to return, and an amazing vertical shot of a bombed building, taken from a high vantage point, with the rescue squads, minuscule from this height, digging out people entombed in the wreckage.

Rodger accomplished much of this work alongside his friend Michie. At first appearance, they were Don Quixote and Sancho Panza. Michie was no taller than five feet eight, stout, jolly, and outspoken, and was constantly chewing on his pipe. A gifted writer, he could be at times boastful and self-centered. He could also talk himself into (or out of) any situation. One of his colleagues would later describe Michie as "a two-legged twister—an enraged hurricane! As much

as we love him, is the guy really sane?"[52] In contrast, the six-foot-tall Rodger was becoming leaner by the minute from lack of sleep and food eaten on the run. Self-effacing and phlegmatic, he rarely spilled his soul except on paper. A solid drinker and smoker, he knew how to have fun and crack jokes; yet he retained an air of seriousness at all times.

Rodger and Michie shared certain values: the desire to help their respective countries, to contribute to the war effort, and to bring to the millions of *Life* readers an understanding of Britain under the threat of Nazi invasion. They wanted to engage the sympathy of Americans against pessimists such as Joseph P. Kennedy, then ambassador to the Court of St. James's, who had cryptic pro-German sympathies and who was dismissive of Britain's chances against Hitler (he would soon be recalled by Roosevelt). Rodger wrote: "Desperately we needed American aid—war materials, fuels, food and money—and in my pictures, published almost weekly, I could show not only how much we needed it but also what we did with it when we got it."[53]

Michie's widow Barbara later recalled that "Allan and George would go to the airfield and meet Peter Townsend, who was with the Royal Air Force, and other Air Force pilots. On the RAF airfields, they interviewed air-raid wardens and firefighters."[54] Michie wrote about one of their trips to a Lincolnshire airfield, in preparation for a *Life* story they did on the RAF: "Huge Halifaxes, wicked-looking in their black camouflage even in the bright sunshine, stand in the open around the edges of the field. Here and there among them you can pick out the high tail fin of the Wellingtons, two-motored machines which carried the main effort of Bomber Command in the first three years of the war. . . . Mechanics, fitters, armorers and electricians swarm over the kites."[55]

During the Blitz, both Rodger and Michie had their share of adventures. Rodger once found himself pulling a lavatory chain in full view of the street—the bathroom wall had just been blown away. Michie was knocked out of his own house by a bomb. While the Battle of Britain was raging, Rodger photographed a British destroyer escorting convoys in the North Atlantic, and Michie spent two weeks aboard writing the story. Both of them traveled outside London and witnessed the damage done by German bombs to civilian areas in Bristol, Liverpool, and Southampton.

According to *Picture Post*'s Tom Hopkinson, Rodger's goal in the Blitz pictures had been to photograph "ordinary people in extraordinary situations" and to emphasize everyday courage, optimism, and a resilient sense of humor.[56] Although these elements are clearly present in Rodger's work of this period, there is much more to these photographs than daily life.

Eve Arnold, a seasoned member of Magnum and herself a prominent pho-

tographer, says that Rodger did some of his best work during the Blitz: "It had a lot of emotion. It was a young man's work."[57] Another English colleague, Peter Marlow, who edited all of Rodger's contact sheets for a 1995 monograph and retrospective, recently remarked: "When they thought of Rodger's Blitz, people always had in mind these Londoners drinking tea in front of ruins. By editing differently, I found that the pictures were really quite tough and unsentimental."[58]

An anonymous writer who authored the text for Rodger's report "The East End at War" found that daily tasks—cooking, sweeping, caring for children, trying to deliver mail—were essential to Londoners' survival: "Perhaps work provides the one hold on reality during the blitzkrieg dream." In Rodger's imagery, the ruins form the permanent, surreal backdrop to their activities—windows are shattered by glass, entire buildings split open. The contrast makes us feel what it must be like to live as civilians in the middle of war. Looking at the strained faces and ruined houses, we can imagine the smell of charred brick, the crunch of grit underfoot, the ubiquitous dust.

During the Blitz, Rodger found all at once his medium, his visual style, his mission, and a way to articulate his ethic. His vision is best summed up in a picture he took in Coventry in November 1940, the morning after the town was razed by Luftwaffe bombers. "After Coventry," Michie wrote, "the Nazis sat back and announced that they had added the word 'coventrate' to the lexicon of war."[59] Rodger's picture does not look spectacular—on the contrary, it has the elegant and classic perspective of the nineteenth-century English landscape photographers he admired: the winding street, the town, and the spire of the famous cathedral in the background. At first, the street seems suffused with fog—only on second glance do we realize that it is billows of smoke rising from the ruins and that the spire is a skeleton of itself.

As a photographer, Rodger was developing a poetic gift for integrating his various experiences. It may seem that he only photographed a single instant, but he had really expanded time into space, linking his memories of sea tempests with the smoke rising from Coventry.

In early December 1940, *Life* offered Rodger his first foreign assignment: four weeks in Africa recording the progress of the Free French fighting the Italians under Charles de Gaulle. The *Life* editors especially wanted pictures that would show America how the Allies were fighting German and Italian troops and their collaborators. He wrote in his memoirs:

> I was very happy working in the Blitz for *Life*, and, with Cicely due to return from Sweden, I wanted to flaunt my new-found prosperity before her. On the other hand, West Africa offered me my first foreign assignment. I cabled Cicely

and she came back right away; but she said I should go. Wisely, she pointed out that, in a very short time, my reserved occupation would be taken off and I would be conscripted into the army, where my usefulness would be problematical. Better to let my pictures talk through *Life*, and the four weeks would soon go by. "Don't worry," she said. "I'll wait." We kept close together in London lest some bomb should happen to have our name on it. It made no sense at all to have one of us killed. Either we had a future together, or no future at all.[60]

Cicely left for Devonshire and Rodger for Glasgow, where he was due to take the SS *Seaforth* bound for Douala and the French Cameroons. Rodger had no idea then that his "four-week assignment" would turn into a two-year, seventy-five-thousand-mile adventure with no fewer than four hundred stopping places—possibly the longest assignment ever for a foreign correspondent.

He would only see England again via China.

5

The Desert Campaign

1940–41

On December 10, 1940, in the rain, Rodger departed from Glasgow for the African front on the SS *Seaforth*, which was blacked out and loaded with munitions.

Rodger pushed Cicely's image away; he knew she was safe in Devonshire with her family. He was elated that *Life* magazine had chosen him for this assignment despite his relative inexperience. In late 1940 there were only six English and American war correspondents to cover what would soon be called "the Desert Campaign," and Rodger, who not so long before had seen himself as a something of a failure, was one of those six. He had made it into that very exclusive international club. He was awed at the thought that his stories would soon be read by more than five million American families. *Life*'s circulation, estimated at half a million when it was launched in 1936, had grown to ten times that number in four years. Rodger hoped that his photographs would soon join those by some of the most celebrated photographers of his time—Margaret Bourke-White, Robert Capa, Eliot Elisofon, Bob Landry, Carl Mydans, John Phillips, George Silk, W. Eugene Smith, and a score of others.

Rodger had been ordered to join Commandant Leclerc and General Charles de Gaulle and their Forces Françaises Libres—the "Free French"—who were fighting Mussolini's advancing troops in Chad. Nobody knew exactly where the action was in Chad, but Rodger was confident he would soon find out.

While bombs rained down on London, the British had succeeded in finding

the money to buy food, ammunition, and ships. But that money was running out, and the British needed a loan, quickly. Winston Churchill pleaded for one with Franklin D. Roosevelt, and got it. The Lend-Lease Act[1] of March 11, 1941, provided the British with special credits; at the same time, the Atlantic Charter offered them hope that the United States would eventually join the war against Hitler. However, Churchill was eager to maintain Britain's independence in at least one area, and he decided that area would be the North African war.

Historian Phillip Knightley has observed: "The desert campaign attracted the best war correspondents, produced some of the best writing, and was given a disproportionate amount of space in the newspapers. It threw up more heroes, more household names, and more legends than any other fronts. It became the most romanticized part of the war, 'a correspondent's paradise,' 'the last gentlemen's campaign.' "[2]

Like many of his colleagues, Rodger was soon working in unprecedented conditions: far from his editorial board, uncontrolled, he was free to plot his own stories and his own ways of circumventing both Allied and Middle Eastern censors.

For this reason and others, 1940 and 1941 would turn out to be among the most mysterious years of Rodger's life. He spent much of his time traveling alone with local guides and interpreters; and he met only sporadically with other war correspondents, as *Life* was cautious not to send two of its men out to the same spot at the same time. Rodger would turn his personal experiences of that time into a book, *Desert Journey*, taken largely from his diary. "I stood on the foredeck, watching the last dim shape of land disappear into the night. Bob Low of *Liberty* joined me together with a friend who, to me, was only a bulky shape in the darkness. Bob introduced us: 'Robert,' he said, 'Here is Rodger from *Life*.' And Robert J. Casey, of the *Chicago Daily News*, always quick-witted, linked his arms through ours and cracked: 'Well, here we go, *Life, Liberty*, and the pursuit of happiness!' "[3]

The *Seaforth* was transporting plenty of munitions but had room for only a handful of passengers. Rodger's autobiography provides a sardonic accounting of them: two Free French officers, a planter from the Gold Coast, the Bishop of Sierra Leone and his entourage, and three black nuns on their way to Takoradi. (In *Desert Journey* he added "two negresses in flamboyant clothing.")

Because of the strong possibility of an attack by German U-boats, the *Seaforth*'s captain decided on a longer but safer route by way of Iceland and Labrador. The ship edged its way through storms and icy waters and by New Year was approaching Africa. As the outside temperatures soared, so did the spirits of those aboard. The journalists placed the ship's navigation officer in charge

of announcing the New Year in each of the Allied nations, so that they could toast the King, De Gaulle, and Roosevelt nonstop, with champagne and brandy. Writer Paul Fussell has observed that during World War II, soldiers and war correspondents alike suffered so much from absurdity, boredom, and "chickenshit" that "the notion that everyone has a perfect, even a constitutional, right to binge was thoroughly established."[4] Like chain smoking (a habit picked up by Rodger and most other English during the Blitz), drinking in the 1940s was considered a natural and harmless way of overcoming boredom or fear while raising good spirits.

By January 2, 1941, four rather headachy journalists had reached Africa. In the absence of any German attack, restlessness quickly set in as they waited for the *Seaforth* to discharge cargo in a series of muggy, sleepy harbors before it set them ashore at their destination, Lagos.

Once they had arrived there, Rodger joined up with Robert Navarro, a cameraman from the *March of Time*.[5] The five men wanted to meet the French in the French Cameroons; Rodger had learned that De Gaulle's Free French had regrouped there.

Rodger was as bored as he had been when he was milking his musical cow in Yorkshire. Exasperated, Low and Casey caught a plane to Cairo, where they hoped to be closer to the action. Rodger and Navarro were reduced to stringing up bananas to ripen on the deckhead. "How quiet and peaceful it all seemed. . . . It was almost impossible to realise that the siren was still wailing in the London we had just left, that thermite bombs were still raining down, setting the city alight, and high explosives were still shattering the homes of friends."[6]

But Rodger's situation did not stay quiet for long. Two days after he disembarked to meet his contact, Commandant Thierry d'Argenlieu, he heard that the *Seaforth*—by then on its way to Douala—had been torpedoed by German U-boats. The captain, chief engineer, mate, steward, radio operator, and crew were all killed.

While Rodger was pondering this, d'Argenlieu informed him and Navarro that they would find their orders in Douala. Rodger and Navarro arrived there on January 25, and Rodger rushed to the post office to send a cable: since leaving Glasgow, forty-six days had passed without a word between Cicely and him.

Rodger was crestfallen to discover that no instructions were waiting regarding their assignment with the Free French. Instead, his orders read: "Social and economic survey of the region." "The Commandant was not going to pander to the whims of a thrill-seeking journalist. I took the no-war-no-work attitude and demanded that the matter be taken up immediately with General de Larminat."[7]

Most war correspondents who had, like Rodger, been placed on "reserved

occupation" (though in theory they were accredited to the forces as noncombatants) were eager to become part of the war machine. Though they were rarely mentioned in dispatches, they considered themselves part of the fighting forces. By the end of 1942 there would be nearly one hundred such correspondents in North Africa, with more coming in. The British Ministry of Information later acknowledged them as "an integral and essential part of our fighting activities on land, on the sea, and in the air."[8] Rodger would be awarded seventeen battlefield medals in the coming years. After the war he would tuck them away in a drawer and never wear them or even mention them.

The two Englishmen in French West Africa needed help. Rodger had studied some French at St. Bees, and could read the language, but he lacked conversation skills. Navarro spoke no French at all. While they waited for de Larminat to arrive from Brazzaville (nine hundred miles away), the commandant assigned them a pleasant house on the outskirts of town and an interpreter, who called himself "the Baron"—according to Rodger "an enigmatic man, difficult to decipher—suave, knowledgeable, exuding charm—the sort of man one took a liking to immediately, but knew one shouldn't."[9]

Rodger and Navarro hung around with a usually drunk and always frantic Baron, who drove his Oldsmobile at manic speed, scattering children, dogs, and goats and raising clouds of red dust in every African village they visited. Between car trips, Rodger would rush to the post office and send a cable or a letter to Cicely. Finally, de Larminat arrived and granted them permission to join him at the oasis of Kufra in Chad, where Colonel Leclerc was organizing a Free French force to attack the fort at El Tadj, an important Italian stronghold.

But no army plane was available, and Kufra was nearly 4,000 miles away as the crow flies. A map showed that the last 1,500 of those miles had no roads at all. North of a town called Mousoro the map showed only a vast white space inscribed *"Région sans eau et sans végétation"* (region without water or vegetation).

The Baron made his move: he had, he claimed, unparalleled knowledge of the Cameroons and French Equatorial Africa. He knew every planter, trader, and official on their way and would thus be the perfect guide for Rodger and Navarro. They had to agree. In a few days the Baron had his own car and a Chevrolet pickup packed with a mountain of gear: Rodger's cameras and typewriter, maps, gas, water, canned food, and camping gear. Having been warned by their guide against the voracious local white ants, they dispatched their newly hired assistant, Anacolet, to purchase steel trunks. The trunks he returned with looked new, but were locked. "Special price," he explained, " 'cause keys lost."[10]

In a spurt of patriotic optimism, the Baron added a case of whisky and another of champagne so that they could celebrate with Commandant Leclerc and

the Free French their pending victory over the Italians at Kufra. Thus equipped, the self-styled *mission de reportage* started out on its four-thousand-mile trek.

The ride was pleasant at first. The road took them through pineapple plantations and hardwood forests where toucans chirped away. But after only two hundred miles the Oldsmobile broke down. The Baron went on ahead to Yaounde, where he found a serviceable Chevrolet pickup and two other local helpers: one for Anacolet, who drove one of the Chevrolets, and a man named Barnaby, who would be cook, interpreter, and mechanic.

In the two vehicles, the six travelers left Yaounde under a tropical downpour that turned the laterite road into red mud. Rodger had his first encounter with black tribal life when they witnessed a local dance. Finally he was taking pictures, although not of the war. As they drove north they left the jungle behind, and palm-frond houses gave way to domed clay huts. Black tribespeople gave way to Haussas, Chadian Arab horsemen, who rode at full tilt alongside the vehicles on horses with silver-studded saddles foaming at the mouth.

Rodger was fascinated with Africa, but his keenness was dampened by his growing exasperation with the Baron, who constantly halted the *mission de reportage* to attend to his own business or catch up with his friends. Both activities involved much drinking. When he made them take a 150-mile detour so that he could inspect his gold mine, Rodger became truly angry: "It would have been easier for me had the Baron known a little about press work and considered the trip a serious enterprise, organised to help the general cause of the Allies, rather than a pleasure jaunt arranged for his own entertainment." [11]

Rodger did not yet realize that he was already falling in love with Africa. He later often commented on it: "I've always felt this affinity with Africa and things African. . . . There is something that seems to draw me. . . . The first time in Africa I felt really close to it." [12]

By early March the travelers had reached the territory of the Sara, hunters who went about naked but armed with spears, bows and arrows, and three-foot knives with barbed prongs. Now that traditional life has largely disappeared from Africa, which is struggling to survive civil wars, drought, famine, and endless political misery, we can only imagine the wonderment Rodger must have felt in 1941, traveling across mainly uncharted country that must have seemed eons from Europe and the war. West Africa then was a patchwork of English and French colonies. Pockets of indigenous life were thriving, and many Africans had never encountered white people.

In "The Vanishing Africa: Safari Through Kenya, Uganda and the Southern Sudan," Rodger would later write:

Africa as a "Dark Continent" is a thing of the past. Enlightenment has crept into the very blackest recesses of her swamps and jungles. The old gods have departed and rule is by the ball-point pen rather than the spear. One must accept now the new Africa and admire the rapid advancement of the African people. And yet, with the passing of tribal rules, something has gone from Africa which no new-found national independence can replace. . . . I, for one, miss the old medicine man and the sorcerers and the ancient tribal rites, the customs and taboos, which was the Africa of the bygone days. I traveled thousands of miles to see if somewhere, in some corner . . . there was not still a little of the old Africa that was known by men like Livingston, Burton, Stanley, and Speke . . . I found that it had almost gone—but not quite.[13]

By the end of 1942 there would be more than one hundred English and American journalists in Africa and the Middle East. This is how Alan Moorehead, a reporter for the *Daily Express,* described it: "Wherever we went in the Middle-East we remained on what we liked to think of as 'British soil.' Like the children of very wealthy parents, it seemed quite natural to us that we should occupy the best houses and hotels, that we should have at our command cars, motor-launches, servants and the best of food."[14]

Rodger was extremely English in many aspects of his personality: his courage was coupled with stoicism, wry humor, a refusal to show emotions or acknowledge feelings. When he arrived in Africa, he knew nothing of the languages or customs of the local people he encountered, and he had to rely on interpreters. But though naïve and at times unwillingly arrogant in his naïveté, Rodger was not one of the colonialists described by Moorehead. He lacked the self-confidence, the sense of entitlement. He had never been cosseted; he had achieved what he had not through privilege but through hard work. At every stage of his life he had had to battle isolation. By the time he arrived in Africa he had survived a lonely childhood; he had been a scared young sailor on a tramp steamer; he had spent seven years in America during the Depression, living hand to mouth; and he had risked his life every day during the London Blitz. Now thirty-three, he had an understanding of solitude that manifested itself as a taste for independence. He had learned to mask his vulnerability under a varnish of dry humor and distant good cheer that would grow more opaque as the years passed.

From the start, he felt an affinity with Africans and Middle Easterners. With them he let his guard down. Their largely nonverbal communications were based on shared feelings. He felt more at ease with them than he did among most of his European and American colleagues. On that first trip, though he appreci-

ated a good meal and the hospitality of a French or English administrator, he quickly came to loathe the endless lunches and social rituals of colonial life. Slowly, Africa was transforming him. He adjusted to the local pace, and learned to build his life and his work around the best light and the least heat. On a deeper level, he began to believe that Westerners had a lot to learn from Africans and Middle Easterners. Ultimately, this belief would affect his own habits and rhythms profoundly. He would trade haste for steadiness; he would abandon news deadlines and scoops for in-depth reporting.

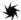

By the end of the first week of February, Rodger, Navarro, the Baron, and their helpers had covered half the distance to Koufra. On February 12 they arrived at Fort Lamy in Chad, where Rodger encountered the administrator, Sultan Kasser, commander of the Haussa:

> He had arranged a *phantasia* [horserace] for my special benefit. I bit my nails to the quick and waited . . . First I had to visit the house of Sultan Kasser and meet his wives. There were eleven of them. . . . The Sultan in his gorgeous robes led the way. I followed and the chief wife followed me. She was a robust woman of no modest mien. In all solemnity, as we mounted the stairs, she slipped a hand up my wide, cool, tropic shorts. No more did she withdraw it when we reached the roof and leaned against the parapet to hear the Sultan extol the virtues of his windswept sandy domain with all its dust and thornscrub.[15]

Rumors that Leclerc had already taken Kufra were now endemic in the streets of Fort Lamy. Had the journalists missed their scoop?

"God help you when you get into the Djourab," declared one of their informers as they entered the "regions without water or vegetation." Navarro had prudently declined to go on. Rodger and the Baron ignored the warning, just as they had the rumor of Kufra's fall. In the next town, Moussoro, they hired an Arab guide and drove on without a trail, cutting across Chad toward Libya.

The Djourab was a desolate expanse of desert with no tracks to follow. To avoid the heat, the travelers drove by moonlight. Their Moussoro guide was entirely covered with lice, so they sat him on the Chevrolet's roof, from which he scanned the dunes, one hand shielding his eyes. The code they agreed on was one punch on the roof for a left turn, two for a right. But for miles on end not a sound came from above, and when Rodger finally stopped the car he found their guide sitting in a trance. As soon as they started up again, the guide began pounding frantically on the roof. Again the travelers stopped. This time, as a test, they

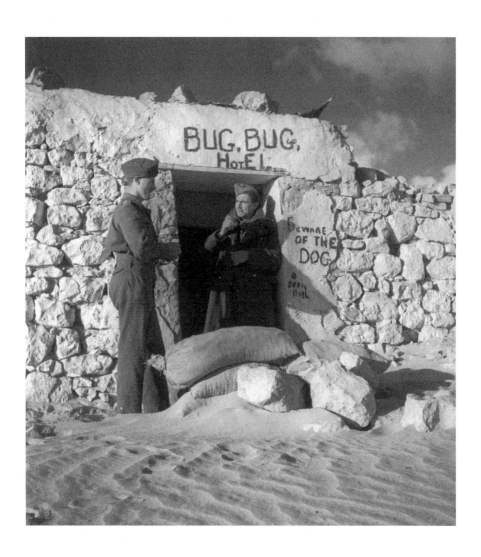

George Rodger in one of his less salubrious desert billets, Western Desert, 1941. © *George Rodger.*

asked him to point toward the next outpost, Kourotoro. He confidently pointed in the direction from which they had just come. Only now did it dawn on them that their guide was mad and that they had been driving in circles. The Chevrolet had been following its own tracks, and sinking in the powdery sand.

They could do nothing but wait. On the second day no help had arrived, and a sandstorm was brewing. Blinded, out of food and almost out of water, they were saved by the last-minute appearance of Senoussi tribesmen, traveling on horseback, who offered them food and camel's milk. "In the darkness," Rodger wrote, "I put my boots into it. I would never have done that in London—either put my boots in the milk or drunk it afterwards."[16] A Senoussi guided them to Faya in just ten hours, a three-hundred-mile drive. Beyond Faya there was a track, but it was littered with meteorite pieces that cut the cars' tires to shreds. Rodger was thrown against the Chevrolet's windshield and snapped off his two front teeth, which had been gripping his pipe. There were times, he later commented, when "you had to forget yourself."[17]

On March 3, 1941, Rodger and the Baron arrived in Sara, just a day's journey from the Kufra oasis. In, front of them they spotted a truck convoy. With a sinking heart, Rodger realized that these were the Free French transporting prisoners: "Vive la France! Koufra est tombé!" Just twenty-four hours earlier the Italians had raised the white flag over the El Tadj fort. The *mission de reportage* had spent three weeks fighting its way across four thousand miles of desert—all for nothing.

Furious at having missed his scoop, Rodger blamed the Baron and lashed out with derogatory comments about Italian troops. Or maybe he simply shared a then common prejudice that Italian soldiers were cowards, softies used to personal luxury who never quite made it to the last part of Mussolini's slogan "Credire, Obbedire, Combattere" (Believe, Obey, Fight). El Tadj, a fortified garrison with enough ammunition for several weeks, had surrendered to a handful of Free French who had only a single machine gun.

With the captain's permission, Rodger and the Baron helped themselves to some spoils of war: Pirelli tires, Pellegrino water, winter coats, gas, and oil. Rodger's morale improved when he learned that the Brigade d'Orient, a Fighting French force, was on its way from Fort Lamy. Rodger was eager for another photo opportunity and convinced himself that a fully armed, motorized force traveling all the way through Africa to fight the Italians would make a great picture story for *Life*. They decided to catch up with the battalion, which had started a week earlier, by cutting through the desert to Abicher in Eritrea. It was three thousand miles to the east, but as Rodger wrote, in a self-mocking, Kiplingesque tone: "This was la Mission de Reportage, for which all things were possible."[18]

They started out recklessly, their speed fueled by the Baron's cry, *"Plus vite! Plus vite!"*—only to crash two days later into a *wadi* (riverbed), breaking a rear axle. Rodger and the two helpers waited next to the broken-down car under a makeshift tent while the Baron and Barnaby dashed to Kufra for a new axle.

They had only four days' worth of water, and by the fifth day the Baron was not yet back. Soon they had no more strength and lay down, weak and delirious from thirst. Before falling into a fitful sleep, Rodger talked to himself; he considered rearranging the jumble of stars in the beautiful, cold sky over his head. "I dreamed I was back at home, in the heather moors with my dog and my gun, but the dog kept changing into a camel." [19] "By the end of the fourth day my tongue was blue and I was already writing out a farewell message to put in a bottle for some wandering camel rider to find, when the Baron arrived in a swirl of dust and a torrent of vitriolic French obscenities." [20]

It seemed that the Baron too had been delirious: Barnaby explained that his boss had been hospitalized in Kufra with sunstroke. When he came to three days later, the doctors would not let him go, so he had to escape to rescue his friends. Rodger was impressed that the Baron had kept his promise of bringing back a new axle. [21] Once revived by drink and sleep, Rodger and his crew wrapped up their hands to avoid blistering from the burning-hot metal and quickly repaired the car.

By mid-March they had caught up with the Brigade d'Orient near Adré. This time, Rodger was indeed able to shoot a striking picture story about a battalion of black Sara tribesmen who had joined the Allied forces. Then they left Chad for Sudan, rejoining de Gaulle at El Fasher on March 20.

De Gaulle was already becoming a legend. His striking physique—he was six-and-a-half feet tall—made him especially noticeable in the desert. He displayed some hauteur in his views as well, and liked to talk about himself in the third person. Rodger spent three days with him and shot a full story, "De Gaulle in Equatorial Africa." It was published first as a six-page spread with a frontispiece in *Life* and then later—with a few variants and a different layout—in the *Illustrated* (June 14, 1941) under the title, "We Visit De Gaulle's Africa." Rodger would stay in contact with the general throughout the desert campaign.

The travelers slowly worked their way through the Sudan. An important encounter for Rodger was with the Nuba of Kordofan. They were warriors who had rarely seen a white man, and never a photographer. He was stunned by the women's beauty: their bodies were oiled and then painted in deep reds and yellows, their hair was waist-length and braided. The warriors were giants with shaved heads who wore only a small loincloth. In the face of growing Muslim op-

position, they remained fiercely faithful to traditions unchanged since the Middle Ages.

Except for their cattle and weapons, they possessed nothing. They lived as far as they could from their Arab neighbors, in villages of conical mud huts. To Rodger's great disappointment, they would not let him take pictures; when he tried, a forbidding wall of spears quickly formed in front of his camera. He left, promising himself that one day he would return. That would not be until some eight years later, in the spring of 1949; the result would be some of the most powerful images he ever took.

By early April, Rodger was getting plenty of action pictures. Under constant machine gun and shell fire, he weaved back and forth between the front lines at Asmara and Massawa, and witnessed the fall of Massawa and the arrest of the Italian officials in charge of the city: Vice Admiral Bonnetti and General Bergonsi. The Italian East African empire, declared by Mussolini exactly four years earlier, had collapsed.

Looking at a stone bust of Il Duce that lay crushed on the ground, Rodger, the middling student with a good memory for poetry, quoted by heart from Shelley's sonnet "Ozymandias":

> . . . on the sand
> Half sunk, a shattered visage lies, whose frown,
> And wrinkled lip, and sneer of cold command,
> Tell that its sculptor well those passions read.[22]

Now Rodger needed to get his films back to London, and quickly. To his dismay, a public relations officer in Cairo told him that the film would have to be developed by Kodak and censored through the British Embassy. The films were then neglected for three weeks, killing his hard-won scoops. Furthermore, the commercial developer had handled the negatives carelessly and ruined them. As a result, the very few remaining pictures of that spring were scratched beyond repair. When his "Harbor of Fallen Massawa"—shot between April 8 and April 14— was finally published two months later on June 14, Rodger commented bitterly: "The editors of *Life* were able to use only a double page from the vast stock of pictures that should have been available. I had sweated across 9,000 miles of Africa to get these pictures. It was a little annoying."[23]

In Khartoum, Rodger and the Baron parted company. Rodger hopped a steamer in Wadi-Halfa, then a train to Cairo. On the morning of May 10 he arrived in Cairo in the blazing heat and found a room to share at the Carleton

Hotel with Captain Ingram, a friend from London who worked with Indian Public Relations.[24]

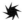

After some administrative misadventures—Rodger was unable to get accredited to British forces because another *Life* photographer, James Jarché, already had been—he found someone he wanted to work with: Desmond Young. Young was that rarity, a PR officer with press experience. They decided to travel together to Abyssinia, where Rodger hoped to record the surrender of the Duke of Aosta and his Fascist army. The two journalists managed an introduction to Haile Selassie, Emperor of Abyssinia, whom Rodger had photographed four years earlier for *Picture Post* when he was a king without a country. This time Rodger made his portrait at the desk of the recently surrendered Duke of Aosta: Haile Selassie looks up with a faint smile, his hands next to an inkstand bearing the Italian golden eagle.

From past dealings with British censors, he had learned never to let go of unprocessed film. This time he developed his negatives himself in an army lab, then dispatched them by air to New York via Lagos. He might as well have hitchhiked with the contact sheets: it took no less than three months for them to reach New York.

Rodger learned that his friend Allan Michie was to arrive in Cairo. He and Young started the long trek from Abyssinia, driving and then finding a plane lift for the last leg. Ever parsimonious, Rodger noted his new penny-pinching record: "So ended a hitch-hike that took me 3,500 miles through four countries, in only seven days, and for a total cost of four pounds."[25]

By early June, Rodger had met up with Michie at the Shepheard's Hotel in Cairo. After his desert travels, the beautiful European-style hotel with its lush gardens near the Nile banks seemed a paradise. Large, rotating fans kept away the damp summer heat; sheets were changed daily; bathtubs were enormous, liquor and food abundant. Rodger took a few days off, and with his Rolleiflex and Leica began roaming the city's streets. Right across from the hotel women of every conceivable skin tone stood at the doorways or hung out the windows, hailing the scurrying soldiers. Michie would describe this red light district in his diaries; Rodger delicately omitted it from his narrative.

Cairo was still a rambling town smelling of jasmine, dust, cardamom, hashish, and horse manure. Rodger's height and blond hair attracted attention, and he was stopped constantly by peddlers of shoes, socks, fly swatters, razor blades, cigarillos, dirty magazines, hashish, and lottery tickets. They did not have much luck with him. Rodger often joined Ingram, Young, or Michie in their

walks in the *souk* among jugglers, acrobats, and snake charmers, or joined gaping soldiers gawking at a performing baboon or a mongoose fight.

Still bleary-eyed, just out of the crumpled uniform in which he had lived and slept for weeks, and only barely recovered from a bad case of "Nile boils" and a diet of canned food, Rodger was flabbergasted to see British officers in creased shorts returning from the Gezira Sporting Club or the Turf Club. Some carried golf bags; others sported polo mallets, rifles, even hunting dogs.

With the typical political insouciance of the day, the British often referred to the *djellaba*-wearing Egyptians as "nightshirts" or "laundry bags." The "laundry bags" did not think much of the British either; but they also understood that they were there to stay, so they resolved to milk them for what they could. They could earn more from a single British tip for opening a door than from a hard day's work in the fields.

British and Allied troops were all over Cairo, on their way to Suez or the Western Desert. Neither food nor liquor was restricted, and the old bars— hastily repainted and renamed *The Spitfire's* or *Churchill's*—were doing brisk business. Red Cross nurses and officers queued for éclairs and *mishmish* (apricot paste) at Groppi's bakery, for European clothes at Robert & Hugues, for cash at Barclay's.

The city never slept. Music blared all night from the open cafés, and loud-speakers broadcast the sound tracks of the open-air movie theaters, which showed Egyptian hits and old English films. Officers roamed late, often drunk and singing, from their bridge, poker, and gambling at the Royal Automobile Club.

And Cairo had become a spy's paradise. The immediate problem for the British was how to gain and keep control in the Middle East. And along with this new wave of espionage there came a massive official effort in public relations and propaganda. The lines between political information, public relations, and propaganda began to blur, so it was often difficult to make out who exactly was playing what role, and what kind of truth words and pictures conveyed.

In the course of writing this book, I was asked point-blank by one of Rodger's colleagues[26] if Rodger was a spy. I do not believe he was. True, he was secretive, and he liked at times to put on mysterious airs, but my sense is that he was too earnest a journalist and politically naïve to have been involved in espionage. Though he wanted his pictures to help the British cause, he would not have crossed the line to propaganda. In fact, propaganda pictures were always his bête noire. As Colin Osman, a British World War II historian, writes: "Some war historians assign clear-cut motives for action, clear directives by propaganda ministries and the obedient carrying-out of them by the lackeys in the field. The truth

is very different: there were good ideas and bad ideas, there was muddle and confusion, there was discipline and indiscipline. The only thing that united everyone was a will to win the war partly born out of pride and partly out of desperation."[27]

The worst result of such desperation, Rodger thought, was the "cooked" picture, manufactured with good intentions and often obtained with offerings of whisky. As the war took its course, it became a more and more common occurrence, a product of the blossoming of British public relations. Rodger would allude with disgust to fabricated pictures for which photographers happily threw "smoke bombs" to simulate enemy fire.[28]

A well-known team of propaganda photographers, Sergeant Chet Chetwyn and his group, was nicknamed by disgruntled colleagues "the Chet Circus" for their habit of showing up at rest camps with lots of booze to entice the troops to put on a good show for them. One famous picture of the battle for Tobruk, published widely to great acclaim, was in fact taken three days after the battle ended.

Rodger always believed strongly that falsifying pictures would lead in the long run to the general discrediting of his medium. Later on he stated: "To maintain their strength, I knew that [the pictures] had to be meticulously factual, honest and true, no staged effects, no Western Desert mockup, no falsity."[29] He also believed that to obtain that difficult truth, personal independence was the only way to go. He refused to join up with the army photographers who were part of the Film and Photography Unit, founded in 1941. Though he felt an affinity with some of his army colleagues, Rodger believed that their lives were vastly different from his. "I could go anywhere I liked and nobody could tell me not to, not even *Life* magazine. . . . But the other photographers with the British Army and with the Film and Photography Unit, they were under army orders and they had to photograph what they were told to photograph."[30] Yet as Rodger knew, the price of independence was isolation. Thus, though he very much admired the work of Bert Hardy—an army photographer who was producing extraordinary images—the two did not become friends until after the war was over. "We went through the war in the same places and we never met . . . because he lived in an army barrack and I lived in the suite at the Shepheard's . . . so there wasn't all that camaraderie, there was no chance of it."[31]

Once again Rodger had to find accreditation. Just as he was pondering what to do, General de Gaulle checked into Shepheard's, and Rodger, the only other towering man in uniform in the lobby, spotted him immediately. The general remembered him from El Fasher and immediately granted Rodger and Michie permission to join the Fighting French. "We grabbed our bedroll and camera equipment, loaded the car with oranges and grapefruits, and went to war," wrote Rodger.[32] Michie boasted of the immediate purchase—on the *Life* expense ac-

count—of a khaki uniform. He also borrowed Rodger's pith helmet "to look more like an army-man."[33]

In Jerusalem, Rodger and Michie joined a growing pool of foreign correspondents, among them Richard Dimbleby, a well-known BBC commentator, and Leonard Mosley, a Reuters war correspondent. Rodger also caught up with Bob Low of *Liberty*, whom he had not seen since their *Seaforth* days.

It had been six months since Rodger had started his "four-week" assignment.

The next day, Rodger and Michie passed the Syrian frontier with no visa, simply stepping on the gas when they came to the border checkpoint. From Sannamein, Michie went back to Jerusalem to interview General Wilson, while Rodger started out for Damascus with Ingram and two other colleagues, Tozer and Tanner. They wanted to cover the Allied forces' final attack. Along the way, eight German bombers decided to target their truck. They barely had time to jump off before a bomb exploded not ten feet away from Rodger. The impact knocked him out for a full minute, but he then sprang up, camera in hand. "I leaped up to get my picture, and immediately froze in horror . . . For a fraction of second I looked the rear gunner straight in the eye. I can't think why I had forgotten the rear gunner. I was so astonished, I just stood there paralysed and let him shoot at me."[34]

Being the target of a low-flying aircraft in the middle of nowhere was, he belatedly realized, much more perilous than any situation he had encountered in the London Blitz.

Toward the end of the conflict, and later in his career, Rodger would sometimes comment on the effect war has on people who are caught in its midst, and would try to describe how it had affected him personally: the hardening, the pushing back of emotions, the dulling of the sense of danger. While they were being bombed on the Damascus road, Rodger had "forgotten" the rear gunner, who could easily have blown him and his companions to bits. Earlier on, he had embarked with too few reserves of water in a trackless area of the desert and had almost died of thirst.

Throughout the war, Rodger regularly pushed himself to his limits, repeatedly crossing the thin line between courage and foolhardiness. There were several factors driving his often impetuous behavior: patriotism, the desire to get good pictures to help the cause of the Allied forces, a personal recklessness. On several occasions he would remember the war in terms of a game or an exciting adventure while in the next breath condemning it on moral grounds.

Rodger was in his very fabric an adventurer: the reckless rider whose taste ran to untamed horses, the motorcycle driver who almost broke his neck, the son who ran away to sea (but, in part to spite his father, did not become an officer), the ob-

stinate wanderer who went his own punishing way all through the Depression in the United States, from one hopeless job to the next. This man, with his strange mix of subtlety and blindness, his craving for love and taste for solitude, his respect for rules and desire to follow his impulses, told his audience and told himself all along that he was a man of duty, when he was also, in fact, a seeker of experience.

Why do adventurers roam? In Rodger's case, one answer that comes to mind is simple: to forget himself and his conflicts through action. World War II, with its blend of sufferings and relentless anonymity, inflicted enormous pain on artists and poets. But for Rodger, at least in the beginning, it was also a blessing: his own problems—the ones he could not run from—would come to light only after the war had ended.

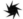

On the road to Damascus, after their truck had been bombed, Rodger and his companions tried to recover in an apricot orchard. After a few days they grew tired of unripe apricots. They also were bombed, it seemed, each time they took their pants off to bathe in the irrigation ditch or attend to more personal matters (Rodger's text hints that the apricots upset their digestion). Finally, they were able to get themselves to Tiberias.

There, they decided to take a twenty-four-hour break; all of them thought that the battle for Damascus was in a stalemate. Unfortunately for them, while they were eating steak and getting drunk on Mount Carmel wine, Damascus surrendered. Privately upset but seemingly unfazed, Rodger put down his glass and rushed back in time to photograph Colonel Collet, General Catroux, and General Legentilhomme, leaders of the Free French, together with British commanders, leaving headquarters after concluding the armistice.

Back in Jerusalem, Rodger again joined Michie at the King David Hotel. Journalists were flocking there from the Balkan front: Russell Hill from the *Herald*, Sam Brewer of the *Chicago Tribune*, Ed Kennedy from Associated Press, and many others. They confirmed the incredible news that Michie had heard on the radio just before Rodger's arrival: on June 22, 1940, at 4 A.M., Germany had launched a massive invasion of Russia, which that fall would culminate in sieges of Leningrad in the north and Sebastopol in the south. Everyone except Michie was upset: "I think it is a good sign," he wrote. "It confirms in my mind the fact that Hitler has lost the war when he failed to invade Britain after the fall of France."[35]

By month's end, Rodger and Michie were back in Cairo, having lunch with de Gaulle and trying to arrange new press accreditation. From the beginning, censorship had been a thorn in their side. Now they had even more reason to

worry: Claude Auchinleck had recently stipulated that all written and photographic material from the Western Front would have to go first through military censorship, then through a political censor from the embassy, and, last but not least, through an Egyptian censor.

Rodger and Michie were soon accredited, and while planning their next move they set out to shoot a story on Cairo. This included atmospheric views of the medieval streets, the mosques and harbor, and Allied personnel at the Sphinx and the Pyramids, as well as more intriguing sites such as the Muslim cemeteries, built near the Muqatam mountains, and the "City of the Dead."

Rodger shot some three hundred pictures for this Cairo essay, most of which were never published. He was frustrated: he was finding out that photographing daily life in the Middle East was very different from working in Europe or on the battlefield. Nothing in his experience had prepared him for the fact that he was automatically excluded from many places just because of who he was and how he was perceived. Many Middle Easterners were downright hostile to picture taking in principle. Photography was *hasuma*—shameful—and against their religious principles. In certain situations where he might have taken some good pictures, Rodger, with his Puritan background and frugal ways, balked at paying *baksheesh*.

Michie went through the same realization as he hit a wall in his attempts to arrange for James Jarché, a *Life* staffer, to photograph Egypt's King Farouk and Queen Farida in their home. The royal couple refused to cooperate, in large part because of the Muslim edict against representations of unveiled women. Both Rodger and Michie were beginning to understand, in Michie's words, "what we're up against in trying *Life*'s usual candid tactics out here."[36]

In mid-July an assignment came through: *Life* wanted a close-up of the Emir Abdullah Ibn Hussein of Transjordan (who would later become king of Jordan), and possibly another of Lt. Gen. John Bagot Glubb (known as "Glubb Pasha") and his Arab Legion. After Cairo's damp heat and their frustrating experiences, Rodger and Michie were eager to go back to journalism the *Life* way: a clear assignment, cooperative subjects.

Rodger was curious about the personality of the "Father of all the Arabs," whose relations with Britain were very cordial, as they were with de Gaulle. The two journalists drove out to meet the emir in Amman, and Rodger succeeded in taking some beautiful, relaxed portraits. At the same time, Abdullah talked to them at length about pan-Arabism. He dreamed of becoming king of an empire that would include Syria, Lebanon, Palestine, and Transjordan—a dream fueled by de Gaulle's recent offer of Syrian independence.

A few days later, the two journalists drove sixty miles out to El Mafrak,

where Rodger had been assigned to photograph the "Desert Patrol," Glubb's Camel Corps detachment. Because of their long robes, braided hair, and kohl-rimmed eyes,[37] they had been nicknamed "Glubb's Girls." Rodger made a one-time exception to his rule never to shoot action that had been set up. "They staged mock battles and charged my camera in mass formation for me to get action shots."[38] All in all, it was an exciting assignment, and Rodger took nearly eight hundred pictures in the four days between July 23 and 27. They were published first in *Picture Post*, then three months later in *Life*.[39]

In both his memoirs and his portraits, Rodger conveyed his perception of Abdullah as a leader whose intensity and serious sense of purpose were tempered with patience and a sense of humor. In this, Rodger may well have been overly idealistic. He described Abdullah in *Desert Journey* as "a man of surprisingly small stature but strongly built"; in contrast, the *Picture Post* journalist Lt. Com. R. Fletcher called him more bluntly "short and slightly plump." Rodger dubbed Glubb a "second Lawrence of Arabia," but the *Picture Post* reporter thought that comparing him with Lawrence was a cliché and a disservice.

The emir made no secret of the animosity he still felt for Lawrence six years after the writer's death. "Lawrence has put a lot of sand on my head, but the wind has blown it all away," he said in a forceful conclusion to Fletcher's interview in *Picture Post*. Lawrence had, after all, seen clearly through Abdullah, noting both his strong points and his limits: "Abdullah was too balanced, too cool, too humorous to be a prophet who, if history be true, succeeded in revolutions. His value would come perhaps in the peace after success. . . . The Arabs thought Abdullah a far-seeing statesman and an astute politician. Astute he certainly was, but not greatly enough to convince us always of his sincerity. His ambition was patent."[40]

Those few days spent in Transjordan with Abdullah made a strong impression on Rodger. It was possibly there that he formed his first bonds with everything Arab, bonds that would last the rest of his days. "After all," he wrote, "Abdullah would give us less trouble in Cyrenaica and Tripoli than the Italians had done. He would be a better neighbor to India than the late Shah, Reza Khan, had been. . . . A bloc of Arab states, each under its native ruler, stretching from Dacca to Suez, policed by a joint United Nations force, might not be a bad idea at all."[41]

When they weren't working, Rodger and Michie were having a good time. Abdullah offered them complete Arab costumes: a white *abbaya* (cloak), *keffiya* (headdress), *anaggal* (cord), and a silver-inlaid *khanjar* (dagger). Michie, who loved to dress up, promptly abandoned his hand-tailored khaki uniform and

Rodger's borrowed pith helmet and asked Rodger to shoot his portrait for his future book, *Retreat to Victory*.[42]

Later that day the journalists were invited to a meal by the Arab villagers. Before the feast Rodger had some fun at his friend's expense, posing as an expert in all things Arabic and assuring him that, as an honored guest, Michie would be offered the choicest part of the roasted sheep: the eyeballs.

6

Taxi to Tehran, a Hammock in the Himalayas

AUGUST-DECEMBER 1941

The train trip to Cairo was as long and hot as could be expected in Egypt in August. Back at Shepheard's Hotel, Rodger and Michie were once more confronted with the war correspondent's nightmare: accreditation renewal. Randolph Churchill's promises had come to nothing, and without accreditation they could not return to the Western Desert.

One thing Rodger could not bear was waiting. He decided to pursue his story on Cairo and went out shooting, ignoring the heat of 130° Fahrenheit. All Middle Easterners agreed that "only mad dogs and Englishmen" would go out at noon. Doggedly, over the first two weeks of August, the Englishman pushed himself. As a result he contracted a serious skin infection that involved malfunction of the sweat glands and had to fly to Jerusalem to see a doctor. Always the stoic, he bore without complaint a medical treatment that was sheer torture: the doctor had to peel off several layers of skin in order to restore his sweat functions. Halfway through the procedure, Rodger, still in the raw, received the long-expected call from Randolph Churchill and immediately boarded a plane back to Cairo.

Now Randolph Churchill began trying to persuade them to cover a naval operation aimed at relieving Tobruk. But the prime minister's son seemed too eager; Rodger sensed that he was trying to manipulate them. The journalists did their homework and, by intercepting a Reuters telex, learned that the British and Russians were planning a simultaneous invasion of Iran. So they confronted Churchill: he retreated behind the higher authority of General Archibald Waver, who had insisted on informing only six correspondents.

In *Desert Journey*, Rodger wrote: "He told Michie: 'If you don't like our arrangements, you can go and make your own.' "[1] Which is what they did. Their plan was simple: race the official correspondents to Iran, and scoop them.

The pair flew into Iraq, landing at Basra on August 28, and then took a taxi to Baghdad. At headquarters, other correspondents from American and British newspapers such as the *New York Times*, the *Times* of London, the *Daily Telegraph*, the *Daily Mail*, the *Chicago Tribune*, and the *Chicago Times* were anxiously awaiting information. With the help of Colonel Arthur Jehu, the officer in charge, Rodger, Michie, and Ted Gennock (a cameraman for Paramount) found an Iraqi cab driver willing to leave immediately. On August 29 they packed the car with canned food, water, and blankets and started the race for Iran.

On the outskirts of Baghdad the road became too rough for driving and their cabbie (whom they nicknamed "George") drove at breakneck speed along the adjoining tracks. By that evening they were in Khanikin, four miles from the Iraq-Iran border, where they learned that the Tenth Indian Division would occupy the town of Kermanshah at nine the next morning. They camped out, then took off before dawn, following a signpost that read PERSIA.

Rodger's fantasies of a lush green Persia with gardens, fountains, and "bejewelled damsels dancing with bells on their toes"[2] did not match the reality: Iran was a barren and scorched land impoverished by war and ravaged by disease. At dawn the next day, just after crossing the six-thousand-foot Paitok Pass, they caught up with the armored British brigade. Rodger photographed the British tanks as they rolled into town.

The two journalists learned that the Russians had been bombing the towns of Kazvin and Hamadan twenty-four hours after the shah had called for a cease-fire. They were granted permission for their taxi to follow the British trucks and contact the Russians. They left town on the tail of the armored British brigade that would occupy Hamadan.

Up until now, Rodger and Michie had been worrying about their competition. Now they knew they had their scoop and that in all likelihood the other correspondents were still in southern Iran. Huddled in the back of the cab, Rodger, Michie, and Gennock raced along with George, who seemed, like the Baron, to have no fear of death whatsoever.

Michie recalled: "On the road in front of us stood the first Russian troops the British had met in the war . . . Gennock started cranking immediately, and Rodger jumped out and began taking stills. I had nothing to do but put in an appearance, but I did win the dubious distinction of being the first newspaperman to see the Russians on the field of battle in the Second World War."[3]

In Kazvin, the elated journalists celebrated their scoop by going to the only

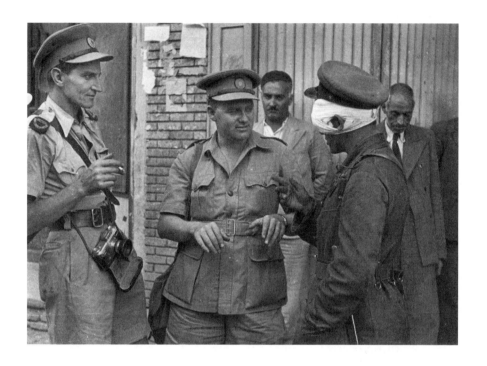

George Rodger and colleague Allan Michie meet the Russian army,
Iran, 1941. © *Rodger Archive.*

hotel in town, which happened to be the Russians' headquarters. When Rodger began snapping pictures of the Russian soldiers, the political commissar, unamused, gave orders to seize his cameras and films. Rodger pulled the old journalist's trick of exchanging exposed for unexposed rolls.

Clearly, it was time to leave town. George was waiting across the street, and off they went once more in their taxi, this time to Tehran, inspired by the thought of a good hotel room and a decent meal with cold drinks.

Along the way they passed column after column of exhausted and hungry Iranian soldiers, demobilized conscripts of the shah's army, who were wearily walking home without food or pay. It was almost midnight when they reached the Ferdowsy Hotel in Tehran, which was hosting other correspondents, among them Ronnie Mathews of the *Daily Herald*, E. R. Noderer of the *Chicago Tribune*, and Daniel De Luce of Associated Press. The kitchen was closed, so the hungry journalists sat down to a meal of cold fried eggs and turpentine-tasting whisky.

The next morning, they decided to spend their first day in Tehran relaxing and taking pictures. They were the only men in the city in British uniform, and the sight of them started the rumor that contrary to the ceasefire agreement, British troops had occupied the town. A crowd of curious adults and children followed them everywhere, including to the camera shop where they had gone to buy equipment.

Tehran was a strange place, ruled by the Shah, Reza Khan Pahlevi, who was bent on Westernizing Iran at any cost—including the welfare of his people. The center of town had beautiful palaces and buildings, wide streets, and lighted boulevards. But there was not a drain or a sewer, and as a result the population was suffering from rampant typhoid and skyrocketing infant mortality. It was a situation the Germans were happy to exploit.

"The amount of German propaganda going on in Iran is terrific," Michie wrote. "Copies of *Signal*, Goebbels's propaganda magazine, sell in all the bookstores. The German film *Victory to the West* played to capacity houses and every German newsreel is sure of a big audience. Theater managers are paid bonuses in addition to getting free films if they show the German newsreels."[4]

Rodger took pictures of the British minister, Sir Reader Ballard, and his Russian counterpart Andrei Smirnov, while Michie interviewed them. That evening they left Tehran and drove all night to Baghdad. The next morning they said goodbye to George, their intrepid taxi driver, who disappeared in a cloud of dust.

Back in Cairo on September 8, Rodger and Michie faced one of their usual problems: How were they to ship films for the next *Life* deadline? Rodger was

clear on one thing—never again would someone else develop his film. In Baghdad he had commandeered a bathroom at the Semiramis Hotel and turned it into a makeshift darkroom. He had blocked out the harsh sunlight with army-issue blankets and then done some cooking. "The heat was terrific. Relays of Iraqi servants kept me supplied with blocks of ice which were dumped into the bath to try to bring the temperature down a little. . . . The cold water tap ran at 102 degrees and there was no way of cooling it. Fortunately I had a little chrome alum with me and, by using it as an emulsion hardener, was able to persuade the emulsion to remain on the film even at so high a temperature."[5]

His negatives were entrusted to Colonel Jehu, who was flying to Singapore by way of Calcutta. The film would then go on a trans-Pacific clipper to New York and to *Life*. But for reasons unknown, *Life* would take a good long time—three months—to run the story.[6]

In Cairo, Michie and Rodger filed another application to join the British for an upcoming battle in the Western Desert. For all the British efforts to dislodge him, Field Marshall Rommel was clinging to the western border of Egypt, and the Luftwaffe was pounding Tobruk.

The British were moving slowly. As a consequence, Rodger and Michie had some time to spare—a rare luxury for war correspondents. The Viceroy of India invited them to visit the Northwestern frontier, so they flew to Karachi, then up the Indus Valley to Peshawar by government plane. From there they traveled to the frontier district between India and Afghanistan.

An armaments tycoon, Malik Samand Khan, invited them to visit his gun and rifle factory in the village of Zarghunkel near the Kohat Pass. Steel for the armaments was obtained by tearing up the Khyber railroad lines, which annoyed both the British authorities and the tribesmen, who had been given the privilege of riding free "because so many train conductors had lost their lives by merely asking a tribesman for a ticket."[7] Energy came cheap as well: the lathes were made of old bicycles parts, and small children powered them with their feet. Interestingly, it did not especially offend Rodger to see children at work—it was then, as it is now, a common sight. A great admirer of tradition and thrift, Rodger marveled at the ingenuity he saw: a factory, without any power-driven machinery was managing to turn out five hundred rifles a year—knock-offs of government models with counterfeit stamps.

Rodger shot his story. Afterwards, he and Michie were treated as guests of honor and served high tea in a proper English teapot. As a special present, Malik Samand Khan gave them two rifles "hot out of the oven," decorated with golden tassels and slings of red wool.[8]

The two journalists then proceeded through the Khyber Pass linking

Afghanistan and India. Both men were impressed by the Khyber defenses, which included dragon's-tooth tank traps, trenches, antitank gun emplacements, concealed pillboxes, camouflaged antitank ditches, and underground quarters. Forts and outposts topped each hill. These preparations and the newly constructed roads made the pass unassailable.

At the home of the governor of the Northwest Frontier, Michie and Rodger gathered information about the Afghan army. They were in no great rush: no one had heard about any impending battle on the Western front. So after taking leave of their hosts, they decided to spend a few weeks in India. They chose Simla, a hill station that was the long-time "summer capital" of the British Raj.

From their terrace at Simla's Cecil Hotel, they gazed at the Himalayas and inhaled the cool, pine-laden air. In this enchanted setting, they worked at processing Rodger's films and captioning the 450 pictures he had taken of the frontier and the Indian army and navy. Rodger then worked at passing his photographs through the Indian censors while Michie wrote a frontier story.

On October 23 they continued on to Calcutta, where they said their good-byes. Michie, who had been assigned to Pearl Harbor, proceeded to Rangoon, the starting point for the Burma Road into China. He was worried about his friend; though Rodger never complained about the length of his *Life* assignment, Michie knew he needed a break. He wrote in his diary:

> Rodger stayed behind in Calcutta. He is pretty disgusted with the way things have worked out. Although I warned the office in mid-August that he should not be kept out here much longer, they ignored my suggestion. When I finally got them to agree that we should go to India, I thought that they must agree to let him continue around the world with me to London via America. However, when I got the [okay] to come home, they suggested that Rodger should return via Cairo and Africa. . . . Walter [Graebner] argued that we couldn't leave the Middle East without a photographer and asked that I send Rodger back there to wait for a relief to come out. And since Walter is still "working" on the question of who to send, I'm sure old George will be sitting in Cairo for the next three months.[9]

Michie's predictions turned out to be accurate: Rodger received a cable enjoining him to stay in either India or Egypt until another correspondent could relieve him. He had already packed his kit and was about to board a plane to Cairo when he was seized with a full-scale attack of dengue fever, which kept him in Calcutta, delirious, for a month. On November 19, when he heard the broadcast of the Western Desert offensive, he was still burning with fever.

Two days later, Rodger, with the "stamina of a cold asparagus and an acute depression—the inevitable aftermath of dengue,"[10] was so anxious not to miss the final British tank offensive against Rommel's Afrika Korps that he hopped on a plane and made it to Cairo by December 2.

Five days later, on December 7, 1941, the Japanese attacked Pearl Harbor. The raid, which no one had anticipated, was photographed for *Life* by staffer Bob Landry. However, the issue of December 8 had gone to press a day too early for the story to run. Landry's pictures did not run in the following issue either, or the one after that, because the censors refused to clear his work. (Later, however, they would be published many times.) In the December 15 issue of the magazine, Pearl Harbor was covered mainly in text, under the headline, WAR! JAPAN LAUNCHES RECKLESS ATTACK ON U.S. Then: "Planes from 6 Japanese aircraft carriers sunk six American battleships, destroyed 164 U.S. planes on the ground and killed over 2,000 sailors."

In Cairo, Rodger was hearing dire news: many of his fellow correspondents had been wounded or killed, and five were missing. His close friend Ingram of Indian Public Relations had suffered a concussion from an exploding shell. On December 9, a full year after he had embarked on the *Seaforth* for a four-week *Life* assignment, Rodger was back at the Western front, camping with British headquarters southeast of Tobruk. Ingram, only barely recovered, joined him there.

Michie has aptly described the extreme confusion of desert skirmishes such as the one Rodger was now witnessing. It was like a battle at sea, "with opposing tanks and armored car forces cruising about like ships off the line, darting in just long enough to take shots at each other. Enemy columns are sighted across the bare, open sand as far off as 15 miles: contact is brief, but the action furious while it lasts."[11]

Rodger had finally arranged proper accreditation, and now had the title of Official Photographer to the Middle East Forces. But to his dismay, he was learning that it was almost impossible to cover any action: the British attack was a five-column drive, spreading westward "like the fingers of a gigantic hand."[12] The enormous distances and the absence of desert roads made it impossible to travel from one column to the next. Rommel's Panzer divisions were swinging back and forth across the Southern Desert, their positions changing by the hour. No one, it seemed, really knew where the enemy was.

From Tobruk, Rodger went in search of more action to photograph, driving to Gazala and Derna. He saw enemy bodies being blown to pieces by African armored cars and battalions. He photographed the entry of the Sikh battalion into Derna and then pushed on into Barce, which had just been liberated by Allied

forces. Around this time he took some of his best Western Desert pictures, including one of a young German soldier dead near his bicycle, west of Gezara; and another of a cross that had been raised over a grave by Rommel's Afrika Corps, stating in neat Gothic letters: "Here lies an unknown English lieutenant who died at war."

Then, in early December, the battle stopped entirely. Rodger could not remember who had told him it never rained in the desert, but that person had been misinformed. Sheets of torrential rain were coming down from morning to evening. Visibility was less than three feet. British and German troops were immobilized, and the red clay soil had turned into a deep mud from which neither man nor tank could budge.

A disgruntled Rodger drove, hitchhiked, and then flew back into Cairo on Christmas Day. A mountain of letters was waiting for him, and he clawed his way into it, looking for Cicely's handwriting. Instead there was a two-week-old cable from *Life*: NEW YORK APPROVES YOU GO SOONEST RANGOON SINGAPORE-WARDS.

7

Burma Fever

Rodger left Cairo on January 22. His new *Life* assignment was to cover the Japanese invasion of Burma. The only other *Life* photographer in Burma was Carl Mydans, who had been patrolling the jungle near Singapore before the Japanese invasion.[1]

Rodger's assignment was as ambitious as it was vague: with no editorial direction, he was to work alone, his "beat" thousands of square miles of extremely dangerous territory. Furthermore, the rules of the game had changed. On the Western front in Africa correspondents had been considered noncombatants. That meant that if captured by the Germans, Rodger would simply have been taken prisoner. The Japanese did not recognize international conventions. In Burma, Rodger and his colleagues would be treated as soldiers. They would have to carry weapons, and their press credentials would provide no protection.

The Allies' situation in Asia was grim. For the first few months after December 7, Japan controlled the Pacific. The U.S. Pacific Fleet had been almost totally destroyed at Pearl Harbor. In a matter of weeks the Japanese had dismantled empires in Asia that had taken the British and the Dutch centuries to build.

The Japanese conquered Hong Kong, Borneo, Java, and Thailand. The Philippines were soon lost, their defeat photographed by *Life*'s Melville Jacoby. In one of the harrowing pictures he took of the American capitulation, grinning Japanese guards were rounding up GIs for the death march from Bataan to Camp O'Donnell. David Scherman, another *Life* photographer, would later describe this image as "perhaps the most shocking scene for Americans of the en-

tire war."[2] And it went on. In February the Japanese captured Singapore from the land side; it had been defended by some ninety thousand British troops, whose guns were trained toward the sea.

Why Burma? Because it bordered northern India, so by conquering it the Japanese would be able to strike at Calcutta. Burma was also the supply line for the Chinese Kuomintang, led by Chiang Kai-Shek, Burma's ally. From Rangoon, this line extended by rail to Lashio, six hundred miles north, and then on into China.

Japan, through its efficient propaganda machine, had promised the Burmese independence from British colonial rule, so at first they welcomed the Japanese as their liberators. It was only in May 1941 that Burma changed its politics: General Aung San and his army of ten thousand Burmese rallied to the British forces against the Japanese.

By way of Basra, Karachi, Allahabad, and Calcutta, Rodger flew into Rangoon, landing at dawn on January 26. He was greeted by the scream of an air raid siren and the rattle of machine guns. He had narrowly missed a raid by Japanese planes. A few moments earlier, while flying over jungle and a range of tall, golden, mist-covered mountains, he had been lost in memories. He remembered, like a distant dream, his first reportage in Assam in 1929, when he was still thinking of becoming a tea planter in India. He was so young then; he knew nothing about war. He'd had a romantic idea of living in nature, writing about his life. He remembered that he had taken up photography because an editor had made a drawing of him in the jungle, holding a machete, fighting cobras and head hunters. All editors, he thought to himself, are liars.

As it turned out, one of Rodger's most extraordinary adventures would take place that summer, in the heart of these same Naga Mountains that he had seen from Assam. And strange enough, his real-life escape into India would look a lot like the fantasized picture that his desk-bound editor in Boston had drawn thirteen years earlier from imagination.

"There were men in Burma," he wrote, "fellow-correspondents and official observers, more fitted than I to refight the battles, to criticize the strategy, and to forecast future effects of the campaign on the general picture of global war. Therefore I, as a war photographer and no journalist, leave to them the recording of history and write, as non-committally as possible, only of what I saw."[3]

Through the pictures that have survived Rodger's Burma campaign, we see that although his writing was plainspoken and factual, he accomplished more with his pictures. He got to know the Burmese intimately, and he was able to photograph their lives in remote villages yet untouched by war. Those pictures, which he often used to inspire as much as to illustrate his writing, served him as

an intimate diary and offered him an altogether different sense of time and space. In them, gestures are slower, expressions are relaxed, and soft, deep shadows underline bodies' contours. They are a relief from the frantic pace of war, small pockets of hope and harmony in a world gone mad. These peaceful respites are probably what kept him sane throughout the hell that was Burma.

Rodger's brief stay at army headquarters was punctuated by repeated Japanese air raids. Rangoon was flooded with Chinese refugees and with British officers fleeing the Japanese invasion of Thailand. These were soon joined by a pack of correspondents, among them journalists from London's *Daily Express* and the United Press, Associated Press, and Reuters agencies.

Rodger relished his independence; even so, there were times when he felt isolated. His fellow correspondents would be sent off to other assignments; often, for months on end there would be no news of them and no way for him to know if they were still alive. He missed Michie's companionship and their teamwork. So he was pleased, and relieved, when one morning he spotted the short, squat silhouette of his old friend Alec Tozer of *Movietone News*. "He had jet black hair and was swarthy as if he had just returned from holiday. This may add an element of truth to the legend that Alec was 'captured' by the Australians in the Western Desert, they thinking him to be Italian."[4]

Tozer was a cameraman whose first credit had appeared in 1939, and who became a war correspondent for *Movietone* in 1940. In June 1944 he would be one of only six correspondents to cover D-Day. He first met Rodger on the Western Front in Egypt, and their paths had crossed several times since. Tozer had arrived in Burma a month before Rodger. Equally happy and relieved to see a familiar face, he shouted: "So you've made it, you old bastard!"

In terms of their work, Rangoon was in chaos. Major Hewitt, the PR unit director, wasn't yet officially recognized by the army, so he had no authority to allot them accommodations, transport, or equipment. The military kept telling them to "wait until the situation has established itself"—but waiting had never been Rodger's strong point.

Because it seemed impossible to get combat pictures right away, Rodger decided to do a story about a group operating from Mingladon Airfield: the Flying Tigers. These volunteers had been nicknamed after the tiger shark's teeth painted on the noses of their planes. This small squadron, established just before the Pearl Harbor attack, had been recruited by Colonel Clare Chenault, a retired U.S. Army air officer, to fight in the service of China. It flew obsolete P-40 fighters that were technically inferior to Japanese planes. Chenault had been able to minimize this disadvantage by having the fighters operate in pairs and dive at the enemy from high altitudes.

There were sixteen Flying Tigers, all of whom posed for Rodger's Rolleiflex.[5] In some of the portraits the pilots wear combat gear and helmet; in others they are in front of their P-40 planes. Sometimes they are caught in more relaxed moments, drinking, reading, or waiting on the wooden verandah.

The Flying Tigers' jungle hangars—staffed mainly by Chinese mechanics—were severely underequipped, so it was not uncommon to see a new wing for a Curtiss P-40 fighter cobbled by hand tools from a sheet of aluminum. Probably this is when Rodger began nursing his lifelong grudge against the American authorities, who in his words "left their boys to fight crack Japanese pilots with nothing but suicide crates to fly in."[6]

On the second day of Rodger's reportage, a Japanese raid was announced and everyone scrambled into the surrounding jungle. But Rodger was yearning to get some action pictures and refused to take the advice of armorer John Musick to take cover. He ended up so close to a Japanese pilot that he could see the expression on his face—and it was an expression that he did not at all like. The pilot tried to crash the RAF bombers' repair pits; fortunately, he missed and dove to his death. The Flying Tigers came back safely from the air raid; the only injured member was Matthew Kuykendall, a pilot from Texas, who was grazed by a Japanese bullet. Rodger went off to photograph another Japanese bomber they had shot down. The dead pilot was surrounded by a crowd of silent locals.

Rodger left for the evening. The following day, when he returned to Mingladon, one pilot was missing: Tom Cole from Missouri, who had been one of Rodger's favorites. He had been shot down and killed that day. Deeply saddened, Rodger promised flight commander John Newkirk that Cole's heroic death would be mentioned in *Life*. He kept his promise—one of the captions in the magazine reads: "Flying Tigers pilot Tom Cole from Missouri, shot down and killed the day after this photograph was taken."

The sympathy that Rodger felt for the Tigers, and his respect for their courage, inspired one of his best wartime stories. It was published in *Life* on March 30, 1942, and had an enormous impact. It appeared just at the right time: Americans had been reading story after story of defeat, so the heroism of the Flying Tigers felt to them like a ray of hope.[7] The piece was republished in London's *Illustrated* on May 23, 1942.

Rodger returned to Rangoon in early February only to learn that all films would have to be developed and vetted by the military censors before they could be sent to New York. There was still no press darkroom. He went on a "wild hypo hunt" for the necessary chemicals—including some favored secret ingredients—then processed his own negatives in the tepid Rangoon tap water and sent the resulting pictures to New York by way of Cairo.

Rodger had sent many cables to *Life* with story ideas but had received no reply. Thus he was left to decide for himself where to spend the next few weeks. He decided to cover the new Yunnan-Burma railroad. A Chinese engineer, Tseng Yang-Fu, was building a 620-mile line through Yunnan. Tseng was an exceptionally strong character: for ten years he had fought with the British authorities, hoping to see his dream of a China-India railroad come true. Once completed, it would stretch from Lashio in Burma to Yunnan in China, through forest-covered mountains fifteen thousand feet high—a region where until the Chinese arrived there had not even been a road. Munitions and other vital supplies would then roll up the line to Chiang Kai-Shek's army, taking some of the strain off the Burma Road.

Tseng was thrilled that Rodger and Tozer wanted to record his life's opus, and he helped them however he could. He supplied them with an interpreter, the faithful Mr. Ting. They piled camp cots, mosquito nets, blankets, canned food, and gas into their jeep and headed north toward Lashio, where Tseng's engineers and a quarter of a million coolies were working frantically, against not only time but also the combined menaces of dysentery, festering wounds, cholera, typhoid, and malaria.

The valleys of the Nam Ting and Salween rivers were matted with bamboo groves, jungle creepers, and rotting plants—perfect conditions for malaria-carrying mosquitoes. An American doctor and sanitary engineers dispatched by the U.S. Health Department had the task of setting up hygienic camps and hospitals in the most remote districts and staffing them with Chinese doctors and nurses, who in turn had to educate the laborers, who were generally distrustful of Western medicine. Dams were built and stagnant waters were blasted with mosquito spray.[8] Rodger and Tozer had to learn a few new rules: drink boiled water only, always use a mosquito net, and stay indoors after dark.

Rodger's pictures from that trip show steep mountainsides and workers struggling to finish grading the track's right of way before the rainy season began. Like so many ants, they were scraping clay into baskets and then hauling those baskets away on poles. To dig into the rockfaces, they had only hand drills. Yet in three months they had cut through fifteen miles of rock.

Over the following weeks the two journalists visited different sections of the railroad, sometimes following rough, steep tracks, at one point crossing a 150-yard floating bamboo bridge. Predictably, the bridge sank as they approached its center. Unfazed, Rodger kept driving, watched by a crowd of frightened Burmese, most of whom had seen few white men in their lives, and in all likelihood none who traveled by swimming car. Finally, after following the right of way beyond the Mekong River, they arrived in Yunnan on February 11. They

reached the Chinese border only to find that all the restaurants and inns were closed—it was the Chinese New Year. Mr. Ting managed to find them rooms.

Rodger was feeling isolated and disconsolate. He still typed letters to Cicely, but with little conviction, as he doubted they would reach her. He felt as if he was in no-man's land, as if nothing existed beyond the violence that surrounded him. Since Christmas in Cairo he had heard nothing from Cicely. And too often, he had been unable to send more than a brief cable to assure her he was still alive.

Rodger had mostly kept a "chin up" attitude in his letters, routinely minimizing the dangers he encountered so as not to frighten Cicely. But in a rare outburst, he confessed to her just how worn out he felt and how he yearned to get back home. In February 1942, from the Burma-China border, he wrote:

> You know Darling, I think I'll be on my way home pretty soon. I hardly dare think of it but it seems now the best thing to do. Facilities for work here are simply impossible. . . . Our ranks are getting pretty well thinned out now after the ones we lost in Libya. Tozer is about the oldest on the job now and I come pretty well near the next. I am getting stale on the job too, and I don't feel I can do my best any more. That is a bad frame of mind to get into, so, when I've cleared up here, I think I'll suggest I pack up. Of course it has cost *Life* a lot to send me out here, so I must justify the expense first. Maybe I'm just tired now and this continual frustration here, and the absolute impossibility of doing a good job, has got me down. And I just long for you more and more till I feel I just can't fight against it any longer, and I must get back. I know I've talked a lot about duty and all that, so maybe I'm just being weak.[9]

In a very different tone, Rodger wrote in *Red Moon Rising* (1943) about his and Tozer's futile attempts at keeping their diary ritual at the Lee Min Hotel:

> We were the only white people there and we were carefully watched all the time. . . . As soon as we set up our typewriters, the other inmates crowded round us and watched the keys, fascinated. One who could read a little English leaned over my shoulder and translated the words as they formed, for the benefit of others. I wrote: 'Chinese crowd around me reading what I write.' They thought this a hell of a joke, roared with laughter, slapped me on the back and shook me by the hand.[10]

Soon, however, the crowd lost interest in Rodger's and Tozer's typing and resumed their habitual activities of diaper washing, card playing, teeth brushing, and feet washing. That night, the journalists could not find sleep in the middle of the snoring, coughing crowd.

They decided to return by the Burma Road. After two unsuccessful attempts, Rodger managed on his third try to get the pictures he wanted of trucks—laden with machine parts, guns, and rice—traveling down it. Several days later, after an accident in which Tozer's jeep was hit by a truck and nearly hurtled into a gorge and a fierce hailstorm during which Rodger was hit in the eye by a piece of ice, they found themselves contending with crazy army truck drivers who took a strange pleasure in trying to drive their jeep off the road. Rodger arrived at a simple method for getting some driving space: pointing his gun directly at the other driver's head.

By mid-February, Rodger and Tozer had completed their story on the Burma Road and arrived back in Lashio. By then, Mandalay and Maymyo had been heavily bombed and Rangoon had been evacuated. For several days Rodger and Tozer tried to gather some accurate news, but all they heard was rumors. They decided to drive on to Mandalay, about 190 miles away, just north of the point where the two roads from Rangoon joined. In the Shan hills Rodger made some of his most beautiful pictures. With the intimacy of a personal chronicle, he recorded fishermen on the lakes, scenes of daily conversation on a wooden verandah at sunset, Shan girls giggling at a local market. "We passed scene after scene of peace and tranquility," he wrote, "but somewhere towards the south, we knew the Japs were creeping stealthily through the jungle ready to engulf all this beauty in the horror of war, to silence the happy laughter and erase the charm of Burma by their ruthless rule." [11]

In Maymyo, Rodger and Tozer found the army's general headquarters and PR unit, met some other war correspondents (together they commandeered an abandoned residence), and tried to get some rest after their exhausting trip. Next came the task of writing and captioning the Burma Road and Yunnan-Burma railroad stories. Rodger left these with the PR unit for transmission and censorship.

By now, the road from Rangoon was crowded with refugees. In spite of the danger, Tozer and Rodger decided to go back and record the last days of the city. They arrived in Rangoon on March 3, fighting against an immense human tide. Most of the tens of thousands were Indians: dock laborers, coolies, clerks, former government employees. The more fortunate were pulling ox carts with their families and all their belongings piled onto them. Others walked wearily, clutching a single bundle.

The scene in Rangoon made its Burmese name—Yangon (city of peace)—seem a tragic joke. Not a soul was left. The broad, leafy boulevards lined with architecture dating back to the British Raj were deserted. So were the shops, the little markets, and the bookstalls Rodger had enjoyed on his previous stay. De-

bris and the carcasses of dead animals floated in the muddy waters of the Hlaing and Yangon rivers.

The city had been devastated by Japanese bombing raids. Rodger's pictures from those days strongly resemble his images from the London Blitz: The ornate, layered roof of the railroad station has been demolished, and the statues at the Shwedagon Pagoda destroyed. A beautiful Buddhist temple has been razed by arsonists. The silk market is a smoldering ruin.

All night long fires blazed, probably set by Burmese looters. In the text for a *Life* photo story that Rodger cabled from Rangoon, he wrote: "I immediately went to where a fire was lighting up the sky. It was in the residential district and houses blazed on either side of the road as I passed by. Roofs crumbled and fell with a roar and a shower of sparks as the flames leapt from house to house."[12]

The Japanese were closing in, and soon all escape routes would be cut. Rodger and Tozer had no choice but to leave Rangoon. With Wilfred Burchett of the *Daily Express*, they went to cover the battle of Shwegyin—an extremely dangerous situation, as well as frustrating. Even in his worst days in the Western Desert Rodger had been able to shoot at least a few pictures. Now, he was risking his life in a jungle battle, and doing so for no reason; there was absolutely no light for taking pictures. They camped in the jungle, every sound and every passing shadow a potential menace. One dawn they barely escaped death from the bullets of snipers, who were invisible to them but whose aim was only too accurate. Tozer, Burchett, and Rodger were all three unable to shoot a single image, still or moving, of the battle of Shwegyin.

When they finally made it back to Maymyo, the three journalists learned that General Joseph Stilwell—commander of the Chinese forces in Burma—had just arrived. Nicknamed "Vinegar Joe" for his acerbic personality, the general granted them an interview during which he told them he could not do much without support or reinforcements and did not expect either to arrive until April, three weeks later. He was hoping only to stop the Japanese from taking Mandalay.

The Japanese offensive to the north was accelerating. Rodger had been at war for fifteen months and had lost all sense of control over his life. He was feeling overwhelmed. "Things were happening too fast," he wrote. "We had to fight against time. Time to reorganize, time to think, time to breathe."[13] Weary from too many bad meals and makeshift sleeping arrangements, aware that bearing witness was often impossible because the lack of light and ruptured communications, he felt that his job had stopped making sense a long time ago: the destruction would never end. A single sheet of flame was catching from town to town, setting the entire country ablaze. Toungoo, Pynmana, Lewe, everywhere, they

saw flames. He began to suffer from nightmares in which those flames kept returning, along with the stench of charred bodies. These dreams would haunt him long after the war was finished.

Tozer was assigned to China by *Movietone*, and left by way of Tibet. Rodger stayed on in Burma with Burchett. They witnessed the bombing of Thazis. Mandalay was a harrowing scene of blackened bodies and ruins. Somewhere there had been a telegraph station, but it was gone and the correspondents felt not only sad but also vulnerable and cut off from the outside world. Burchett expressed what they were both thinking: "It's the beginning of the end, you know. Soon all Burma will be like that." [14]

They met up with Jack Belden from Time-Life, who was just arriving, and Clare Boothe, the wife of *Life*'s founding editor, Henry Luce. Boothe-Luce looked incongruous, Rodger felt, with her well-fed, rested face and her impeccably creased slacks and white blouse. Perhaps taking some pleasure in shocking the new arrival, they immediately took her to see Mandalay's ruins. Roger had to admit that Clare Boothe-Luce was not easily daunted.

A few days later, in Maymyo, Rodger learned of the arrival of Chiang Kai-Shek and Madame Chiang, and he planned to get their picture with General Stilwell. Chiang, a leader of the Kuomintang regime, was viewed by a minority of Americans as a dictator. Most, however, shared President Roosevelt's conviction that Chiang was a national hero leading a government supported by the majority of Chinese people, and that Mao Zedong, who was becoming a public figure, was a ferocious outlaw.

Roosevelt believed that Chiang would become an important player in the war, and China a world power. He had sent General Stilwell to China because of his extensive service at the U.S. Embassy in China and his fluency in Chinese.

Henry Luce was the son of a missionary in China and a fierce defender of Chiang Kai-Shek. All of Luce's newspapers and magazines—including *Life*—were deploying a vast propaganda campaign to persuade Americans and British that Chiang's "powerful belligerence should be fueled by supplies of arms and cash." [15]

Chiang Kai-Shek was in fact an extortionist who sowed disorder and corruption. But Rodger knew little about Chinese politics and probably went along with *Life*'s point of view. Excited by the notion of a clear-cut assignment after months of exhausting wandering, he set out for a shoot that would become one of many pieces in *Life* extolling Chiang Kai-Shek.

When Rodger met Stilwell, he was not only the general commander of all U.S. forces in the China-India-Burma theater, but Roosevelt's personal representative to Chiang and the administrator of Lend-Lease Aid. Two years later, in

November 1944, Stilwell was recalled. At that point the embittered general revealed the truth: his main job had been to persuade Chiang's troops not to loot and sell the U.S.-sent war supplies.

Under Luce's editorial leadership, *Life* supported Roosevelt's perspective. Naturally, Clare Boothe-Luce served as a go-between for Rodger's meeting with Chiang Kai-Shek. "I thought I would probably have to pose them," recalled Rodger, "but Madame Chiang knew exactly what kind of picture I wanted even before I asked. The 'Entente Cordiale' picture she called it, as she placed herself between the Generalissimo and 'Uncle Joe' and took their arms, smiling into the camera."[16] Madame Chiang was a master of public relations and what Rodger rather naïvely called "a photographer's dream": subject and assistant all rolled into one. She even took care of maintaining a lively conversation so that Rodger's editors would have a variety of expressions to choose from.[17]

The Chiang-Stilwell shots gave the *Life* reader a somewhat rose-colored sense of what was going on in Burma. They contrasted sharply with an earlier seven-page story by Rodger, "The Japanese Sweep Through Burma," a pessimistic piece focusing on the devastation that the Japanese left in their wake—a story that corresponded more closely to Rodger's own experience.

Cover pictures, like faces, can lie: the Chinese and American generals had agreed to pose together for the sake of propaganda, but the fact is they were unlikely allies who did not get along. Chiang was suspicious of foreigners, very stubborn, and deeply corrupt. "Vinegar Joe" Stilwell did not at all share Roosevelt's faith in the Chinese leader, whom he distrusted and privately referred to as "Peanut."

Once the assignment's excitement was over, Rodger fell back into his gloomy mood. It seemed to him that everything was going wrong. The Japanese had apparently taken Burma. His film supply was almost exhausted. Worst of all, he had had no word from the outside world for three months. Both he and Burchett felt utterly isolated and despondent.

Over the next two weeks the Japanese took Maymyo and Lashio, the last British strongholds. All retreat routes had been cut off. By April 10, Rodger and Burchett had decided that their only chance of escape was through northern Burma into India, and made plans to drive right through the Hukwang Valley. They expected the six-hundred-mile journey to take three weeks. No one had ever taken that route to India.

LIFE REPORT: ESCAPE FROM BURMA
 Our headquarters in Maymyo had been blitzed.
 One hundred and fifty bombs had fallen in as many seconds, and as the

pandemonium subsided, streams of refugees picked their way through the debris and headed North. . . . My friend Burchett of the *Daily Express* and I chose a route to the north, hoping to reach India in our two jeeps across the high mountainous country that divides Burma from Assam. It is the home of the headhunting Naga tribesmen. A country so wild and inaccessible that it is unadministered . . . by the Governments of India or Burma. Practically unexplored by any white man, it has for centuries lain undisturbed, and is probably one of the least-known places in the world. . . . There are tigers, leopards, thirty-foot snakes, and it is the last retreat of the rare white rhinoceros.[18]

In mid-April, Burchett and Rodger arrived in Myitkyina, Burma, after driving four hundred miles. There was a military airport there. They could have claimed seats on an airplane, but they decided to leave them to civilian refugees fleeing the Japanese. Rodger had witnessed horrific wartime abuses: women raped, men bayoneted, bedridden wounded soaked in gasoline and set on fire. He did not want to leave the refugees to such treatment. But the deciding factor may well have been his sense that after all these weeks of unclear and difficult assignments, he very much needed a new scene.

Their expedition had gone well enough. Rodger had been happy to observe and photograph scenes of everyday life in the Shan villages they passed on their way to the Paungsau Pass. To both men it was a great relief to be far away from the war and its destruction. Rodger took offbeat, relaxed pictures of what he saw. He was even recovering his sense of humor:

> We drove through Mogaung and Kamaing in the beautiful Northern Shan country, where each village we passed was like a stage set in a costume play. . . . Though the men were naked to the waist, the girls wore starched white bodices, tight sleeved and sometimes partly boleroed behind. . . . One girl with a red and saffron "lungyi" and a form that would put the Venus de Milo to shame, led a gross and ugly Burmese buffalo, with a four-foot horn span, by a grass rope passed through his nostrils—Beauty and the Beast.[19]

With the help of Kachin tribesmen, the travelers crossed the rivers on bamboo rafts. Rain fell steadily, the terrain becoming muddier. When they reached Naga country north of Shingbwiyang, they found only a faint trail. They were soon exhausted from jungle fever, insect bites, lack of sleep, and a dismal diet. Refugees had consumed all food in the region, and the only canned foods they had managed to buy were asparagus tips, fresh cream, and cherries. Slashing their way through the jungle with *dahs* (swords) bought from the Kachins, they cut a slow path, often helped by Naga tribesmen. All the while it was raining. "All

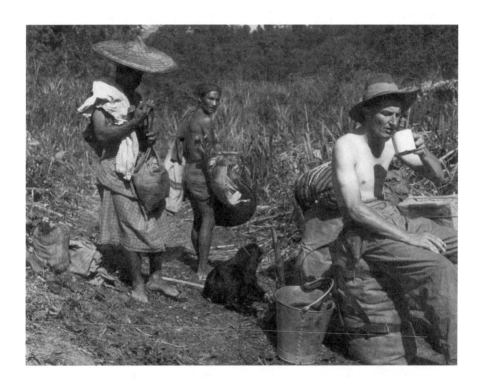

Self-portrait on escape from Burma, 1942. © *George Rodger.*

our gear in the jeeps was saturated and I wrapped my cameras and film in a ground sheet to keep them dry. At night we made lean-to shacks out of bamboo and banana leaves, and slept in our wet clothes shivering with fever. It was impossible to sleep much. Our mosquito nets kept out the larger insects, but ants, jungle ticks, and sand-flies got through the mesh and gave us hell."[20]

When the rain stopped, Rodger thought things might improve, but their jeeps got stuck in a deep ravine and they had to abandon them, with the prospect of a 130-mile trek to Assam. Rodger's description of that journey makes it clear that he thrived on life-threatening conditions. Perhaps the expedition was a way of forgetting the fifteen months of war he had just experienced, of ridding himself of the stench of charred cities and corpses. Perhaps the eerie silence of the jungle was his antidote for the thunder of Japanese bombs. Later he would refer to the seven-day adventure, which he and Burchett only barely survived, as "one after my own heart."

In Rodger's writings, it is clear that his war experiences led him to often question the benefits of "civilization." He was impressed, for example, by the Naga people and their values, and found their way of life in many ways superior. He wrote to Cicely:

> They are practically naked; they eat snakes and beetles and curry made out of tadpoles; but they can lie in the sun or, if they want to work, they can clear the jungle and grow opium and corn and rice and their wild potatoes. . . . But they are at peace. There are no Japs lurking in their jungles; there are no bombers or tanks or rattling machine gun bullets. As I walked day after day through the paths they made across their jungle-covered mountain tops I couldn't help wonder what the advantages of civilisation are.[21]

Rodger's sense of connection with indigenous peoples—a connection that was not based in language—and his belief that they had a wisdom the white man had lost, would remain with him for the duration of the war and for the rest of his life. Wherever he was, whatever his assignment, he would often refer to that vision. When bombs were falling around him in Naples or Salerno, he commented: "I would not mind going back there and living among those people at all, in fact I found them very easy to get along with."[22] It seems almost as if he felt at peace only in his idealized relationship with Cicely or in his links to the indigenous world. After the war this feeling would become a driving force for Rodger, leading him to seek African peoples that had never in their history encountered whites. When Rodger describes to Cicely walking marathons that began at six in

the morning and went until four in the afternoon—hunger, thirst, jungle fever, leeches—there is a boastful and joyous tone to his writing:

> The path was like a tunnel through the vegetation, just like a game trail, quite dark, and it led, always, directly towards the top of any mountain rather than going round by an easier grade. My legs became practically paralised and my heart beat till I thought I was going to break loose or burst or something. But the worst thing of all was the leeches. I first found them when I noticed my socks were soaked in blood, though I had not felt anything. They were sticking to my skin, fat and bloated like large purple gooseberries.[23]

In his letters to Cicely, Rodger constantly entertained a vision of the paradise he would gain through his sufferings: endless bliss with his beloved, an idealized future with her that he described in touching, almost ingenuous terms:

> If one allowed one's thought out there to be ruled by doubts and misgivings, life would be impossible to live. One just has to go on from day to day and not be affected by the folly of death and futility, of destruction one sees around one. In Burma I've spent nights in deserted houses with the sound of Japanese machine-gun fire all around me, groans coming from the wounded in the same room, and I thought of nothing as I lay waiting for sleep to come, but our meeting again sometime in the future, of the time when eventually we shall be together for always, and I build up pictures of the little house we'd have some day, and how, for always in our own home, we'll have coffee in the morning out of little white bowls with russet red spots on them.[24]

Anesthetized by war, Rodger had developed a tough outer skin, while inside thrived another life—just as unrealistic—of feelings and emotion and fantasy. But was there anything between the two?

When Rodger and Burchett finally arrived in Ledo in northeastern India on April 24, they were not served "coffee in white bowls with russet red spots." But after a hearty "Dr. Livingstone, I presume," they were handed the next best thing: a glass of beer.

By the end of April they were in Calcutta. In the first British newspaper he could find, Rodger saw that Exeter had just been bombed. The Hussey-Freke family residence was there. He sent the following cable: "Arrived Calcutta. Heard Exeter blitzed are you OK Honey STOP Expect leaving newyorkwards soon will cable when definite STOP Reply cable care american consul calcutta all love darlingest Rodger."[25]

8

A Reluctant Hero

Rodger had to wait a full month—which he spent in Calcutta, Delhi, then Cairo—before hearing from *Life*. They wanted him in New York, then back in London, where he would be a civilian again.

Rodger had been separated from Cicely for eighteen months and should have been elated at the prospect. But even though he had assured her that he hated war—and especially the last months in Burma—still he felt conflicted at the idea of leaving the front for the comforts of the London office.

Honey since talking with Walter [Graebner] things don't seem any too bright about my future in London. He says he expects I'll get a good raise out of the firm etc etc as they are all so pleased with my work. . . . He also says he knows there is a vacancy for me in the London office, and when I asked him if he thought I could get accredited to the home forces, he said I wouldn't have to ask he was sure the W.O. [War Office] would give me exemption after all the work I have done out here.

But, Darlingest, that is just what I can't do.—How could I possibly go back to civilian life now, while all this show is still on? I just couldn't do it. It would be divine to be with you all the time. It is what I want more than anything else in the World. But, knowing what war is like,—having seen so many people killed; such ghastly atrocities perpetrated—so many countries raped and robbed of their very souls—I just couldn't lift up my head at all, if I were to walk around in flannels and a sports jacket in England, while I knew it was still going on in the

places I had left. I just couldn't bear it and I wouldn't feel a man fit to be your husband.[1]

Cicely was left to swallow the bitter pill. A few days after writing her that letter, on a beautiful July morning, Rodger landed in New York.

When he arrived, he was already a hero. A few days earlier, Time-Life had broadcast an entire radio program on his Burma adventures. Clare Boothe-Luce had written about him in *Life* in glowing terms. Allan Michie's best-selling book *Retreat To Victory*, illustrated almost exclusively with Rodger's photographs, had just been published in Chicago and New York to excellent reviews. In the book's foreword, Michie paid Rodger homage: "There is *Life* photographer George Rodger, who for eighteen months in Africa, the Middle East, India and Burma, has endured more hardships to get pictures than any other photographer in this war. I want to tell him that he is the best campaign companion anyone could ask for."[2]

Life put Rodger up at the Lexington Hotel, a few blocks from the office. He had arrived exhausted, but rest proved almost impossible. His sleep was disturbed by violent, recurring dreams of fire, snipers, stray bullets; he was waking drenched in sweat. He could find no peace of mind, and without assignments and deadlines he felt lost and useless.

Rodger had looked forward to a hot bath. But when he took out his kit and wiped the steam from the mirror to shave, he was shocked by his own reflection. In Burma he and Tozer had shaved quickly with a splash of cold water, pulling the skin taught with their fingers. Mirrors were not allowed: sunrays might hit them and signal their position to a hidden sniper or a Japanese plane. Now Rodger saw that his hair had turned entirely gray. There were deep shadows under his eyes and creases on either side of his nose. His expression, he now saw, had become weary and bitter. Eighteen months of war had taken his youth away.

Rodger knew he had lost weight on his trek to India—a result of jungle fever and a diet of cherries and asparagus tips—but he had not known how much. His ribs were showing; he had probably lost thirty pounds since December.

Worst of all, instead of being relieved, he felt disconnected and depressed. Even his four-pound-a-week raise did not cheer him up. At the office, he reluctantly complained of violent migraines and muscular pains. The nightmares that haunted him did not help his state of mind.

The company doctor found nothing physically wrong with him. He also visited an ophthalmologist, and had a dentist replace the two teeth he'd broken in North Africa. Slowly he began to gain back weight. The Bond stores were adver-

tising men's suits, but it was some time before he could bring himself to shop for clothes, however badly he needed them. The weather was warm, but he found it difficult to let go of his cape and beret.

Rodger could not believe how peaceful New York was. The abundance of food and consumer goods appalled him and made him strangely angry and resentful. The new food automats were attracting lines. He walked among crowds of shoppers carrying full bags, watched mothers and starched nannies pushing baby carriages in Central Park. No one seemed to really care about Europe; it was just life as usual. War was a distant concept happening somewhere else, thousands of miles away.

Rodger was chain smoking. One of the only things that made him smile was the new Camel billboard, at 44th Street and Broadway, that puffed out five-foot-wide smoke rings of steam.

It was hard for him to be with people in social settings. They made him ill at ease, so he often turned down invitations to dinners organized by *Life* in his honor. He preferred to go back to his room at the Lexington and write to Cicely.

A week after his arrival, in a long letter, he confided in her about his physical state and the despondency he could not seem to shake: "I didn't tell you, but for six weeks now I have had a pain in my head every night that [drives] me crazy, and when I arrived here last week, I just cracked up, or at least my nerves did. It was just an inevitable reaction after all I went through—physical and nervous fatigue."[3]

Rodger acknowledged the physical part of his illness, which he attributed to shellshock. Meanwhile the emotions he had ignored while at the front, while constantly on the move and physically exhausted, were catching up with him, marching forward like a dark army. He feared them more than any real enemy he could fight in the open. Since childhood he had made a practice of ignoring his feelings. He had succeeded only too well: now he was a prisoner of his own habits and incapable of connecting with the horrors that ruled him from within. In their own way those horrors were worse than the desert sandstorms, the jungles, the feverish nights. External events could at least be touched; his private storms were unassailable.

He felt like a charlatan. Where did that hollow, hounding feeling come from—that he had not done enough, had not made a difference? Why were his standards of behavior so strict that he could not help but fail to meet them? Why would an honorable discharge make him a failure in Cicely's eyes? She, too, was depressed and lonely. She would in fact have been thrilled if he had gone back to England to work for *Life*. Even with the world regarding him as a hero, Rodger had little sense of his own worth.

In the beautiful, crisp summer light, ghosts pursued him. He had made it, but so many war correspondents, his friends and colleagues, had not. The pictures he had taken were now haunting him with perfect, painful clarity. His mind was reeling with them, and the violent headaches came almost as a relief, blacking them out. His camera had been a shield as much as a tool, keeping danger and death at bay; he had photographed, but had he really *looked?* Now the war was raging within: He kept seeing crumpled bodies littering the dunes, the rows and rows of crosses with British names hastily erected in the desert cemeteries, the wounded doused with gasoline and set on fire by the Japanese, and even Tom Cole's body, which he had never actually seen.

No one would understand who had not been at war. There was no one he could really talk to. He did see a few friends, but at their houses he would just sit and not talk much, happy for company that could relieve him of his obsessions, if only temporarily.

Barbara Michie, Allan Michie's widow, is one of the few who saw Rodger that summer. When I visited her, she showed me snapshots that Rodger had taken around that time of her baby girl, Bobby. She recalled the first time she met him, at the end of July, not long after Rodger's arrival in New York:

> He was a very tall, very thin man. He must have been very tired then but I did not realize it. . . . He had light-hearted stories to tell about his trips—like the time when Allan and he were presented ornamental rifles with tassles in bright red and yellow colored threads by the tribesmen at Khyber Pass, while they were crossing over from Afghanistan into India. He was a reticent person. He did mention that he had Cicely in England but he did not talk about it, did not dwell on his private life.[4]

It is possible that Barbara Michie did not realize how much Rodger enjoyed visiting her. He wrote to Cicely:

> I think probably Allan's wife, Barbara, has done more for me here than anyone else could. Honey, she is a perfect Darling. The baby "Bobby" is simply sweet—Whenever I can, I go out to their flat and just relax, listening to good music on a radiogram. She has given me some lipsticks for you, which I thought was very sweet of her. . . . But how jealous it makes me feel, Darling, to be in their home. In a lot of ways she is very much like you—enough to make me imagine the whole set up as being mine instead of Allan's—And Oh God it makes me homesick for you.[5]

Life was planning a seven-page tribute to Rodger's war adventures. No photographer had ever been honored in that manner. Buried for a week in work—picture editing and layout, and writing all the captions—Rodger felt better. He wrote to Cicely: "In one of the coming issues, *Life* is devoting 7 whole pages to my trip— with 76 pictures—and that is unprecedented in the history of the magazine—No one has ever been handed a laurel like that before. But I have told them that my primary object is to help win the war, and that I am not going to waste time and energy doing anything that doesn't point directly in that direction."[6]

As soon as the preparations for the *Life* spread were finished, Rodger fell into another deep funk, perhaps triggered by the upcoming exposure, or simply be- cause—for the first time—he had had a good look at all the images he had taken in the past eighteen months. He had developed a few of his contact sheets but had sent many films sight unseen. Now, while writing captions, he was projected back to each of the moments he had photographed, and the memories came like a punch to the gut. After completing the layout he was exhausted, and took refuge at the summer house of his friends the Whitcombs in New Hampshire.

Away from all commitments, he took long walks in nature as he had done in his youth. With time to let his thoughts wander, he came up with a kind of mis- sion: "I am starting a drive to try and unite the British and Americans more closely—Darling, their criticism of the British, especially among the US men in Africa, the Middle East and the Far East, is deplorable. They say openly that we don't fight, and call the RAF 'Run Away Fast' boys. They simply haven't got a good word for us—and all their criticism is born merely of ignorance and uttered by men who have no experience themselves."[7]

Rodger's bitter remarks help us begin to understand why he was so ill at ease. Why was he, a British citizen, being given a hero's welcome while his compatri- ots were reviled? Time-Life was now planning a series of conferences for him. The first would be with potential advertisers; after that there would be a two- month national lecture tour.

He felt that he could not refuse the lecture series: it would be useful for Americans to have a first-hand account from a British combatant, and besides, the lectures would pay him well. He still needed money to establish himself and Cicely.

Although Rodger claimed that his one and only desire was to be reunited with her, around this time he turned down an opportunity to have her join him in New York. He made that decision without even consulting her: "I only wish you were with me here, you could help me so—but that is no good Darling—I've given a lot of thought to getting you out here, and have decided against it as—

when the time comes for me to go again—life would be unbearable for you, and you'd hate it.[8]

Already disconsolate, Rodger must have feared the vulnerability that would inevitably result from a reunion with Cicely. Such a meeting might soften his backbone, erode his sense of duty, and bring about an unbearable confusion of feelings. If there was one thing the dauntless Rodger feared, it was not danger, and it was not even death. It was simple, everyday happiness.

Almost immediately after Rodger arrived in New York, *Life* offered him a full-time staff position, which he accepted. On August 10 it published the seven-page piece on him, with maps of northern Africa, the Cameroons, and India and as an opener a dashing portrait of Rodger in his uniform (shot in 1940). The headline ran: IN HIS OWN PICTURES AND WORDS, GEORGE RODGER TELLS OF HIS TRAVELS AS LIFE WAR PHOTOGRAPHER.[9] *Life* touted Rodger's trials as "the longest journey by any photo-reporter or newswriter in this or probably any other war."

Rodger, ostensibly to counter the blaring American-style pomposity—but also undoubtedly to distance himself from his own life—wrote laconic captions in language that verged on telegraphese: "Not shown are vicious mout-mout flies"; "The jungle, which is greatly overrated, is thinning out." A grid design of seventy-six photographs, laid out like contact sheets, retraced his 75,000-mile trek and his four hundred stopping places. Some of these stops were only listed; others were illustrated with simple, diarylike photographs that told as much about the correspondent's daily life as about the war. The whole is rather dated in layout but very modern in spirit.

This sort of first-person chronicling in pictures was virtually unheard of in an era when photographers generally were not remembered by name. Some of the more famous American photographers—Alfred Stieglitz, Ansel Adams, Edward Weston—had written diaries, monographs, or reflections on photography, but people like these considered themselves *artists*. Photojournalists—especially war photographers—were supposed to report, to bring readers an objective, neutral view of the world. In that sense, Rodger's *Life* spread was unprecedented. After it was published he was an overnight hero, besieged by reporters wanting more interviews, stopped on the street by people who recognized him.

In a 1985 interview, he recalled: "I didn't enjoy the glamour. . . . You know, some old lady would come up in the train and say: 'Ah, aren't you George Rodger?' And I said, 'No, I'm Little Lord Fauntleroy. . . . I had shellshock anyway, and the most terrible pain in my head, and I couldn't take all these things." [10]

By August 6, Rodger had given four talks, one of them at a girls' camp in

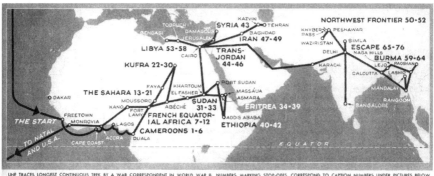

LINE TRACES LONGEST CONTINUOUS TREK BY A WAR CORRESPONDENT IN WORLD WAR II. NUMBERS, MARKING STOP-OFFS, CORRESPOND TO CAPTION NUMBERS UNDER PICTURES BELOW

75,000 MILES

IN HIS OWN PICTURES AND WORDS, GEORGE RODGER
TELLS OF HIS TRAVELS AS LIFE WAR PHOTOGRAPHER

GEORGE RODGER, LIFE PHOTOGRAPHER

Early the morning of July 9, 1942, a lean young Englishman in British Army uniform stepped alone from an Atlantic Clipper at LaGuardia Airport in New York and lit a cigarette. This ritual marked for George Rodger, LIFE staff photographer, the end of the longest journey by any photo-reporter or newswriter in this or probably any other war. He had gone 75,000 miles from December 1940 to early last month—more than three times around the world. His war picture odyssey

took him from Glasgow, Scotland, to Duala, Africa, across the Sahara and into Eritrea, Ethiopia, Iran, Syria, Libya, India, China and Burma (see map above). Constantly doubling back on his tracks, he saw battle action in a dozen places.

From time to time LIFE has published photo-reportage by George Rodger on this roving assignment. Now the editors let him tell his own story of his travels, with his own pictures arranged chronologically and his own words used as captions.

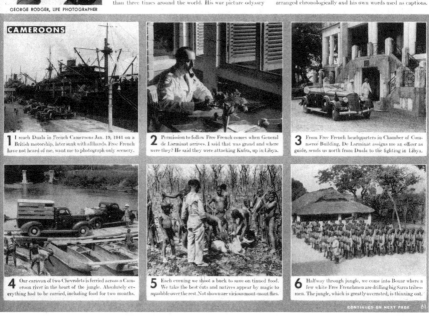

CAMEROONS

1 I reach Duala in French Cameroons Jan. 19, 1941 on a British motorship, later sunk with all hands. Free French have not heard of me, want me to photograph only scenery.

2 Permission to follow Free French comes when General de Larminat arrives. I said that was grand and where were they? He said they were attacking Kufra, up in Libya.

3 From Free French headquarters in Chamber of Commerce Building, De Larminat assigns me an officer as guide, sends us north from Duala to the fighting in Libya.

4 Our caravan of two Chevrolets is ferried across a Cameroon river in the heart of the jungle. Absolutely everything had to be carried, including food for two months.

5 Each evening we shoot a buck to save on tinned food. We take the best cuts and natives appear by magic to squabble over the rest. Not shown are vicious mout-mout flies.

6 Halfway through jungle, we come into Bouar where a few white Free Frenchmen are drilling big Sara tribesmen. The jungle, which is greatly overrated, is thinning out.

CONTINUED ON NEXT PAGE 61

75,000 Miles: *Life* magazine spread with Rodger's war story. Vol. 13, #6, August 1942, page 61. Text © 1942 Time Inc. reprinted by permission. *Photographs © George Rodger/Time Pix.*

New Hampshire. This event he described in a letter to Cicely: "By the time an odd hundred little lassies had sung to me at the end of lunch in the big hall, everything became so ludicrous, my sense of humour got the better of me and I thoroughly enjoyed it." [11] Back in New York, he delivered a lecture at the Waldorf-Astoria, which, he grumpily commented, went a bit "too well."

Rodger simply could not recognize himself in the image the world was reflecting back at him, and it made him unhappy.

He and Cicely had decided to get married as soon as they could, and Rodger asked Wilson Hicks, *Life*'s picture editor, for a leave. Through his friends the Lovetts, he met a jewelry designer, and he asked Cicely to have her finger measured for a ring. They began exchanging letters about their wedding. Rodger was adamant: "We'll handle this alright Darling, as soon as I get back, we'll be married just as soon as ever we can, we won't have any fuss and bother and announcements like Helen's—We'll just go right ahead quietly and get married and that will be that." [12]

Helen, Cicely's older sister, had recently married a friend of their brother Ambrose from Cambridge. She had always been the star in the family. According to Cicely's younger sister Dorothy, and also to Dorothy's daughter Linda Morgan, Helen was a rather self-centered coquette who had taken up most of their mother's attention and was fiercely competitive with her sisters. Linda Morgan remembered:

> Helen was a beauty in her day. She married probably three times. Every man who visited fell in love with her. When Cicely, Dorothy or Peggy—her twin sister—invited a boyfriend over, Helen had a habit of showing up "by chance" at the top of this huge stairway they had, all dressed up in an expensive dress, and she would try to seduce them. . . . Cicely on the contrary had been considered rather dull until she met George, and . . . everything about her changed when they met. She was absolutely glowing and exuded a beauty that we did not know was in her. [13]

Hicks did not give Rodger his requested leave. Instead, he was sent off on another lecture tour, this one to Cleveland and Chicago, where he was expected to parade as the hero to boost *Life*'s advertising revenues. The scheme backfired: "He brought this ordeal to an end by inadvertently telling the President of Boeing Aircraft that the RAF's Lancasters were proving more effective than Boeing's Flying Fortresses." [14] While Rodger was going on about the Lancasters, Hicks was furiously, but to no avail, kicking his leg under the table. Thus ended

Rodger's career as a lecturer, for which he had received forty dollars per appearance (the only part he did enjoy).

From Chicago, Rodger wrote to Cicely, restating his priorities: duty before life. It was almost as he saw getting married as a brief ellipsis before he resumed his war adventures: "While there is a war on, our lives just aren't our own, and if I have to go I'll just have to Darling, the same way that millions of others have had to. That is why I want to get married so that at least we shall have as long as possible together."[15] Hicks, however, had still not granted Rodger a leave.

Alerted to the photographer's adventures by the *Life* story and by the write-ups of his lecture tour, Cresset Press offered Rodger a contract for his war memoirs. He started work on *Desert Journey* almost immediately, using the diary he had been keeping faithfully all through the desert campaign to jog his memory, as well as his contact sheets, now easily accessible at Time-Life. One of his bi-weekly letters to Cicely contains an apologetic self-portrait: "Please don't expect me all sunburned and handsome. I was when I got out of Burma—sunburned I mean—but now I look like death warmed up, kind of grey and soapy . . . My hair was going grey when I left England, but now it definitely *is* grey! . . . I lost over two stone coming out of Burma and haven't got it back yet. My hips are now razor-edged."[16]

In September, Rodger, now a celebrity, was approached by several Hollywood movie companies who wanted him as a consultant on films they were shooting in the Middle East and Africa. He was also asked to collaborate on a screenplay about the war in Burma. He did not even go to a meeting: "They want to fly me out there immediately and offered me an astronomical salary. I turned it down: that's not my idea of winning the war."[17]

At long last, Hicks relented and gave Rodger his leave of absence. On August 31 he flew over to London, where he was met by an elated Cicely. Little is known of the next few months of Cicely and Rodger's life. Rodger stopped keeping his diary for almost a year; he seems to have been consumed with writing his war memoirs. He spent his time with Cicely, mainly in his old London flat. On weekends they traveled either to his family or to hers.

While on paid leave from *Life*, Rodger was supposed to be resting and recovering. But resting had always been an alien notion to him. Over the next six months he produced not one but two memoirs: *Desert Journey*, about his time with the Free French in the Western Desert; and *Red Moon Rising*, about his time in Burma.

At long last he was living with Cicely, yet he remained focused on work. If he was not out on the front lines, then perhaps the next best thing was to write about his experiences. His two books are competent and often funny, but Rodger's

writing lacks something: his cool, self-deprecating style often comes across as overwrought and flippant. In his memoirs war never shows its true weight. He does little to evoke the horrors he saw; he comes across to readers as an unflappable, phlegmatic, and somewhat remote hero bouncing from one adventure to the next.

Even so, both his books were warmly received and became instant bestsellers. Possibly, Rodger had written exactly what people wanted to read. The *Daily Mail*, the *Sunday Graphic*, the *Illustrated London News*, the *Spectator*, and the *Observer* all published glowing reviews. In its August 1943 issue, *Readers' Digest* published a long extract from *Red Moon Rising* under the title "Iron Road of Burma." One of the most flattering reviews was written by George Orwell: "As a picture book, *Red Moon Rising* could stand alone. As a narration it is, in its way, unique."[18] Another plaudit came from Elizabeth Bowen: "Here are the grim actualities of warfare set on a background that somehow belongs to dreams.[19]

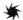

On October 15, 1942, at Saint David's Church in Exeter, Rodger and Cicely were married. As the local newspaper reported: "The bride was attired in a smoke-blue dress of angora wool with a toque of the same material and black accessories. She wore a spray of carnations." Allan Michie was Rodger's best man. It was an intimate ceremony that only family and close friends attended—not the large affair that Cicely's mother (and perhaps Cicely herself) might have wanted. The couple spent their honeymoon in Buckinghamshire. Rodger had received accreditation to the American forces in Europe, and the shadow of his possible departure must have been with the newlyweds throughout their early months together.

Rodger's order to join the Middle East forces arrived at the end of July 1943. By August 4 he was on a plane to Marrakech. Cicely's fears and Rodger's desires had been fulfilled: he was back at war.

9

Where George Rodger Meets Robert Capa

AUGUST 1943-MAY 1944

In Algiers, Rodger struck up a friendship with another photojournalist, Robert Capa. Since the *Life* write-up, Rodger had come to be renowned as the most traveled war correspondent of all time, a hero whose uniform now bore seventeen medals. The Hungarian-born Capa had been dubbed "the most famous war photographer in the world" since the publication of his 1936 image, the "Falling Soldier," taken during the Spanish Civil War; the photograph had become an anti-Fascist icon.

Capa, six years Rodger's junior, was many things that Rodger was not: socially adept, outspoken, brash, and generous with his time and his money. A good businessman and an excellent long-term strategist, he had a knack for getting along with powerful men while having a good time with them. Rodger became Capa's close friend and colleague, an attentive listener with whom he could share ideas. Discreet, reliable, and thoughtful, Rodger had a moderating influence on some of Capa's wilder schemes. These two veteran war photographers did share one important trait: a sense of humor.

Many years later Rodger would still remember Capa's friendly, Hungarian-accented exhortation: "Listen, old goat: today doesn't matter and tomorrow doesn't matter, but it's the end of the game that counts, and what counts is . . . how many chips you've got in your pocket, and that is, if you're still playing."[1]

On August 17, 1943, the American forces entered Messina in Sicily. After only thirty-nine days of fighting, the island was under American control. Toward the end of August, Rodger and Capa crossed from Morocco to Paestum. On

September 3, the Allies launched Operation Baytown, the invasion of mainland Italy. That same morning, Montgomery's Eighth Army crossed the straits of Messina, while other sections of the Eighth Army disembarked near Taranto. The Italian government accepted an armistice and agreed that no Italian troops would fight the Allies. It was a historic moment: the Germans now had a second European front to defend.

Because he had originally been assigned to Messina, Capa arrived at Paestum two weeks later than Rodger. On September 6, Rodger covered the landing at Salerno of General Mark Clark's Anglo-American Fifth Army. Throughout this assignment, he was hampered by poor light and the difficulty of covering intelligibly a confused and scattered action. Richard Whelan, Capa's biographer, believes that Rodger's photographs of the landing in *Life* were not compelling:

> [Capa] felt licked because he was stranded in Sicily while the first Allied invasion of the European mainland was in progress at Salerno—although in fact, he probably wouldn't have gotten much even if he had been there from the start, for the invasion had started at 3:30 A.M., and by daylight the worst was over. (George Rodger, one of *Life*'s most seasoned war photographers, covered the landing, but the magazine had to publish drawings to carry any sense of the drama.) [2]

However, Rodger felt that he had covered the event well, and he resented the addition of the drawings. "The Americans had a well-equipped Public Relations Unit and soon I had a jeep to myself which paid off as *Life* gave me eight pages on the invasion story." [3]

Camping out in groves, orchards, and vineyards, Rodger followed the Salerno operation. From under an orange tree he wrote Cicely an upbeat letter in which his feelings for "poor" Capa, whom he had just outscooped at Salerno, are easy to discern:

> Poor Bob Capa was thwarted in his plans to cover the invasion with the airborne troops for they were called off at the last moment. He never got into the invasion at all and has only just managed to get here by sea. I did a series of pictures on the embarkation of troops in Sicily and then our landing which I believe were the first pictures to get back. I have just had a letter from Don Sutton who is managing the "Pool" to say that my first pictures are already getting a big play in the States and that everyone is highly appreciative of them. He also says that my thorough way of treating a story with full captions is a good example for all other photographers to try to emulate. So much for that. I haven't heard what Wilson Hicks thinks of them. Since getting there I have shipped five stories in

ten days. One on our landing, one on front line action stuff which was mostly shelling and artillery fire, one on the story of a bridgehead, and then one on the capture of Batapaglia and Ebli—therefore I feel justified in taking to-day off in order to write to you![4]

A few months earlier, Cicely had started work as a secretary for Time-Life, where Rodger had introduced her shortly after they got married. He counted on her to alleviate his isolation and was always asking for news from colleagues like Frank Sherschel, Dave Scherman, and Hans Wild. Photographers could not communicate easily from the field, but they were all in touch with the office.

Montgomery's forces soon joined in the fighting, and the Germans began retreating toward Naples. On October 1, Rodger and Capa joined the Eighth Army on Italy's Adriatic coast. Five days later they crossed over to Naples to witness the city's recapture by the Allies. With their colleague Will Lang they met a prominent anti-Fascist, Italo di Feo, owner of a villa in Vomero, who invited them to stay with him.

The Villa Lucia was a palatial setting—it had been the summer residence of Ferdinand I, King of Naples, before becoming (through di Feo) a meeting place for anti-Fascists. From the villa's balconies they had a view of an orchard, and beyond it Naples, with Vesuvius puffing smoke on the horizon. By day the two photographers worked on an extensive story about Naples. Di Feo helped them: he knew everyone in town.

Together Capa and Rodger witnessed scene after scene of desolation in a city flattened by German bombs. Thousands of homeless families were camping out. German soldiers had looted the city and broken into shops and private houses. The Church of Santa Chiara, where Rodger went to take pictures, had been destroyed by bombs. The University of Naples had been vandalized, its books, tapestries, and paintings torched, its furniture smashed.

Infuriated by the Italians' refusal to volunteer for the German army, the Nazis had invaded houses and dragged men out by force; by then, however, many were already in hiding with relatives in the country or in nearby caves. In reprisal, the Germans had opened fire on anyone they saw. The booby traps they left behind destroyed what was left of many public buildings and killed many people; the city's streets were strewn with more than two thousand bodies.

In the Vomero district, Capa stumbled onto a funeral of young high school students. There were twenty coffins containing the bodies of boys who had died fighting the Germans in the last days of the occupation. They would be Capa's encapsulating memory of the European war—one that would still be haunting him years later:

Inside [the schoolhouse] were twenty primitive coffins not well enough covered with flowers and too small to hide the feet of children—children old enough to fight the Germans and be killed, but just a little too old to fit in children's coffins. These children of Naples had stolen rifles and bullets and had fought the Germans for fourteen days while we had been pinned down in the Chinuzi pass. These children's feet were my real welcome to Europe. I who had been born there. More real by far than the welcome of the hysterically cheering crowds I had met along the road, many of them the same that had yelled "Duce!" in an earlier year.[5]

Capa shot powerful images of the boys' grieving mothers, and said of the photographs: "Those were my truest pictures of victory."[6]

Capa and Rodger spent more than a month on their story. Rodger was becoming sick of the ubiquity of death. He described to Cicely the scene at a cemetery where Italian civilians killed by the Germans were being buried: "There were some 2,000 of them and as there were hundreds still unburied, their coffins lying broken on the surface, the stench was a bit too much and I was glad to get the job done and be able to scram." His work would be much easier to take, he added, "if *Life* were not quite so fond of bodies."[7]

One of Rodger's most powerful *Life* stories was about two children wounded by hand grenades:

To round off the day of horror, I went to a hospital where there were two little boys I had heard of. It seems they had been working in the fields close to a German H.Q. with their Mother and Father, when two German soldiers appeared at a window of the H.Q. and beckoned them over. The two children approached them and then they threw a hand-grenade at them. The youngest kid had both of his legs blown off and the other managed to run a few yards before collapsing but he also had to have one of his legs amputated. An Italian soldier rescued them but the two Germans ran away before he could see who they were. I checked the story with the Father, the Mother, the soldier who picked them up and the kids themselves and they were all exactly the same, so I guess there isn't any doubt about that little bit of German culture.[8]

After Naples, Capa took a break and went back to London for a while. Rodger sent him to meet Cicely at the Time-Life office, but the two did not hit it off. Capa could not resist provoking Cicely, first with cynical generalizations about "men" and "women," then with his opinion that Rodger was happy at war and did not really want to come back—otherwise wouldn't he be in London with them? That particular arrow struck home, and Cicely immediately complained

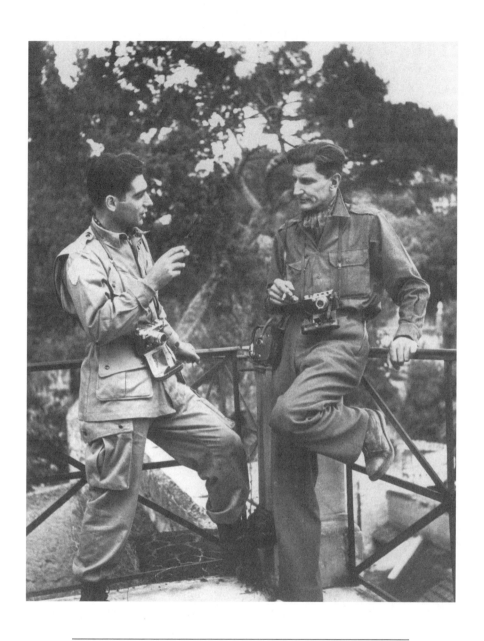

Robert Capa and George Rodger, Naples 1943. © *Magnum Photos.*

to Rodger, who tried to placate his wife: "You just have to take Bob Capa as he comes and make the best of it. He is a strange mixture of kindheartedness and extreme egotism and I myself am not always sure which is uppermost at any given time."[9]

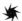

One of the most difficult aspects of the war for Rodger was that he never saw his contact sheets or his *Life* publications. Cicely's letters, full of information, were a precious lifeline to him: "Darling, you have no idea how interesting your letters have been. For instance I had no idea what I had got into the magazine. Nobody has troubled to cable me—and when you told me that my first story ran 11 pages, I was simply amazed. And then to be followed up by another couple of pages the very next week sounds simply grand."[10]

Cicely was keeping a press book in which she assembled all the clippings concerning *Desert Journey*. An announcement by Rodger's publisher in the *Times Literary Supplement* listed *Desert Journey* as being in stock along with prestigious books such as Carson McCullers's *The Heart Is a Lonely Hunter* and Nora Walk's *The House of Exile*. The notice also announced the release of *Red Moon Rising* by the end of 1943. Rodger's reputation as a writer was also growing in the United States. Long excerpts of his two books were published by Macmillan in New York under the title *Far On the Ringing Plains*, and the book was written up by one of the top American reviewers, John Chamberlain of the *New York Times*.

In spite of the harrowing scenes he witnessed, Rodger's stay in Vomero was not entirely unpleasant. Di Feo looked after him well, and Capa was soon back from London. Rodger was enjoying their company and that of Will Lang. The depression and shell shock that had plagued him in New York were beginning to lift. He wrote to Cicely: "Fortunately I seem to have no vestige remaining of my old nervous troubles—I haven't had a touch of it since I left Algiers. In fact, the trickier [the] positions I get into the better I feel. A rough life seems to do me good!"[11]

In October, Rodger decided to take a short vacation and was rowed out by fishermen to Capri, where he remained for four days. There, he experienced an epiphany of sorts, a purification of the psyche. In a rare admission, he told Cicely that war had made him feel "sullied," as if his body and soul had soaked up the violence around him. His had been, he wrote,

a mood born of an utter surfeit of war; of all the ghastly waste and carnage. A mood, sated to a state of indifference to death and senseless, wanton destruction. And then when I reached Capri . . . everything was crystalline and fresh

and untrammelled. I seemed to be the only sullied blot . . . until a fisherman's family found me and mama took all my clothes and washed them and scrubbed me with a brush made of hog's bristles. . . . And the fisherman sat in the sand and sang to his guitar, and his two daughters harmonised the rich, nostalgic, Napolitean love songs. . . . Unconsciously they tipped the balance in favour of a world that suddenly was clean again . . . and suddenly the horror of the war had gone from inside me.[12]

When Rodger got back to Vomero, he and Capa began having long discussions about their future: they were now envisioning it together. For some time, Capa had wanted independence. He did not want to be an employee or to cater to editors' whims. He dreamed of plotting his own stories, owning his own copyrights (the "Falling Soldier" picture had made him famous but not rich), and controlling his own publications as well as attaining a degree of financial independence by owning his archive. In brief, he thought that photographers ought to be authors—a revolutionary thought in the 1940s when they were mostly seen as secondary to writers, in charge of illustrating and reinforcing text. Very often, published pictures did not even have a copyright. Capa's dream of a cooperative agency had been the stuff of his conversations with any sympathetic photographer he met. But Rodger was different: he took Capa very seriously. They saw each other as kindred spirits.

The two spent evening after evening on the Villa Lucia's balcony drinking whisky that Capa had obtained through some unmentionable means. Capa's words made a profound impression on Rodger, who tended to get deeply absorbed by each experience he lived and to inhabit each moment as if it were the last. He had not planned his career and rarely projected a future for himself beyond the present confusion, except that he wanted a future with Cicely. By engaging with someone whose mind functioned in a much more strategic way, Rodger could let himself imagine a time when the war would no longer be raging. Capa had a clear mind (if at times a cynical one), but he needed the support and feedback of a friend, and Rodger's attentive thoughtfulness was helping his ideas take shape. Their rapport was such that Capa felt no need to provoke and play games with Rodger, who thus saw a side of him that few others had. "He was not exactly the same flamboyant figure that various biographers have made him into at all," Rodger later said. "[He was] helpful, very reasonable, very quiet, very perceptive."[13] But of course this vision of Capa may have been idealized by memory.

For most of their careers, the two photographers had not been free agents; they had had no control over their own lives and little choice in their assignments. One goal became all-important to them: freedom of expression, the

possibility of taking pictures that would not be censored by anybody. A game with rules they themselves could control. Thus was born the idea of Magnum Photos (as yet unnamed), a cooperative fraternity of photographers who would show things as they were without editorial censorship. Rodger later explained:

> We spoke about it all over the Middle East and Africa and especially in Vomero. Capa and I both very definitely had the same idea of an eventual brotherhood . . . that we would be free of all sorts of editorial bias and that we could work on the stories that we . . . knew were valid, and have a staff or even just a single person who could handle the material when it came back so that we didn't have to go through all the sweat of processing and editing and dispatching and talking to editors.[14]

Cicely was writing regularly from London, keeping Rodger informed of his publications: "[Margery Murphy] got me the air edition nr 1 of *Life* which had your pictures of the refugees that had been freed from internment. . . . There were also Bob Capa's pictures of the bombing of the Naples post office. Then, at the Kenwards yesterday, Dot [Cicely's sister] had a copy of the 27th September *Life* with your Salerno pictures."[15]

Sometime in November, Rodger and Capa parted company. According to one of Rodger's diaries, in which only dates and places are recorded, he spent the end of 1943 and the beginning of 1944 on the Ortona front. For most of the winter he stayed in a damp, dilapidated farmhouse, where the fireplace smoked him in rather than warming him up. He slept in his long underwear and overcoat and waited impatiently for a sheepskin vest that Cicely had mailed to him from London. In her letters, she was telling him about her daily life and her errands. Touchingly given his own circumstances, he congratulated her on buying herself a fur coat, for which he had sent her £100 through Capa because she was only making £7.15 a week at her job.

Away from the action, Rodger was growing frustrated and despondent. His isolation was heightened by the fact that *Life* had not sent him his clippings. In almost each letter he implored Cicely to keep an updated file of his published stories.

But when he finally received the September issue with his Salerno story—two months after it was published—he was furious to discover that the editors had added two drawings to the photographs. Furthermore, the Naples story on which he and Capa had spent so much time and effort had been discarded: "Darling, they definitely have not run our Naples story. That was quite separate from

the entry into Naples, and all I can think is that it has been killed by Maggie B-W [Margaret Bourke-White]. You can imagine how Bob and I feel." [16]

It is unclear whether Bourke-White really was responsible, but distance was making Rodger paranoid. Capa was furious at the news, and sulked in Algiers for two-and-a-half weeks. Rodger was frustrated by the way editors had treated his work and was beginning to conclude that he did not want to shoot any more news stories. He now intended to shoot a long essay on the Eighth Army: "This essay on the Eighth Army is the first one I've tried. I am going to develop the films myself in Naples and edit the story and, if possible, send prints over instead of just a mass of undeveloped negatives." [17]

Rodger's journalistic sensibilities were maturing; he was setting his sites on becoming an essayist rather than a news photographer. One of his ideas was a photo story about the supply route to Russia from the Russian side—an assignment that Bourke-White had been planning to take. Instead she had decided to wait in Italy until the fall of Rome—an event that Capa and Rodger wanted for themselves. This bitter professional competition was not helped by Bourke-White's hard-nosed personality and Rodger's feelings (probably justified) that *Life* treated her like a star and Capa and himself indifferently.

Rodger wanted to be sure he would receive a promised raise as of November as well as a Christmas bonus. He had spent all of his money on a much-needed car, and reimbursement was slow in coming. Meanwhile, Capa had left Algiers and was back in Naples, with a gorgeous new girlfriend, Elaine Fisher. This made Rodger more aware of his own loneliness. He wrote to Cicely on Christmas Day, 1943: "Bob Capa has a wonderful blonde in tow and seems to be living in Naples now. . . . It makes me very mad to feel I am on a fruitless quest when I might be back at home with you. . . . It seems years since I left you in London and yet it is only five months ago." [18]

In December, Rodger received a published copy of his Burma book, *Red Moon Rising*, and a long-awaited cable from *Life's* picture editor Wilson Hicks, telling him he approved of his Eighth Army story and would run twelve pages and the cover if Rodger produced the pictures. Meanwhile, Capa and Bourke-White were in fierce competition over a story about the French troops. Rodger complained: "Maggie B-W continues to fuck us all up (pardon me! one gets into the way of this army slang!) She agreed to lay off the French troops as Bob was doing that story and now we hear that she slipped in and took a barrel of stuff which she slipped off to N.Y. before his was ready." [19]

In her letters, Cicely recounted the simple, happy events of her daily life: she had found lemons to buy, she had started smoking Philip Morris because American cigarettes were hard to find, she had bought nylons and had her first tailored

suit made. She also complained about Capa, who had returned to London for a short time and had failed to give her a package and message from George that had arrived at the office. "He made some crack to Frances about bloody husbands with bloody wives over here and why the hell should he have to look after them . . . he is evidently one of these people who cannot credit anyone with any deep feelings—food, drink and Pinky to sleep with is about all he has in mind."[20]

To entertain Rodger she reported the latest office gossip. One of the Time-Life employees was in the habit of jotting snatches of overheard conversations, one of which featured Capa's remark to his girlfriend: "Pinky, mostly when I kiss you it is like strawberries and cream, but Pinky sometimes when I kiss you it's like kissing an ashtray."[21]

Cicely was feeling lonely and missing Rodger immensely: "I only feel half alive when you are away," she once wrote. But Rodger was not coming home. And it was not through his letters—in which he was always sparing her—but through his *Life* stories that she discovered just how many risks he had been taking. Among his most dangerous assignments was the battle for Monte Cassino, a hill town crowned by a famous medieval monastery that the Allies had to capture before they could advance on Rome. On February 12, Allied planes circled overhead and dropped leaflets warning civilians that the town was about to become a target. Nobody moved. On February 15, four hundred tons of bombs were dropped on the town and its monastery, killing the bishop and some 250 civilian refugees. The town was wiped out. In spite of that bombing and their infantry assault, the Allied troops failed to dislodge the German defenders, who counterattacked furiously. The casualties on both sides were enormous.

Life gave big play to Rodger's pictures of Monte Cassino. The opener was a double-page showing a line-up of jeeps with Red Cross flags waiting to evacuate the wounded.

Dead mules lay along the route into Cassino. At one corner, two ambulances, a truck and an armoured car were piled up together, riddled by shrapnel. The stench from the dead lying around them was nauseating. As I neared the first building, enemy shells began bursting ahead of me. I stopped to photograph them. The shells started bursting to my left and I was forced to get behind three bren-gun carriers and the cliff. Unfortunately it was those carriers that the Germans were trying to hit. For the next fifteen minutes all hell broke loose. . . . Even the medics by now would not risk trying to get much-needed supplies into the town and the evacuation of wounded along that route was being abandoned because of the casualties among the stretcher-bearers. Overhead German rockets were screaming into the town.[22]

In March and April Rodger was with Capa in Naples. He had been assigned to shoot a portrait of General Montgomery, but Monty, unimpressed by Rodger's *Life* credentials, made him wait several days and then agreed only to a five-minute shoot. The resulting *Life* cover of May 15 is nevertheless a striking portrait: Montgomery, wearing his signature beret,[23] is plainly trying for an optimistic expression but instead comes across as utterly exhausted.

Rodger was called back to London in May, and stayed there until the beginning of July. An overjoyed Cicely tried to fatten him up by cooking meals in the small apartment she had rented and furnished in his absence.

> For the first time I was issued by the War Office an official accreditation to the British Army. . . . It was a relief to be officially recognised at last. But even in Europe I hopped and changed from one Army to another, not only the U.S. 5th, the British 8th, and the Free French, but the Free Poles, the Free Italians, the Dutch Resistance and Marshall Tito's Yugoslav Partisans. To suit everyone I had a composite uniform of my own design, tailored in London's Saville Row, with the concession of a cravat of camouflage parachute silk rather than a collar and tie.[24]

One of the first places Rodger visited to show off his uniform was the Time-Life office. It was there that he first met John Morris, an editor with whom he would be working for many years to come. After a two-year stint as a researcher, Morris had been hired by *Life* in 1940, at first based in Los Angeles as a Hollywood correspondent. In the summer of 1942 he was called back to New York to work with Wilson Hicks as an assistant picture editor. In the fall of 1943 Morris was promoted to London picture editor. As he later recalled: "We had about 35 people in that office by the time George came back from Italy to get ready for the next job: Normandy. But he needed a rest, he was exhausted. I did not push him or Capa very much. My one big job was to be sure of coverage for the invasion."[25]

10

The Dire Sink of Iniquity

JUNE 1944-MAY 1945

For the invasion of Europe the Allies had chosen the Normandy coast, which was ideal because of its long beaches protected from western winds and its two important ports, Cherbourg and Le Havre. Through a campaign of misinformation they had persuaded the Germans that "Operation Overlord," as it was dubbed, would be launched across the Pas de Calais, two hundred miles to the northeast. So it was there that the Germans anticipated a landing and had concentrated their defenses.

Six divisions formed the initial landing force: three American, two British, one Canadian. The Americans were to land near the base of the Cotentin peninsula. The British and Canadians would land farther east near the mouth of the Orne River, with orders to capture the road junction to Caen, which was to anchor the beachhead. The Allies had divided the Normandy beaches between Valognes and Caen into five sections, code-named Utah, Omaha, Gold, Juno, and Sword. Each section in turn was divided into green (west) and red (east).

D-Day was the story of the century, the one every newsman had been dreaming about. No fewer than 558 writers, radio reporters, photographers, and cameramen had been accredited to cover it. Courier planes and speedboats were at the ready to carry them back. The BBC alone had dispatched forty-eight correspondents, including their stars, Chester Wilmot and Richard Dimbleby.

By dawn of June 6, 1944, eighteen thousand British and American paratroops were on the ground in Normandy. That same morning, at 6:30, the Americans came ashore at Utah Beach.

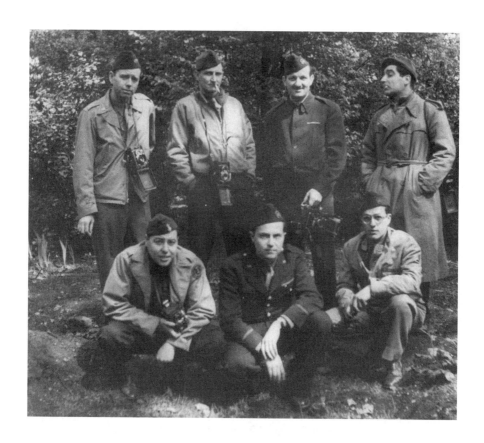

Life's D-Day photographers pose in Grosvenor Square a week before the Normandy invasion, London, 1945. *Top row, left to right:* Bob Landry, George Rodger, Frank Scherschel, Robert Capa. *Front row, left to right*: Ralph Morse, John G. Morris, editor and David Scherman. © *Time Pix.*

John Morris had sent out six *Life* photographers,[1] each to a different location. Frank Scherschel went with the Air Force (he had already flown a mission over Germany), Rodger with the British army, and Ralph Morse with Patton's Third Army,[2] while Dave Scherman was assigned to the invasion headquarters. All of Landry's D-Day films were later lost. Robert Capa went with the First Infantry Division's Sixteenth Regiment. He took 106 pictures of the battle, then returned by landing craft to the invasion fleet off Omaha Beach.[3]

By 7:25 A.M., the first British soldiers were ashore at Gold and Sword beaches, closely followed at Juno by 2,400 Canadians and amphibious tanks. Running through the waves under rain and artillery fire, Capa placed himself at enormous risk and sent in the first and best pictures of D-Day—photographs of history being made, whose blurred, up-close, cinematic quality made those who saw them feel the urgency of the landing. But only eight of his pictures could be published by *Life*; the rest had been ruined at the London office by a darkroom assistant who in his impatience turned the heat up too high in the drying machine, thus melting the negatives.

Other correspondents were carried away by their own empty rhetoric: "The great history of the world is unfolding before us at this very moment," announced W. Helmore of the BBC.[4] Writer Ernie Pyle was one of the few who distanced himself from the breathless, heroic tone that generally prevailed, who stripped the glory from the mythical war correspondent: "Angry shells hitting near us would make heavy thuds as the concussion carried through the water and struck the hull of our ship. But in our wardroom men in gas-impregnated uniforms and wearing lifebelts sat reading *Life* and listening to the BBC telling us how the war before our eyes was going. But it wasn't like that ashore. No, it wasn't like that ashore."[5]

This time, Capa had outscooped Rodger: "Bob Capa had a tough time at Omaha Beach where nothing seemed to go right while I landed at Arromanches in a blaze of anticlimax. *Life* naturally published his sensational coverage. Bob was still probably trying to recover his breath while I was already enjoying steak au poivre at the Lion d'Or in Bayeux." During the course of the day, Capa had nearly drowned.[6]

Hitler was enraged that the Allies had succeeded in establishing a beachhead, but he did not consider himself beaten yet. He ordered Rommel to drive the invaders "back into the sea" by midnight. They were not driven back. By June 10 the Allies had consolidated their positions and landed more than 325,000 soldiers. Two days before, Stalin had telegraphed Churchill: "*Overlord* is a source of joy to us all."[7]

Later in June, Rodger took a short break in London. It was there in the city,

away from hard news, on a neighborhood street, that he took one of his best war pictures—indeed, one of the best pictures of his whole career. John Morris recalls that it came about by pure chance: "George Rodger was back from Normandy. . . . I was organizing my gear at the office when we heard the now familiar noise of a buzz bomb exploding nearby. George offered to go have a look and came back with one of the most moving images of the war—a woman lying serenely on a stretcher as she is carried off through dust and rubble." [8]

What came to be known as *The V2 Picture* was taken on June 17, 1944, after a German bomb destroyed the Surrey Hounds pub near London's Clay Junction Station. The photograph's central figure is an old woman on a stretcher who has just been pulled from the wreckage. A team of firefighters is lifting her from the ground. The dust from the explosion has not yet settled, and through it the sun's rays form a cone of soft light on her closed eyes and strangely serene face. In the foreground, the firefighters' helmets are gleaming.

Like Capa's pictures of American soldiers sprinting for Omaha Beach, Rodger's photograph became an instant icon of the war. But where Capa's are intense action images, Rodger's single shot has the feel of a Rembrandt tableau. The delicate light on the woman's face and the firefighters' helmets transforms the chaos into a moment of balance and peace, offering some hope that despite the war, all will be well. In approach, Capa and Rodger could not have been more different; Rodger knew it, and summed it up this way: "Gene Smith and Capa were combat photographers; I was photographing at war." [9]

Before he could see his picture published, Rodger was back in Normandy, where he followed the Allies' dogged advance toward Paris. On June 27 the Americans took Cherbourg, but by then the Germans had destroyed the portworks and blocked access to the harbor with sunken ships. Perhaps sensing that the end would soon be at hand, Hitler was putting up a bitter fight. West of Caen the Americans had to contend with the *bocage*—thick hedgerows that lined the fields and roads and offered the Germans perfect defensive positions. Even so, by June 28 some 750,000 Allied soldiers were ashore and 40,000 German prisoners had been taken.

Faced with heavy losses, Rommel quickly moved reinforcements to Normandy. But his fresh troops—whose portraits Rodger took with a heavy heart after St-Lô was taken—were only children. American photographer Walter Rosenblum, also shooting at the time, observed that "a lot of the Germans we took prisoners were just little kids in army uniforms . . . they seemed terribly bewildered, lost and frightened. They were 14, 15, 16." [10]

Caen had been the Allies' D-Day objective, yet they did not capture it until July 25, and only at huge cost. For his piece about the battle for *Life*, as for all his

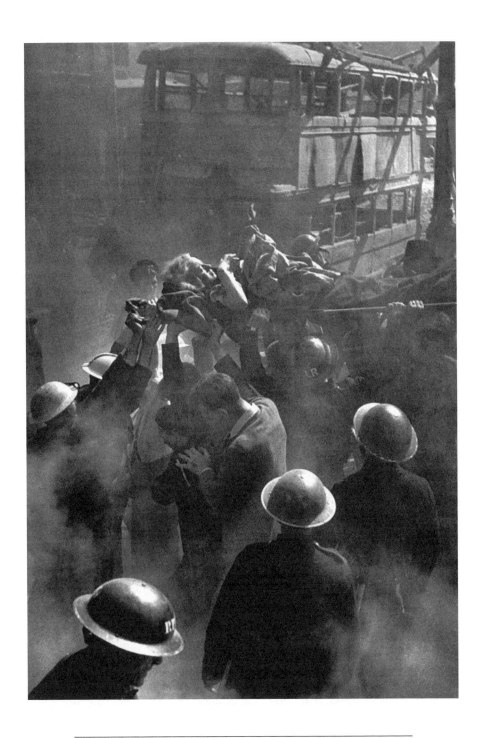

A woman is rescued from the ruins of the Surrey Hounds pub after a
V2 raid, London, 1944. © *George Rodger / Time Pix.*

major stories, Rodger used both a Rolleiflex and a Leica. The magazine published his images of a tank repair shop on the battlefield, of German prisoners at the Caen train station, and of the caves of Fleury-sur-Orne, where civilians were hiding. Rodger's photographs showed a destroyed city where some three thousand Frenchmen had been killed.

On one of Rodger's contact sheets—twelve Rolleiflex shots of the Allies' advance in Normandy—a rare self-portrait appears, and shows eloquently how much strain he was under, how much emotion he was keeping in. His eyes are sad, his expression tired and drawn, almost resigned.

Hitler ordered a counterattack against the Americans near Avranches. It failed, and the Germans found themselves run to ground near Falaise; more than ten thousand Germans died in that pocket of France and another fifty thousand surrendered. The Falaise battle was one of the most bitter of the Normandy campaign. There, Rodger shot some of his hardest-hitting pictures since Monte Cassino.

In one of these, the face of a dead German tank driver, leathered like a mummy's, pokes out from the mangled wreckage of a tank. In the foreground of another, a slumped body, head covered with an overcoat, is surrounded by wood, metal, and fabric debris, while in the background a neat picket fence protects a well-tended garden: a stone ledge, lace curtains, five pots of geraniums in line, all touched by the summer sun. The picture recalls Rodger's best work during the Blitz. He had a gift—a near literary gift—for breathing life into dead objects, for conjuring a war scene indirectly out of small, everyday details that many would have neglected. As A.J. Liebling did in his writing, Rodger discovered in those details a larger, universal power.

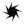

By August 17 the Allies had reached the Seine near Mantes, thirty miles from the French capital. The battle for Paris had begun. Near Orléans, a British Special Air Service detachment, "Operation Wallace," joined forces with the local French Resistance for a joint attack on the Germans, and a French armored division began its advance. In a last-ditch effort, the Germans attacked the Resistance fighters who had taken over the Grand Palais, setting the building on fire; meanwhile, in the center of Paris, Germans and patriots were engaged in bitter fighting. The Résistance forces came out victorious; as a first gesture they freed all French prisoners in Paris. On August 24 a French armored column under Colonel Pierre Billotte entered the city from the south. With flags and wine, food and flowers, tens of thousands of Parisians came out to welcome their liberators.

The next day, Capa, Rodger, and Charles Wertenbaker—Time-Life's chief correspondent—in a Packard "requisitioned" from the German army, entered Paris just behind the tanks of General Leclerc, commander of the French Second Armored Division, whom Rodger had met during the Desert Campaign. They were followed by a unit of the U.S. Fourth Division.

By the time Capa turned up at the Hôtel Scribe, Rodger had already booked them a room. The place was packed with correspondents, among them the top ranks of American reporters: Ernie Pyle, William Shirer, Janet Flanner, and A. J. Liebling. Some had been at the bar for a few days even before the Allies' official arrival.

That same afternoon, General Dietrich von Choltitz, the Germans' commander in Paris, surrendered, and General de Gaulle entered the capital. He was the star of this day, towering over his surroundings in a perfectly creased uniform, a rare smile playing below his neatly trimmed mustache. He made his way through ecstatic crowds to the Hôtel de Ville, where a few German snipers were still hiding. They began firing into the crowd. While they were being flushed out, Capa, who had a sixth sense for gunpowder, photographed the terrified crowds. As for Rodger, he photographed de Gaulle's victory parade on the Champs-Élysées. In one of his close-ups, the general bows to the Tomb of the Unknown Soldier under the Arc de Triomphe and places on it a bouquet of flowers.

Rodger continued with the parade down the Champs Elysées. Near the Rond-Point, Place de la Concorde, a tall, slightly stooped photographer with blue eyes, his Leica hanging from his neck by an old belt, stepped onto a bench for a clear view. He found himself riveted by a tall, British-looking soldier with a black beret pulled over grayish-blond hair. Rodger was standing in the Packard with an American star on the front door, holding his Leica at the ready and scanning the scene. The photographer was Henri Cartier-Bresson. He raised his own camera and took the shot. Rodger would recall: "This is when Henri photographed me heading the parade, De Gaulle's parade, down the Champs-Élysées. When he had no idea who I was."[11] Cartier-Bresson could not know that two years later, the two of them would meet as founding members of Magnum Photos.

Rodger and Capa spent the following week roaming the liberated capital, snapping pictures and taking in the giddy atmosphere. The balconies were draped with flags, the streets packed on both sides with only a narrow corridor left for tanks and jeeps. Enthusiastic men, women, and children threw flowers and confetti, hugged their liberators, shook their hands, kissed them. Women were dressed up in white or red blouses and blue skirts, with flowers in their hair.

Over the cheering, the correspondents could still hear distant explosions

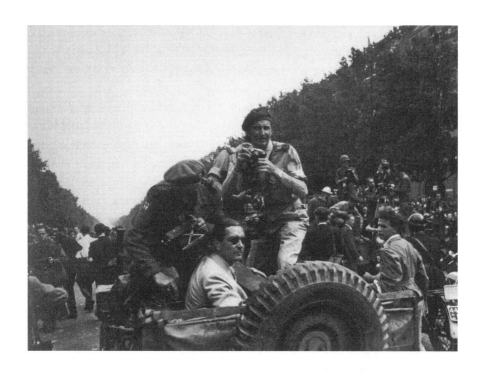

George Rodger photographed by Henri Cartier-Bresson during the Liberation of Paris, 1945. At the time of the photograph they did not know each other, but two years later they became co-founders of the agency Magnum Photos. © *Henri Cartier-Bresson/Magnum Photos.*

and the occasional rattle of machine guns: in a last desperate rear-guard action, the Germans were trying to destroy the Seine bridges. But for the moment at hand, Paris couldn't care less.

Rodger finally let his hair down—by getting drunk on Pernod—which may or may not explain why his pictures of the city's joyful liberation did not reach London in time for *Life*'s deadline.[12] Across the Channel at London's Time-Life office, John Morris edited the 1,300 frames shot by *Life* photographers on the liberation of Paris and sent them to New York.

Cicely was growing more and more frustrated. She had not seen Rodger in months. She was disenchanted with her job as a secretary and felt that the Time-Life office on Dean Street "just drift[ed] along like a rudderless boat." In her eyes, the main culprit was her boss, bureau chief Morris. "He really is a fatuous ass," she wrote to Rodger:

> Sometimes I wonder if he is able to read at all. . . . I was rather amused that in answer to his reams of suggestions for postwar coverage . . . Fill had replied: "We'll be sending lots of ideas on postwar and current setups shortly meanwhile this acknowledges your cabled ideas with thanks." I think John thought he was going to plan *Life* for the next two years single-handed and probably be awarded the Purple heart for it. . . . I find him more and more irritating. He said he wished the British would get a move on—be more reckless like the Americans![13]

Cicely also complained about other members of the office. The casual anti-Semitism of one of her comments is, in retrospect, especially chilling: "Renée is a Jewess, although she is one of the few nice ones around." This was after she had made a disparaging remark about Jollis, another Jew on Time-Life's London team.[14]

Rodger did not sound much better in his reply, resorting to the ancient slur about Jews being money-grabbing war profiteers: "Don't worry, Darlingest, as soon as the flying bomb menace stops and there is no longer fear of a V2, then the Jews will come back to London and the market will rise again."[15] These remarks are all the more troubling because they don't seem to blend with Rodger's personality. Capa, his closest friend at the time, was Jewish. True, Capa did not usually discuss his background or mention that his real name was Endre Fried-mann. Capa wanted to be an international figure and to blend into the secular French culture, in which race and religion were rarely mentioned. Were Rodger and Cicely thoughtlessly echoing the casual anti-Semitism of their social class? Did their feelings run deeper than that? No one can say.

In early September the British Second, Canadian First, and U.S. First

armies drove into Belgium while Patton's forces swung into northeastern France. Soon most of Belgium and Luxembourg were in Allied hands. Rodger covered the liberation of Brussels, witnessing more scenes of euphoria on the streets.

At the end of October, Cicely received good news: she had been accredited to work at Time-Life's Paris office. She met Rodger at the Lancaster Hotel, where he showered her with belated birthday presents, including lipstick and a bottle of L'Heure Bleue by Guerlain. She had turned thirty-one in August.

Rodger would often have to leave to cover more European stories, but now at least they had a common base and could get together between assignments. Rodger spent his New Year's break in Paris, then drove to Brussels on January 2, 1945. By then he was carrying a small black notebook in which he jotted notes every evening.

Rodger wanted to do a story on Walcheren Island. While they were being driven back, the Germans destroyed its harbor to make sure the Allies could not use it; as a result, the invaders were forced to rely on their original Normandy beachhead, which greatly lengthened their supply lines. On October 3, 247 British aircraft attacked the dykes that protected Walcheren Island from the sea, and the waves rushed in. As in Monte Cassino, Caen, and Colleville-sur-Mer, the attack succeeded but at a very high cost in civilian lives: 125 islanders were killed. The air attacks continued for a month before the British and Canadians took Walcheren.

In Middleburg, Rodger joined up with another correspondent, Rudy Aster. A strong eastern wind was blowing, and the canals were frozen solid. "The tide is at its lowest ebb," Rodger would write later, in his *War Diary,* "and only a few feet of water lie over the gap made in the dyke walls. The top of German blockhauses show above the water where hundreds of Germans were caught and drowned. A sickly yellow sun struggles through the clouds and I am able to photograph the harbour sabotaged by the Germans and the stage where Cicely and I landed in 1937. Everything is completely destroyed including the railway station."[16]

Rodger photographed Dutch farmers adrift on a raft made of doors. He found a couple, the Huismans, who lived in Brigdamme with their four daughters. Like many islanders the family had refused evacuation. To them the calamity was an act of God, not of men. So they waited it out, going about their lives despite the rising waters. When the tide reached their front door, they contended that it only came inside during the full moon.

On February 16, Rodger returned to Brussels. He spent the rest of February and March on the move between Paris, Brussels, and London, rejoining the Second Army on March 14 and taking a few days' break with Cicely. "Paris is be-

coming Spring like," he wrote in his diary. "Trees are budding and air is warm. There are more bicycles on the street and girls are wearing white dresses. There seems to be some optimism regarding the early ending of the war." [17]

Bergen-Belsen

In Germany and Poland more than six million Jews, Gypsies, Communists, and Resistance fighters had been killed. Yet except for a handful of British journalists, no one seemed to have heard about the death camps. In June 1944, four Jews had succeeded in escaping from Auschwitz. They carried their accounts of the gas chambers to other Jews in Slovakia, who in turn delivered the news to Switzerland. By June 24, 1944, London and Washington had been informed about the camps. At the same time, the group appealed to the Allies to bomb the railroad lines leading to Auschwitz. Churchill informed Stalin and Roosevelt that he approved of the bombing. But the British Air Ministry and the American Assistant Secretary of War, John McCloy, refused to countenance any such plan, so the lines were never bombed. It seems that Europe's Jews were not a priority.

By early 1945 the Germans were destroying evidence of the camps. On January 20 they blew up the crematoria at Birkenau. On January 25, Stutthof was evacuated. At Auschwitz, Birkenau, and Monovitz, the survivors—mostly Jews but also Poles and forced laborers of a dozen nationalities—were waiting for the Red Army to arrive. The SS wanted to prevent their liberation at all costs. On January 18 an order of immediate evacuation was given, and long columns of prisoners set off on foot in freezing winter from Auschwitz and from the slave labor camps of Upper Silesia. In these death marches, anyone who fell and could not rise again was shot.

Rodger knew nothing about the camps and their evacuation. Germany was just one more assignment to him when, on March 19, he decided to follow Churchill's troops to witness their crossing of the Rhine. On March 21 he entered Germany. It was the fiftieth country he had set foot in since the beginning of the war.

Two days later, on March 23, the correspondents were briefed about the impending leap across the Rhine. The same day, the U.S. Third Army crossed the river south of Mainz. The following day, Rodger noted:

> The din of the battle goes on all night with the barrage increasing for each successive attack. Flares, tracers, star shells, searchlights and guns flashing light the sky. I spend the night in a German observation post overlooking Xanten and soon after dark I go down to the river where troops are crossing by buffaloes,

speedboats and ferry. I cross over to the far side of the Rhine to get pictures of the first prisoners coming in and then go back to my observation post to watch the Air Armada arriving.[18]

The same day, he shared with Cicely his formula for survival—avoiding thinking at all costs: "I only feel nervous when I'm thinking about things and not at all when I'm actually in the thick of things. Today my nerves were just as steady as a rock."[19]

Rodger made contact with Churchill, who crossed the Rhine on March 26 "in company of Monty, Ritchie, Dimpsey Hogart, Sir Allan Brooke. He crossed by the Xanten bridge . . . made a speech to the men of British Squadron 11th Royal Tank Regiment who ran buffaloes and said, 'We are driving back a beaten army to the dire sink of iniquity.' "[20] Rodger thought the old boy was overdoing his metaphors a bit.

Rodger had seen some fifty-one war fronts and there was nothing, he thought, that could shock him. Between March 28 and 31 he was on the road to Münster, taking tragic pictures of the destroyed town and of corpses lying on the road. Displaced persons of all nationalities were flocking toward the rear of the Allied lines: Italians, Russians, Yugoslavs, Poles, Belgian, French, and Dutch, escaped prisoners and slave laborers.

On April 4, American troops entered the concentration camp of Ohrdruf, where they counted four thousand corpses—inmates who had been murdered by the Germans the night before. Bodies in striped uniforms were piled by the hundreds like cordwood, each bearing a neat little hole at the base of the skull.

Immediately, pictures of the camps began to circulate in European newspapers and magazines, generating a wave of shock and revulsion. On April 9 the first photos appeared in the *Times* of London, the *News Chronicle*, and the *Daily Mirror*. The next day the *New York Times*, the *Los Angeles Times*, and the *Washington Post* all published a picture of the Ohrdruf corpses. The same picture was soon published again in the *Daily Telegraph*, the *Daily Sketch*, and the *Daily Mail*. The entry of American troops into Buchenwald on April 11 came as an even greater shock. By the time Rodger returned to Germany on April 19, after a short assignment in Paris to cover the French reaction to Roosevelt's death, he had most probably seen pictures of Ohrdruf and Buchenwald. The Holocaust was finally making headlines, albeit too late for the Jews of Europe.

When he arrived at Oyle in northwestern Germany, Rodger heard about Bergen-Belsen, which had been liberated the day before, and decided to go and see for himself. The camp had originally been a Wehrmacht facility for wounded prisoners of war. In the fall of 1943 an internment camp had been set up there,

Two survivors, Bergen-Belsen, 1945. © *George Rodger / Time Pix.*

and a number of officials had been transferred to it from Auschwitz. Haupt-sturmführer Josef Kramer, a former commander of Birkenau, was given the top post; Dr. Fritz Klein, an Auschwitz doctor, was named chief camp doctor.

As the German front lines began to disintegrate and massive numbers of German soldiers surrendered, the administration of the camps broke down. More and more inmates were sent to Bergen-Belsen—as many as 28,000 during the week of April 4 to 13 alone. "The food supply was shut off, roll calls were stopped, and the starving inmates were left to their own devices. Typhus and di-arrhea raged unchecked, corpses rotted in barracks and dung heaps. Rats at-tacked living inmates, and the bodies of the dead were eaten by starving prisoners."[21]

Rodger would never forget April 20, 1945, the day he entered Bergen-Belsen. The camp was six square miles, surrounded by fields and forests. Inside its barbed wire fence sixty thousand men, women, and children were starving to death.

In the spring of 1997, fifty-two years after the war's end, I went with Jinx Rodger to the Cumbrian village of Penrith to meet Dick Stratford, who had been Rodger's driver since two weeks before D-Day. Stratford was a reserved man with a military bearing; he had dressed neatly for the interview in a blue blazer and polka-dot tie. He had never spoken about Bergen-Belsen, and his words came pouring out:

> Rodger was a very independent person. He knew what he wanted and went to great lengths to get it. He did not mix with other photographers. We went out mainly on our own. He did not work with a writer. He wanted to be on his own and write his own background information.
>
> When we went into Belsen, the gates were wide open and I did not see any other photographer or army personnel. We just drove around. The size was quite huge. A field like a football pitch covered with bodies piled six or seven high. . . . There was nothing we could do. We just said hello to people and that was all. There was no possible conversation.
>
> A day after that the army arrived to take charge of the camp. . . . They got the SS to pick up the bodies and bury them properly, because there were just mounds of bodies. It was beyond imagination. . . .
>
> [George] was the only person in there taking still photographs. He had a little black book and he took notes. He also typed every night. I never saw him really upset, it was all part of the job. Never, except after Belsen.[22]

On the night of April 20, Rodger could not sleep. He scribbled to himself in his black notebook:

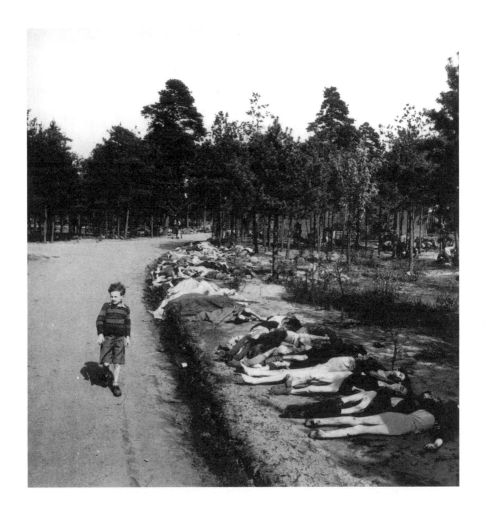

A Dutch Jewish boy walks among the dead, Bergen-Belsen, 1945. ©
George Rodger/ Time Pix.

I visit Belsen extermination camp and see for myself the horror we have read about so often and never dared to believe.

After being dusted with DDT against lice I go into No 1 camp where worst atrocities were committed. Here, 60,000 people were being slowly killed by starvation. There are 3,000 to 4,000 dead lying among the trees and others far beyond human help die before my eyes. Typhus and dysentery take their toll but 90% of the deaths are from starvation alone. A mass grave holds bodies and is gradually filled up by the former SS guards who are made to collect the bodies and drag them to the grave. 28 SS men were taken at the camp and 26 girls who are reputed to be even more cruel than the men. The commandant Josef Kramer has already been taken away.

[April 21]: I spend the day writing the Belsen story and shivering with cold. . . . I receive cable instructing me to go to Berlin but to cover Bremen, Hamburg, Kell, Amsterdam, etc. . . . then take a rest![23]

The next day he wrote a report for Time-Life to go along with his pictures:

During the month of March 17,000 people died of starvation and they still die at the rate of 300 to 350 every 24 hours, far beyond the help of the British authorities. . . . Under the pine trees the scattered dead were lying not in twos or three dozens, but in thousands. The living tore ragged clothing from the corpses to build fires over which they boiled pine needles and roots for soup. Little children rested their heads against the stinking corpses of their mothers, too nearly dead themselves to cry. A man hobbled up to me and spoke to me in German. I couldn't understand what he said and I shall never know, for he fell dead at my feet in the middle of a sentence. The living lay side by side with the dead, their shrivelled limbs and sunken features making them almost undistinguishable. . . . Naked bodies with gaping wounds in their backs and chests showed where those who still had the strength to use a knife had cut out the kidneys, livers and hearts of their fellow men and eaten them that they themselves might live.[24]

What is striking about Rodger's two texts is that although he describes the camp in a detailed, matter-of-fact manner, he never gives a name to the victims. Who are these whom he calls simply "people," and whom he makes "dead," transforming them into "bodies" or "corpses"? And why is it that he can refer to Germans but cannot bring himself to write even once the word "Jew"? He describes the scene as a massacre, as a crime against humanity, but never as a systematic and planned genocide directed against the Jews and designed to wipe them from the earth. His omission, surely unconscious, raises many uneasy questions.

For perhaps the first time in Rodger's career, the photojournalist who had

"seen it all" had seen more than he could stand. Fear grabbed him by the legs—he literally could not move. After that, the only way he could function was by blocking out all thought—an exercise he was by then familiar with—and forcing himself to take pictures. Soon, to his own bafflement, he was shooting in a sort of frenzy. In a strange way, he found himself inspired by the carnage, "subconsciously arranging groups and bodies on the ground into artistic compositions in the viewfinder . . . treating this pitiful human flotsam as if it were some gigantic still life." [25]

The next day, Rodger left Belsen to photograph Josef Kramer:

> Statement that Hauptsturmführer Josef Kramer had died was contradicted today so Ronnie Munsen [26] and I go to Pelle where he is held in P.W. cage. I find brutish hulk of a man with close-set piggish eyes. Although he is being treated much better than he deserves, he is obviously suffering already from mental strain. His lips and hands tremble as he replies to our questions about his activities at Belsen. His mind very alert and he gives quick and clever replies except when asked what he thinks of the Jews. He hesitates and answers that he has been taught to hate them since he joined the Nazi party. [27]

Rodger later characterized his Belsen pictures as "artistic compositions." It was the only time he ever referred to his work in those terms. He never believed in the photographer as an artist, and he usually emphasized content over form. He generally referred to his photographs with terms such as "honesty," "clarity," and "simplicity of purpose." Yet it must be admitted that his Belsen pictures are beautiful. The first series he shot, in 35-millimeter, was an extraordinary sequence of overviews of the camp, its surroundings, and the dead lying beneath the trees. The images' hushed, contemplative spirit conveys the otherworldly silence of the camp, the silence that follows calamity. The photographs are strangely peaceful. Their detached stance and classic compositions make them stronger than any dramatic close-up could be.

After Bergen-Belsen, Rodger had not only to block out the unbearable horror, but also to forgive himself. That he had made something beautiful from Belsen cast him into an abyss of guilt. Yet it is the very beauty of his pictures that makes them so profoundly disturbing; as in the 1940 Coventry photograph of the destroyed cathedral spear, it is only after a double-take that we register the real landscape: these are not logs, not fallen trees lying on the ground, but *corpses*, among which a young survivor walks, his head turned away, in the glorious spring sunlight that touches living and dead without discrimination.

Rodger made another series: brutal close-ups of female SS guards, whose

expressions hover between fear and bewilderment. He shot these pictures with his Rolleiflex, in square format to resemble police mugshots. Although Rodger later denied that he hated the SS, these pictures are obviously charged by his deep contempt and cold fury. The faces of these young women—according to the captions, they are all between twenty and twenty-five—look like stones: desensitized, devoid of human expression.

A final series from Bergen-Belsen shows male and female SS members in the middle of a huge common grave, up to their knees in a sea of bodies, which they are burying under the supervision of American soldiers. Again, the photographer's apparent detachment from the scene seems only to redouble its nightmarish feeling.

In one of the only interviews that Rodger granted on the subject (and it was much later in life), he explained:

> The natural instinct as a photographer is always to take good pictures, at the right exposure, with a good composition. But it shocked me that I was still trying to do this when my subjects were dead bodies. I realised there must be something wrong with me. Otherwise I would have recoiled from taking them at all. I recoiled from photographing the so-called "hospital," which was so horrific that pictures were not justified. . . . From that moment, I determined never ever to photograph war again or to make money from other people's misery. If I had my time again, I wouldn't do war photography.[28]

Photographing at Belsen was for Rodger a personal disaster. It triggered a guilt even greater than that he usually harbored, as if being a witness to horror, and taking pictures of it, was something unspeakable and forbidden. As if it somehow made him an accomplice. He was so traumatized by Belsen that for the next forty-five years he could not bear to look at the pictures he had made there and wished he could erase them. Yet Belsen resisted being forgotten. Psychoanalyst Jacques Hassoun has observed: "One cannot drink the five o'clock tea at Bergen-Belsen. It's unforgivable. He was guilty of having given an image to horror, which has no image."[29]

Rodger's pictures of Belsen were published in *Life* almost immediately, on April 30, 1945, together with Margaret Bourke-White's photographs of inmates clutching the bars at Buchenwald.

By May the Holocaust was news, and more reports were streaming in from Europe, from correspondents such as William Shirer and Margaret Higgins.

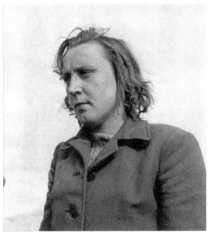
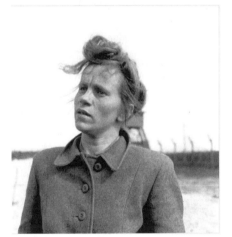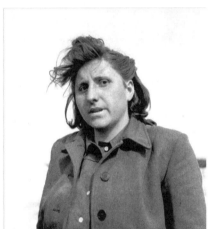

Four camp superintendents, Bergen-Belsen, 1945. © *George Rodger/Time Pix*.

Richard Dimbleby—not usually faint of heart—was the first radio reporter in Belsen; he broke down, stammered, and wept on the air for the first time in his career as he began his broadcast. Edward R. Murrow, already a celebrity on war reporting, was at Buchenwald, as were Gene Currivan of the *New York Times* and Larry Solon of the *London News Chronicle*. American photographer Walter Rosenblum had arrived first in Dachau; he saw forty boxcars on a railroad siding, "loaded all the way to the top" with emaciated bodies. He recalled, as Rodger did, that "the survivors grabbed at you, at your uniform." [30]

With the visual coverage of the Holocaust, documentary photography came into the public eye with a new status as irrefutable *evidence*. Questions were raised: Can horror be represented? Are documentary images capable of informing those who look at them?

The pictures of the Holocaust, however striking, were in fact not comprehensively informative. Editors laid them out without context, as generalized and interchangeable images of suffering, and they showed only one aspect of the Holocaust, the "final phase" of the Nazis' horrific system of incarceration and extermination. Pictures alone could offer no explanation of the broader Nazi enterprise. As one British MP, Mavis Tate, put it: "You can photograph results of suffering but never suffering itself." [31]

Rodger was of course not alone in stating that the camps had changed him irrevocably as a professional. Several photographers who had been present at the camps' liberation reported reacting with traumatic disbelief. Bourke-White, who had accompanied the U.S. liberating forces into Erla and then Buchenwald, and who was a famously tough operator, described the same feelings that Rodger did—a traumatized stupor, leading to utter disconnection from what she was doing: "In photographing the murder camps, the protective veil was so tightly drawn that I hardly knew what I had taken until I saw prints of my own photographs." [32] But few of the photographers judged themselves as harshly as Rodger did.

In the United States, the camp pictures had a profound and lasting impact on those who saw them. This is attested by a score of novels and memoirs by authors who were only adolescents in 1945, but whose sense of self was shaped forever by those images. Chaim Potok saw Rodger's *Life* pictures of Belsen. In his book *In the Beginning*, he describes how the representation of mass murder seems to recede from the viewer, only to return and permeate all the rest of life—just as the stench of death penetrated the camps:

> Now the magazines were out and they had photographs too—large, sharp, black and white and starkly horrifying. Every day now there were photographs. All

through May the flow of rectangles continued across the ocean onto the pages of our newspapers: hills of corpses, pits of bones, the naked rubble of the dead and the staring faces and hollow eyes of the survivors. . . . They lay beyond the grasp of my mind, those malevolent rectangles of spectral horror. They would not let me into them. . . . Later that day I sat in the class and could not keep my eyes upon the words in my volume of Talmud. I gazed out the tall wide windows at the street, and there, upon the cobblestones, saw the photographs of Bergen-Belsen. . . . I saw a deep rectangular pit scooped out of the earth. Women SS guards in long-skirted uniforms were filling the pit with dead bodies. In the foreground two stocky women, standing with their sides to the camera, were lifting off the ground the shrunken corpse of a woman.[33]

On May 7, *Life* published Rodger's pictures again,[34] together with images by other photographers. The story, titled "Atrocities," depicted prisoners at Buchenwald, dying women at Belsen, and burning bodies at Gadellegen. There were three pages of Rodger's pictures, ending with his image of a German guard placing bodies in a Belsen grave. The accompanying text ran: "With the armies in Germany were four *Life* photographers whose pictures are presented on these pages. The things they show are horrible. They are printed for the reason stated seven years ago when, in publishing early pictures of war's death and destruction in Spain and China, *Life* stated, 'Dead men have indeed died in vain if live men refuse to look at them.' "[35]

As was so typical for Rodger, his experience at Belsen, which had had such a profound impact on him, was impossible for him to share with anyone. His second wife Jinx would remark: "He parked his emotions behind a wall."[36] It was not until a few months before he died, exactly fifty years after seeing Belsen, that he relented and accepted that his camp pictures were essential. He agreed to allow them be published in his 1995 Phaidon book, *Humanity and Inhumanity.*[37]

Among Rodger's many letters to Cicely around this time, there is only one that mentions the atrocities at the death camps: "The horrible thing is that every word of it is true! Unfortunately I have had to see it all myself. It is impossible to imagine that human beings could be so coldly brutal."[38] Perhaps he felt that Cicely's upright sensibilities could not take more than this. (She has been described as "very English" and lacking depth by more than one acquaintance, including her niece, Linda Morgan.[39]) Also, he describes Belsen's systematic destruction repeatedly in general terms—as "atrocities," not *genocide*; and again, not once in his black notebook, not once in his Time-Life report, does he use the word "Jew." It may well be that he felt guilty for his past anti-Semitic remarks and could not bring himself to dwell on that central aspect of the camps.

In her reply to Rodger's letter, Cicely's main concern was for his own welfare. Like Rodger, she did not mention the Jews. Also, she talked about pictures rather than people: "I kept thinking of you in that horror of Belsen. It must be a sight you will never forget. Just the pictures in the papers and the accounts haunt me all the time. It just seems unbelievable and yet there is the evidence to prove it."[40]

Mussolini died on April 30, 1945. The following day, Hitler's death in the *Führerbunker* deep beneath the *Reichskanzlei* was announced over German radio. On May 2 the German Baltic Army collapsed. Two days later, Rodger was the only still photographer present at Lüneburg, where Montgomery accepted the surrender from the High German Command. Rodger wrote: "We are met by Monty who tells us that we are to see the signing of the surrender of all armies facing him on the Western Front. Signing takes place in a small tent. German representation are General Von Friedeburg, General Keisel, Rear Admiral Wagner, Colonel Poleck, Major Freide."[41]

The next day, with a few other correspondents—Harold Glandi, Vic Thompson, Joe Illingsworth, and Harry Standish—Rodger left for Denmark.

> I tied a small Union Jack to the windshield of my jeep and, with my driver, set out for Denmark. It was the most momentous journey I had ever made. Tens of thousands of Hitler's demoralised Wermacht cluttered the main road. . . . My driver pressed heavily on the horn and I waved cheerfully as we sped by. What I didn't know was the German field communications had completely broken down and the army, fleeing north into Schleswig-Holstein, probably for a last stand, had no idea the war was already over, and their reaction as my jeep drew alongside each laden truck was interesting. Most stared down in disbelief; some smiled and cheered; some waved; no one gave the Nazi salute, but all looked back to see what was following. There was nothing.[42]

In Schleswig, Rodger asked an SS stormtrooper the way to Denmark. The trooper pointed his Schmeiser automatic at Rodger's stomach and brought him to SS headquarters, where a colonel questioned him. "He admitted my presence was unusual but wouldn't accept that the war was over. I showed him a copy of the Surrender Terms which Monty's adjutant had given me."[43]

Finally convinced of their defeat, the SS assigned Rodger an escort to Copenhagen. They set off for the Danish frontier accompanied by a black Mercedes carrying two German colonels. On the roadside, people were waving flags and throwing bouquets to them—in no time the jeep was quite full. At Nyborg, near Copenhagen, theirs was the first British car to use the ferry in six years. On

May 7 they reached Copenhagen, where Rodger was welcomed by friends from the Danish Resistance: Kaj Andersen, Ulla Wrinkel, and Preben Butzer, who offered to show him around town. Rodger took pictures of cheering crowds, some holding up to the camera newspapers bearing headlines of the German surrender.

After five years, Rodger's war was over. "For the first time," he wrote in his black notebook, "I look over a city from a high balcony which is lit up by street lights. All is peace and quiet but I find it impossible to realise there is no more war."[44]

11

Welcome to the Time, Inc., Stink Club

SUMMER 1945-JUNE 1947

Rodger's war was over, and if anyone needed proof that he was a hero, he had seventeen medals pinned to his uniform, which looked, he quipped, "like a herbaceous border."[1] He stuck them in a drawer and locked it. He got a good haircut, hung up his uniforms, and let Cicely buy him new corduroy trousers, shirts, and two tweed jackets.

Some liked to say that war matured people and gave them wisdom, but he did not believe it. What war did was steal your youth away and addict you to danger. It made you different from everybody else, and you could not share that experience with others. He had started out almost as young and carefree as Cicely; now there was an essential part of his life that he could not or would not communicate to her.

Hitler and Mussolini were dead, but the millions of corpses they had left in their wake now returned to life in Rodger's nightmares. Over and over in his dreams, he saw himself standing in front of the piles of Belsen corpses, looking for the best camera angles. He could not stop wondering why he had survived when so many of his friends had not.

"There are men whose mind the Dead have ravished," Wilfred Owen wrote.[2] Though he tried to deny it, Rodger was certainly one of those men. For four years he had worked with a sense of mission, a belief that he was part of a bigger picture and doing important work. He had been able to follow his sense of duty, to do what was right. Even in the bleakest situations, he could take comfort in that; duty had been his lodestar and seen him through the chaos of war. And he had been his own man; no editor could tell him what to shoot or where to go.

Rodger regretted his new "freedom" even though he had acquired it at enormous personal risk, and his comments were bitter:

> I was no longer arbiter of my own destiny. . . . Though I was grateful for all *Life* had done for me during the war years, when travel became possible again editorial staff emerged from Rockefeller Center with their own idea of what the world should be like. They converged [in] Paris—all new brooms. At times their ideas were far from reality and it was impossible to illustrate them with integrity. A rebellious spirit rose in me and I knew the time was approaching for me to leave. The London staff of *Life* loyally kept me in nice, cosy little escapist stories but the big feature suggestions came from New York.[3]

To Rodger, independence was paramount. It was the only way he could function, and his conversations with Capa had only reinforced the feeling he had, born of his circumstances and formed very early in life, that he could depend only on himself. During the war, the general confusion and the constant battling with incompetent censors and public relations officers had convinced him more than ever that he had to operate alone. But now, in times of peace, bureaucrats and magazine editors were asserting their power. Henry Luce had recently written a letter to the *Life* staff that had no reference to content, only to money and their wise use of it. A letter about content, he said, would follow. This much was obvious: within the magazine's political culture, and probably everywhere else as well, photographers were no longer in charge. From now on their pictures would be expected to illustrate editors' ideas; and editors, according to Rodger, never left their desks and knew nothing about "reality."

On the surface, life was not so bad. Rodger and Cicely had both received raises and could afford to rent a room by the month at the Hotel Lancaster, on the rue de Berri, not far from the *Life* office. "Grateful Parisians kept us supplied with petits cadeaux. Martel gave us a case of their special 'Cordon d'Argent' replenished when necessary. Guerlain gave Cicely a large cut glass bottle of their Mitsouko and the hotel manager, Monsieur Wolf, never let a day go by without a huge bowl of fresh red roses put on the table in our room."[4]

One assignment Rodger did enjoy took him to Spain to document the sites of Spanish Civil War battles. He sent Cicely a wry little poem:

> I went to Spain
> travelin' south
> sun in my eyes
> dust in my mouth.

Trees bent double
as I sped by
headin for trouble
Chickens floppin
dyin
in the backyard,
feathers flyin
kids cryin
Holy Thunder
Mother's under
The Packard
Maimed dogs crawlin
hogs callin
folks bawlin
in the rubble
of the villages I passed through
on my way to Spain
spitting flame.[5]

His Spanish essay included several villages, but he shot perhaps his most interesting series in the Castilian village of Uriaganda, where the irregular paved streets dated back to the reign of the Roman Emperor Trajan. The strong Spanish sun cast hard shadows. Rodger's beautiful and spontaneous pictures capture scenes of everyday life: young women washing at the public laundry, old women sewing in the sun in front of their houses, a home for old people based in a church. Rodger felt totally at ease with his subject. For him, the simplicity of village life and the landscape of hills, wheat fields, and olive trees evoked the Middle East. His powerful black-and-white portraits may well have inspired W. Eugene Smith's famous photo-essay, "Spanish Village." Indeed, looking at Rodger's story, one wonders whether Smith looked through old issues of *Life* to find ideas. Gene tackled a similar subject, though in a more dramatic, almost cinematic way, instructing the Spanish villagers to "do what they did every day, only better"—an approach Rodger would never have taken.

Slowly, Rodger regained the inner strength to confront his war memories. He tried to evaluate his experiences and consider the future. He now harbored a bitter and profound contempt for Western civilization and its "values"; they had produced chaos and, ultimately, the death camps. In his life, Rodger had been truly peaceful and happy only in the desert or in some parts of Africa.

Something about Africa soothed his tortured soul and made him happy. There he had recognized something strangely familiar yet at the same time un-

namable—an intimate bond that words could not express. He wanted to recapture that feeling: "I was determined to visit tribal Africa, where the people were unspoiled and uncomplicated. I thought it was the only way I could get rid of the stench of war that was still in me. But I had insufficient funds and it was essential to be fired so I could draw my severance pay."[6] But at *Life* everyone loved him— how could he get himself fired?

In February, Cicely and Rodger, tiring of hotel life, decided to move back to London. In England the postwar economy was in very bad shape, partly because of the Americans' refusal in 1945 to renew the Lend-Lease Act. It was difficult to find an apartment; over the course of the war, two hundred thousand houses had been destroyed in London and five hundred thousand others seriously damaged. And there had been almost no new construction in four years.

Rationing was often stricter than it had been during the war. There were times when even bread and potatoes could not be found. Fresh vegetables and fruit were almost impossible to buy, and Cicely rejoiced when she found a few lemons at a local market. Coal and other fuels were being rationed, and winters were extremely hard. When Rodger and Cicely finally found a small apartment, life became somewhat easier; at least they had a place of their own.

In February, Rodger was given a *Life* assignment from New York:

Someone suggested a story on the terrific tribulations of the Dutch people. Their misery and their degradation after so many years under the Nazi jackboot heel. I went there and found the country freshly cleansed and garnished; the people happy and smiling; businesses opening up and all the tulips in bloom. Surely if I sent in a story diametrically opposed to *Life*'s request I would, at least, be reprimanded. But no! *Life* gave me a cover and eight pages for what became known as "The Dutch Essay." I was in a quandary—congratulatory cables when I would sooner have been fired.[7]

In May, Rodger was given one of the "social" assignments he so detested: the wedding of Patricia Mountbatten to Baron Brabour in Hampshire, a high-society affair with British royals featured prominently on the guest list. He felt as if he had been thrown back to his worst days at the BBC. In June and July, things were not much better—a story on the Ascot races, another on the Glyndebourne opera house that had been closed during the war and was reopening with a performance of Benjamin Britten's *The Rape of Lucretia*.

Between assignments, Rodger and Cicely often went to Exeter and Torrington to visit their families, returning to London laden with fresh eggs and produce. They went house hunting in the countryside, and asked Cicely's family for

financial help in purchasing a home. After many discussions—which in the end turned sour and strained relations between the Rodgers and Cicely's family—Cicely's mother refused to lend them money for a house they wanted to buy in Devon on the grounds that it was too isolated and impractical.[8]

They spent a lot of time with Allan and Barbara Michie, who had just arrived from America with their young daughter, Bobby. The couples took jaunts together to Lavenham in Suffolk, staying at the Swan (where Rodger had always lodged during the war). Barbara recalls that they socialized over "bitters or half-halfs—which is half bitter, half mild—in small glasses, at room temperature. . . . George used to mix Angostura bitters and gin in a glass to make 'pinkies'. . . . George and Cicely were very happy together."[9]

In January 1946, Rodger did a feature on author and illustrator Beatrix Potter. This shoot included landscape photographs of her property, Tarn Hows, as well as pictures of some of her lifelong friends who had often appeared as characters in her illustrations, in books such as *The Story of Jemima Puddleduck* and *The Fairy Caravan*. But one specific story assigned to him in the summer, "Rabbits Who Walk on Front Paws," drew his ironic contempt—dancing rabbits! For a war photographer, it was as low as he could sink. He could not wait to leave *Life*.

His December story for *Life*'s Christmas issue—on the Punch and Judy show, a puppetry tradition dating from the seventeenth century—was slightly better. Rodger worked mainly in London's East End at an elementary school, where he photographed the young audience as well as the theater and the play itself.

Nevertheless, his spirits remained low. He needed to leave a job he had come to despise, but how? Then, in the middle of that especially wet and dismal English winter, Rodger and Cicely received a letter from an American friend describing the beauty of Cyprus: blue sea and cloudless sky, masses of flowers, a warm winter, an early spring. They decided on the spot to buy a house on Cyprus rather than in England. The island was cheap, and they could rent at first. If Rodger could only find a way to get fired from *Life*, he very much wanted to work in the Middle East and in Africa. To that end, a house in Cyprus would make the perfect base.

Finally, on February 28, 1947, after Rodger had shot a story on Mary Martin—his last at *Life*—the Rodgers got the news they had been hoping for: *Life* was giving Rodger the sack. They happily collected his severance pay. As an added bonus, he received a check from Paris for the French translation of *Desert Journey*, which Editions du Vieux Colombier had just published as *Voyage au Désert*.

An excellent mechanic since boyhood, Rodger spent a few weeks repairing

the Packard roadster he had "liberated" from the German High Command in Brussels. The white star of the U.S. Fifth Army still adorned the door panel.

Len Spooner, the editor of the *Illustrated*, gave Rodger his first non-*Life* assignment in several years: he was to retrace and document Montgomery's victorious route along the north coast of Africa, from Hareth to El Alamein. "We wanted to test our conditions," Rodger wrote, "find out through experience what equipment is necessary, in fact make all our mistakes on a trip that didn't matter in preparation for bigger and better trips in the future.[10]

He and Cicely drove down to Marseilles and on March 23 boarded the SS *Ville d'Oran* for Algiers. From there they started driving. The French did not consider their route an easy one. "In Souk el Arba, where we lost our way in the narrow streets, a gendarme came over and asked what street we were looking for. 'Nous cherchons la route pour Le Caire' we said. 'Vous allez au Caire?' he queried, as though he had not heard correctly, and when we assured him that was the case he turned his eyes to heaven, said 'mon Dieu' and crossed himself."[11]

Farther south, in Tunisia, Rodger documented the traces of the Allied armies' passage. "There were trucks, gaunt and rusted, blasted into grotesque shapes by landmines; guns, their full-mouthed roaring silenced and their raised barrels pointing forlornly at the sky; and tanks, their dreadful power gone, reduced to the pitiful shapeless things round which once lived and played. There were wrecked planes, like bleached skeletons, and the wind whistled through their bare ribs."[12]

The Packard struggled valiantly through sandstorms, with strong winds blowing thick dust over the road. Rodger was not simply documenting for the *Illustrated*; he was also exploring his own memories. "Tokra, Barce, Giovanni Bertha, Derna. How vivid was each name, and each mile of the road conjured up some memory almost forgotten. It seemed strange to be driving through familiar places without being continually on the watch for marauding Messerschmitts and diving for the ditch as they zoomed overhead."[13]

As they left London farther and farther behind, Rodger's heart grew lighter. He was happy to play guide and introduce Cicely to the desert, and he was beginning to recover his sense of humor. Well into the desert, they pushed toward the oases of Hammamet and Gabès. As always, Rodger kept a precise account of his expenses, including gas; thus, we know they averaged 250 to 300 kilometers a day—quite a distance, considering the terrain.

At the Tripoli police station, they learned that the resident inspector had known Cicely's father in China—a fact that helped expedite their paperwork. While they were waiting, Rodger went to the harbor and photographed sponge divers working between the sunken boats that nearly blocked the port entrance.

He was eager to see the photographs right away and developed the films at a friend's, in a makeshift darkroom.

During this assignment, Rodger and Cicely took some time off. They explored the old city of Tripoli, and they made expeditions into the desert mountains, where Rodger shot some striking landscapes. Curious about the Muslim religion, he found his way to a ceremony where the celebrants pounded on drums and chanted at the tomb of a local *marabout* (holy man). In Tajiura he saw the famous trance ritual of the Zikhr, during which "frenzied villagers pierce their cheeks and bellies with bodkins, swallow nails, fall on swords and eat cactus." [14]

One of the most memorable events of their journey was their visit to the Roman city of Septis Magna. In the slanting light of the evening, they imagined what life must have been like two millennia before, when the ruins had been a living city. They also visited an archaeological dig at Cyrene, where civilizations were pressed together layer on layer—a Christian basilica, traces of a Roman harbor, an old theater, Roman mosaics laid over the foundations of a Greek building. Rodger noted in his diary: "The temple of Zeus standing by itself on a hilltop was still majestic though pillars once huge and massive all have tumbled inwards by an earthquake." [15]

Many years later, Rodger would return to explore these places and others for a color project on the theme of "ancient cities of the Middle East." [16] Those stories would include the site of his Italian landing, the Zeus and Hera temple at Paestum, which he had photographed in 1944 with Allied tanks and soldiers in front of the Doric columns.

On May 5, after documenting a war-shattered Tobruk and its military cemetery, Rodger and Cicely crossed the Egyptian border. Their arrival in Cairo a few days later coincided with celebrations marking the anniversary of the crowning of King Farouk. They stayed at the Shepheard's Hotel; Rodger was delighted to show his wife where he had spent time between assignments, poring over her many letters from home.

When the *Illustrated* assignment was complete, Rodger sent out his text and pictures. Then he and Cicely took the next ship to Cyprus. In Limassol, they quickly found a little house that they decided would do as a base. It was fun to play house—they whitewashed the outside walls, painted the inside sky-blue, knocked some shelves together, and looked for old, cheap furniture to buy. The weather was getting warmer; soon they would be able to swim in the Mediterranean.

Then on June 6, when they went to the Limassol bank to collect their mail as they did every week, they found a telegram that had been chasing them all over the Mediterranean, from Tunis to Cairo. It bore the cryptic words:

Rodger's conversations with Robert Capa in Algiers and Vomero came back to him in a flash. He understood right away: his friend had made their fantasy a reality.

In March, just before leaving, they had seen Capa in London. He struck them as disillusioned with photography; his prospects were so slim that he was wondering whether to continue at all. It did not help his state of mind that he, a world-class womanizer, had no woman to take care of him. His turbulent affair with Ingrid Bergman had petered out (he was not used to being left by a woman), and he had even been abandoned by his always patient girlfriend of seven years, Elaine Fisher, "Pinky." She had put up with a lot, but finally got tired of waiting for a commitment. She had just married Charles Romine, a public relations officer who, to make matters worse, was a friend of Capa.

Capa was also getting tired of losing all his negatives and copyrights to *Life*. He felt that if he had been able to hold on to them, he would now be living comfortably off the sales of his most famous pictures, such as *The Falling Soldier* and the D-Day images. His finances were now a mess, and to top it off he had just lost all his savings—two thousand dollars—at a gaming table.

Later in March, Capa went to New York. As he sat in a hotel bar he met the writer John Steinbeck—equally disgruntled—sitting on the next stool. They became fast friends, and Capa persuaded Steinbeck to take him along on a trip to the Soviet Union that the writer was envisioning as the first of its kind since the war. Steinbeck's idea was to write a first-hand account of the Soviet people, without getting involved in politics. With Capa's help and contacts, Steinbeck sold the concept to the *New York Herald Tribune*. But at the end of April, visas obtained and bags packed, Steinbeck fell and broke a kneecap. The trip had to be postponed for six weeks.

So it could be said that it was Steinbeck's kneecap that was the impetus for starting Magnum Photos. Capa was too restless and frustrated to remain idle, and decided the time was ripe to organize the agency he had been talking about since before the war. If he was to remain a photographer, it would be on his own terms.

Capa pulled every string he could think of. First, he called Henri Cartier-Bresson. He thought the French photographer's distanced, elegant style would be a good complement to his own. Cartier-Bresson had a strong knowledge of India and the Far East and was becoming a star in Europe. His early pictures taken in Mexico, and those taken during the Spanish Civil War, and his latest

film *Le Retour* (The Return)—about the homecoming of the French Resistance soldiers—had all generated plenty of attention. One of his pictures, of a female Nazi guard recognized by one of her former inmates, had become an icon of the war, as had Rodger's V2 picture and Capa's Omaha Beach series.

In New York, Cartier-Bresson's friends Lincoln Kirstein and Beaumont and Nancy Newhall had become curators in the recently established photography department of the Museum of Modern Art, which had a mandate to champion photography as an art form. They had had no news from Cartier-Bresson for two years and were certain he had died in a German POW camp. Actually, he had escaped from one after three tries. In the spring of 1947 they organized a "posthumous" exhibition of Cartier-Bresson that was to span all of his work, from his surrealist-inspired images of Mexico to his pictures of the liberation of Paris (including his Liberation Day photograph of Rodger, whom Cartier-Bresson would not meet in person until 1952). Greatly amused, Cartier-Bresson and his wife sailed for New York and surprised the curators. Having resurrected himself, he proposed to add new pictures. To that purpose, he set off on an assignment for *Harper's Bazaar.* The first stop was New Orleans with Truman Capote; from there he began a fifteen-thousand-mile trans-America journey with poet John Malcolm Brinnin.[17]

Capa also contacted William Vandivert, an excellent New York-based photojournalist, and talked him into joining the new agency. Vandivert, by then well-established as a photographer, was reluctant to give up his freelance work with *Fortune* and *Holiday.* But tempted by the camaraderie, he said he would go along. His wife Rita was an excellent businesswoman and had always managed his office; she too would be a good addition to the growing team.

Of the five original photographers and would-be members of the agency, David "Chim" Seymour was probably the least well known. He had been prominent in Europe before the war but had done no photography for several years and was almost unknown in the United States. He certainly did not have Vandivert's reputation as a serious, reliable professional, or Cartier-Bresson's as an aesthete and photographic prodigy, or Capa's as "the best war photographer who ever lived," or Rodger's as a war hero and consummate professional. Nevertheless, Cartier-Bresson, for one, firmly maintains that Magnum could not have been born without Chim: "The one thanks to whom Magnum was founded was not Capa, not me, not Rodger, but Chim—he is the one who did the bylaws, who gave Magnum its structure."[18]

Born David Szymin in Warsaw, Chim came from a family of Jewish printers and was supposed to take over the family business. Instead, while studying in Paris he became involved in the relatively new medium of photography. Early

pictures by Chim were published in the left-wing magazine *Regards* in 1934. While photographing the Front Populaire and other political subjects, Chim met and befriended Capa and Cartier-Bresson. The three of them were then being represented by a new agency, Alliance Photos, run by a German émigrée named Maria Eisner. Like Capa, Chim first became known for his coverage of the Spanish Civil War. In 1939 he documented the journey of Loyalist Spanish refugees to Mexico. He arrived in the United States at the outbreak of World War II, became an American citizen, and during the war served as a U.S. Army photographer, analyzing reconnaissance photographs in Europe.[19]

Chim did not stand out in a crowd. At thirty-six he had already lost most of his hair. He was short, wore Coke-bottle glasses, and often seemed (in Cartier-Bresson's words) "as if he carried the world's misery on his shoulders."[20] Yet he had a sharp, forward-looking mind that belied his appearance. He also knew the best restaurants in every city, and although he did not flaunt his girlfriends the way Capa did, he had plenty of them. (According to Cartier-Bresson, whose task it was to visit them after Chim's untimely death in 1956, he had promised marriage to each one.[21])

Chim was capable of blending into any milieu, from the Vatican to the world of high financiers to that of the poorest immigrants, and his impressive social network would prove to be a huge asset for Magnum.

Thanks to Capa, the initial Magnum team was, it seemed, in place.

Sitting on the beach that fronted their little house, George and Cicely Rodger were now learning from Rita Vandivert's letter that the final discussions about Magnum Photos, as it was now called, had taken place two weeks earlier in the penthouse restaurant of the Museum of Modern Art in New York. Magnum would be an international cooperative with seven members: Capa, Chim, Cartier-Bresson, Rodger, and Vandivert as photographers; Rita Vandivert as president and head of the New York office; and Maria Eisner as secretary-treasurer and chief of the Paris bureau. Each member of the cooperative would have to put up four hundred dollars and agree to work only through the agency, which would take a portion of the fees: 40 percent for assignments set up by the agency, 30 percent for those arranged by the photographers themselves, 50 percent for reprints.[22]

Magnum Photos: it was a good name, one that sounded well in any language. Like the large bottle of champagne from which it was derived, it suggested style, freedom, and luxury. Quickly, Capa divided the world along the lines of the photographers' interests: Chim would continue in Europe; Capa would be a corre-

spondent at large; Cartier-Bresson would travel to the Far East and China; and Rodger would have the Middle East and Africa. As for Bill Vandivert, he would pursue his arrangement with *Holiday* to photograph in the United States.

Rita Vandivert's letter outlined the details:

> Now, take a deep breath, here is the great new scheme, just the facts, no trimmings. . . .
>
> The tentative title for the company is MAGNUM PHOTOS INC., it will be incorporated here with all seven original members as directors, myself as President, the rest of you all Vice-Presidents, & Maria treasurer and secretary.
>
> We are keeping our investment as low as possible, planning to get running expenses, which will be kept very low, out of returns pretty soon. . . . The idea is that from the start of the agency each photographer puts in all his photographic assignments which are magazine or newspapers work, e.g., Capa puts in his Russia deal, Bill puts in his *Fortune* & whatever other magazine deals he has pending or makes from then on, et cetera . . .
>
> [The *Illustrated's*] Len Spooner is over here now, has been sitting in our discussions, is going to have a special contract with the agency . . . whereby he gets first look from England at all our photographers' pictures. . . . The way Capa sees it working out for himself and some of the others is this: he makes a deal with a publication to send him somewhere, gets expense money, etc & does the agreed number of stories or pages for them. Then he shoots as much material as he can on the side, keeping closely in touch with both Paris and New York offices so that we know what he can get, just where he will be and how long he thinks it worthwhile to stay. Only by this close co-operation however can we hope to save waste of time, energy & material—the photographer must know what the magazines are interested in, and the agency girls must know at all times what the photographers are up to (except on their evenings off).[23]

All in all, Rodger was rather stunned, as his response to Rita shows: "I'm pleased to be on the ground floor. It's just the suddenness of its birth which knocked the wind out of me. True, Capa did mention something about organising an agency in Paris with New York representation but I'm afraid he was a little too vague and mysterious."[24]

Cautious by nature, Rodger wanted more details before committing. Would Magnum handle advertising or only photojournalism? In which currencies would the photographers be paid? How would they receive money for expenses (an important point, as he was at the time running out of film, flash bulbs, and almost everything else)? Were Paris and New York separate accounts? He also raised a specific point about Magnum's status—one that the other photographers

were perhaps not ready to address because of their independent spirit and eagerness to control their own destiny, but that would become crucial later:

> Does it make sense to have a board of directors, five sevenths of which is bound to be spread over the four corners of the world? Even one annual board meeting would be very difficult to arrange when, be it held in . . . New York, London or Paris, it would mean calling the entire productive force of the company away from their fields of operations in distant countries. Production would have to stand still while the board met. . . . I would have suggested having perhaps a legal mind somewhere on the board, and someone of Spooner's standing with an American publishing house. Both could draw directors' fees named beforehand. In that way there would be at least three people in one spot all the time which would form the nucleus of a meeting and yet photographers would still have controlling votes on any decision.[25]

But Rodger's reservations weighed little against his enthusiasm. To him, as to the other photographers involved, Magnum was immediately more than a professional endeavor: it was a family of sorts, a symbol of solidarity and cooperation very much needed in the aftermath of war. It was a way, he thought, of working on his own while still feeling some connection to others.

While he and Cicely were still considering the implications of Rita's letter and whether it made sense to return to Paris and discuss it in person, they got another letter, from their old acquaintance John Morris, who a few months earlier had been hired as an editor at *Ladies' Home Journal*.

At first Morris had hesitated to take the job: the *Journal* did not have *Life's* prestige and was not news oriented. It was a rather sedate magazine that explored women's issues and published some color features. After he finally accepted, Morris hired as his assistant a *Life* researcher, a young and talented American woman named Lois "Jinx" Witherspoon, who already knew and admired Rodger's work.

In his letter Morris suggested to Rodger that while traveling in the Middle East and Africa, he shoot stories on two or three families of farmers. The stories were to be included in a new series, "People Are People the World Over."

As an editor at *Life*, Morris had been, as he put it, "accustomed to cover the extraordinary, not the familiar."[26] Now that he worked for the Goulds, the husband-and-wife team who edited the *Journal*, his challenge was to find interesting stories that did *not* focus on the sensational. It was with this in view that he came up with an ambitious comparative photo-essay about ways of life around the world. The series would involve a group of photojournalists (whom Morris

knew) documenting over one year and covering all continents. As he pitched it to the Goulds, the project would "explain people to people in intimate, vivid terms, taking them not country by country but trait by trait, problem by problem."[27] To cut down costs, Morris wanted to capitalize on some of the photographers' existing assignments: those who were already working in a given part of the world could also keep an eye open for the *Journal*, wherever they happened to be.

Since Capa already had a well-paid assignment to travel to Russia with Steinbeck, it was natural for Morris to contact him. Capa immediately wanted to make "People Are People" a Magnum project, so to that end he relayed the idea to his three friends. The Goulds were interested in Morris's idea but wanted to give it a trial in the United States before going global. So Capa and Morris flew out for a week-long test story in Iowa, where Capa shot photographs at the farm of the Pratt family, near the small town of Glidden, a hundred miles from Des Moines.

The Goulds liked Capa's pictures and agreed on a budget of $15,000—about $2,000 per photographer. It was decided that shooting would begin by the summer of 1947 and be done by the fall. The photographers would have to follow a simple but rather rigid shooting script. The series would focus on twelve farming families all over the world; it would start in the spring and appear monthly for a year. The project's journalists were to cover how the world farms, cooks, eats, washes, bathes, studies, shops, worships, relaxes, travels, and sleeps.

Cartier-Bresson was planning trips to China and Japan. Capa wanted him to photograph families there, but Morris worried that the Frenchman was far too independent to stick to a shooting script. Morris chose instead to assign that part of Asia to an ex-*Life* photographer, Horace Bristol, who was based in Tokyo.

Chim, at this point working in Europe for UNESCO, would photograph one family in France and one in Germany. For the countries that Magnum photographers could not cover, Capa and Morris hired stringers: Larry Burrows in England, Marie Hansen in Italy, and Phil Schultz in Mexico.

Much like Magnum itself, the global concept of "People Are People" was typical of the postwar period when everyone was weary of divisiveness. The idea of *fraternity* was in the air creatively, politically, and ideologically. Many wanted to emphasize resemblances among people rather than differences and conflicts. The "People Are People" project has been credited as the main inspiration behind Edward Steichen's seminal "Family of Man" exhibition, which opened in 1955 at the Museum of Modern Art (the accompanying book is in print to this day). This exhibition, which included a large number of Magnum photographs, became the most visited and popular show in the history of the medium.[28]

Excited by these new prospects, Rodger and Cicely flew to Paris, where the Magnum members were gathering. There was much to discuss and much to look forward to:

> Cicely and I returned hot footed to Paris and we all gathered in the bistro under the office. Capa smote the world and divided it into four. Henri had China and the Far East; I had Africa and the Middle East; Chim had Europe, and Capa was Ambassador-at-Large, hopping back and forth across the Atlantic and playing the horses at Longchamp when the Paris office needed refunding.
>
> They were great and glorious days.
>
> I remember walking down the Faubourg St. Honoré and thinking if someone were to ask me what more I needed to be happy I had no reply. I had Cicely in her gold brocade dress designed by Maggy Rouff and a touch of Mitsouko. I had my black Packard battle wagon with the bullet hole in the windshield. I had enough money and I had wonderful friends in Magnum who were like my brothers.[29]

Rodger was walking on a cloud. In this rare moment of elation, his professional and personal life seemed to go hand in hand.

12

Into Africa

FEBRUARY 1948-FEBRUARY 1949

On February 8, 1948, Rodger and Cicely left by boat for Johannesburg, South Africa, their starting point on a yearlong journey to Cairo by way of Rhodesia, Tanganyika, Uganda, the southern Sudan, Abyssinia, and Eritrea. They would then cross the Sahara to Lake Chad, Nigeria, the Cameroons, and the Congo.

They would be traveling at their own pace, halting whenever they saw an interesting story. Rodger was accredited to the *Weekly Illustrated* in London and would be counting on Magnum to distribute other stories to clients. They knew their expedition's success would depend on self-reliance, so to that end, they put together "a truck, a trailer and a station wagon to form a complete self-contained unit which will include tents, beds, mosquito nets, stoves and radio, besides such essentials as food, camera equipment, and mechanical tools."[1]

Rodger was ready to turn a page. This would be, he swore, a radical departure from his war years, in subjects, style, and goals. Free of any deadlines, he planned on developing his personal stories methodically and over time—several years if necessary. He was less interested than Cartier-Bresson in capturing the single, unique picture that sums up an entire situation through a blend of artistic and informational qualities. On many occasions, he did shoot such icons: consider his Blitz pictures, his V2 picture, that of the Korongo Nuba wrestler, those of the Pygmies' courting dance and of the Masai. But his approach is best described as literary: he believed in stories, in building in-depth understanding of different ways of life, layer on layer and through ramifications in space.

The inventor of the "package story" that combined text with images, Rodger

was nearly as gifted a writer as he was a photographer. He would write on-the-spot detailed captions and weekly stories based on his notes and diaries. Then he would send the stories to Europe with his undeveloped rolls of film; later he would add to the stories. "In most cases it would be months, and sometimes years, before he saw the results of his work, so he had to carry in his mind the threads of an unfolding story to which he would regularly contribute an installment." [2]

In the spring of 1948, South Africa was not the haven of healing innocence that Rodger had dreamed of. Politics permeated every aspect of life; the elections were just bringing into power the reactionary and racist National Party. In South Africa, political power was moving in the opposite direction from the rest of the continent, where nationalism and self-determination for black Africans were on the rise. In South Africa the whites had consolidated their control over the state, tightened their grip on the blacks, and all but eliminated the British government's legal power to intervene in South African affairs. Whites dominated every sector of the economy through the use of cheap black labor in fields, mines, factories, and homes. Desperate and hungry, pulled from the impoverished outlands by the prospect of city jobs, more and more blacks were migrating to Johannesburg, Cape Town, Durban, Pretoria, and Port Elizabeth. The government tried and failed to stop this human wave. In the absence of any housing programs, the migrants ended up in shacks of cardboard, wood, and corrugated iron on the outskirts of towns and cities.

During World War II, South Africa had fought on the side of the Allies. A few black South Africans had been trained as gunners, and the whites found this threatening. Radio broadcasts were disseminating racist Nazi propaganda all over the country in Afrikaans. Many South African intellectuals had studied at German universities; now, after the war, they were propagating ideas borrowed from National Socialism, emphasizing white supremacy and the preservation of the white race at all costs. It was a good moment for Rodger to shoot a controversial story about South African politics.

For the *Weekly Illustrated*, he reported on the campaign of National Party leader Daniel Malan. Rodger's pictures show a satisfied, jolly, somewhat sinister politician surrounded by a crowd of supporters. As soon as Malan was in power, his party eliminated all vestiges of black participation in the political system, and apartheid was on its way to becoming the most notorious form of racial domination in the postwar era. The whites had taken absolute control over the state, which assumed no obligation whatsoever to provide equal facilities for other South Africans, even though those "others" constituted the great majority. Mixed marriages and sexual relations between races were forbidden. Strict segregation was imposed at all levels of education. Whites were encouraged to re-

gard apartheid society as normal, and its critics as Communists or Communist sympathizers.

After sending the election story to the *Weekly Illustrated*, Rodger and Cicely traveled to Cape Town, where they stayed until early April. Then they resumed their journey along the south coast, taking the Garden Route to Oudtshoorn. Rodger had another assignment for the *Illustrated* to complete: a story on the ostrich farms of Oudtshoorn. For him, this was essentially a way of boosting the expedition's finances.

The Rodgers then continued to Transkei, the only remaining part of South Africa that had not been fragmented by white settlements. It was known as "the Land of the Red People" getting its name, according to Rodger, "from the red of the soil, the russet red blankets which are worn by the people and the red appearance of the people's skins which are dusted with their native clay."[3]

Since the 1920s, the lot of Transkei's blacks had deteriorated sharply. Land shortages, population increases, and taxation had so impoverished them that they could no longer make a living from farming. Mistreated and misunderstood, they were fiercely protective of their ancient rituals, their only remaining source of dignity and identity. Those rituals were being threatened with extinction, so Rodger concentrated on documenting them.

In a moving series of photographs shot in both color and in black and white, Rodger told the story of one of the most important rituals of the Pondo people— the *Ntonjane*, a girl's coming-of-age ceremony. His subject's name was Tshudwana, and she was sixteen years old. His story included scenes of the *kraal*'s preparations for the ceremony, and portraits of Tshudwana and her mother on the last day of Tshudwana's freedom as an adolescent. He shot guests arriving for the *Ntonjane*: young Xosa men from neighboring *kraals* and girls in russet skirts embroidered with brass beads, with thin brass bands on their limbs. "As they approach the *kraal* their slim bodies glitter as though studded in gold."[4] Tshudwana's grandmother, bearing a stick, led a women's dance with no music, only the rhythm of clapped hands.

Breathing in the powerful smell of melted grease and fermented beer, taking in the shrill laughs, Rodger worked through the smoke that constantly rose from the bluegum fires. He had been told that the Red Men were all rivals and all wished to be chosen as husband for Tshudwana, but that the decision must come from her father, Ngxande. One of the central elements of the ceremony was Ngxande's slaughtering of an ox. The flesh was roasted on sticks in the fires, then ritually divided among the guests. Tshudwana was then brought to her hut, where she was to wait an entire month in isolation—protected from evil spirits— before her marriage. That evening, her brothers brought Tshudwana the choic-

est cut of the ox and a fetish was slipped under her covering blanket to bring her strength, fortune, and fertility. To ward off evil spirits, she rubbed the bitter gall from the slaughtered ox over her face.

After nightfall, when even Tshudwana's friends could not stay near her hut, the Red Men began dancing and singing. They were no longer paying attention to Rodger, who secretly went near the girl's hut and crouched at ground level near the narrow opening. He could not use flash, and no doubt his heart was pounding as he waited for the moon to cast some light on Tshudwana. He shot his best picture while she was peacefully asleep, a blanket tightly wrapped around her body and covering her mouth, most of her face in shadow. In one of Rodger's most heartfelt captions, he imagines the girl's thoughts a moment earlier: "And Tshudwana, as the hubbub dies, turns in her blanket, listens to the faroff singing of the Red Men. Among them she knows is one whose future will be shared with her. She visualises him, handsome, brave and strong, the future father of many children and, with the first of twenty eight long days gone, she sleeps with her maiden dreams behind the wicker curtains." [5]

A few days later, Rodger, deeply moved by his encounter with the Pondo and Xosa people, sent a letter to a friend in New York:

> There is a country which I believe is the most tranquil and serene of any I have visited. . . . The Pondos and Xosas who live there are happy, carefree people. They are a proud people, proud of their country and of their tribal traditions, and completely free from the inferiority complex of their urbanized brothers. Being tolerant of strangers they allowed us to visit them in their kraals and see for ourselves how they lived. We were impressed by the simplicity of their lives and perhaps a little envious. Some of the Pondo people invited us to their kraal where they were having a feast—drink and dancing to celebrate the initiation of a young girl into womanhood. . . . I did a color story on it and asked Rita to show it to John [Morris]—not that I think LHJ [Ladies' Home Journal] is the place for it, but I thought both you and he would be interested in seeing it. [6]

The letter's addressee, Lois "Jinx" Witherspoon, was a twenty-four-year-old American, the daughter of a minister. She had gone to New York to become an actress but had taken a job as a researcher for Time-Life. She met Rodger and Cicely in 1946, just after John Morris hired her as his assistant at the Ladies' Homes Journal, but by then she was already familiar with his work. She admired it and may even have been infatuated with him, and he enjoyed being idolized. A keen and gifted writer, she had started a correspondence with the couple, explaining that she felt confined in her day job at the Journal and would like to

share, at least vicariously, their adventurous life. Many years later, she remembered: "It was through reading George and Cicely's letters that I first became attracted to them both and their way of life. I dearly wanted to see the world."[7] Rodger and Cicely left the Red People and started for Basutoland, a country of high mountains, tablelands, and twisting trails, overlooking the Transvaal plains. Rodger likened the beautiful scenery to a "rougher Switzerland." The Basuto were very poor and had no livelihood other than pony and cattle breeding and some farming. They lived in stone or mud houses covered with orange-red clay. Rodger's work here was not as intimate as what he had just accomplished in Transkei, because he was not invited to observe any rituals. But the people were striking, with coffee-colored skin, slanted eyes, and prominent cheekbones, and he was able to shoot good portraits of them in both color and black and white, especially of the women and children, who had bundled themselves against the cold in colorful blankets.

By the end of April the Rodgers were back in Johannesburg and busy transmitting stories to the Magnum office. Rodger found a stack of more than fifty letters, some professional, some from family and friends. A good number of the latter were from Jinx. A few days later he mailed her a long, warm, and detailed answer, typed on the same portable Remington that he had carried all through the war:

> We are on the banks of the Sabi River in a district called Skukusa. . . . The night seems alive with noise from the river banks only a few yards away. There are the inevitable cicadas which chirrup incessantly and, away down the river, I can hear every now and again, the deep bass grunt of a hippo. We saw him this morning, in all his lordly ugliness, foraging among the reeds not twenty yards from us. There were two big crocodiles too, sunning themselves on a rock. They, I think, are the most sinister and repulsive of all God's creatures. Twice tonight, in fact since I began this letter, I have heard the reverberating roar of a lion not very far away.[8]

In the previous months, Jinx had managed to get her name on the magazine's masthead, as well as a raise. She had also rented an apartment and saved $600 of "dream money." All of this she proudly related to Rodger in her letter. In the last page of his answer, he encouraged her dream of joining them on their trip:

> Go down to Pan American airways with your dream money and get a passage immediately on their direct flight to Johannesburg—you can be there in two

days. . . . You'll go with us through the game reserves to Rhodesia, to Nyassa-land, Tanganyika, Kenya, Uganda, the Congo and we'll put you back on the plane at Juba in the Southern Sudan. . . . Cicely needs a feminine companion on a trip like this, it would help her a lot if you were here with your cheerfulness and your enthusiasm about everything you see. Then you could drive too and your help on stories would be invaluable to me. It isn't really as fantastic as it seems. All you have to do is persuade John that six weeks leave of absence on top of your vacation would be well worth while.[9]

Rodger was attracted to Jinx, as she was to him—although he probably did not admit it to himself. If she took up his offer and joined them he would be able to bask in her company without breaking any of his own moral rules ("Cicely needs a feminine companion"). But the plan did not work: John Morris was not persuaded, and Jinx had to stay in New York and be happy with the tales of Africa Rodger and Cicely sent her. She loved it when the heavy envelopes arrived at the *Journal*, and she spent more time with his stories than with those of other photographers, editing texts and selecting pictures.

In May the Rodgers headed for Kruger National Park, one of the largest reserves in Africa. Besides his Rollei and 35-millimeter cameras, loaded with both black and white and color film, Rodger had a movie camera, which both he and Cicely used. Their truck was equipped with "a hop complete with trap door," for use as a blind for photographing wildlife.[10]

Rodger, who had loved animals since childhood, plunged headfirst into a kind of photography he had never practiced. He had no experience shooting wildlife, so he had to learn by trial and error. Some of his animal subjects tolerated his efforts and did not pay too much attention to him. But toward the end of June, when he tried to film a herd of buffalo with the movie camera, he ran into serious trouble:

From behind the rotting trunk, I raised my head to have a look at what was ahead of us and was greeted by a terrifying sight. All the old bulls had come forward and were ranged, shoulder to shoulder, facing us—about 50 or 60 of them in a long line. The cows and calves were ranged behind. It was a true battle array. . . . All of a sudden, the whole herd stampeded . . . If we had been out in the open and they had been able to identify us as human beings, the buffalo would probably have charged. But it was the uncertainty that saved us. We were partly concealed and the noise of the movie camera turning was something they could not associate with any known menace so they had used their discretion and

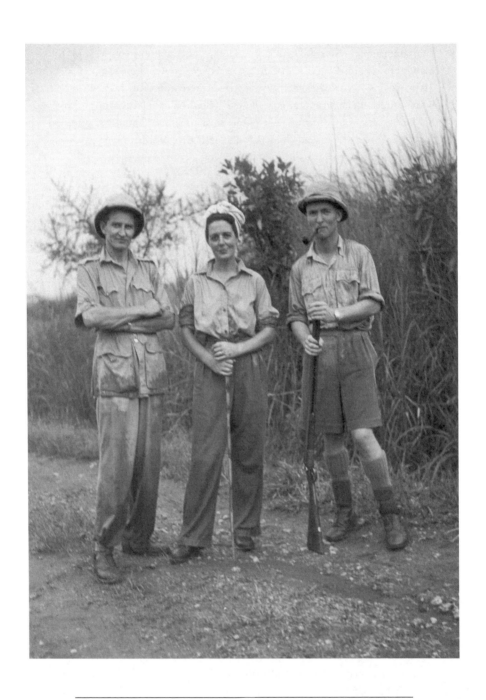

George Rodger with Cicely Rodger and David Driver, District Commissioner, Yei, Sudan, 1948. © *George Rodger*.

bolted. As they left, a pall of dust rose above them and the sound of their horns clashing together was like falling timber.[11]

Rodger had learned the hard way what not to do in the presence of animals: no sudden movements, and no shutter clicks up close unless the animals were busy eating and drinking. He was not using a telescopic lens and was taking pains to get near his subjects. He followed their schedule, rising at dawn and tiptoeing out of the tent while Cicely was asleep. He waited by the rivers to catch the lions unaware, while they were drinking. He loved walking on the veldt. However quietly he moved, he would wake up clouds of birds that rose in circles into the pale summer sky.

He and Cicely would spend the hottest hours of the day inside; then just before sunset he would head out again, hoping to get pictures of a lion asleep near his prey, a lioness feeding her cubs, or a giraffe nibbling on high leaves. Though in his youth he had been an excellent shot with a rifle, after the war he almost never carried a gun except for protection in extreme situations. He disliked those who felt the need to decorate their walls with stuffed heads—indeed, Rodger became an early advocate for conservation. He had a deep respect for wild animals, for their presence and their mystery, and he wanted to convey their beauty in his pictures, some of which can only be described as portraits.

Pafuri, the most breathtaking part of Kruger Park, was set in thick tropical forest. On the open veldt a photographer could position himself easily. In that regard the tropical forest, with its unpredictable light, was an enormous challenge. Rodger would always remember his time there:

> We would leave the truck and trailer and walk a lot. I was fascinated by the rain forest, this dampness that comes from the fact that it is always in the clouds, and the smell of the orchids. Already at 200 feet we started smelling their heavy, sweet and pungent smell, almost intoxicating. The trees were covered in blossoms. There were arborescent ferns with such delicate shapes, and creepers. People think that the forest is full of lions and tigers and wild animals. But in fact it is completely silent. . . . As we walked up, we encountered different layers of animal and plant life: some were living close to the earth in a perpetual obscurity. Above our heads there was a canopy of trees and gigantic species of mushrooms. High up life became more animated, and at the very top we discovered birds, butterflies and monkeys. It was probably one of the most intact regions of Africa because it was very hard to access.[12]

In early July, Rodger took stock of the photographic material he had accumulated. In both color and black and white, he had shot lions, hippos, buffalo, gi-

raffes, elephants, and twenty species of birds. He selected a series of twelve color and scenic pictures. Then he and Cicely prepared a package of films and captions to send out to the agency.

The Rodgers continued on to Southern Rhodesia (now Zimbabwe) across vast, dry plains covered with thorn scrub, which would turn lush green after the coming rains. At the frontier of Nyasaland (now Malawi), they crossed the Mazoe River: "To pass the rivers they had those cockeyed ferries, made out of two canoes linked by two planks thrown across. You had to drive onto the planks. Sometimes the native driver forgot to put the brakes on and the car would go over. As soon as we stepped in the canoes started going under water, then they surfaced, then the same thing happened [when we reached] the other side."[13]

After being checked at the frontier by "fly control" inspectors searching for tsetse flies, the Rodgers headed for Lujeri, the southern tip of Nyasaland, close to the Portuguese-East Africa border. The tropical forest was choked with tree ferns and orchids, and the logging industry was booming. It was here that a cable from the *Weekly Illustrated* reached them: the magazine wanted a big story from Rodger on an enterprise funded by the British government in southern Tanganyika (now Tanzania) known as the "Groundnut Scheme." When it had been announced a year earlier, the plan to turn vast barren tracts of land in Tanganyika, Kenya, and Northern Rhodesia (now Zambia) into a reservoir of food had stirred British imaginations. Supposedly, Africa's food shortages and Britain's oil and fat shortages would both be ended if 3,150,000 acres of bush could be cleared and planted with groundnuts.

At first Rodger was thrilled with the assignment because of the prospect of repeat sales on a popular subject. But when they arrived in Nashingwa on August 5, they immediately saw that the facts simply did not match the *Weekly Illustrated*'s expectations. The British were implementing deforestation like a marauding army. They apparently thought they could import European methods to Africa, and they did not realize they would have to adapt to a drastically different terrain and a different workforce. Besides, Africa's very humid climate made it impossible to work with wood and stone. Many British architects, builders, stonemasons, and carpenters had been brought in at great cost, but their expertise was useless.

Rodger, who disliked political propaganda and wanted to represent the truth as he saw it, found himself in a quandary:

> If from Nashingwa I produced a wonderful story of British enterprise, of men taming the wild jungle of Africa . . . and planting the life-saving peanut where

nothing but scrub had grown, I would make plenty of money. The story would run well in the British and colonial press and, even in America, it would have a good chance of a big spread. But if I told the truth and produced a story of shocking inefficiency and wicked waste of taxpayers' money, I might get a small spread in *Illustrated* and that would be all. . . . In spite of the financial loss I decided to represent it exactly as I had found it, pulling no punches and concealing nothing, and we wrote off the time and money we had spent on the story as a dead loss.[14]

Besides highlighting for us Rodger's beliefs and experiences, his diary suggests the enormous changes that have taken place in magazines in the intervening years. If such a scandal erupted today, Rodger would have had no problem placing his story of good intentions and naïveté, misplaced funds and corruption. He would, in fact, have had competing offers from several magazines, and possibly a movie deal. He might, indeed, even have wondered whether his principles would allow him to make money out of British embarrassment, even though he would be telling only the truth.

On August 10, after ten days' work, demoralized by their financial loss, but not beaten, the Rodgers left Nashingwa. As Rodger had foreseen, their story on the groundnut scheme was not given big play in the *Weekly Illustrated*.

After visiting an island off the coast of Zanzibar, Kilwa Kisiwani, the Rodgers heard an unusual story of a diamond prospector named John Thoburn Williamson, who was on his way to becoming one of the richest men in the world. Rodger quickly became fascinated by Williamson, with whom he sensed a certain affinity—each was a true adventurer dissatisfied with routine.

A Canadian of Irish descent, Williamson had studied geology and mineralogy and worked with the Quebec Geological Survey before getting himself hired as a geologist at a gold mine in South Africa. While working in the South African gold-mining district known as the Rand, Williamson developed a theory about diamonds: by studying land formations, he believed, he could locate somewhere in East Africa the original "pipe" through which diamonds had been spewed up while the earth's crust was forming. He followed his hunch, and after six long years of frustration, dysentery, and backbreaking work, he located the Mwadui mine and staked his claim.

Eight years later Williamson became famous when he sent a gift of a 100-carat pink diamond to Princess Elizabeth of England. Mwadui was a state-of-the art installation equipped with bungalows and a clubhouse for Europeans. The mine was yielding 450 carats a day, which made it the richest site in South Africa.

Williamson worked at the mine himself, with a staff of 60 Europeans and 1,500 African and Indian workers. He was a recluse, usually wary of the press, but he made an appearance for Rodger, who spent about a week at the mine and produced a thoroughly researched black-and-white essay for Magnum to distribute. Rodger's text is rather conventional and reads almost like PR copy: it conveys admiration for Williamson's success and for his philanthropic work. But Rodger's pictures tell a much sadder and darker story. In powerful chiaroscuro that is reminiscent of W. Eugene Smith's work, he photographed the punishing conditions faced by the black mine laborers. Under the close watch of Askari guards, they were made to leave their clothes outside the sorting shed and put on special shirts with one sleeve stitched up at the cuff to prevent pilfering. They then spent the day picking diamonds from gravel. Another armed Askari stood guard by the excavators, still another one by the concentrating pans, where the diamonds were sifted from gravel and rock. Every worker's move was watched with hawklike scrutiny. Groups of exhausted miners covered in sweat crawled through tunnels or dug underground pits. Rodger noted: "The temperature was hot and fetid down there and so humid that my camera lenses steamed up. At cramped quarters and standing in ankle-deep grey slime, I got shots of native miners drilling at the rock face." [15]

By early September the Rodgers were in northern Tanganyika. One of their local contacts directed them to the Wakusuma people, who had a secret society of snake worshippers called the Bayogangi, who met at irregular intervals to perform the *mbina*, or snake dance. The *mbina* was to take place soon, 150 miles away in the village of a Wakusuma chief. They left their bush camp near Bahi and arrived in time for the ceremony. Rodger recalled their approach to the village: "The deep-throated beating of the court drums could be heard ten miles across the plain below the village and Mtemi Kudililwa himself, together with his counselors, performed a dance of welcome round the drums as we approached." [16]

The gathering of a dozen dancers was held in a natural amphitheater on a hillside near the village. Soon the drumming grew wilder, accompanied by raucous singing. Once the dust had settled they had a good view of the Wakusuma dancers. Gazelle horns were attached to their foreheads; cowrie shells were attached to their necks, wrists, and waists and whirled around as they danced. Their leather aprons were beaded with triangular motifs; under them, copper bells stitched to their thongs rattled at every step.

Positioning himself as close as he could without interfering with the dance, Rodger began photographing. He soon found out that he had great freedom of action—the dancers were completely absorbed in their ritual. When the drumming reached a climax, the dance leader seized a large wicker basket and whipped

off the lid with a flourish. Amid the wild yells of the audience, several large pythons and cobras slithered out. They coiled around his arms and neck and then slipped to the ground to twist away through the dust. Whichever way a snake turned, a dancer pranced before it, singing to it and stamping the ground nearby. Their ankle-bells added accents to the song. When the snakes came too near, some of the audience fled in panic. Several times, Rodger himself stepped back.

The dance continued into the night; soon there was no more light except for a sliver of moon. Rodger stopped photographing and let himself relax. By the fire, he and Cicely listened to the hypnotic sound of the drums and watched the dramatic play of shadows. As the night marched on, the dancers became bolder, performing acts of self-torture; they threw sand in their own eyes, swallowed glowing coals, pierced their skin with splinters. They themselves became snakes, crawling in the dust, inviting the pythons to coil around their legs and necks.

By the end of September, Rodger had exposed twenty-four rolls of film— about one-third of what many of today's photojournalists routinely shoot in a single day. Rodger was a frugal man with a reflective personality who firmly believed that "less is more." He did not press the shutter until he was sure he had a picture that was informative, well balanced, and necessary to the story. Looking at one of his African contact sheets, it is obvious just how compact and well thought out his stories are.

The next month, en route to Nairobi, Rodger had an encounter that would be among the most important of his life.

It was cold, and a white fog hung in low tatters. As the Rodgers' jeep crawled along a road cluttered with gray rocks, a group of Masai came out of the bush in single file. They towered over six feet, and their skin was so black it had bluish undertones. They had walked more than three hundred miles with hardly a break, yet still they walked steadily, leading their cattle by leather ropes. They were on their way to market to sell their cattle, something they did two or three times a year when they needed cash to purchase a bride.

Just then, a violent storm broke. Rodger had to stop the jeep, but the Masai continued on under sheets of rain. For an instant, lightning illuminated their proud, chiseled faces. In the torrent, their wool blankets were plastered to their shoulders and their spears shone. They did not even bother to look at the two whites who were following them. Stunned, Rodger decided then and there that he wanted to photograph the Masai.

The next morning he was able to shoot the cattle sale, which was held on the

rim of the Ngorongoro crater. African, Arab, and Sikh traders were at the fair as buyers; the Masai were only selling.

On October 18 the Rodgers drove fifty miles south from Nairobi to Kajiado to meet Sweetman, a district commissioner who was an authority on the Masai. In a few days, Rodger learned a great deal about them. But he was unable to get a story on Masai rituals:

> They are a race of warriors and, even today, are proud and aloof, considering themselves vastly superior even to the white man. . . . In spite of the story of the Masai being so interesting, I was unable to photograph any part of it. The independent nature of the Masai . . . made it quite impossible. They refused to cooperate or even show any interest . . . I would have to gain their trust and confidence first, then . . . would have to wait for invitations to their ceremonies and tribal functions before being permitted to photograph them.[17]

In his project of photographing African people's lives, this was the first serious obstacle Rodger had encountered. The Masai did not have a very high opinion of whites. They lived frugally and had no use for money or extra goods—on the contrary, they were insulted by what they considered to be bribes. Rodger understood that he had no choice but to gain their trust. He had no way of knowing it would be thirty years before he succeeded.

Rodger and Cicely decided to complete their previous wildlife story by photographing hippopotami, leopards, and giraffes in Kruger National Park. After that they would follow the footsteps of earlier African explorers to Mount Kilimanjaro, Mount Kenya, and the sources of the Nile.

It was pure chance that led Rodger to one of his best stories. On November 1 they were buying fruit at a market in the hamlet of K'Bali when they were approached by a group of Pygmies, who had wrapped their spears in banana-skin fiber to announce that their mission was peaceful. The Pygmies had traveled sixty miles to bring the Rodgers a note from a man they had never met, Peter Matthews. He was inviting them to his home in the mountains of Kigezi, eight thousand feet above sea level.

Matthews was famous by then and had been nicknamed "King of Kigezi." He had settled in Africa thirty years before and was the only white living in the Kigezi forest. Rodger and Cicely had heard many stories about him. A professional hunter and gold miner, he had over time become a friend, doctor, and counselor to the Batwa, Wachimbiri, Wagasero, and Wahundi people who

dwelled in the forest. He had learned their languages and was attending to their needs. The Pygmies were friendly with Matthews and did not think twice about walking thirty miles to ask him for quinine, or for advice in tribal disputes, or to trade animal skins with him.

In his invitation to the Rodgers, Matthews mentioned as an aside that he had sent the various Kigezi groups a request that they perform ritual courting dances near his home. If the couple cared to make the trip, Rodger could photograph and film them as he wished. Such an offer could hardly be refused, and on November 4 the Rodgers started out, following Matthews's instructions. They drove forty-seven miles to a valley in the hills, where they were met by Wahundi porters who would help them complete the difficult climb to the summit. "They wrapped our luggage in banana leaves and then, with the packages balanced on their heads, we started walking, a guide in front, Cicely and myself behind him, and twenty tribesmen following after us, some carrying our loads and others as armed escort." [18]

Soon exhausted by the heat, the humidity, and the altitude (they were climbing at a 45-degree angle), Cicely was unable to continue. Out of bamboo poles, gunny sacks, and laced creepers, the Wahundi made her a stretcher, and the expedition proceeded. At four thousand feet the jungle gave way to dark, ominous, and damp forest. All was silent except for the cries of colobus monkeys. It took them seven hours with hardly a break to reach Matthews's home, Naisura ("Holding the Summit"). Now that they had climbed above the vast, rolling clouds, they could see beyond the mountains as far as the Congo border. It was as if they were "on a ledge perched precariously on the edge of the world." [19]

The climb made a deep impression on Rodger, as did his first meeting with Matthews. Three months later, in a letter to Jinx Witherspoon, his recollection was still vivid:

It was cool but damp and steamy. Long streamers of moss hung from the trees and orchids grew on their branches. For another ten miles we walked through the forest until at the end, we were faced by a four hundred foot flight of steps cut into the mountain side and which led to Naisura. At the end of the steps was the King of Kigezi himself, waiting for us. He was charming—an Irishman of the old school, a loud voice and a twinkle to his eye. He had tea waiting for us, drinks and a hot bath in a tin tub discreetly screened off behind drapes of monkey skins. His camp was built of hardwood planks but it was open to the cold night air and as we sat drinking after our baths, tribesmen kept appearing out of the mist to announce the arrival of bands of forest people who had come to dance for us the following day. By midnight the Batwa Pygmies were there . . . we could hear

their drums beating long into the morning as we slept snugly. . . . The dance was held on a ledge high up on the hill side which commanded a view across the mountains of the Congo. Then, when the mists roll up and the thunderstorms are below you and the weird grotesque trees, bearded in moss, come and go as the clouds pass, it is all the fanciful thinking of Grimm and Hans Anderssen brought to reality. It is gorilla country too and at night one can hear them beating on their chests. It makes a sound like the rumble of distant thunder.[20]

The elders, women, and young people of three different Pygmy groups walked slowly into the clearing: the Wagasero, the Wachimbiri, and the Batwa. The women had rubbed their bodies and shaved heads with *simsin* oil and shone like coffee beans. The men and boys wore copper bracelets and tunics of yellow-and-black duiker skins, worn fur against skin. They carried drums, as well as sticks to help them scale the steep, wet mountainsides.

First came the *kamundare*, the courting dance of the Wachimbiri. Half a dozen women provided the rhythm, beating their skin skirts with their palms and singing in lilting voices while the female dancers arranged themselves in a circle. Their moves were slow and gentle. Rodger stepped close, photographing in black and white and filming (with Cicely's help) a dance that seemed to replicate the movement of wind in trees and the passing of clouds. Men and women alternated stepping up to and back from one another.

Then it was the turn of the Wagasero, who danced the *chanyangi*, leaping, clapping hands, and stamping the ground. Finally, the Batwa danced the *nkusiri* (growing old) dance. Matthews stood beside Rodger and interpreted the song's words for him. Rodger jotted the words in his notebook and later included them in a letter to Jinx, as well as in his story:

> I am growing old
> no longer am I able
> My feet are heavy
> and pains creep
> in my bones.
> I am growing old.
> The wild grass withers in the sun
> but when the rain comes
> from the dead roots new grass springs.
> I am growing old
> but still I shall live in my children.

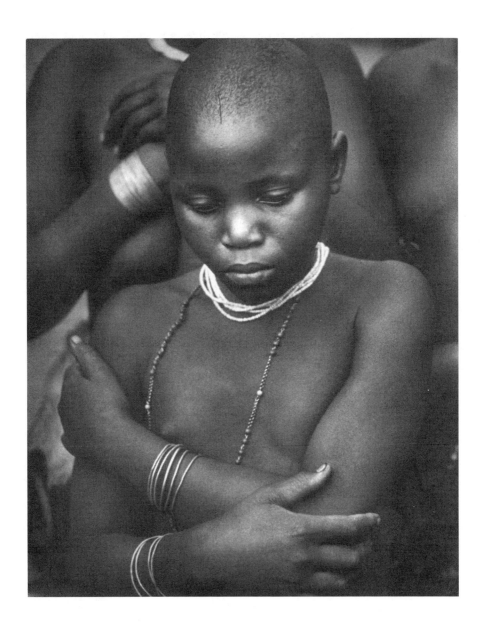

A girl of the Bachimbiri people in the Kigezi rain forest, Uganda, 1948. © *George Rodger/Magnum Photos.*

Then, without warning, the dances were over. A warm rain began to fall hard. The forest people vanished under the canopy of trees while the mist rolled in. If it had not been for the weight of the rolls of film in his pocket and the imprints of the dancers' heels on the ground, Rodger thought, he might have dreamed the whole scene.

The next day the Rodgers returned to the valley. By November 9 they were in the Congo on their way to Kampala for their next *Weekly Illustrated* assignment: the wedding of Edward Mutesa II, *kabaka* (king) of Uganda, in Kampala. The contrast with the rainforest dance was stark: no mossy trees, but marble columns; no mist, but velvet curtains; instead of muddy ground, shiny parquets; instead of drums, a classical orchestra.

The official ceremony was to take place in front of 25,000 people and was to be followed by a reception at the palace for 750 guests. Rodger, who needed to top up the expedition's funds, dutifully photographed in black and white and color the lavish buffet, the king's guests paying their respects to the royal couple, and the dancing.

As Rodger watched the Europeanized crowd in their finery—tuxedos and evening gowns, with only the occasional traditional garb—he was painfully aware that the gap was closing quickly between Europe and Africa. Even if most of the faces here were black, the king's party was not that different from those events in England that Rodger had so disliked photographing for *Life*. From all sides, the Western civilization he had grown to loathe since entering Belsen was closing in. He knew that the peace he sought would be harder and harder to find, and he recognized the paradox for what it was: he was an Englishman in Africa, loving what was most authentic about the country, yet understanding that by their very presence, white men—including himself—were changing the culture. It was, as Peter Beard would later put it, "the beginning of the end."[21]

On November 26, after a few days writing captions and shipping film, Rodger and Cicely crossed the Kitchwamba, the channel joining Lake Edward to Lake George, and were welcomed by Wakonjo fishermen in the village of Katwe. Rodger went out at dawn with them. Clad in antelope-skin tunics and armed only with wooden harpoons, standing in their dugout canoes, they maneuvered along the reeds while the rest of the fishers beat the water with bamboo poles, driving the *ngege* and *semutunde* into nets. The fish were salted or smoked and piled on layers of grass to dry.

The Rodgers decided to stay for a week, and enrolled the help of a local guide, Bartolomew. The entire channel was a photographer's paradise, where they could observe with binoculars and photograph with both Leica and Rollei an abundance of wildlife—families of hippos and herds of elephants, waterbucks,

and buffaloes, and well as countless birds. Rodger experienced a childlike joy as he recognized all the species he had seen in his bird guide at the Bridestones, and others that he had never heard of. He carefully noted them by name in his diary—the eagles, vultures, cranes, herons, Egyptian geese, cormorants, egrets, lowries, bee-eaters, kingfishers, pelicans, and marabou storks who "stride along the shoreline like old gentlemen pacing the club-room floor with their hands behind them."[22]

At one point the Rodgers found themselves unexpectedly only about thirty yards from a herd of elephants. "With ears flapping and trunks raised they gave me an anxious moment or two. I did not dare raise my camera or the slight movement might have attracted their attention and pinpointed my exact position."[23]

A few days later, while he was pointing his Leica, Rodger was charged by a hippopotamus. "It let out an angry grunt like the blast from a big bad tuba and, seemingly in one concentrated movement, turned and charged. If the back view had been formidable, the front view was terrifying!"[24] Rodger was saved by Bartolomew, who fired his rifle over the hippo's head; surprised, the beast turned and rushed for the water.

A few weeks later the Rodgers drove to Katwe, where they bought oil and water and had their vehicles' engines checked before heading for Yei, in the Sudan, where they arrived on December 11. Their speedometer at that point read 17,600 miles. They settled in Yei for a few days, long enough to ship Rodger's film to London by air freight—a complicated procedure that had to be done through a contact in Khartoum.

They intended to work in the Sudan for about four months; in order to do this they had to fill out endless paperwork to arrange travel permits for the restricted territories of Equatoria, Baha-el-Ghazal, and Kordofan, where Rodger hoped to photograph the Nuba of Kordofan. He had asked Magnum to contact *National Geographic* about an assignment. Like the Masai, the Nuba had a reputation for being difficult to approach. Even so, Rodger hoped to make a go of it.

In mid-January of 1949, after stocking up on oranges, grapefruit, limes, and pineapples at the market, they started out from Juba for the southestern Sudan, but they had to stop almost right away: Cicely was ill. There was no doctor nearby and they did not yet realize that she was in the first month of pregnancy. By early February she had recovered, and they continued traveling across dry, thorny terrain, on tracks that had been hardened by a spell of cold weather.

On February 9 they crossed to the east bank of the Nile. They were fortunate to arrive just before the time of an important festival of the Latuka people: their new year ceremony, the *Nalam*, the intent of which was to persuade the local rainmaker to summon the rains and ensure good crops.

When the Rodgers arrived at the Latuka village at dawn, the women and children were still asleep. The rainmaker himself came out to welcome them. Soon the warriors joined them; for the past two days they had been hunting in the surrounding bush. According to Latuka beliefs, the first animal that fell to their spears told the future of the next season's crops: a small animal or a male was a very poor omen, whereas a large or female animal meant a rich harvest. As the hunters approached, the villagers sighed with relief; dangling from a wooden pole across their shoulders was a large female water buffalo. Everyone immediately began preparing the *Nalam*. They mounted a tall ebony pylon in the middle of the dance floor and soon were so engrossed in their preparations that they forgot about the Rodgers.

After giving the buffalo to the rainmaker as an offering, the warriors entered their huts, coming out later dressed in their regalia. The Rodgers' guide had told them that Latuka men were obsessed with their appearance, but still they were stunned. The men were tall and dark with very long limbs and a graceful demeanor; their bodies were entirely smeared with red or gray clay, and their torsos were scarred with deep incisions. They wore breastplates, blue bead ornaments, and elaborate brass helmets crowned with ostrich feathers. Their shields were made of sun-bleached buffalo hides hung with ostrich feathers. Each of their Lamudung rods was affixed with the brilliant scarlet breast feathers of the tiny bishop bird. Rodger was told that the feathers of six hundred birds were required for each decoration.

In contrast, the women wore simple tunics, pearl bands across their foreheads, and brass necklaces. As for the children, they wore nothing at all; however, as they arrived at the dance area in the center of the village they were neatly arranged by size, from the tallest to the smallest.

The sun was setting. The rainmaker sounded the horn and the crowd took a deep breath. It was time for the dance to begin. Holding his Leica, Rodger positioned himself at the edge of the arena while Cicely held the movie camera.

Gourds filled with strong, sweet beer were passed from mouth to mouth. The rhythm of the drums began to work the people into a frenzy. The girls sang tribal chants, the warriors punctuating their song with ecstatic cries. Bodies swayed with the rhythm or leapt high in the air; more and more beer was consumed as the dance continued through the night. By morning, the dancers had collapsed on the dance floor, reassured that their harvest would be good. Rodger too was pleased with the pictures he had taken.

Three days later, on February 12, the Rodgers were in Duk Fadiat, south of Malakal, at a gathering of the Dinka, who lived in the marshlands along the Nile. By now the Rodgers were accustomed to being surrounded by clusters of chil-

dren and curious old women when they entered a village for the first time. But in Duk Fadiat, the greeting they received was more colorful. "All the young men arranged themselves in front of us. They wore nothing but tight corsets of coloured beads, either pale blue or yellow, which they wore in a band about ten inches wide round their waists. The colour contrast was most striking, but I doubt if any of the pictures I took would pass the morality censor!"[25]

The next day the Dinka began their dance, a series of leaps accompanied by the bass tolling of large copper bells. Rodger photographed both women and men and made portraits of the long-limbed young women with their white face ornaments and leather tunics.

A week later the Rodgers arrived in the village of Raikha, where they received word from *National Geographic*: Rodger's assignment to photograph the Nuba had been approved.

13

Village of the Nuba

FEBRUARY-MARCH 1949

In February 1949 the Rodgers started out for Nuba country. Some three hundred thousand Nuba were living in isolation in Kordofan province. Very few anthropologists and no photographers had been able to gain their confidence.[1] Rodger had been promised publication in the *Weekly Illustrated* and in the prestigious *National Geographic* for a story about them.

The Nuba, Rodger had learned, were probably the earliest inhabitants of the area. A sturdily built and physically striking people, they had been since the Greek and Roman times an important source of slaves for the Middle East. To escape the Arab slavers they had taken refuge in the Jebel Mountains, four thousand feet above the plain. Isolation had helped preserve their traditional way of life. They wore no clothing and had few material possessions. They lived happily and self-reliantly in a bygone era and did not want to know about the modern world. Centuries of oppression had made them both wary and defiant of outsiders. Over the years the Nuba had evolved into fifty different groups, each with its own dialect, customs, and mores.

By the 1940s, like the Zulus and the Masai, these great warriors had renounced fighting with their neighbors. Yet they still retained their ritual athletic competitions such as spear throwing, wrestling, stick fighting, and—the most lethal of all—fighting with copper bracelets. Rodger was keenly interested in photographing the fights as well as Nuba everyday life.

Permits to enter the central Sudan were obtained easily enough. However, Kordofan was almost unapproachable by road except during the few weeks of the

year between the floods and the rains; it was bordered by swamps to the south and desert to the north. The end of February was the only time the Rodgers could reach Kordofan. They chose one of the southern approaches, and after loading their two jeeps with supplies, headed for Juba. There they crossed the Nile and followed its course along a mud track through dense jungle. The go-ahead message from the district commissioner of Bor had ended with these cryptic words: "Mind the elephants." His meaning became clear only after they began noticing two-foot-deep imprints on the track. While trying to negotiate these huge, muddy holes, they saw a troupe of thirty elephants in single file walking slowly but relentlessly toward them, heading for the river. Just in time, they forced their jeeps into the dense bush.

After five hundred miles of rutted roads, they arrived in Malakal, where they crossed the Nile again to the west bank, within eighty miles of the Kordofan border. From there they followed a very poor track of rough black soil, baked and cracked by the sun, until they reached the Jebel mountains.

Cicely was usually a good traveler, but all through this journey she was ill. George and Cicely believed her stomachaches and nausea were symptoms of dysentery—in fact, she was nearly two months pregnant.

Conditions were difficult. The storms were terrible, and dysentery was striking Rodger hard. On February 21 they arrived at Reikha in the heart of Nuba country, where they met Jack Thompson, the district commissioner. (At the time, the Sudan was an Anglo-Egyptian administration, and it would remain so until it achieved independence in 1953.) Thompson was arranging with the Jebel sheikhs permission for Rodger to attend and photograph Nuba ceremonies. He told them that a gathering of about two thousand Nuba would be taking place only an hour later, just a few miles away, at Buram. The Rodgers left for Buram immediately while their helpers Andrea and Serapio set up their equipment in the rest house.

When they arrived, the wrestlers, their bodies rubbed with ash, were already waiting under the thorn trees. A procession of women and young girls came down from the Jebel, led by a Nuba beating a large drum. The people formed a circle around the wrestlers, who faced one another in a crouch. The fighting began immediately.

Rodger was thrown into the heart of a ceremony he did not understand, performed by a people he knew little about. He was dazzled by the appearance of the naked fighters and of the audience: one girl had adorned herself with beer bottle-caps; a man had an entire heron attached to his back; another had cowbells strapped around his stomach. Many wore ostrich plumes and had elaborate geometric designs painted all over their bodies. In a way it was a photographer's par-

adise—but the very visual wealth made it difficult for Rodger, who literally did not know where to turn. "There was endless photographic material but was difficult to get on account of the speed at which everything happened, the throng of people who were invariably in the way and also the changing light."[2]

In Rodger's photographs the formidable, round-headed fighters look eerily quiet; their arm movements and their high jumps and twists echo the arcs of the thorn trees behind them. Their ash-whitened bodies absorb light and blend into the landscape, connect to the ground, the trees, and one another.

But pictures, of course, can be deceptive. We know from Rodger's diary that the fighters were far from silent. They grunted; they stuck their thumbs in their mouths and produced a terrifying sound like the cry of a pouncing eagle. Their calf muscles trembled with impatience, and they stomped the ground with their feet before seizing each other. The women spectators vibrated their tongues between their lips, producing high-pitched ululations to punctuate the fight's most emotional moments.

Rodger absorbed it all as if in a fever—the clamor, the fighters' deep grunting, the crowd's roars. The sun was high and the light bounced off the hard ground. Cicely was trying to film with a small, hand-held movie camera (the result would be jumpy and disconnected). Rodger was juggling two cameras, a Rolleiflex and a Leica, and using both black and white and color—*National Geographic* had specifically requested color. Generally he liked to use the Rollei for individual portraits and landscapes and the 35-millimeter for details and movement, but right now he was just doing whatever he could. To make matters worse, when he tried to measure his exposures he found that his light meter was dead; he had to wing it and guess the exposures. Because he never used a telescopic lens, he risked being trampled by positioning himself close to the fighters. Imagine a sports photographer walking onto a field in the middle of an American football game to shoot close-ups in both color and black and white, with two cameras, no light meter, no zoom—and no knowledge of the rules of the game.

At the end of this fight, Rodger succeeded in taking one of his most famous photographs. His shot of a Korongo Nuba wrestler being carried on his adversary's shoulders is an iconic image that over the decades has been reproduced all over the world—on posters, postcards, and record covers, as well as in books.[3] Many people know this image without knowing who took it.

Rodger recalled the scene at the end of that extraordinary battle: "A dull roar from a thousand throats announced that someone had been thrown. Eventually, the winner was hoisted onto the shoulders of a husky giant to be carried through the throng while the women thrilled in a high key before him. . . . Both winner

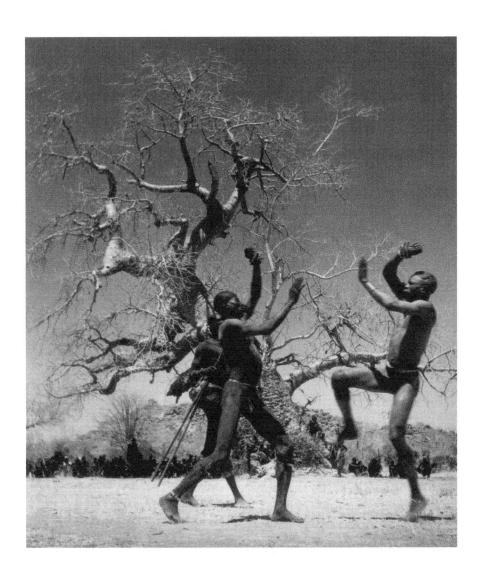

Nuba bracelet fighting at Kao-Nyaro, Kordofan, Southern Sudan,
1949. © *George Rodger/Magnum Photos.*

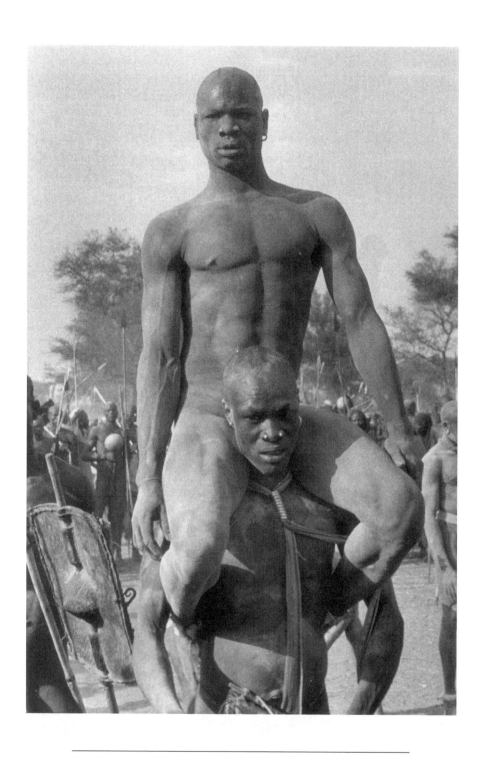

The champion of a Korongo Nuba wrestling match, Southern
Sudan, 1949. © *George Rodger/Magnum Photos.*

and loser laughed together, and enjoyed the celebrations with as much pleasure as any of the spectators."[4]

The next day the Rodgers went up into the Masakin Jebel. Along the way Rodger photographed women who had planted tobacco by cutting holes in the parched ground and loosening the dirt around the young plants by hand. Then they watered the holes, bringing the water from afar, in gourds carried on their heads. They visited the village, and Rodger admired its simple and functional organization. "Each house was constructed by joining four or five *tukl* with a central courtyard. From the outside they looked like a cluster of fat pepper pots, each with an overhanging cover. Inside, I found that one *tukl* was a storeroom for grain, another was a grinding room where the grain was made into flour, a third was a brewery and had large earthenware pots arranged inside in rows, the fourth was a bedroom and the fifth for the sheep, pigs and goats."[5]

Drawn by the simple, elegant shape of the *tukl*'s keyhole entrance and by the way bodies were configured against it in the broad sunlight, Rodger photographed the Nuba from inside as they carried in gourds or containers of grain. Later in the evening he tried to photograph everyday activities such as cooking, but there was not enough light left. He set up flashes with extensions coming out of the opening connected to his generator, "but the flashlight scared the people. They said we were killing them by magic and it was only by presenting them with the used flashbulbs that we managed to gain their confidence."[6]

That evening the Rodgers returned to their camp, hoping to get a good night's sleep, but they were attacked mercilessly by safari ants and had to retreat to their jeep. By the following day their appreciation of the Korongo wrestlers had been broadcast from *jebel* to *jebel*. Not wanting to be outdone, Salim Abdullah, the *mek* of Masakin Tiwal, invited them to his *jebel*, about fifteen miles away, to witness another type of contest: the stick fight.

There the Rodgers were offered tea, and muddy water mixed with honey. While waiting for the Makasin fighters to arrive, Rodger took portraits of the thirty-odd children who had been following them excitedly.

The fighters were not naked as the Korongo had been; instead they wore clay helmets, cloths tied around their waists, ankle bells, and horse's tails. This time the fighting was more organized—the *mek* acted as a master of ceremonies—but it was every bit as brutal as the previous day's had been. "The fighting was fast and deadly. In two minutes one man was knocked out cold with a blow in the forehead. There was no quarter given. The men fought wildly using every ounce of strength behind each blow, and in ten minutes or so the ground was littered with splintered clubs which had been shattered over unprotected shoulders and thighs."[7] Rodger was not as taken by the stick fight as he had been

by the wrestling at Buram, and he shot only twenty 35-millimeter pictures, all of them dynamic and competent but none as powerful as his pictures of the Korongo Nuba.

On February 25 the travelers got word from Kendrick, the British district commissioner at Rashad, to wait for him at the village of Talodi. They settled there for the weekend. The heat was so intense that butter turned to oil, meat turned bad, and water nearly boiled. Cicely was suffering from severe stomach pains. Rodger passed the time studying local maps bearing illuminating inscriptions such as "high heglig and talh," "sand," "bush," and—most often "no water." With the help of their mechanic Andrea, Rodger repaired the station wagon's clutch with a part salvaged from a wrecked plane—a skill he had acquired in the Western Desert. Kendrick finally arrived with good news: they were invited to see a bracelet-fighting contest in the village of Kau.

They drove the hundred miles to Kau in four hours, on a road flat as a tabletop that wound between huge rock outcrops where other Nuba villages were nesting. Plastered in red clay and thatched with grass, the huts were so well camouflaged that they were hard to distinguish from the rock.

They set up camp at the edge of the village, building a hut of reeds under a fig tree. Runners were sent to the neighboring villages of Nyaro and Fangor to summon all the young men for a *sibr* the next morning. The Nuba welcomed the Rodgers and showered them with gifts of food: a young goat, a chicken, eggs, gourds filled with milk or honey—so much that they gave some away to their Askari helper and the water carriers.

At dawn the next day they were awakened by three Nuba beating small drums, soon joined by six female dancers, their bodies smeared in bright clay. "We would have given anything for a recorder so we could have taken the rhythm away with us to dub later to our film," wrote Rodger.[8] Then they followed the sheikh to a small clearing in the baobab trees, under which the fighters from Nyaro and Kau were waiting, each naked except for a thin belt of rawhide. "Each fighter wore on his wrist the murderous brass bracelet with a double flange on it standing out a couple of inches and with a sharpened edge that could crack a skull with one blow."[9]

The fighting, the most violent Rodger would ever witness, was in two rounds, the first between the men of Kau and Nyaro, the second between the men of Kau and those of Fangor. All were reputed to be highly skilled. As guest of honor, Rodger on both occasions was seated next to Sheikh Nuru of Kau. Again it was by no means easy to take photographs. "It was so quick and I was warned several times not to get too close as, when the fighters' blood is up, they give no quarters and are just as likely to turn on seconds and onlookers as each

other. I got some good close-ups but will not know if the actual knockout blow can be seen until the films are processed."[10]

Rodger did indeed catch the "knockout blow" on film. His vivid words bring movement and sound to his astonishing pictures, which show pairs of giants hurling themselves at each other:

> They fought wildly, savagely, like dogs, crashing the heavy bracelets down on unprotected heads so that we could hear the dull crunch of heavy brass biting into the very bone. Blood poured from their heads and necks where the bracelets cut deep. But they fought on, eyes blazing and fists flailing madly. . . . One man, after a particularly savage blow, disentangled himself from his opponent's clinch with a four inch gash at the base of his skull. Blood poured down in a glutinous mass over his back and buttocks, down to his ankles, yet he fought on and paid no more attention to it than a boxer would to a black eye. During another bout one of the fighters had the teeth smashed from his bottom jaw, but it was always the same—the more blood that was spilled the harder they fought and it was only the intervention of the seconds [arbiters] that prevented a killing.[11]

Rodger concludes with the vision of a fighter who had "a four inch triangle of scalp hanging loose." After the fight, that man came to their hut and with a shy smile presented them with a gift of three eggs.

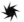

On March 3, while Rodger and Cicely were having breakfast and preparing to leave Kau, they heard shouting in the village. A stray spark from a cooking fire had lodged in a thatched roof, and within minutes the entire village was enveloped in sheets of flame:

> I climbed up the *jebel* to look down on the scene and there below me was a blazing inferno. The wind, which in the early morning was always strong, whipped the flames to a fury and the heat was terrific. . . . In less than half an hour there was hardly a house left standing and what had been a picturesque Nuba village was nothing but a heap of charred ruins. . . . Two hundred and thirty houses had been destroyed, about six hundred people were homeless and, what was worse, their grain stores for a year had been destroyed.[12]

It was the third time in the history of Kau that the village had burned down. Fortunately, there were no human casualties. The sheikh promptly dispatched a run-

ner on a 250-mile journey to tell the district commissioner about the tragedy and ask for relief supplies. Emergency food was needed, as well as help to rebuild.

The following day, after dividing the remaining meat from their goat among the bracelet fighters, the Rodgers packed their jeep, said goodbye to their friends, and drove out of Jebel country onto an arid plain where the *wadis* had run dry.

In El Obeid, Rodger found in his mail a month-old letter from Jinx Witherspoon. In his reply, which he wrote the following day, he described some of the local customs that he found especially interesting:

> We've had a very grueling but interesting time in Kordofan. There probably, Africa is about at its rawest. Among some of the remote tribes of Nuba there is no vestige of what we call civilization. . . . In some of the *jebels* the people had never seen a white woman before and the women, whenever they could get Cicely alone, tried to feel her all over to see if she was made the same way as they were. As they were invariably bent on lifting her skirts up she said it got quite embarrassing at times and took to wearing slacks. . . . I'm not kidding at all when I tell you the accepted greeting of the Temein in the Nyimang Jebels, man to girl, is gently to squeeze her left breast. That is the same to them as handshaking is to us, but it is very difficult to keep a straight face when a bunch of these dusky beauties comes up to say hello and you have to squeeze solemnly each breast which is presented to you.[13]

Rodger's private admission to Jinx that their time in Kordofan was "grueling" is one of the rare occasions that he was candid about difficulties. Usually he underplayed them. For the benefit of books and magazines he presented himself as a gentleman photographer to whom things came easily and naturally. As a result, much has been written about his capacity for self-effacement and for capturing the most "natural" aspects of indigenous life. Rodger did very little himself to dispel this aura of uncanny and spontaneous immediacy. Yet it is clear that capturing his subjects in "natural" and relaxed moments did not come easily in the context of his African subjects, except perhaps with children. When it came to photographing women, Cicely's presence and his own highly developed patience must have helped slowly establish a relationship that allowed them to be at ease around him. Nonetheless, most of his portraits of Nuba women are posed (as evidenced by Rodger's contact sheets), and those women are more often in groups. Regarding the Nuba women, he noted carefully in his diary that photographic collaboration was the exception rather than the rule. Of one particular young woman—whom he describes as "a magnificent figure of a girl" and a "dusky Venus"—he wrote:

"She was unusual in that she was able to pose quite naturally without becoming stiff and awkward as is much more usual among native tribes."[14]

When a few years later Rodger published his work as a book, *Le Village des Noubas*,[15] which included his own text, his tone was poetic, elegiac. He greatly downplayed the violence of the Nuba customs and emphasized the more generous and pacific aspects of their character—for example, their generosity with their possessions and their time. He said nothing about Nuba women and their relationship to Cicely and to photography.

Rodger's Nuba photographs were first published as a documentary story in the *Weekly Illustrated* (in black and white); later they appeared in *National Geographic* in a longer version that included some color pictures. The stories earned him enormous respect in the photographic community and beyond; they also established him as a specialist in Africa and as one of the most insightful journalists of his generation. On a personal level, his encounter with the Nuba began a friendship that he would develop all his life. He became a champion of their traditional way of life, which was soon to come under fierce attack from the Arab northerners.

Half a century later, after Rodger's death, Jinx and I were sifting through his archive of Nuba vintage prints in the New York offices of Magnum. Editor's guidelines had been scribbled on the backs of several of the prints that had been used by *National Geographic* and *Weekly Illustrated*: "Make a skirt for this one, Bill," was written on a print in which a Nuba man's genitals were clearly showing; "Airbrush blood, Bill," was the recommendation on other prints of wounded fighters. "Bill" had made a skirt and airbrushed the blood. Rodger's Nuba pictures were being published in the 1950s, one of the most oppressively narrowminded eras in American history. (In the same era, Beaumont Newhall at the Museum of Modern Art in New York would ask an indignant André Kertész to reframe some of his "Distortions" so that pubic hair would not be visible![16])

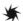

Throughout his life, Rodger would assert that he had found his salvation in Africa—that he had found on that continent a pure and unsullied civilization, one that was deeply religious, attuned to nature, and indifferent to material goods and that helped him set aside his brutal memories of World War II and the concentration camps. His intent was to purify himself, to forget, to reinvent himself in the soothing context of his African experiences. But in the scenes he observed we find that harmony and violence were often woven together. His best pictures, like the one of the Nuba warrior, reflect this tension honestly and frankly. It is both sad and ironic that these photographs would ultimately help draw attention to the Nuba—attention that would change their way of life forever.

Another issue came to the fore for Rodger as he worked with the Nuba: freedom. From youth he had been expressing his desire to be free, and he saw his life as a freelance photographer and adventurer as a way of achieving freedom. The tribal way of life that still survived in parts of Africa was a kind of ideal to him. He felt that in the Nuba he had found a utopic society: peaceful, nonmaterialistic, and providing generously for its elders and children.

By 1949, however, the Nuba were no longer a free people. They were already under the control of the Muslim government of Khartoum, which permitted them to live within their traditions as long as they agreed to restrict themselves to the most barren regions of the country—the *jebels*. Their secluded villages were little more than reserves, and Rodger must have known this, since he had had to ask permission from the sheikh administrators to visit the Nuba. Ten years later, the Islamic vise would begin to tighten on them.

Khartoum began by banning most Nuba customs and festivals. Offended by their nudity and especially by the uncircumcised bodies of the pagan wrestlers, the government prohibited the wrestling matches and issued edicts under a "public order" act forbidding gatherings. Khartoum talked of "civilizing" the Nuba; of course, the real intent was to Arabize the Sudan. Exiled, prosecuted, allowed to live in the Sudan but only within a wilderness "ghetto," the Nuba became for the Arabs what the Jews had been for the Germans: a people to be kept on a short leash; a people allowed to live for a while on sufferance, and even then only under certain conditions, until the time came to destroy them.

Visually, the Nuba were extraordinary: towering in stature, physically beautiful and as strong as they were beautiful. All of this lent the contests Rodger photographed an almost mythic quality, one so striking that it was easy for him to forget these people's past and present circumstances.

Two years later, in the spring of 1951, when Rodger's extensive essay was published in *National Geographic*, the Nuba photographs caught the attention of one particular reader who had always been obsessed by physical beauty and strength: German photographer and filmmaker Leni Riefenstahl, director of the renowned film on the 1936 Berlin Olympics *Olympische Spiele* and of the Nazi propaganda film *Triumph of the Will*. Riefenstahl was deeply struck by Rodger's photograph of the Korongo wrestlers and became fixated on the idea of photographing the Nuba herself. She wrote to Rodger, offering him $1,000 if he would introduce her to the wrestlers. His response was the indignant rebuff of a war photographer who had witnessed Belsen and had no sympathy for Nazi propagandists: "Dear Madam, knowing your background and mine I don't really have anything to say to you at all." [17]

For better or worse, Riefenstahl was a very obstinate woman who usually got

what she wanted. It took her more than ten years to make her way to the Nuba, but she eventually did in 1962, and again in 1975. Her two expeditions and her extended stays with them resulted in two lush color books that were highly acclaimed in Europe and the United States. She later wrote: "The time among the Nuba was the only time in my life during which I was happy."[18] It is interesting that although their approaches were profoundly different, Riefenstahl and Rodger had this feeling in common. Among the Nuba, Rodger and Riefenstahl were both, for a short while, something they longed to be: removed from themselves, people without a past.

Riefenstahl had always been a profoundly self-centered woman who relied on her instincts. Her creativity did not involve critical thinking, which is why she allowed herself to become the Nazi propagandist she later denied having been. Her lack of foresight would bring catastrophe to the Nuba.

It has generally been argued that the two groups of Nuba photographs—Rodger's and Riefenstahl's—are distinctly opposed. Susan Sontag and many other commentators from Tom Hopkinson to Peter Hamilton have contended that whereas Rodger showed his empathy for the Nuba and was attracted mainly to their humanity, Riefenstahl's pictures—most of which show Nuba women and social customs—are crudely staged to at least some degree. It is said that she paid the Nuba to undress and perform rituals that had by then been banned by their Islamic rulers, and thereby endangered them by bringing them to the attention of the Muslim fundamentalists in Khartoum.

Yet another examination of the photographs from the distance of many years reveals that Riefenstahl's pictures are in a sense as valid as the ones Rodger took, and that her love for the Nuba was probably heartfelt, if sentimentalized. She has been accused of posing the Nuba. She did—and so did Rodger. However, she worked more thoroughly than he had, residing with the Nuba on two separate occasions for extended periods. She studied their language, recorded their music, and photographed their rituals and agricultural practices through the four seasons. She photographed the Nuba almost exclusively in color and made much of their facial and body ornaments and of the dramatic landscape of eroded *jebels* in which they lived. Whereas Rodger often adopted a low perspective, crouching to get a shot of the Nuba integrated with the landscape, Riefenstahl stepped back and composed stagy, flamboyant photographs. She is an observer, always discrete from the subject, whereas Rodger is something of a participant, an empathetic eye.

Rodger's attitude toward Riefenstahl was ambivalent. He kept her books (with her written dedications to him) on the shelves of his library in Smarden, along with his other books on Africa.[19] Publicly, however, he always disparaged

her. When later in his life he became a fierce advocate of the Nuba cause and was asked if he knew whether Riefenstahl was aware of what was happening to them, he growled: "I don't really know. But if she did I doubt she would care."[20]

If Rodger needed to differentiate himself so completely from Riefenstahl, it may well have been because he felt responsible—perhaps indirectly—for the fate of the Nuba. It was, after all, his own photographs that had drawn Riefenstahl to them.[21] Her pictures of naked men's bodies and unconcealed women's breasts and buttocks had infuriated the prudish and racist Khartoum government and thereby heightened the repression against them. Riefenstahl was almost certainly unaware of the damage she had caused; in contrast, for a highly moral person such as Rodger, the thought of being in any way responsible for their tragic fate must have been unbearable. However, it is more than probable that in absence of pictures, the Khartoum government would have found another excuse to destroy the Nuba.

Fifty years later, on this ever-shrinking planet where travel is no longer considered "adventurous," and now that we have seen countless pictures of Africa's plight in the media, Rodger's photographs of the Nuba retain much of their mystery and fascination. This is in part because the Africa Rodger knew and loved has vanished from this earth. Entire regions have been devastated. Nowadays the images of Africa by Rodger's colleagues—James Nachtwey, Raymond Depardon, Gilles Peress, Sebastião Salgado, and others—are more than likely to include refugees, famine, drought, emaciated bodies, common graves, and the violence of ethnic and civil wars. Rodger's Nuba photographs, in contrast, bring us a world that is self-contained, pacific, desirable—and gone.

Rodger wagered that he could understand and be understood by any human being, however different from him. He followed his highly personal sense of human propriety for example, when the Nuba were frightened by his flashbulbs and accused him of wanting to kill them with his magic, he decided intuitively to borrow from their own custom of gift giving and to present them with the bulbs. By doing this he was both demonstrating that the bulbs were not dangerous and endowing them with value, making them into something the Nuba could use for their own purposes. Similarly, at the end of his assignment he made a speech of thanks in front of the assembled people, correctly guessing that everyone would understand his intentions, although they did not speak a word of English. Again, his instinct was right.

When Rodger worked, he usually relied on a local interpreter. In some way the very fact that he did not know the language of those he photographed served

his goals as a photographer: it freed him from distraction. While the translators were doing their job, he could observe the body language and reactions of those he was going to photograph. He was accepted because he was nonjudgmental, nonintrusive, and patient enough to wait until the Nuba were used to him and his camera.

In 1949, when Rodger and Cicely photographed and filmed them, the Nuba had never before seen white people with cameras. Today they are accustomed to seeing foreigners, they know about photography and tape recorders, and they know much about white people.

But the wrestling ceremonies witnessed by Rodger and Cicely are now almost gone.[22] The wrestling arenas have become battlefields, and the Nuba can no longer practice a sacred custom that is traceable back to the time of the ancient Egyptians. The young are ignorant of their own traditions. As one Nuba youth puts it in Arthur Howes's 1989 film *Nuba Conversations*, "The elders have never told us their secrets."

At the time of this writing, the Sudan has for twenty years been in the throes of a civil war, a war that its Muslim antagonists call sacred. The rainy season is the only time of respite from the fighting. According to the most recent inquiries of human rights groups such as Amnesty International, Africa Watch, and Survival International, the repressive activities directed against the Nuba have included forced relocation to remote labor camps and redistribution of their lands to those allied to the fundamentalist government in Khartoum. Armed by this government, Arabs from the north have entered the territory of the Nuba, looted their goods, taken over their fields and wells, stolen their cattle, and killed their young people by burning them alive. More than fifteen thousand young children have been taken from their parents, rounded up into trucks, and brought to "peace camps" to be converted to Islam.

Most of the Nuba villages are now deserted. The *tukl* have all been burned—not by bad luck and strong winds as when Rodger and Cicely were there, but by malicious will. There are almost no adult men left; they are in exile in other parts of Africa, or they have been forced into the army. Women and whatever children are left have fled and are scattered in the mountains, where they lead a hidden existence, fleeing from *jebel* to *jebel*, from crevice to cave.

The Nuba had not wanted to enter a war where they felt they did not belong, but they were in effect caught between northern and southern Sudan. Some managed to escape on foot to Ethiopia or Kenya. Those who refused to convert or to join the army were tortured. The young men who were forced into the army eventually came to comprise 40 percent of it. "There is no other work

but to kill your own brothers," says one man in the film *Nuba Conversations*. "In my heart I don't want to be a soldier but if you are oppressed you also oppress."

Sadly, the fate of the Nuba has become just one more story of a broken, homesick people decimated by illness, confined to transit camps, and living in exile. Like the Holocaust in Europe, the destruction of the Nuba has taken place in almost complete silence and the studied ignorance of the international community. Only recently have articles in popular magazines brought some attention to their plight. One journalist recently remarked: "This is modern war. It's not so much about winning territory as gripping power by uprooting people, cutting at life's basics, seeding terror so that the simplest act is shrouded in uncertainty."[23]

In this light, Rodger's pictures, with their uncommon mix of raw poetry and careful composition, can be seen anew. Now that the Nuba have been caught up in a civil war and disenfranchised from their own history, Rodger's photographs have taken on a new role—one he would have been pleased with. They serve as a testimony to how things were, as a chronicle for more recent generations of Nubas, as a reminder for them to be proud of their heritage.

14

Speak to Me

How frustrating it was not to be able to see the Nuba story right away! Rodger sensed it was good, but he would have to wait until he was back in Europe to edit it.

Cicely and Rodger spent April and May on Cyprus, in their rented beach house near Limassol. The island was a good base for any African or Middle Eastern story, and Rodger hoped that by setting up house there he would be able to combine professional and family life. By now they knew a baby was on the way.

Cicely's pregnancy was not going well. She suffered from constant headaches and blurred vision. She had gained a lot of weight and detested the sight of her swollen body and legs and her puffy cheeks—she worried Rodger would not be attracted to her anymore. Often tense and emotional, even depressed, she would burst into tears for no reason. She was also terrified of the approaching birth, something Rodger had not thought much about and could not understand—it was a natural thing that women did, wasn't it?

Together, they attended her regular appointments at the nearby hospital in Amiandos, which was run by nuns. The facilities were very clean and modern. The attending doctor found her in good health and dismissed her fears. If it made her feel better, he said, she could come and settle in the hospital for a few days in advance of her due date.

In early June Rodger received bad news from Congleton: his mother needed an operation for breast cancer in the next few weeks. He was shocked that she had not told him earlier about her condition, but she had not wanted to worry

him. He did not think Cicely could take the fatigue of a trip in the last trimester of her pregnancy, so he decided to return to England on his own, leaving her in the care of the couple's close friend, George Kirziz. When they parted, Cicely clung to him in tears. Rodger was baffled—after all, they had been separated for much longer periods during the war, and this time it would be for only a couple of months. He planned to be back mid-August, a full month before Cicely's due date.

By early June, Rodger was in London, where at long last he saw his Nuba contact sheets. For once he did not have a shred of doubt: he already knew he had produced extremely powerful pictures. Now he realized that they surpassed his expectations. "This Kordofan story is simply immense. I have 100 color frames in 35mm, 180 Rolleiflex and 150 Leica. That is edited down about as far as I can go, and every single one is good! . . . There are some lovely personal pictures too. I like the one where we are having breakfast under the paw-paw trees at that Gîte d'Étape in the Congo just before we arrived at Aru on the Uganda border. Do you remember it? We took it with the self-timer."[1]

On Cyprus, Cicely was feeling lonely. Rodger had left at a time when she was especially vulnerable, and although she admired his talent and was usually supportive of him, she would have much preferred that he stay with her. He sent her a book from London, *The Revelation of Childbirth*, in the naïve hope it would alleviate her fears, but it was no comfort at all to her.

Rodger, excited and nervous at the idea of soon becoming a father, went on a shopping spree—highly unusual for him—for baby equipment and clothing. He also received a lot of second-hand clothing from friends, which he added to his growing pile. Jinx Witherspoon, who was in London by then and hoping to spend her summer vacation with the Rodgers on Cyprus, also went shopping for baby clothes with Dorothy, Cicely's sister. Rodger joked: "[Jinx] wants to know what goodies you want brought over. . . . When she finds out she is already bringing me a strobe outfit, a Speedgraphic, dozens of rolls of film and some darkroom equipment—maybe she won't be so keen!"[2]

Toward the middle of June, Rodger drove the winding road to Congleton in his car, a Hillman Minx nicknamed "Minxie." The farmers were working late into the evening, and from the open windows the powerful smell of hay drifted from the fields. On June 24, his mother underwent a mastectomy; the operation was successful, and she was released from hospital on July 8.

Relieved by the outcome, Rodger began planning his return to Cyprus. Jinx took a three-month leave from *The Ladies' Home Journal*. She would travel to Cyprus with Rodger, who met her at the harbor at Le Havre in early July. They drove to Paris for cocktails at the Lancaster Hotel, window shopping on the

Champs Élysées, and a memorable Magnum lunch attended by Elizabeth "Crocky" Reeves; Len Spooner; Inge Morath, then a writer and aspiring photographer; the photographer Ernst Haas, not yet a member of the agency; Chim; Carl Perutz, a freelance photographer; and Warren Trabant and his wife.

Rodger was delighted and amused by Jinx's eagerness and naïveté, and basked in her unreserved admiration for him. Jinx later commented: "I was just a little secretary from New York and here was this guy who had traveled to all those places where I always wanted to go all my life. In the very beginning it was sort of hero worship." [3] Although she never admitted it—and had a good number of boyfriends—Jinx was infatuated with George. With her, Rodger could play the experienced Pygmalion with no responsibility. Jinx delighted in the role of the ingenue and couple's friend, toting her suitcase full of baby clothes and a copy of *War and Peace*.

From Paris, Jinx and George drove to Brussels along back roads. Rodger became wistful as he recounted stories of the liberation of Brussels, now five years in the past. From Brussels they retraced the route that Montgomery's forces had taken to the Battle of the Bulge. Road signs in German were still standing. The roads were rutted and marked with deep potholes, lined with small shrines erected by the families of soldiers.

They passed Mulhouse, Bâle, and Lucerne, then drove over the Alps through Andermatt to Locarno and the Lago Maggiore. They stopped for the night in Argegno at the Belvedere, a beautiful hotel with views of the Lago di Como. There was a garden of camellias and magnolias, whose perfumes wafted through the open windows. George and Jinx had booked a single, very large room with two beds. At night they both wrote furiously—Jinx on her Olivetti, Rodger on his Remington—letters and diary entries.

They traveled well together, it turned out. Jinx was practical and open-minded and loved to entertain George with conversation as he drove. She was curious about her surroundings and bombarded him with questions. Her wicked sense of humor matched his, and her observations on Capa, Chim, and her boss John Morris were entertaining. Still unsure of herself, she was an attractive mix of liberated American woman and minister's shy daughter. Rodger found himself dazzled by her alternating declarations of independence and moments of submissiveness. To him, this easy intimacy with Jinx was alluring and of course frightening. For the past ten years he had lived his whole life for Cicely, or the idea he was forming of Cicely. Still, Jinx's admiration for him was so pure and unaffected that he could not help being moved.

Furthermore, Jinx was a lovely brunette with shapely legs, a pageboy hairdo, arched eyebrows, and an upturned nose. Her matte skin was lightly freckled, and

her slanted hazel eyes had a mischievous glint. Except for bold-red lipstick, she did not like to wear makeup; except for a silver pendant, she wore no jewelry. Rodger taunted Jinx about her preference for traveling in Levis, which he thought "perfectly ghastly."[4]

On July 24 they parked the Hillman at a garage on the outskirts of Venice before boarding a gondola for the Regina Hotel. The next day, "Minxie" was hauled aboard the *Campodoglio* bound for Limassol. Jinx noted that "George has been quite tense and worried but intent on not showing it. He is becoming a father in six weeks, has money worries and they don't have a place of their own yet."[5]

Jinx was unaware that a few days earlier, Rodger had sent Cicely a letter in which he ostensibly asked "permission" to share a cabin with Jinx. Of course the travelers would be already at sea before any answer could come. The letter is heavy with various indiscretions:

Sweetheart may I please have your permission to live in sin?—only for a few days!! When I picked my tickets from Venise to Limassol on the *Campodoglio* I found, as the boat is bound for Haifa, I was crowded into a six-berth cabin along with five mid-European Jews. Jinx was the same with five female varieties of the same species. I just couldn't take it. It would be awful. So I got the tickets changed for a three berth cabin which we can have to ourselves thinking the moral dangers of sharing with Jinx would really be much less than the psychological reactions of sharing with five Polish Jews. It is perfectly bloody. I haven't told Jinx—don't know what she'll say! She'll just bloody well have to lump it. It shouldn't really be too bad as there are bathrooms for washing etc. and we can always make our own arrangements about dressing in turn or something. Can't do these things without telling my Poodle first and I'm sure you won't mind for, come hell or high water, I'll stay in my own bunk!! What a waste though, a trip like this, without you. O Precious I do love you so much. Last night when I went to bed I could feel you in my arms and I kissed you in my mind over and over again. But when you get this my Darling, I'll be on my way—it is less than three weeks now. Bye bye my Precious and look after yourself.

 Lots and lots of love—George.[6]

This mix of anxious sentimentality, insincerity, and anti-Semitism is especially unpleasant in view of the fact that those very "mid-European Jews" bound for Haifa, with whom Rodger could not stand to share space for fear of "psychological reactions," were camp survivors en route to their new land. This was only

four years after Rodger had been a firsthand witness of the mass killings of the Jews at Bergen-Belsen.

Although he did not admit it to himself, to Jinx, or to Cicely, Rodger of course wanted to be as close to Jinx as he could without breaking his moral code. In his letter he was using the Jews (whom he knew Cicely disliked) as an expedience, to justify his own decision to share a cabin with Jinx.

As representatives of the English and American press, Jinx and Rodger were assigned a three-birth cabin and upgraded to first class. From Venice, as they sailed toward Bari, they saw dolphins at play in the Mediterranean. During the trip, in the course of endless conversations, Rodger let go of the pretense that he was an ideal husband in a picture-perfect marriage. Loosening up, he confided to Jinx his worries. With some satisfaction, she noted in her diary: "I finally got G. R. to talk about his problems."[7]

He loved Cicely and very much wanted to have a family with her, yet his romantic feelings for her had for much of the time been fueled by separation and absence. He had spent most of the past ten years on his own; lately, especially since the beginning of Cicely's pregnancy, he had been having problems maintaining a daily intimacy. He felt cooped up and restless, and he did not know what to do with himself when he was not working. And though he had placed himself in that role, he was growing tired of being forever the chivalrous knight. He longed for a companionship that would allow him to relax.

He confessed to Jinx that he was terrified by the prospect of becoming a father; he dreaded the thought that he might somehow be as bad a father as his own had been. He also did not know if he was ready to change his way of life, to give up his freedom of movement and his constant travels. And there was no way he was going to admit these feelings to Cicely.

A few weeks later, in a letter to Jinx from Cyprus, Rodger was feeling ambivalent if not downright scared at having confided in her. He even tried to dismiss the whole episode as unreal:

It is so seldom one can stand knowing a person really, really well. The fact is, for ten whole days my defences were completely down and I talked too bloody much. . . . A month ago we were together on the shores of Lago di Como. Was that another life or only a strange interlude? Maybe only a dream. In the long days ago, before Le Havre, I was just a mythical figure to you—a figure of fantasy built up over vast distances by the medium of a letter or two. . . . But now you have seen deep into my mind. You know all of these little faults and weaknesses which normally one keeps hidden, and, I can assure you, nobody but you has

ever been expected to endure such a revealing insight to my somewhat tangled soul. The thought scares me now and I hope I have not shattered an illusion.[8]

If Jinx was the only person to have looked into Rodger's "somewhat tangled soul," we may wonder what his intimacy with Cicely was based on; it would seem that he had spared her any real view of himself.

In early August, Rodger and Jinx disembarked from the *Capodoglio* and were met by an overjoyed and very pregnant Cicely. Jinx immediately felt at home on Cyprus: with its pastel buildings and whitewashed villages, it reminded her strongly of her childhood in the Middle East. George moved into the rented house with Cicely; Jinx stayed with George Kirziz. Jinx and Rodger went house hunting and soon found a small, old Turkish house that Cicely and Rodger could afford. It was surrounded by almond trees and had a small outbuilding that Rodger could use as a studio. All in all, it was perfect. He designed a cupboard, a table, a bed, and a set of shelves to be made by a local carpenter, and bought a stove in Limassol. A young maid, Katina, completed the arrangement.

In mid-August, Jinx sailed for Beirut for two weeks' traveling in the Middle East. She wanted to see her birthplace and her childhood landscapes and to travel some more in Europe before returning to her job in New York.

On August 21 the Rodgers settled into their new house. His inspiration sustained by a few bottles of ouzo, he began writing the text and captions for his Kordofan pictures. Cicely bustled about, arranging the nursery next to their bedroom with all the clothes that Rodger and Jinx had brought with them. Rodger designed furniture for the nursery and gave the room a fresh coat of paint. Everything was ready for the baby.

Now that George was back, Cicely's morale rose, but still she complained of dizziness, headaches, and blurred vision. Her legs were very swollen, and she was anxious for the baby to arrive. She also missed Jinx's companionship. "We both miss you an awful lot," she wrote to her, "and I do wish you could have been with us to move into the new house. . . . We are counting on you coming back next year and really staying with us. Anyway you have to come to meet Junior. We insist on that."[9]

The baby was now way overdue—by three weeks—and George and Cicely enjoyed their unexpected free time like a honeymoon. In a letter Rodger later wrote to Cicely's sister Dorothy, he described their evening strolls:

> The shadows of the pinetrees lengthen and everything is touched with gold and a great stillness comes over the world so one dares not speak. We used to walk

home hand in hand through the pine-woods over a thick carpet of pineneedles. I thank God for the three weeks that the baby was delayed. They perhaps were the happiest weeks of our married life. There was so much to look forward to and so much to discuss and, as we were all alone up there, there was nobody else to disturb our thoughts of one another.[10]

On October 2, Cicely felt the first strong contractions of labor and her water broke. George drove her to the hospital in Amiandos. The labor began normally, and by the next morning Cicely was close to giving birth. But suddenly she was seized by extremely violent convulsions. The baby, a little girl, stopped breathing as a result of them and came out stillborn.

"This must be a sad letter," George wrote to Jinx, "as our little baby girl was born dead. It was perfectly all right up to the very last moment and two more minutes would have seen it born safely. But poor Cicely suddenly got convulsions and it was then that the baby died. O God how can I tell her. She is too weak to know now and I shall have to tell her."[11]

White-faced, her body still swollen, Cicely was drifting in and out of consciousness. She had a high fever and was delirious. For seven days George sat by her side, hoping she would survive. To add to his nightmare, the doctor had told him not to break the news of the baby's death to her; Rodger had to pretend that the baby was alive and that he was sending out cables and birth announcements to their friends. The doctor told Cicely that she was too weak to nurse and that they had found a wet nurse in the village, so she could not see the baby right away.

For a day or two, Cicely improved. She was able to sit up and even do her hair. They chose the baby's name, Sally Ann, and discussed who would be godfather and godmother. The doctor and Rodger did not tell Cicely she also was in mortal danger. Rodger remembered that week as one of the worst of his life. He was traumatized, frozen inside by shock, yet he managed to maintain his stiff upper lip and keep up the charade. He later wrote to Cicely's sister:

If only I could have taken her in my arms knowing that she had little chance to live and just held her to me, but I couldn't do that because, if I cracked for a split second, she would have known there was something wrong. I had to be natural and make little jokes to amuse her. . . . I'm sure she had no idea of the danger she was in. . . . When I think of that wonderful light she had in her eyes when she spoke of her baby, I just want to shoot myself for having to lie to her. Sometimes I think I am going crazy and then I get all cold like I was at Belsen when I sud-

denly found myself thinking of the dead only as photographic compositions and I think I must be inhuman.[12]

On October 10, at dawn, Cicely drifted into coma and died of internal bleeding and acute kidney failure. She had a rare condition called eclampsia, which most often strikes women in their first pregnancy. Even fifty years later little is known about this condition.[13] It is rarely fatal; that being said, better care would not necessarily have saved her. Perhaps early detection of her illness might have helped. Had it been, she would have spent her last trimester hospitalized or at least carefully monitored. Her delivery would have been assisted with antiseizure drugs.

Rodger was undone. "I was forty," he wrote, "and for the first time darkness clouded my world."[14]

For the next two weeks, Rodger stayed with friends in Limassol. He was unable to go back to their house and face the freshly painted nursery, the cupboard full of Cicely's clothes—an evening dress made from a sari he had bought in India and that she had never worn; a gold brocade evening jacket bought in Banaras; all the finely embroidered baby clothes that Cicely's family had sent.

He was deep in shock. The man who had seen it all through sixty-two war campaigns—who had lost many friends in battle, more than once barely escaping their fate, and who had been surrounded by death—had never thought it could strike in his private life. He had always kept the horror of his work separate from his home; he had always shielded Cicely from the most gruesome aspects of his professional life; he very much needed the personal and the professional to remain separate spheres.

But death had not respected the line he had drawn so carefully, and it hit him now at the core. He felt that Cicely's death was his fault: if she had been in a London hospital, he told himself, she might have been saved. Cicely was in fact aware that eclampsia, a hereditary condition, was common in her family: her mother, grandmother, and great-grandmother had all suffered from a milder form of it.[15] But she had never spoken of it, nor had she acknowledged the possibility that she herself might have it. Whatever her reasons, ultimately Cicely's silence may have contributed to her death.

Rodger's friends were quickly alerted, and letters and telegrams poured in at the Limassol post office, from George's parents, Cicely's mother, Joan Bush, Capa, Chim, Cartier-Bresson. Many of Rodger's male friends seemed like him unable to express their feelings openly, and quickly retreated to the safer professional realm. Kip Ross of *National Geographic* wrote:

You have my deepest sympathy and if there is anything in the world I can do, please let me know. . . . Just after settling up the Nuba story I had to take off on leave and I have not had the opportunity to write you about it. I did my best to get the maximum price for your pictures here, but as you know we do not generally pay quite as well as *Life*, for instance. Nevertherless, I hope you are satisfied with the transaction, and I know you will be well pleased with the presentation of your pictures, which will appear in our January issue.[16]

In the same vein, John Morris confessed: "I am no God-damned good at writing at times like this."[17] Elizabeth Reeves of *Magnum*, Marcelle Legros of the *Herald Tribune*, and Allan and Barbara Michie all wrote warm, heartfelt letters, using the same terms about the deaths: *cruel, savage, purposeless.* In November, John Morris was finally able to reach Jinx at her parents' home. Profoundly shocked, she hurried back to New York, where she found a telegram and several letters from Rodger.

Even though his friends begged him to leave Cyprus and come to Paris, London, or New York, Rodger stayed alone in Limassol until mid-November. He could not bear to leave. It would feel like he was abandoning Cicely.

There were times, early in the morning or late at night, when he felt more at peace. But generally he was restless, fearful, jumping at every noise or movement. He did not feel like eating, and he was drinking too much. He could not work or even read, and he made no entries in his diary. He paced the rooms of their little house, surrounded by Cicely's clothes and possessions, or he went for walks in the hills.

He did not want to send the bodies of Cicely and Sally Ann to the family plot near Hannington Hall. It was as if he did not want to share the death, and his grief, with anyone. He felt that Cicely and Sally Ann belonged here, on the island where they were to start their life as a family. Kirziz helped him secure two plots side by side in the small village cemetery, overlooking the sea and circled by a wall overgrown with wild roses. Later on, simple marble plaques and crosses were raised. Rodger covered the stones with white dahlias from the doctor's garden in Amiandos.

He moved from shock and disbelief to anger and guilt. No one seemed able to reach out to him: he was inconsolable, lost on his own plane of sadness. His entire world had come to a halt.

Rodger never was able to complete his mourning; for the rest of his life he would remain stuck to his memory of Cicely by a powerful mixture of pain, self-hatred, and grief. For the rest of his life he would blame himself for her death. He had been unable to protect her, and this to him was unbearable. On his worst

days he even doubted that he had ever made her happy. In later years, around October 10, he would stop communicating with everyone, shut himself up in his room, and break down all over again.

A few days after Cicely's death, he wrote her a poem:

> Speak to me, Darling,
> in this deep, dark hour of night.
> Speak to me in the stillness of this
> last hushed hour before the light
> of day, like a silver blade, strikes
> to cut me from my fantasy.
>
> Let me hear you speak.
> Softly, my love, until
> in your nearness time itself is still.
> Speak to me. Tenderly,
> and, with your lips so close to mine,
> your words might weave a web
> around us; bind us into one;
> one thought; one entity.
>
> Then let me lie,
> your voice around me and your hand in mine,
> in quiet ecstasy until the time
> when, once again, I fight
> to hold you back against the day
> which, unrelenting,
> drowns you in its light
> and leaves me nothing
> but the cold, damp, greyness of reality.[18]

Cicely died before their real life could begin. As he had wished in his poem, Rodger remained bound to her as "one thought, one entity." He could not let go, he could not live in the "greyness of reality."

Rodger would remain bound to Cicely for the rest of his life; he was fused with a ghost that would not let go of his soul. He refused intimacy more firmly than ever. His unresolved grief diverted a large part of his emotional energy away from his work, which from this point lost some of its energy and generosity. He constructed for himself an idealized past, an idealized Cicely, an idealized life they might have had together.

Peter Rodger, the youngest of Rodger's three children from his second marriage, still remembers twenty years later that when he was sixteen, Rodger took him to Cyprus to see Cicely's grave. Peter told his father: "You should take care of the living rather than the dead."[19] But Rodger could not. His second wife would find in Cicely the worst sort of rival: one that could not be reached and against whom she was helpless, a shadow of crushing weight that could not be lifted.

15

New Beginnings

FALL 1949-AUGUST 1951

On November 10, Rodger left Limassol for Genoa aboard the *Kedma*, then continued to Paris, where he took refuge at the Magnum office. He was living one day at a time, with no plan. Joan Bush, a friend and an editor at Magnum, suggested he help with the office filing, labeling and classifying negatives, captions, and contact sheets. She hoped the mindless job would take the edge off his pain. Chim and Capa knew someone who was good at repairing and overhauling equipment; Rodger's cameras surely needed it after four years of travel in African climates.

Capa was always hiring enthusiastic young professional women for the Magnum office; that is how Rodger met Inge Morath, who had been an editor and researcher at *Fotografie* and *Heute*, and whom Magnum had just hired as an editor. Morath, who would later become a renowned photographer in her own right, has vivid memories of Rodger from that period. Obviously, he was sad, but perhaps most striking of all was his inscrutability. "He remained an enigma," Morath recalled. "You could not really know him. He would not let himself be known." [1]

Morath found Rodger to be a handsome man, "not unvain," but rather reserved with women. She also noted the strict division in his personality: "There were two sides to his character. He was this very British man with a stiff upper lip and a special sense of humor, but he could also be very generous. . . . In some ways he was kind of sad, in others he enjoyed life." [2]

The atmosphere at Magnum in those early years was heady and companionable. Morath recalled:

[It] was a period when everybody had time to look at everybody's pictures. Rodger looked at [Ernst] Haas's pictures of Africa. I looked at [Rodger's] contact sheets. His sequences in pictures were also very good. The whole thing of shooting a sequence was very much in the air. You had to do your "package stories" every night; it was a lot of work.

But even at that time, when he was very sad, George always gave out a feeling of protectiveness. . . . George didn't necessarily commit himself but he was encouraging and he was somebody you felt comfortable with.[3]

Morath sensed that Rodger could not really engage in relationships, could not let his guard down, that his emotions came out only indirectly in things he could not control, such as his resonant voice, full of emotion—"a warm voice, very peculiar, very vibrating, unexpected coming from him."[4]

Rodger decided to visit Allan and Barbara Michie in London. "George came back from Cyprus and telephoned," Barbara Michie recalled. "He was in tears. . . . He told us the whole story. That's the only time when he was not reticent. We did not know what to do to help him."[5] Perhaps because he did not feel he had to keep up appearances with the Michies, Rodger experienced a breakdown with violent migraines.

He had lost all confidence in his work. He was sure everyone had forgotten about him; he would have given a great deal for just a portion of the fame he had rejected in the summer of 1942, when people were recognizing him on the street. Allan Michie proposed a trip to New York for a joint assignment, and Joan Bush encouraged Rodger to go:

I would say that your reputation isn't so much "sadly lost" as sort of clouded over with various desert dusts—you are a little out of touch—you and your photography just now. You have been away so long and one has to face the fact that editors just don't seem all that interested in far away people and how they are living—unless some "modern" happening brings them into the limelight. Thus with a trip to the States, you will be able to pick up contact with the US editors . . . and later bathe in a joint glory when the editors begin to remember that George Rodger is back in circulation and producing good stuff. . . . I'm sure after you've broken the back of that first story, that though it won't be plain sailing, it should be a bit smoother and smoother still as you go on.[6]

Michie got them two assignments for the *Weekly Illustrated*, and they arrived in New York toward the end of February. Their first story, "Mr. Congressman Goes to Washington," focused on Congressman L. G. Sassur, whom they followed for a week, covering his life in Washington and his travels to his con-

stituency. Sassur was involved in the Atlantic Pact, which would have a strong impact on Britain's future. The other *Illustrated* piece was on the Empire State Building. Rodger focused on the visitors to the 102nd floor, pictured against a vista of skyscrapers. The images are not in Rodger's habitual style—he usually faced people directly, and back shots are very rare in his work. It is almost as if he could not bring himself to photograph directly and openly.[7]

In New York, Rodger regained a measure of professional confidence. He also began seeing Jinx on a regular basis:

> I saw a lot of him then. He was lonely. . . . Most weekends he spent with Dorothy [Cicely's sister] but we saw each other during the week. He said, "I would like to go some place warm. Why don't you come with me and help me on a story?"
>
> I got a leave of absence from John Morris to go to Haiti with him. . . . It was the first time we were working together and our collaboration went very well. I did the research and captions, I carried the cameras. We did a story on Haitian artists, and one on voodoo. We did not have an assignment but Magnum got the stories published in various magazines.[8]

Haiti was a convalescence of sorts for Rodger. He did not photograph very seriously, but he enjoyed the scenery. In the profusion of flowers—frangipani, flamboyants, poinsettia, and hibiscus—and the depths of the forest, he found an echo of the African and Burmese jungles. But he also felt at a remove from life, and incapable of relating to the latest news from Magnum relayed by their friend and colleague Maria Eisner. "It seems so ridiculously unimportant," he wrote, "whether or not we pay for the whole floor at Magnum, whether Hans Habr lives up to his contract. I think the lizard is laughing at me."[9]

Rodger had always relied on work to give him direction. He had lived for and through work, often relating more closely and strongly to his subjects than to any friend. But for perhaps the first time in his life, he was unable to motivate himself.

Jinx sensed his unease, and it only drew her closer to him. "It was in Haiti that I really fell in love with George," she remembered. "In Venice it had been infatuation."[10] She was writing regularly to Morris in New York—he was to her a surrogate father of sorts. He wrote back: "I am delighted that things have worked out for you so that you can work together. Without sounding paternal, my advice to you both is forget ECA [Economic Cooperation Administration, a potential client for Rodger] and concentrate on the story, the big story, of your own lives. May it go happily."[11]

At the end of March, reluctantly, Jinx flew back to her job at *Ladies' Home Journal*. Rodger went on to Kingston, Jamaica, at the invitation of a former girl-friend, Rhoda Jackson. "He had known her when he was in London working for the BBC and she was an art student," Jinx recalled. "She became quite a good artist and she was a lovely person. George was always full of women!"[12]

Just as he had written to Cicely about Jinx, Rodger—ever the provocateur—was now recounting his adventures with Rhoda in letters to Jinx, written first from Kingston and then from a mountain inn where he was staying with Rhoda. He seemed to flourish in love triangles; this one served both to provoke Jinx and to prove his independence.

After two weeks in Jamaica, Rodger returned to Paris, where he had rented a small flat just outside the city, in Sèvres. That summer he did several jobs for the *Weekly Illustrated* and traveled to Italy on a magazine assignment to photograph gardens in full color. When he arrived on the shores of Lago di Como, his memories of happier times returned with the clarity of photographs, flooding him with unbearable emotions, which he shared in letters to Jinx: "I could see Cicely looking through the window at the Dents du Midi with the early-morning sun shining out on its snowy peaks making them pink and gold. And then there was the little restaurant by the water's edge where we used to sit of an evening to watch the sun go down again. Every detail I could remember—the very table where we sat and what we said to one another."[13]

But Jinx too had been to Lago di Como with George, and for the first time he acknowledged—albeit somewhat cagily—how attracted to her he had been while they were traveling together to Cyprus:

> That second bed in my room . . . ought to have you in it. As I said in my other letter I have the same one I had before, and the one beside me looks terribly empty. Always of course, night and day, it is Cicely whom I look for—whom I see in my mind's eye—and so, being here in this little room that you and I shared, I am more than ever glad that there are no pangs of conscience connected with it. If we had not behaved ourselves and I had let Cicely down, I would never be able to face it again now.[14]

Rodger was weaving together past and present, as if he could only tolerate moving back into life by binding Jinx to Cicely, the living to the dead.

Was George in love with her? Jinx was not sure. She was weighing her options and deciding whether to stay with the *Journal* in New York or move to Europe. She realized she had her heart set on someone who was mired in a confusion of feelings—grief, regrets, guilt, desire—and she did not quite know

what she would find if she joined him in Paris. There was a dim possibility of an opening at the Magnum Paris office. George was waving in front of her all sorts of possible trips with him, but none of them definite: "There is a lot of work to be done around the Middle East. The thing is if I am in Greece or Turkey or Persia will you come to meet me there? We'll go on into Africa, if we can arrange it. . . . I know it's too vague to decide now. But bear it in mind and keep it to yourself. Nothing to John, Maria or anyone in Magnum. Keep your plans to yourself." [15] Jinx wondered—what plans?

Joan Bush, who had been both an office manager and an editor, was quitting her job at the Magnum Paris office. Rodger told Jinx that Maria Eisner had thought of her as a replacement but that he had refused the job in her name—allegedly because he would not wish such a job on anyone. Finally he came to the point and admitted why he was waffling: he did not want Jinx to take *any* job, he said, because he wanted her all to himself:

> I do hope all the time that we will be able to arrange things so you can work with me as you did in Haiti. Any job, either at ECA or with Magnum would exclude that, so you see, I am personally biased. I have so much back work that could be rehashed and re-edited that I am sure you could make a full-time job of looking after me alone if you were to come at the end of this month instead of the middle of October. I will let you know as soon as there are definite plans regarding Turkey and Iran so you'll be able to cancel your passage on the Ile de France and take a ship to Beirut.[16]

"I might have been slightly confused at the other end," noted Jinx. "He did not know what he wanted. Companionship? He wanted everything from me, I think." [17]

Finally, Rodger had come out and said he needed Jinx and wanted her with him. But he never used the word "love": "You can move in any time you want and look after the place, and look after me, and look after everything if you want to. I would be honoured. As a matter of fact you are the only person in the whole world whom I can stand in large doses . . . I've often wondered about this and I know that you have too—why is it that you should be the only person now with whom I can be perfectly natural?" [18]

That letter—in which George comes across as lost, vulnerable, and needy—might just have persuaded Jinx, although he had promised nothing more than to let her "look after" him. Shortly afterward, she resigned from the *Journal* and, at the request of Capa and Maria Eisner, joined the Magnum office in Paris.

There was plenty of work to be done, it turned out, but the salary was terri-

ble—most of it paid in invitations to restaurants. Jinx could not afford rent and had to share an apartment with a German friend named Traudl Feliu (who later became Magnum's European editor and the wife of photographer Erich Lessing).

Then a former boyfriend of Jinx's, Norton Wood, who had become head of the Economic Cooperation Administration in Europe, assigned Jinx and Rodger the job of covering the reconstruction of polders in the Netherlands. The ECA had been created by President Harry Truman to aid postwar economic reconstruction in Western Europe. In June 1947, Secretary of State George Marshall had announced a plan to provide economic assistance to all European nations that were willing to help draft a program for recovery. The American aid stemmed from humanitarian concerns, but also from fears that Europe would become a permanent drain on the United States if it did not rebuild quickly. In April the U.S. Congress approved the creation of the ECA, the agency that would administer the Marshall Plan. Over the next three years, the plan channeled more than $12 billion of American aid into Europe.

Rodger left for the Netherlands first. As soon as he was there, he wrote to Jinx, expressing his fears, stressing their age difference—he was forty-two to Jinx's twenty-four—and begging her to reconsider: "There is not a sensible reason whatever that you should sacrifice the smallest part of your life or your future on my accord. You are so generous and so kind-hearted that you'll probably say you don't agree but do, Jinxie dear, please try to consider how helping me will affect you yourself. Will you try to take that into consideration when you make your decision?"[19]

It was too late. Jinx was already on her way to their first European assignment and to what would be, for better and for worse, the rest of her life with her hero.

Perhaps sensing that Rodger was the stern type and might drive her with an iron hand, Jinx had plenty of fun on the boat to the Hague—parties, dances, banquets, and music. "I did have to let down a little towards the end however," she wrote to John and Dele Morris, "for I received a cable the night of the Captain's dinner which read: 'Essentialest you arrive unhungover stop work begins again in Rotterdam signed George.' "[20]

On October 9, pacing up and down, wrapped in coat and scarves against the bitter cold, Rodger was at the dock, ready to go. For the next two weeks they explored the entire country, George photographing and Jinx doing research, interviews, and captions. Their main assignment was covering the mega-project of draining the Zuyder Zee and building a new dike to keep the North Sea at bay. In a region called Northeast Polder, all that had been sea five years earlier was slowly being transformed into farmland. Jinx wrote:

By the time we finish this extensive story, I'm sure there won't be a dike, bridge, government office, school, church, windmill, or Dutch cheese market that I missed seeing. . . . We are continually on the go from early morning until late at night. It is the best thing for George, because you know what this week means to him. . . . He got through the first anniversary of Cicely's death quite well; somehow I feel he's going to pull out of his grief and begin enjoying life once more. Of course it isn't all easy and there have been several very bad moments—but I wish you could see the improvement. . . . And he's even begun to enjoy the idea of returning to Africa.[21]

Truman had decided to extend the Marshall Plan to assist underdeveloped countries, and Norton Wood wanted to send Rodger and Jinx off to West Africa for six months. Rodger was expected to photograph Marshall Plan projects and achievements. His pictures would then be published in American magazines to show the public how well their tax dollars were being spent. At first Rodger balked at the idea: he hated to photograph with an agenda. The only time he had felt good about doing it was during London's Blitz—but that had been for a cause in which he believed. He expressed his ambivalence in a letter to Eisner: "I'll have to go through with it and make a success of it for Woody's sake though where I am to find the material to work on I don't know. I hate trying to prove something that doesn't exist and laud an ideal with which I have no sympathy. . . . If there is anything to photograph in Africa with ECA angles we shall find it but it is a cockeyed assignment."[22]

Meanwhile, in Paris, Magnum was growing: Capa had taken on two new members, Ernst Haas and Werner Bischof. Magazines were eager for stories, and Magnum had begun to acquire a strong reputation for its work, such as Cartier-Bresson's coverage of India around the time Gandhi was assassinated and of China during the Communist takeover. Bischof would soon be reporting on the famine in Bihar, providing stunning pictures that would move the Truman government to send aid to India. Capa and Chim did powerful stories on Israel's first steps as a nation and on the arrival of new immigrants at Haifa.

By this time, Capa was working both as a photographer and as a "packager of stories."[23] He came up with a new one on a large scale—one that would capitalize on the success of the "People Are People" project. "Generation X" was to be a story about children coming of age after the war. He sold the idea to *McCalls*, which provided a handsome advance. Then, determined that the entire project should be handled exclusively by Magnum, he proceeded to hire new stringers: Eve Arnold, Dennis Stock, and Erich Hartmann. Erich Lessing, an Austrian

photographer with Associated Press, was recruited by Chim. There were now ten photographers working for Magnum under Capa's direction.

Rodger's main motivation in accepting the ECA assignment may well have been the possibility of doing a "Generation X" story on the side. Jinx of course was thrilled at the prospect of discovering for herself the continent that she had read so much about in Rodger's letters. But the trip would not show her the romantic Africa of her imaginings. What followed instead was, for her, a short course in the worst aspects of African politics. Rodger, for his part, would remember it as one of the most frustrating half-years of his life.

Between early December 1950 and late May 1951 they traveled nonstop by jeep, truck, or caterpillar tractor, from the Congo to French Gabon to the French Cameroons, Senegal, Niger, the Ivory Coast, Togo, Dahomey, Chad, Ubangui-Chari (now the Central African Republic), and the Portuguese territories of Angola and Mozambique, following an ECA-approved itinerary that had been reproduced before they left in fourteen carbon copies.

Almost everywhere they went, they discovered that ECA money earmarked for modernizing Africa was being squandered. Roads were being built without any planning. Equipment was rotting on beaches because no one knew how to use it and there were no spare parts. And a large portion of the American aid money was being spent on imported luxury goods for local bureaucrats. As an added difficulty, the Rodgers were unwanted and often treated with suspicion by the government officials on whom they depended. They were seen not as journalists but as American spies sent to expose corruption.

More often than not, the trails they followed were punctured with elephant footprints four feet wide. Sometimes it took them five hours to drive seventy miles. Covered with *potopot* (a glutinous mud), and tormented by mosquitos, beetles, ants, and fleas, the travelers also had to contend with humidity so high that exposure meters gave out. It was like the Burmese jungle, but duller. Rodger wrote to Wood:

> The dampness here is the worst I have ever encountered. Each morning I have to clean the mold from my cameras. Shoes get green with it overnight, likewise my wallet, briefcase, anything made of leather . . . I fear very much for the film emulsion. . . . I'll have restless nights until I get a report on this shipment from Magnum. If it's affected and we don't get a story after all we've been through, I'll be ready to quit. We have to work like hell and test our physical endurance to the utmost for very, very small returns in terms of achievements.[24]

On Christmas Eve their journey touched bottom. They had gone for a three-day work trip to the interior of Gabon to photograph the building of new roads, and returned to Libreville to find not a soul around. The governor's apartment was locked and the *chef du cabinet* had disappeared. In a letter to John and Dele Morris, Rodger described the bleak scene and then remarked wistfully: "It is a little difficult to imagine that this should be Christmas—stranger perhaps for Jinx than it is for me. I have known it before—the feeling of loneliness, of being out of touch and forgotten and everything rotting around one."[25] Rodger and Jinx spent that Christmas plucking ticks off each other's skin with tweezers and placing bets on the giant cockroaches that were racing in pairs across their room.

There was nothing to redeem the bleakness of this assignment, no cause to justify the discomfort. Rodger was feeling like a charlatan, sick of being ECA's mouthpiece. In a letter to Wood he confided: "This is about the toughest assignment I've ever had in my life."[26]

On January 12, by French plane from Libreville ("Air Chance" was the local nickname), they sent out a three-thousand-word essay with films and captions. It had taken them six weeks to complete what should have been a fourteen-day story.

Jinx, too, was disenchanted. She wrote to her parents:

Africa . . . where news of the outside world takes over one month to reach the bored ears of the government officials. . . . Where garbage, refuse, kegs of wine, and shipments of machinery are left to rot along the beaches. Where the natives are slowly dying off from the effect of alcohol, venereal diseases and sleeping sickness. . . . Since writing you last week we have still received . . . no news at all from the outside world. For all we know, ECA might have completely packed up, the Chinese might have conquered the whole of the Far East, and the entire Magnum office might have moved to Timbuctoo.[27]

On January 19, Rodger and Jinx took a break in Port Gentil. There they received an invitation that lifted their somber mood: Dr. Albert Schweitzer, who ran a model hospital for lepers in Lambarene, and to whom they had written earlier, asked them to come and stay with him. Schweitzer was hoping that published stories would help him raise much-needed funds for his hospital.

Three days later they started for Lambarene. Schweitzer dispatched several dugout canoes to pick them up, rowed by leper oarsmen. The seventy-six-year-old doctor wore a helmet and a tattered but spotless safari suit. He had piercing blue eyes, a crooked nose, and a heavy white mustache. He greeted them with a

resounding *"Bienvenue, le Plan Marche Mal!"*[28]—which dissolved in laughter some of their frustrations of the preceding weeks.

Schweitzer, by then already quite famous, spoke only French and German. Jinx and George's French was halting, but the three of them nonetheless hit it off immediately. They admired the dedication of the hospital staff, who worked in primitive conditions for pitiful salaries and never complained. Schweitzer was treating not only lepers but also victims of typhoid, malaria, tuberculosis, venereal disease, sleeping sickness, and elephantiasis—a veritable catalog of Africa's ailments.

Lambarene functioned as a kind of secular monastery, with the doctor as abbot. Knowing that his patients would be put off by a modern, gleaming white hospital, he had designed quarters that resembled their own villages, where they would feel more at home. The wards were rows of small tin or bamboo huts with an operating room at one end. Patients brought their entire families to Lambarene to live with them. There were only two doctors and fifteen nurses. Because there was no electricity, nighttime operations had to be performed under a hurricane lamp.

Schweitzer kept a vegetable garden and an orchard, which meant that for the first time in months, after surviving mainly on canned goods and luxury items imported from France, Rodger and Jinx had fresh fruit and vegetables to eat and even goat's milk to drink. Along with the goats Schweitzer kept many other pets, such as a blue-faced monkey, talking parrots, and two enormous pelicans that slept on their veranda. In the evenings, Schweitzer played Bach on his organ; after dinner he read passages from the Bible. During their two weeks in Lambarene, Rodger shot beautiful black-and-white portraits of Schweitzer, whom he followed on his daily rounds.[29]

Rodger also photographed a story on one of the nurses, a twenty-three-year-old Swiss girl named Trudy, who single-handedly cared for some 140 lepers. "The first time I saw a man afflicted with elephantiasis whose leg was 7 times the normal size," wrote Jinx to her parents, "I thought I might pass out. But now I have seen many. The lepers are even harder to take, but after working with Trudy for one full day, I can even face the saddest cases and the most horrible sores without flinching. It is terribly sad to see all these people—there should be a thousand Schweitzers—not only one."[30]

Rodger and Jinx were no longer despondent; they had recovered a sense of purpose. Perhaps being confronted daily with other people's very tangible miseries helped soothe Rodger's harrowing sadness and guilt. They found that even at Lambarene real joy could be found. Long afterwards they would remember

the mass they attended: the congregation sang a version of "Abide With Me" in creole while Schweitzer played the organ. The nurses conducted the service and gave a sermon in French, translated by two native chiefs. Black babies in sun hats, goats, chickens, parrots, Schweitzer's pelicans, and several mangy dogs completed the picture of this unconventional ceremony, throughout which half the congregation lay on stretchers or reed mattresses.

George and Jinx were growing closer, probably in part because they were each other's only support in these isolated and difficult circumstances. Jinx confided to John Morris: "Slowly he began to talk of the future and not so much of the past, and his future included me. Cicely is still George's great love as Dele is yours, but we have been happy together, and for me there never has been or could be anyone else."[31]

Sorry to leave Lambarene, but certain that they finally had a powerful story, Jinx and Rodger left for Brazzaville on February 4. From then until they left Africa in late May, they covered economic stories for the ECA. Rodger worked competently but with little enthusiasm, maintaining the ECA charade. They had been told that ECA had built a new port in Abidjan, but when they got there, there was no new port to be found. It was the same story in Conakry: $1.5 million in Marshall Plan money had supposedly been spent there to develop iron ore mines, but there were no mines to be found.

Where had the American dollars gone? If there was a story, it was the story of one of the biggest corruption scandals in history, and it could not be photographed.

By the end of their African trip, Jinx had decided she would spend her life with Rodger, and Rodger had not turned her down. But shooting pictures for a story that was often nonexistent and which, when it existed, he did not believe in, had made him bitter, and his dry wit had turned cynical. "My only consolation," wrote Jinx gamely, "is the fact that I wouldn't have seen Africa by any other means."[32]

When they landed in Paris on May 29, Cartier-Bresson, Chim, and Charlie Steinheimer (a Magnum stringer) were at the airport to greet them and help them fill a cab with their baggage, which included a collection of spears, poison arrows, solar *topees*, and walking sticks, along with fourteen cases of photographic equipment.

They were thrilled to be back. After a few days spent unwinding, they began looking over the seven thousand captioned photographs Rodger had taken in Africa. It was the first time he had seen them, and to his surprise, he saw quite a few that he liked. Some of them found their way into ECA brochures, a few into European magazines.

Soon after, they learned that the *Weekly Illustrated* was planning a big story on Schweitzer. As other good news followed, they began to lose the feeling that their African trip had been a black hole in Rodger's career: "Magnum informed me this morning that *Paris-Match* . . . has bought our Schweitzer story for 100,000FF. . . . And we will have the rest of Europe for distribution. So we ought to be making some money from the stuff soon. . . . Our diamond story runs in *Saturday Evening Post* sometime in August. *Holiday* may run our big Dutch story soon."[33]

But once again Rodger, who should have been happy about all the acclaim—more than he had hoped for—was knocked flat by depressions accompanied by migraines. Was he disturbed by his success? On June 2 he left for Brussels; Jinx joined him there a few days later. From there they traveled through the Netherlands, then to London and to his parents' home in Cheshire before returning to Paris, where Jinx worked on her text for the *Weekly Illustrated*'s Schweitzer story.[34]

In early July they set off for Strasbourg. Schweitzer was staying in his hometown for a few weeks and had invited them to visit. He was delighted with the prints Rodger brought him. Jinx, who was an excellent pianist herself, wrote in her diary: "No other photographer has ever been invited to come see him and spend the day taking pictures. I think the old man was so pleased with the pictures we took in Africa, that he is really anxious to have more. . . . The old man stepped into a soft pair of shoes, loosened his tie, then sat down at the [piano] bench. The next hour was one of the most memorable of my life. We sat at each side of him and listened at the world's greatest interpreter."[35]

Later that month, Rodger and Jinx went to Austria for a *Weekly Illustrated* assignment and a short vacation, then to England to join one of Rodger's Desert Campaign companions, Desmond Young. After the war, Young had made a name for himself with the screenplay for the film *Desert Fox*, directed by Henry Hathaway, with James Mason starring. Rodger shot stills for Young's new Twentieth Century Fox production *Ships Ashore*.

At the end of August, Jinx and Rodger parted: he went to London to work on some *Saturday Evening Post* stories (and to have a few of his teeth replaced), while she returned to Paris where she spent two months at the Magnum office, reorganizing files and editing contact sheets from Bischof and Cartier-Bresson. Rodger would be leaving in September for a two-month trip. He would start in Egypt, where he had been assigned a cover story on the Canal Zone. After that he had several more assignments lined up in the Middle East, where Jinx planned to meet him in November.

16

Dire Straits

While in Paris, Jinx went out after work or wrote letters to Morris, filling him in on the Paris gossip. When Capa was not in Paris wreaking havoc in the office, he was having a new love affair with a girl named Jamie and running around Europe. Chim had just left for Greece: "I'll never forget the day [Chim] took off, sad and pathetic, with his little camera bag strapped onto his back, and his shoulders hunched—all alone Chim, going off into the great big world. We were all sitting around the little bistro—and Cartier[-Bresson] said, 'There is no one in the world more happy than Chim when he looks so sad.' " [1]

Jinx flew to Amman to join Rodger. They began preparing a Christmas story for *Weekly Illustrated* called "Jerusalem Anno 1951." The concept: What would Christ find if he returned to the Holy Land today? It was meant to be a joyful piece with coverage of all the sites that had become important symbols to Christians around the world: the Via Dolorosa, the Gardens of Gethsemane, the Basilica, the Russian Church of Saint Mary Magdalene. But Jinx and Rodger could not come up with a postcard-happy vision of Jerusalem. Eight-and-a-half years after the "peace agreement" between Arabs and Jews, conflicts over the capital had hardly been resolved. In the center of the Old City, a road divided Jews from Arabs. The Jews could not pray at the Wailing Wall, and the Arabs had no access to Nazareth. It was a volatile atmosphere, not at all one of "peace on earth, good will toward men."

A visit Rodger made to Palestinian refugees in Beet Jibreen near Jerusalem had a profound impact on him. An entire village had fled from a zone near Jaffa

218

and had been living in a camp for the past four years. In that span of time the camp's population had swollen from 1,500 to 80,000. By that time Rodger had taken the side of the Palestinians—he had a deep need to find victims and side with them—even though in order to do so he had to ignore important aspects of the political situation. Appalled at what he was seeing, Rodger wrote to Morris: "Am I right or wrong in believing that there must be a conspiracy of silence in America designed to suppress all information from this part of the world that could in any way be taken as anti-Jewish?"[2] Rodger's facts were often skewed, his numbers often inflated. The official figure of 700,000 refugees became 900,000 in his letter. He argued erroneously that only 1.3 percent of Palestinians were nomads and that all the rest were professionals and small land owners; he stated that the Israeli economy was bankrupt; he exaggerated the communist peril ("Do you know that the headquarters of the Communist organisation and the source of all this anti-American propaganda is in Haifa in Israel.")[3] At the same time he decried American politics and the loans extended to Israel by America's "Jewish financiers"—without acknowledging that American Jews (and others) were trying to help people who were Holocaust survivors and did not themselves wish to resettle in Palestine.

While Rodger had been in the thick of World War II as a photojournalist, he did not seem to realize that all through the war, many Arab states had seen a German victory as a potential boost to their cause of nationhood. In contrast, most Zionists had sided immediately with the Allies and saw an Allied victory as improving their chances of creating a new Jewish state.

Jinx shared Rodger's conviction that the American press was controlled by the Jews. From Jerusalem she wrote to the Morrises:

> It is a very sad city, bombed, and crowded, and piled with rubble. The streets are blocked with tank traps, and there is barbed wire everywhere. Never in my life have I known such bitterness against a race as the Arabs feel now towards the Jews—and if you were here now, you would soon know why. The lepers now wander the streets for there are no hospitals for them. Families once of above middle-class, with education and respectability, now huddle together in a leaking room, sometimes nine or ten of them together. Hunger is all around us . . . But there seems no solution to the problem of *what* will happen to those million homeless people . . . What we are trying to do is to get an article published in the States—but we shall have the Jews against us tooth and nail.[4]

But after several weeks visiting refugee camps, Jinx acknowledged something that Rodger—who had faith in the Arabs—had difficulty accepting: Israel was

not entirely at fault. It actually suited most Arab governments of the region that the Palestinians were being confined to camps. The Palestinians could easily have been absorbed into the nations surrounding Israel; the political leaders in those countries feared the impact that tens of thousands of Palestinian immigrants would have on their own nations. They also knew that by taking them in, they would be discouraging the Palestinians from leading the fight against the Israelis. Far better to leave them in squalor near their homeland and foster their resentment. "Nobody wants [the refugees] around (including the Arab countries)," wrote Jinx. "And the U.N. itself is sick and tired of hearing about the refugee problem.' "[5]

With the help of the mayor of Jerusalem, Aref Pasha Aref, who had documents about the partition and was writing a history of the city, Rodger completed the text of his story, "The Damned Can Be Dangerous." Shortly afterwards he returned to Limassol. Since Cicely's death he had not gone back to Cyprus.

Jinx wrote her parents:

> I hope that the trip will bring him a bit of comfort instead of bringing back nightmarish memories . . . He has never been back to Cicely's grave, the fact that he can now means, I hope, that he has gone through the worst of the shock and pain. What will be difficult is that all his and Cicely's possessions are still in Cyprus and he will, of course, now have to do something about them . . . I only hope he doesn't break down again. When he returns I shall insist that we start work immediately on our next story so that he can get his mind quickly on something else.[6]

Although she remained outwardly cheerful, Jinx had moments of doubt and discouragement over Rodger's recurring depressions. They were still essentially friends and no more. She did not find with Rodger the sense of joy and romance that she craved—it was always work, work, and more work. While in Jerusalem she was courted by a UN worker named Max Scheller, who fell in love with her and immediately wanted to marry her. She was tempted by his urgency and romancing—she was not unattracted to Scheller and at some level may have been encouraging him. But the relationship conflicted with her loyalty to Rodger, who as she well knew needed her desperately. In the end she decided it would be unfair to leave him. When Rodger returned from Cyprus, feeling understandably low, he feigned indifference about Jinx's fling. In fact he was deeply jealous.

Rodger received a long letter from Capa, partly an update on Magnum's progress. He stated that the agency was "beginning to make sense." Capa had

traveled to the United States to coordinate the Paris and New York offices and to clarify the agency's relationship with magazine editors (whom he described as "stupid and scared . . . It takes five people to be seen at the same magazine before you can straighten out the smallest matter"). But in the end, Capa said, his trip had been "highly successful." He had sold his "Generation X" idea to *Holiday* magazine. He asked Rodger to photograph the life of a Transjordanian boy representative of his generation's aspirations in that part of the world. The story would run as part of a forty-eight-page spread, a joint venture by all Magnum members. Also, *Argosy* magazine was showing interest in Rodger's story on Glubb's Arab Legion, and both the *Weekly Illustrated* and *Look* were seeking color stories with news value.

But to Rodger's dismay, the bulk of Capa's letter was a forthright criticism of his work in the Middle East. The "Christmas in Bethlehem" story had arrived too late and was "too literary." *Life*'s editor, Ed Thompson, had rejected Rodger's story on the Palestinians, but, Capa argued, it was not turned down on political grounds: "The text piece, not because I am not in agreement with it, is the best example of what you should not do. No magazine will print editorial conclusions instead of reporting. Eighty percent of your text was ponderous, general and editorial in the sense that columnists are editorial. I know that you feel very deeply and if you wanted to put your point over, it should have been far more disguised—in facts, conversations, colorful bits and pieces, etc."[7]

As Capa saw it, the intensity of Rodger's feelings had served him well when he was dealing with indigenous people in Africa; but in politically loaded situations like that of the Palestinians, the same intensity was disastrous. Rodger had taken sides—something that according to Capa a journalist must never do directly.[8]

Capa also pointed out another problem in Rodger's piece: the relationship between pictures and text was unbalanced and lacked strategy. "The worst part of it," Capa wrote, "is that where your text is full of misery and drama, your pictures showed a fairly peaceful and nearly contented camp, certainly far more orderly and clean than the camps on the other side. So the two of them did not go together at all. Indeed the opposite, a relaxed text with very measured statements and more dramatic pictures would have done the job."[9]

However, Capa took pains to tell Rodger that he should not take this criticism too much to heart, that the mistakes he had been making were common ones for reporters who are "far away, and isolated, and impressed." It had happened to him too, he said. Generally, Capa tried to steer Rodger toward breaking news: "When Suez and Teheran are burning, the quiet middle between the two is not going to excite editors . . . a Suez story today would be worth five of your

dead ones, assigned or not. The part of the world where you are is in the head-
lines, except for the part where you are moving yourself." [10]

Capa's businesslike perspective on Magnum clashed sharply with Rodger's
notions of covering everyday life in depth. Capa had a very clear sense of what
New York editors wanted, and he was aware that Magnum needed those editors
as clients more than ever because the European magazines were seriously short
of both paper and funds, and were assigning far fewer stories than before. There-
fore, he said, Rodger should take the initiative and find subjects himself. It was
no longer possible to work only by assignment.

Capa had struck a sore spot: the absence of drama in Rodger's pictures was
often underscored by the excessive drama of his texts. Of course it was difficult, if
not impossible, to show the Palestinian plight in dramatic photographs because
it involved protracted suffering without much action (over the following decades
many photographers would run into the same problem, producing scores of
earnest but dull pictures of sad people sitting around in refugee camps). But
Rodger was stubborn and wanted to do things his own way. He would not be
forced into the classic mold of photojournalism. He did not want to work for
Magnum, he wanted Magnum to work for him.

By February 1952, Rodger and Jinx were in Kuwait, based at the American
Mission and working on a story about oil. Overcoming a sandstorm followed by
an eclipse followed by a swarm of locusts, they produced a color story that would
appear first as a nine-page spread in *Point de Vue/Images du Monde*, then a few
months later in *National Geographic* as "Boom Time in Kuwait." It marked the
beginning of Rodger's long connection to *National Geographic*.

Kuwait, a state "slightly smaller than New Jersey," as Rodger's collaborator
on the story Paul Case put it, was producing roughly half of American crude oil
requirements. His Highness Abdullah Salim, whose portrait Rodger had made,
was now one of the world's richest men. Case's text and Rodger's pictures, in
black and white and color, presented the sheikh as a benefactor who had poured
most of his profits back into schools, hospitals, roads, and public buildings, turn-
ing the capital into a swelling boomtown reminiscent of the American southwest.

In March, Rodger and Jinx went to Aleppo, Syria, to shoot a story for Capa's
"Generation X" project. Their subject was an eighteen-year-old youth, Burhan
Jabri, who was attending college. Rodger followed him around at school, at
home, in the Aleppo *souk*, in the citadel, and at archaeological sites, trying to give
an overall sense of the young man's life. The reportage was competent but rather
banal. Clearly, Rodger was not inspired by this type of assignment, which he
considered illustration, and for which his own initiative was minimal. He might
well have been talking about himself when later on, in a letter to Jinx, he made

this comment about his colleague Ernst Haas: "I know just how much he would like to get away from the necessity of having to have assignments and the necessity of having to stick to a shooting script for American magazines and then the awful stigma of becoming a yes man and having to go out and prove other people's ideas . . . I feel so much the same and only wish there were some way of operating in complete freedom." [11]

After stopovers in Beirut (Jinx's hometown) and Cyprus, George and Jinx flew back to Europe, he to London and she to Paris, where Magnum quickly moved her into the top floor of the agency building. Her living quarters was a maid's room with a view of the Paris rooftops. There she typed the text and captions for Rodger's "Generation X" pictures. Capa was happy with the piece.

Magnum was again in difficult straits. Capa and Chim were working every night until almost dawn to stabilize the agency's finances. But they made sure Jinx had a lot of fun: they took her to the races, to lunches and dinners. There were animated talks about the future of the agency. Capa, Chim, and Cartier-Bresson all felt that it should represent only a small group of photographers rather than become an ambitious, overgrown, complicated agency. In the end their opinion would not prevail.

In April, Capa, who felt he had too many administrative tasks and not enough time to take pictures, stepped down from his post as Magnum's president and asked Rodger to take over in an acting capacity. Rodger returned to Paris and became a coordinator; he was also responsible for the agency's finances. He asked everyone to write down and air their grievances. One of Magnum's problems was that the agency had taken on far too many stringers: there were thirty on the New York books and nearly fifty in Paris. They took up an enormous amount of office time and resources while contributing little. Rodger agonized over figures, disagreements, and crises, one of which was a decrease in the number of commissions from European magazines. "George hated being president," Jinx recalls. [12]

He stayed in Paris most of that spring, but took a quick break in May for an assignment on the Isle of Skye for the *Weekly Illustrated*. In mid-June he was forced to return to London. He was sinking into what was to become a yearly breakdown, and was battling profound depression, the symptoms of which included dizziness along with migraines so severe that they often forced him to stay in bed in a darkened room.

He consulted a London physician, Dr. Banszky, who treated him with vitamin injections and provided him with physical explanations for his symptoms ("Cramping of the arteries in the head caused by wear and tear on nervous system") but who never looked into the psychological aspects of his depressions.

Jinx visited Rodger several times in London, and it was during that summer that their relationship stopped being platonic. Soon after, she wrote to Rodger: "I woke up abruptly, shockingly, overnight, came to my sense, passed from a child to a woman . . . My life really started that night in London and I don't want to think about what went on before." [13]

But Rodger wanted a period apart from Jinx before she committed to being with him. Jinx recalls that they separated "because he said: 'You want to go back to the U.S. and decide what you want to do.' He knew his own failures and knew he was haunted and knew he was eighteen years older. He stayed in Congleton as long as he could stand it. After about six weeks he asked me to marry him." [14]

Jinx wanted to spend the summer vacation with her parents in Ohio. She stopped in New York on the way. While there, she cast her vote for Eisenhower; met Eve Arnold, the new photographer in the Magnum office who was working on the elections in Chicago; befriended Inge Bondi, a new editor; and attended parties at the home of Cornell Capa, Robert Capa's brother. The regular guests were Ernst Haas, Eve Arnold and her husband, Erich Hartmann, Kris Taconis, Erich Lessing, and Dennis Stock. Bischof was mostly in the Far East but came when he was in town. There were arguments, and tempers flared, but Chim always succeeded in calming everyone down and choosing the best place for dinner. Inge and Heini Bondi were often present at the soirées as well. Inge Bondi, a refugee form Nazi Germany, had arrived in London alone when she was thirteen years old and taken British citizenship. In 1947 she and her husband moved to New York; the following year, when Maria Eisner decided to leave Magnum at the end of her pregnancy, she hired Bondi to replace her as an editor at the New York office. Bondi would stay with Magnum for the next twenty-five years, and during that time was one of Rodger's closest friends and strongest allies. It was she who would find him most of his assignments. She began writing in the mid-1970s and is the author of the first monograph on Rodger, published in 1974. [15]

From Congleton, Rodger was staying in touch:

Damn it if I did not dream vividly that this had happened again—the S. [Scheller] show! It was a sort of nightmare. I had a rendezvous with you somewhere in the Middle East—a dream city without substance—and I traveled far to reach you. When I got there I found you, you had a combination of the "leopard skin look" [a sexy short skirt that Jinx had been given and that she wore at parties] and the "hunted and guilty look" . . . Instead of going straight to our rendezvous you had gone to his house several days earlier than you had said. See, when I woke up I could at least be thankful it was only a dream this time! El

Humd'L'Allah! I guess it must have gone in pretty deep—deeper than I thought. I'm feeling rebellious at being stuck here, tied to Banszky's hypodermic needle.[16]

Rodger was refusing work offers from *Life*, in part because he was depressed but also because he did not want to be tied up with the magazine again: "Gene Farmer was hunting for me yesterday to do a cover for them! . . . Then when I said I wasn't allowed to work, he wanted me to let him know when I was better as he had a lot I could do. I said when I was better I'd be moving so fast out of London he'd only see a vapor trail."[17]

Jinx was making every effort to lift Rodger's spirits with her cheerful letters. Although he depended heavily on her support and good humor, he was also possessive and jealous of her buoyancy, and scolded her for behaving "like a child." Around this time, he wrote her a long letter in which he explained his ideas about love. He thought they were different in their expectations, because of their cultural differences as an Englishman and an American. He depicted himself as someone deeply rooted in the past, who believed in slow progress rather than sudden infatuation. To him, sex ("the animal instincts of sex") and love existed on entirely different planes:

> I can say how terribly I miss you, even painfully, and how you are the closest, dearest and most cherished person I have . . . There is of course a difference between the British, American and Continental conception of these things. That is why I took such pains to show you England and Scotland—so you could understand—so you yourself might absorb something from the moss-grown antiquity of the old places I showed you . . . All this is in me, bred in deeply. It is part of me, whether I like it or not, and I took you through it all purposely that you might . . . understand why I could not take you in my arms and say you were the only girl in the world to me and the kind of girl I really wanted to marry—as S. could after knowing you for only two days . . . To me, that sort of thing just isn't sincere . . . Love, of a permanent nature, isn't founded on a blazing aurora of tobacco smoke.[18]

In the same letter, he expressed his belief that love went beyond the corporeal, and—tellingly—that love could be found only with some distance between two people:

> You don't find out in each other's arms. You might find out about sex, but not love. You find out about love when you are away from the person in question, when distance separates you. It is a gentle thing that creeps in quietly and lodges

in your heart, sometimes without you even knowing about it. But, once it is there, it is strong and unbreakable. It still persists when the black ox of depression and loneliness tramps in circles around you . . . I am glad that our relationships have been founded on tough times. They have a better chance of surviving and of helping to grow something that will be really strong and permanent.[19]

Rodger and his sisters helped his parents, who were moving from the Bridestones to a suburban house ("Imagine me, with my African background, having my parents living in a Congleton villa called 'The Kraal' "). He did all the electrical and carpentry work, laid down carpets, hung pictures, and put up shelves and racks. At one point he nearly killed himself by absentmindedly using pliers on a live wire. He wrote Jinx romantic descriptions of sunsets at the Cloud, and sent her a sprig of the heather he had gathered with his mother.

But Rodger detested living with his parents. Witnessing their difficult relationship—the cold way his father treated his mother, her passivity and resignation—brought back all his childhood misery. He began driving his "Minxie" at full speed, just as in his youth he had recklessly ridden his motorcycle "Boanerges" and risked several accidents on the winding, narrow roads—his way of fending off "the black ox of depression." Love was indeed easier for Rodger from long distance. In his letter he had made a generalization about what applied mainly to his own trouble with the intimacies of everyday life. Away from Jinx, he allowed himself to feel more than when they were together. But with his deepening attachment to her came other intense feelings, including paranoia. He was afraid of gossip and worried that Jinx would confide to their colleagues, especially to John Morris. Jinx and Rodger were supposed to be just friends (although of course no one by then believed that). And Rodger did not include Jinx in certain important decisions. For example, it was a week after the fact that she learned he had resigned as Magnum's treasurer.

Jinx meanwhile was keeping Rodger informed of all new developments. Eve Arnold and Erich Hartmann had joined Magnum as stockholders. So (soon after) had Ernst Haas and Werner Bischof. But the great news that fall of 1952 was unquestionably the release in Paris and New York of Henri Cartier-Bresson's *Images à la Sauvette* (Images on the Sly), published in France by Éditions Verve and in America—with the title *The Decisive Moment*—by Simon and Schuster.[20]

Cartier-Bresson's French publisher, Tériade, had an exclusive catalog of books by fine artists such as Bonnard, Chagall, Picasso, Léger, and Matisse, with texts by poets. He had never before published the work of a photographer and would never publish one after Cartier-Bresson's. This fact in itself placed the

photographer on a different conceptual plane than most of his colleagues—which many would come to resent. The book's printing and typography, by the Draeger brothers, were impeccable, the format huge. The 126 photographs were full page or double-trucks, with all the captions placed at the end of the book so that reader could view the pictures for themselves, not as illustrations of a time and place. Cartier-Bresson's ten-page foreword to the book—the only text on theory he would ever write—explores his notion of "the decisive moment." It was quite unusual for a photographer to take on the authority of an author. The blue, green, and white Matisse lithograph on the cover was also unprecedented; the milieu of photojournalism was at the time very separate from the arts.

Cartier-Bresson had worried about sales, but the book was an immediate success on both sides of the Atlantic. Around this time, Rodger, Jinx, and Cartier-Bresson exchanged many letters, sending one another pictures, books, and little presents. In October, Cartier-Bresson described to Jinx the amazing amount of attention his book was receiving.

> It just came out on the same day as the U.S. edition; it is very well received; I have sent the pages in *Match* and *Arts* to the office, there was a whole page in *Combat*, I must get a copy and send it, there was something on the radio this morning, even *Samedi Soir* is going to do something. Tériade is pleasantly surprised I think, I don't think he realized before how effective our office is . . . I have received the clippings from *Life*, I know that *Harper's Bazaar* did pages on the book but I did not receive the clippings yet.[21]

Most articles were positive, but there was one that made Cartier-Bresson especially happy: a *New York Times* piece by Walker Evans, a photographer whose work he admired and whose opinion he highly valued.

Meanwhile, Rodger was gearing up to travel again. But this time he would start out from New York, where he was meeting his American bride-to-be. He and Jinx had decided to get married.

He wrote to Cartier-Bresson: "Out of the blue came an ideal assignment. Carte Blanche to cover all the Far Eastern installations of Stanvak. Plus six stories for the house magazine of Standard Oil, the *Lamp*. The only proviso was that the subject must be related to a bi-product of the oil industry."[22] In the same letter, Rodger aired his complaints about Magnum's New York office: "Magnum here cannot tell a good picture from a bad one; relegates everything to the archives before it has been shown to more than the top few magazines; has no idea what saleable material there is in the files; has no idea how to present and sell a story that is not an assigned job; has no sales organisation anyway." He did not

feel he should go off on his Far East trip "until we had set up some organisation here to handle my stories when I send them back." But he praised Chim's positive attitude: "So far, our problems have failed to dampen the optimistic spirit he brought here with him. He is taking a very balanced point of view of the whole thing and refuses to get excited about it. It is very good to have his steady judgement."December was a rocky month for Magnum, which had to handle the resignations of Fenno Jacobs, Homer Page, and Carl Perutz. At the same time, the decision was made that the agency should be run by a board of directors consisting of the four original stockholders: Chim, Cartier-Bresson, Capa, and Rodger. Magnum had so far not followed Rodger's practical suggestion that "we must have a general manager responsible for the business organisation of both offices,"[23] but had reelected Capa as president in charge of general policy and Paris production. In that capacity, Capa would have to travel once a year to the United States to supervise and coordinate New York production and sales of Paris material, and would also make three annual visits to London and one to other European markets.

That month, however, Capa did heed one of Rodger's suggestions: he asked John Morris to quit his job at the *Ladies' Home Journal* to become an editor at Magnum.

Morris started in his new post on February 1, 1953. His first task was to clean house: he got rid of most of the stringers, moved the Magnum office to posher quarters on East 64th Street, and hired two new photographers, Eliott Erwitt and Burt Glinn—both of whom would prove to be among the agency's best money makers. But almost immediately, he clashed with Capa: Morris wanted to run Magnum like a news agency, assigning photographers to breaking stories and coordinating the two offices. Capa contended that Magnum was never meant to be a growing, commercial kind of agency; it could only serve a limited number of photographers—ones who were at least as interested in work as they were in money.

On January 29, George and Jinx were married at her father's church in Akron, Ohio. It was a quiet ceremony attended by Jinx's family and a few friends. Afterwards, they left for a short honeymoon in New Mexico, Arizona, and California.

As Rodger had told Cartier-Bresson, he had been given one of those open-ended assignments he loved best: a commission from Standard Oil to photograph their installations worldwide. While these were not going to be very exciting pictures—how different is one oil well from another?—it was the perfect excuse to travel and find other stories on the way.

In the space of four months, their complicated itinerary took them to the

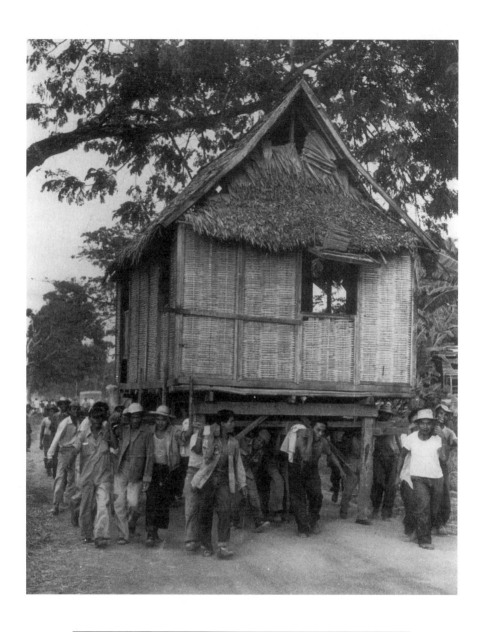

Moving house on the island of Mactan in the Philippines, 1953. ©
George Rodger/Magnum Photos.

Philippines, Indonesia, Sumatra, and Java, as well as three cities—Rangoon, Calcutta, and Bombay—that Rodger had not seen since the war. In the Philippines they did a story for the series "Generation Women" (a sequel to "Generation X"), which Capa had sold to *Picture Post* and a few American magazines). Their subject was a Filipino stewardess named Cora Lahora, who came from a poor family in the southern part of the island of Luzon but had managed to attend college and learn Spanish and English.

George and Jinx arrived in Bali at the time of the Temple Anniversary, the most important social and religious event of the year. They stayed for a month, during which Rodger shot on speculation some of his best pictures in black and white, of Anak Agung Ngurah, one of Bali's leading dancers, as he performed the Pandjak, a warlike dance accompanied by a single drum. They also witnessed a religious ceremony, the Melis, in which a procession is followed by a symbolic immersion of the gods' statues in the river.

Rodger was at ease in Bali because, like Africans in a traditional context, the Balinese were not preoccupied by material possessions and spent much of their time looking after their spiritual well-being. He also produced some excellent color work, in which people and environment seem almost to blend in the luxuriance of tones. Sharp light-and-shadow contrasts, as well as the delicate grace of his subjects, made for several beautiful black-and-white pictures, such as that of two young girls conversing under a tree near a rice field. The image has both elegance and strength. It seemed that Rodger was getting his inspiration back, as if he were starting anew.

17

The End of an Era

1954

Jinx and George had easily agreed that living in Limassol would be too painful. With her efficient help he cleared out all traces of his old life on Cyprus. They emptied the house and the studio, gave away Cicely's possessions, and packed the photo equipment he had stored there. By December 19 they were aboard the *Aeolia* on their way to Beirut; it would be an excellent base for any Middle Eastern or African assignment and easy for the Magnum office to reach. They celebrated the New Year there. Early in the morning, Jinx typed a piece for the *Holiday* story that George had shot in Bali, on a woman from a wealthy background who worked in Bombay as a welfare officer over the objections of her family and her social milieu.

That same week Rodger accepted with some misgivings an assignment from *Life*. They would pay him well[1] to go to Kenya to do a story about the Mau-Mau, a Kikuyu secret society that had declared war on its own people and had sworn to drive the white man out of Africa. By the third week in January, after a quick trip to Damascus to shoot a color story on spec for *Time*, Rodger and Jinx were in Cairo to shoot for *The Lamp*, Standard Oil's company magazine. The city had nearly one hundred registered peddlers of Esso kerosene; Rodger would choose one as the focus of his story.

Rodger was happy to get back to one of his favorite cities, and he treated Jinx to stories of his life as a war correspondent. Together they roamed the streets, but wherever they walked, conversations stopped—there were no tourists at the time, and foreigners did not usually venture far from their hotels except to visit

231

archaeological sites. The six-foot-tall Rodger stood out in the crowds, with his brushed back gray hair, gray-blue eyes, and tanned face creased with worry lines. He always wore a khaki outfit and his father's wristwatch. His strong hands cradled his silent Leica.

Misr El Kadima had changed little since the Middle Ages. The street vendors pushed their merchandise, calling out its praises: "O dates, even your pits are almonds!" "Sweeter than honey, O watermelon!" "American, O apples!" Among them, Rodger found his subject: Mohammed Khalil, a man in his eighties who had in his donkey cart containers of kerosene shipped from Saudi Arabia that Cairenes bought for their copper lamps and cooking stoves.

Heeding Capa's advice about showing more initiative, Rodger used his time in Cairo to shoot two other stories on spec: one on the spiritual leader of the Bektashiyas, a religious sect that claims to reach God through fasting and ritual dances, and another on the tomb of Sri Baba, which pious Muslims visit in hope of better health or spiritual well-being.

While Rodger was focusing on these traditional aspects of Egyptian society, the country was undergoing profound change. Gamal Abdel Nasser, who the previous year had driven the corrupt King Farouk from the throne, was about to launch a social revolution; his agricultural and educational reforms would profoundly alter the fabric of Egyptian society. Nationalist and pro-Islamic sentiments were running high in Egypt, and most foreigners were being hounded from the country. Copts were being persecuted, and Egyptian Jews were leaving for Europe, Canada, the United States, or (more rarely) Israel. Egypt's hostililty to outsiders would lead soon to a war over the Suez Canal. Partly because of that conflict but also because the region's crude oil was hugely important to the world economy, the Middle East was fast becoming one of the world's most serious trouble spots. There, a new generation of photojournalists would soon be filing reports on the latest wars, racial divisions, and religious crusades.

On January 24 the Rodgers left Cairo for Nairobi, where Mary Nash and her husband Ernest Hemingway were based. Nash, who had worked with *Time* in London, was an old friend of George's and had introduced her husband to Robert Capa.

Rodger did not like Hemingway. "Called in to see Hemingway at the New Stanley Hotel," he wrote, "and managed to expose a roll of film on him in spite of him being as cross as a bear and thoroughly un-British." [2] "Un-British" was, of course, about the ugliest slur Rodger could deliver. He also thought the writer was a boorish and truculent drunk. Hemingway pretended not to remember Capa at all. Jinx recalls that Rodger was also irritated by Hemingway's heroic posturing and by the way he boasted about his war experiences and the lions he

had killed on a recent safari.[3] Rodger never boasted, even though he had a drawer full of medals from the war; furthermore, he hated both war bluster and animal hunting. In his 1955 text *Africa on a Shoestring*, he wrote: "Personally, I prefer photographic trophies to the stuffed ones. Where did you get me? the trophy leers. Kilimanjaro? Are you sure it wasn't on Delamer Avenue in Nairobi? You can do that, you know. Order your trophies by telephone and have them made to measure. Nobody will know the difference. They look just as impressive by the time they reach you in Westchester County. But pictures are different. It is difficult to avoid the truth in them."[4] (*Africa on a Shoestring* also includes an episode in which an enraged rhinoceros charges Rodger, just missing him by a hair. His companion wryly remarks: "The bloody fool must have mistaken you for Ernest Hemingway.")

Not surprisingly, Rodger's portrait of Hemingway does not flatter its subject: the writer looks angry, dejected, and shallow, as well as somewhat hung over. Almost a caricature, it reveals Rodger's private dislike for Hemingway.

In fact, Rodger had little interest in and patience for Westerners generally, even famous ones. What he wanted was to venture deeper into the African continent. The disastrous ECA trip had not fulfilled that wish—a wish that was about Africa, but also about mending the fabric of his life, which had been shredded by Cicely's death. Thus Rodger's African opus begins with a lyrical visual poem about an Africa still unaffected by Western conflicts and its own, an Africa where man and nature still live at peace: "The old Africa, sans frontières . . . almost gone, but not quite."[5]

The bitter irony that covering Mau-Mau violence would help him finance more peaceful expeditions in Kenya and the Sudan was not lost on Rodger. He knew he had to act quickly, before what he was after disappeared entirely.

Until the third week of March the Rodgers traveled in Kenya, living out of their Land Rover, which they had packed carefully with necessary supplies. Jinx remembers how organized Rodger was: "In all the time we traveled together, we never went hungry or thirsty or ran out of gas."[6]

In the text (eventually published in *Picture Post*) that accompanied Rodger's striking photo-reportage "What is Mau-Mau?" one African explains that "Mau-Mau was never born but grew up in the night."[7] The Kikuyu people, like so many others in Africa, had been living under British administration since 1895, and the first demands that the whites leave their country dated back to 1930. On the Mau-Mau issue, the Africans were divided. Many wanted the British out and agreed that all Kikuyu should be unified; but by no means all of them approved of the terrorist methods the Mau-Mau were employing.

In his articles, Rodger seems to have followed Capa's advice about remain-

ing politically objective: the writing is factual, the words of an observer striving for neutrality.[8] But of course Rodger himself felt divided. He was an Englishman in an Africa ruled in part by the English—but what he loved most about Africa was not the Westernized part, but rather what remained of the Africa that had been seen by Burton, Livingstone, and Stanley: "the Africa of great tribal kings—Mutesa and Kansazi—of wild beasts, and of men who were fierce, naked, uninhibited and right deep close to the earth."[9] He knew that some thirty thousand Kikuyu were homeless and unemployed and thus easy recruits for the Mau-Mau, who were promising to improve their dismal living conditions. Those recruits were required to take a chilling oath: "If I am told to bring the head of a European and I refuse/*this oath will kill me*/If I am called at any time of the night and do not go/*this oath will kill me.*[10]

This is where Rodger drew the line. With all he had seen and experienced as a war photographer, he despised the escalating violence. And it was no longer a war of black against white: the Mau-Mau were committing bestial atrocities against their own people, even cutting to pieces those who refused to join their ranks. The British were retaliating with steadily increasing aggression.

Rodger's pictures are striking, especially those of General China, a Mau-Mau leader whose trial he followed. China, in prison uniform, stands between four Kikuyu in military kit. His braided hair stands askew on his head. His lips are closed, his eyes haunted and judging. (A few years later Rodger would meet China again. Now dressed in a fine suit, he was Kenya's new Minister of Education.)

By the end of February the Rodgers had left behind them the nightmarish Nyeri landscape: drawbridges, poisoned wooden spikes planted in moats, Mau-Mau bodies strewn on the ground by the thousand.[11]

After stopping in Nairobi, they headed for the Sudan, arriving in Yei on March 24. "It is quite impossible," Rodger wrote, "to reduce to words on paper the stillness and the charm of the Sudan—its tranquillity and the [bond] between common men, regardless of color, that one finds here."[12]

In Yei Rodger did a story on a rural school: the little girls left their village naked, but on the way to their mission class, where they learned to read and write, they picked fresh leaves, which they used as skirts. The students sat on their heels, and as paper and pencils were scarce, they traced letters and figures with their fingers in the dust, their small faces furrowed in concentration.

Farther on, in the depths of the African forest near Moyo, a Western Nile province of Uganda, Rodger approached the Madi people, who had had little contact with civilization. He made a stunning portrait of a young fisherman holding his spear, and another of a boy whose focus in aiming his bamboo bow reflects that of the photographer in capturing his picture. Rodger had come to

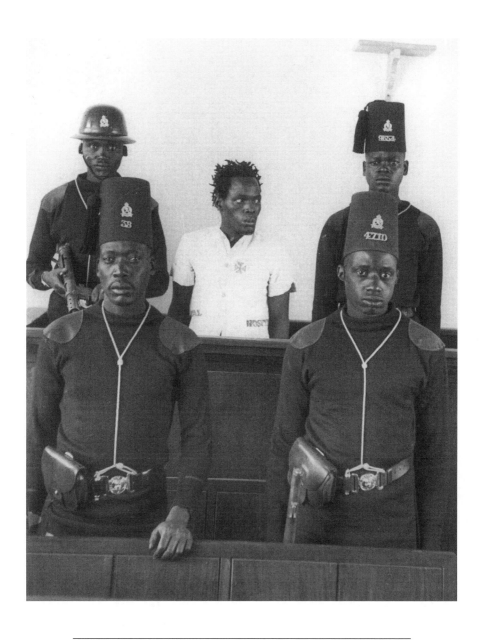

The trial of "General China" in the Nyeri courthouse during the
Mau-Mau revolt, Kenya, January 15, 1954. © *George Rodger/Magnum
Photos.*

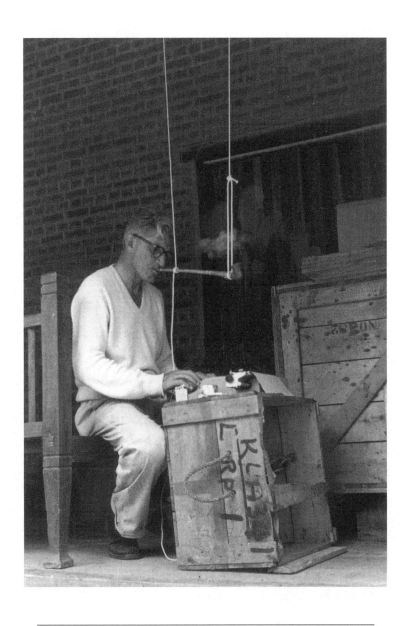

George Rodger discovers how to type and smoke his Dinka pipe at the same time, Yei, Southern Sudan, 1954. © *Jinx Rodger.*

this part of Uganda in 1948 and would return twice more. Four decades later he observed: "By now the four trips I made in Uganda are mingling in memory . . . I have approached Uganda from every angle."[13]

On April 19 the travelers reached the town of Hoima. They had been invited by the court to witness the *m'pango* (recoronation ceremony) of His Royal Highness Omukama Bukirabasaija ("Above All Men") Acutumba ("Who Cures All Troubles") Tito Gafabusa Winyi IV. This ritual had never before been photographed. Gafabusa would be the central character of one of Rodger's best stories, "King of Bunyoro"[14]—a story after Rodger's own heart, for Gafabusa's grandfather had been king when Speke and Grant entered the territory in 1862.

The seven-day ceremony they were attending involved the recrowning of the king with all the crowns of his ancestors, as well as a party with dancing, singing, and heavy consumption of *pombe* (millet beer). There were a few modern touches—a royal limousine, a mass at the Anglican Cathedral of St. Peter, and a football game. But most of the ceremony was traditional. Rodger's pictures show every aspect of the processions, including the royal trumpeters playing six-century-old instruments; the members of the sacred guilds in ochre tunics and colobus-monkey beards; the bearers of the sacred shields and of the royal rake; and the royal executioners (who now served only a symbolic function but nevertheless cut striking figures with their axes slung over their shoulders like giant oars). A crowd of about ten thousand Bunyoro subjects followed the officials, everyone dancing and supporting a portable bamboo arcade over their heads.

Then the chief drummer lifted his drumstick and everyone fell silent: the king was coming. He was wearing a fig-tree bark robe and the same crown that his ancestor Mukama Rukidi, first king of the dynasty, had worn thirty generations earlier: a cylindrical soft hat of red and white pearls with matching pearl beard, topped by a thick spray of ostrich feathers. The drum roll that proclaimed his royalty did not stop for seven days and seven nights, with new drummers arriving to replace those who could drum no longer. Sitting on a dais covered with sixty leopard skins, the king and queen received visitors and were entertained by snake charmers. Rodger, who was shooting in both black and white and color, recalled: "The program repeated itself for seven days . . . wanting to show proper respect for the King and the dignitaries who had finally permitted the rituals to be photographed, he [the photographer] was obliged to continue through the week—with the result that he had seven sets of pictures that were similar except for the fact that different headdresses were used for the various recrownings."[15]

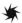

Rodger was on a lucky streak: besides completing his "King of Bunyoro" story he had also found by chance the subject for his next piece. "Generation Children," conceived by Capa and assigned by John Morris, was a sequel to "Generation X" and "Generation Women." Magnum photographers were to shoot it in the part of the world where they regularly worked—Cartier-Bresson in the Far East, Chim in Europe, Capa in the United States, and Rodger in Africa. In a letter to Margot Shore, who was then running the Paris office, Rodger wrote:

> Then, strangely enough, we ran into our G.C. subject. "Ran into" is correct because in reality, Jinx merely tripped over him while visiting the King in his throne room. From deep in the folds of his red bark tunic, a little voice said, "I'm sorry, Madam" which was about all the English he knew; and there he was—GC! He is not the son of a cheiftain, but Keeper of the Sacred Shield in the royal household of Bunyoro and that is good enough. We worked for a week on him . . . I am anxious-est to know what the pictures look like.[16]

Emanuel Rwahwice, twelve years old, touched the Rodgers' heart. He had a beautiful smile and dark, expressive eyes that sparkled when he was happy and clouded over when he was sad. He lived a double life: at court he held his official title, but each day after Catholic school he worked with his mother in the fields. The official story was that his father had died, but he may have been an illegitimate son of the king. When he was free, Emanuel would hunt in the tall grass and the manioc fields; one of Rodger's best portraits shows him, spear in hand, stalking a water buffalo. Emanuel had many responsibilities but also had a knack for disappearing when Rodger needed him; when found again after a long search, he would be playing. The boy possessed, in Rodger's words, "a naturalness and unself-consciousness that I have never found before in Africa."[17]

But the encounter also struck another chord: Rodger, who was then forty-eight, had no children. He and Jinx grew very attached to Emanuel and even considered adopting him, but decided it would be unfair to take him away from an environment where he was obviously happy. Later, in the 1970s, when I met Rodger—who by then was the father of three children with Jinx—he expressed a sadness that as an Englishman, he was almost certain to survive Emanuel, although Rodger was nearly four decades his senior.

In May 1954, George and Jinx headed out for Karamoja country in northeastern Uganda, where they came across two rival groups, the Jie and the Dodoth. Rodger photographed the hunting rituals of the Napore and the ceremonies of the Jie and Dodoth against a flat, dry landscape of thorns and bushes,

framed at one end by the Kadam Mountain and at the other by the Morongolo. Although they lived near the track that joined the towns of Soroli and Moroto, the two groups had seen no white people for some thirty years; one of Rodger's pictures shows Karamojong men from the Jie in Kaabong approaching to examine the foreigners. Holding the long spears and clubs with which they hunted, clad in short cloth tunics, the warriors were over six feet tall. Some wore headdresses of cowrie shells and silver bracelets on their forearms; others had strange chignons, caked with clay, hanging to the napes of their necks. Their custom was to wear some of their ancestors' hair entwined with their own; also, they used the chignons as receptacles for pearls, tobacco, snuffboxes, and small firesticks. The Karamojong greeted the foreigners by lightly touching the palms of their hands. Rodger and Jinx were invited to witness the preparations for a hunt, which involved the blessing of spears and the blare of three-foot trumpets.

The travelers had been thinking of journeying to the Nile's sources, but they were delayed by a railroad strike in the Sudan. Rodger wrote to John Morris:

> We were strikebound for fifteen days in that little tropical cul-de-sac called Juba. We tried every way of escape but without success . . . This became so boring that we decided to enliven things by going on a white-rhino hunt. The white ones are bigger and better than the black ones, weighing between three and four tons each and standing about six feet at the shoulder . . . The first one charged when the click of the Contax gave my position away and this is very upsetting when there is nothing but thorn bushes around and no trees to climb up . . . That is how we met—face to face. Now this is a terrifying thing. I had the impression of being faced with an irate mountain with something like the spire of the Cologne cathedral stuck on it.[18]

Rodger managed a very narrow escape by climbing a tree.

They stayed on in the southern Sudan, driving through several reserves in their Land Rover, photographing elephants, hippos, crocodiles, and buffalo along the way, then following the White Nile toward Uganda. In a camp at the game warden's base at the Murchison Falls reserve—the best park in East Africa at the time—they discovered a landscape of tropical forest, and Rodger photographed the Nile waters as they tumbled down the rocks. A campfire meal in a cave near Mubende included fried termites as a main course.

In *Africa on a Shoestring*, Rodger wrote:

> That road was like a book. In its dusty pages was written a record of the night—
> a fleeting record that was erased each morning by wind or rain. It made fascinat-

ing reading. We saw the footprints where a pride of lion had followed an ante-
lope, and they in turn had been tailed by hyenas and jackals. We saw where a
herd of a hundred buffalo had crossed; where kongoni had played, where a lone
rhino had stopped to roll in the dust. It was all written down in writing that var-
ied between the two-foot hieroglyphics of an elephant to the tiny imprint of a
shrew.[19]

After being completely out of touch with the outside world for several weeks, the
travelers reached Shellal, where the river met the train to Cairo. It wasn't till they
were back in Egypt that they heard some devastating news:

> At the height of the hot season in 1954, I was returning out of Africa . . . It was
> intolerably hot in the railway coach and the metal buttons of my bush jacket
> burned into my skin. An Egyptian newsvendor walked in the hot sand beside the
> line and I bought a month-old copy of *Time*. I opened at random, too hot to take
> immediate interest. Then, suddenly, the world stood still, I couldn't believe the
> cruel outcry of the print—Indo-China. Dien Bien Phu—Bob Capa was dead. As
> though this was not shock enough, I read in the same issue of *Time* that our gen-
> tle, talented, sensitive Werner was dead also—killed during the same week but
> on the other side of the world on assignment in Peru.[20]

Both deaths had been sudden and horrible: Werner Bischof had died in a car ac-
cident on May 16; Robert Capa had stepped on a landmine near Thai Bin on
May 25.[21]

Capa, who had been hailed by *Picture Post* as "the Greatest War Photogra-
pher in the World," was mourned internationally by friends and colleagues. John
Steinbeck, who had collaborated with him on many stories, summarized the gen-
eral opinion when he wrote in his obituary: "We were so used to his involvement
with war that we truly believed him indestructible."[22]

On his way to Saigon on a *Life* assignment, Capa, while waiting for a change
of planes, had as usual written notes to all Magnum members; these would be his
last communications with them. Word of his death reached the Paris and New
York offices within hours. But it was two-and-a-half weeks before George and
Jinx heard the news.

Stricken, they arrived at the Carlton Hotel in Cairo, where they found sev-
eral cables and a long letter from Margot Shore: "Certainly by the time you read
this you will know what we all know: that we are forever missing our Bob and our
Werner. You were notified immediately of these tragedies, but when we didn't
hear from you, we knew that something must have gone wrong . . . Chim is in
New York. He went there for a service that was held for Bob and Werner, and to

act as a treasurer in getting all the facts and figures about Magnum on paper—to bring order to the house."[23] Shore went on to announce that Cornell Capa, Robert Capa's younger brother and longtime printer, had decided to join Magnum, and that all members were trying to convene at the Paris office around the end of June. Shore continued: "The meeting of all of you in Paris is important to everybody's clarity of mind, and future, and I cannot think of a better thing for you to do than to come here so there can be a meeting. It will be George, Henri, Ernst, Cornell and Chim . . . the remaining stockholders."[24]

Rodger and Jinx did not need any prompting to take the first plane to Paris, and the Magnum meeting took place at the beginning of July. Chim took on Robert Capa's duties as president and tried to keep the agency going. This was not an easy task, as Capa had been a shrewd administrator and knew not only how to sell a story to an editor, but also the differences between the European and American markets—as well as the strengths and weaknesses of every Magnum member. He knew which assignments were best for each photographer and what advice, support, and criticism to provide for each. To many members of Magnum he had been not only a close friend but also a father figure.

That summer, Rodger helped Chim keep Magnum afloat through changes of staff in Paris and reorganizations in New York. Life had to go on without Capa, and there was little time to mourn him. The photographers had to find new working ideas. The magazine market had peaked in the 1940s and early 1950s, and now freewheeling assignments were more difficult to come by and to finance. The going would get even tougher by 1957. Accepting industrial reports and even commercial shoots would become a necessity for most members. Tom Hopkinson, picture editor at *Picture Post*, observed: "Sales [at the *Post*] had been over 1,380,000 between January and June, 1950. They had sunk to 1,225,000 by June 1951, and to 935,000 by June 1952. They remained not far below the crucial one million mark until 1956, when they started to melt away more rapidly, and by May 1957, when the magazine folded, a printing paper reported that *Picture Post*'s average sale in recent weeks was understood to have fallen below 600,000."[25]

Rodger was again at a low point. Capa's death filled him with a sense of loss, guilt, and dread. The headaches that had tortured him since the end of the war came back with a vengeance.

Then in August he met a friend of Cartier-Bresson, Robert Delpire, a gifted designer who was starting a collection of photography books that did not look like the usual illustrated books, but more like small novels. When Delpire saw Rodger's 1949 Nuba pictures, he decided to publish them in his collection "Huit" with the title *Le Village des Noubas*.[26]

Rodger understood that his Nuba pictures were extraordinary, yet he had never thought of himself as more than a photojournalist. Fighting constant headaches, he immediately started work on the text and, amazingly, finished it in a week, by August 27. The book format chosen by Delpire for *Le Village des Noubas* was small—only 8 by 12 centimeters. On its cover, the powerful figures of two half-crouching Nuba warriors, their bodies rubbed with white ash, run from front to back against an emerald-green background. In typical 1950s fashion, the photographs—all full-page or two-page spreads—are bled to the edge and sometimes cropped (Rodger did not share Cartier-Bresson's deference for the uncropped image and was concerned only with the most effective presentation). Rodger's text, which is divided into six parts, begins with a meditation on his favorite continent:

> Africa's face is changing as technical progress and teaching are reaching deep into the most obscure regions. From Cairo to Rand, Lagos to Mombassa, this metamorphosis can be felt, and soon Livingstone and Brazza's Africa will only live in history. But . . . there still are almost inaccessible regions, around which nature has built a protective wall against Western invasion. There can still be found the true Africa, without the white influence, keeping the customs and traditions of the ancient tribes.[27]

While writing this text, Rodger was not only grieving for an Africa that was vanishing. He was also mourning the loss of his friend Capa and remembering his trip with Cicely to the Nuba. Was his destiny always to outlive those he loved most? *Le Village des Noubas* is dedicated to "the memory of my wife Cicely, for whom that trip was the last."

By early September the Rodgers were back in London. Rodger resumed his visits to Dr. Banszky, who continued to give him injections that were of little help. The unnamed illness—his severe depression—was ruining his life, weakening him to the point where he couldn't work. He suffered from almost constant headaches. He worried about Magnum's future; without Capa's diplomatic skills, friction was growing among the members about the agency's future. Morris was arguing in favor of a merger of the Paris office with a French agency, Rado-Grosset (which would later become Rapho); others wanted the cooperative to remain independent.

By the end of September, somewhat revived by the prospect of a World Bank assignment in Turkey and Bombay, Rodger was back on his feet. He had missed a Magnum meeting in London but threw himself into their argument over a new European director. He wrote the agency a memo:

I fully agree on the appointment of Trudy [Feliu] and the work she has to do as outlined in Chim's memo. I just as fully disagree with the appointment of Jerry [Hannefin]. This is, in a way, a duplication of Trudy's position and a duplication of John's. It will be a long time before Magnum can afford two people of John's calibre and cost and I see no need to rush into it . . . Bluntly, this is how it stands at the moment:

> Henri doesn't want Jerry.
> Ernst Haas doesn't want Jerry.
> Kryn [Taconis] doesn't want Jerry.
> Eric [Lessing] doesn't want Jerry.
> Inge [Bondi] doesn't want Jerry.
> I don't want Jerry.[28]

In early October, George and Jinx were on a flight to Bombay. During the flight, Rodger blacked out. He realized that his depression and headaches were so debilitating that he would not be able to carry out his assignment. Marc Riboud, then an aspiring young photographer whom the couple had befriended in Paris, remembers receiving a letter from Rodger that month: "I cannot do that work in Turkey. I give it to you on the condition that you come and stay with us in Beirut before going."[29]

As Rodger wrote to Cartier-Bresson: "For me, it would just be another dreary assignment and a few dollars. But for Marc it will be his first assignment out of Europe, and should be the stepping stone to bigger things . . . At the moment I could not do anything at all and cannot even leave the house by myself. All the time I have this dreadful nervous tension which is terribly depressing. I cannot even walk by myself, speak with people, eat in a restaurant—simply anything seems to upset me and I just crumple up!"[30]

Riboud recalls:

I ended up staying over two months in Beirut. Then I left for Aleppo and Ankara where I spent time doing his assignment and shooting for myself. I think that his breakdown came from accumulated traumas. Certainly war had played its part—he had been knocked out by the bombings; then of course there was the death of his wife Cicely: it also played a major role, even more than Capa's death, because she was pregnant and the worst happened at a moment of the most wonderful expectations. George was made fragile all his life because of that, in his personal, professional and amicable relationships.

In photography there are two kinds of people: those who try to subsist through ugliness, monstrosity; and those who stress tenderness. George was of

that second kind. He never really got over his Belsen pictures, and the world did not, either.[31]

Rodger was in a Beirut hospital on and off for most of November and December; meanwhile, enormous changes were taking place at the agency. By the end of the year, Magnum had twenty-four new members and associates. Among the Europeans, there were Eve Arnold, Ted Castle, Inge Morath, and Marc Riboud. The American contingent included Eliott Erwitt, Burt Glinn, Erich Hartmann, and Dennis Stock. After Capa and Bischof's death, it was a whole new generation.

18

Desert and Africa

1955–1958

In Beirut, George and Jinx lived in a small apartment on the rue Phenice, op-
posite the British Embassy. The year 1955 was a difficult one for Rodger. He
was depressed much of the time and had many stays at the Beirut Clinic for
Nervous Diseases, under the care of Dr. Ford-Robertson, who treated him
with vitamin C, gland extract, barbital, and occasionally a drug called "Obliv-
ion." Rodger even tried occupational therapy, making lamps out of Iranian can-
dlesticks. His diary indicates that he was consumed by feelings of despondency
and helplessness, incomprehension at the roots of his illness, and an indiffer-
ence to the outside world that is surprising as well as painful to see in a charac-
ter such as Rodger's. One entry reads: "Woke up feeling better but terrible
depression developed during the day, then tension which built up to despair
at about 3.30."[1] He did not once take out his camera, but he was able to write
several text pieces, including *Africa on a Shoestring*, which he finished on
February 12.

His symptoms included headaches, tension, and pain in his arms and legs.
He could rarely sleep more than four hours at a time, and when he did he suf-
fered nightmares.

Riboud joined the Rodgers in February and left Beirut on March 12 for the
Turkish assignment. In May, Rodger was feeling a little better. He and Jinx
bought a Land Rover and began traveling again, to Jordan, Syria, and Turkey.
Rodger did only one story during these trips, on the Tapline oasis in Turkey.

Then they returned to Europe through Greece, Yugoslavia, Austria, Germany, and Belgium before reaching Congleton at the end of August.

They were feeling more and more that they could no longer live out of suitcases, and began looking for a base in England. In September they moved into a rented house in Bovingdon, Hartfordshire; from there, they took occasional house-hunting trips.

Rodger was tired and feeling disconnected from Magnum's affairs. He wrote to John Morris that he might be "too much of an old crock to take part in things." Yet at the same time he was worried about Morris's plans for the agency: "I do think that you are trying to do too much and Magnum itself seems to be growing into a great big beautiful thing that, as far as I know, none of us on this side [meaning Henri and Chim] particularly wants to have."[2]

Morris had greatly enlarged Magnum's members' list. Also, the agency now had a three-tier system (still in use today), with associates (Brian Brake, Jean Marquis, Ernst Scheidegger) and contributing photographers (Ansel Adams, Philippe Halsman, Dorothea Lange, Russell Lee, Herbert List). Trudy Feliu was heading the Paris office; John Morris was still an executive editor; Inge Bondi was secretary-treasurer; Chim was president; Cornell Capa was vice-president of American operations; Cartier-Bresson was vice-president of European operations.

Rodger was a little cheered by the French publication of *Le Village des Noubas*. Also, several of his pictures had been chosen for "Family of Man," the seminal exhibition curated by Edward Steichen at New York's Museum of Modern Art. Among them were some of his Kordofan Nuba pictures from 1949, and others of women walking in single file, carrying baskets, from the Aluma Plateau in French Equatorial Africa. It was the first time his work had been shown in a museum.

He spent the early part of 1956 in Bovingdon where he began working again on an assignment for the Land Rover company. By February he and Jinx were working on a story proposal for *National Geographic*. Magnum had found them an assignment in Libya, but just as they were about to set off in early April, it was canceled because of border skirmishes on the Algerian frontier. The Rodgers were out of work and out of money, and obliged to run a tab at the local grocery store. Rodger patched things up momentarily with a few European assignments—Germany, Belgium England—but he was looking for an excuse to travel farther afield.

On November 3, 1956, Rodger's father died at eighty-six. "Father died this afternoon at 3.30," he wrote in his diary. "He was last conscious yesterday morning when his last whispered words to me were 'I think I'll go to sleep'—and his

passing was as simple and peaceful as that."³ Rodger, Sr., was cremated a few days later at Stoke-on-Trent; his ashes were sent to Selkirk in Scotland. The funeral took place on November 8. Two days later, Jinx and George moved to Weeks Farm in Kent. From there they continued to look for a house to buy.

More bad news quickly followed. A few days after an armistice had been signed between Israel and Egypt, Chim, on assignment in Egypt, set out to photograph an exchange of wounded soldiers at El Qantara. On November 10, near the Suez Canal, Egyptian machine gun bullets struck the jeep in which he and journalist Jean Roy were driving. The jeep turned over into the canal. Both men died on the spot.

Jinx wrote in her diary: "This morning Trudy [Feliu] telephoned from Paris the unbelievable, tragic news that Chimsky—our dear Chimsky—was killed in Egypt. We feel so sad—so terribly sad . . . Magnum has been severely hit for the third time."⁴ Rodger was shocked by the loss of his friend. It did not seem right that a peaceful person like Chim should die at war—Chim had never considered himself a war photographer.

Of the original Magnum founders, now only Cartier-Bresson and Rodger were still alive. The agency was in crisis, rudderless. Cartier-Bresson was trying to hold things together, but he had to leave for an assignment in Poland and needed help. The Rodgers traveled to Paris for an emergency meeting with Cornell Capa and Cartier-Bresson to discuss the future of the agency.

Rodger was shocked to almost complete silence. In September he had written to Cartier-Bresson asking the agency to compensate Chim for his work as executive director: Chim had been getting no pay for his efforts. And on October 22, Chim in turn had sent Rodger a letter from Rome: he was eager to talk things over with him before the annual general meeting in November. "My executive functions . . . were more frustrating than you can imagine," he wrote.⁵

In a memo dated November 16, 1956, Cartier-Bresson noted: "Although deeply shaken, Trudy and the whole Paris office have carried on quietly what had to be done immediately." At the following January's meeting, Cornell Capa stepped in to replace Chim.

A few days after the news of Chim's death, Cicely's mother, Lady Hussey-Freke, also died. "What a month it has been," wrote Rodger in his diary on November 19. "Fazzy, Chim, and now mother Hussey-Freke."

Though his financial situation was dire, Rodger had to turn down a *Fortune* assignment to fly to the Sahara; he would have had to go alone and he did not feel well enough for the plane trip, nor did he feel he could function on his own. While in Paris he had dinner with Marc Riboud's brother Jean, and they talked of going

on a trip to the Sahara, on assignment from Schlumberger. On December 8, the arrangement was firmed up: Jean Riboud gave them a three-week assignment at $100 a day to cover oil-drilling projects and new French highways in the Sahara.

With only that small advance behind them, the Rodgers decided to launch a cross-Sahara expedition. They would find other stories to cover along the way. They had made tentative contacts with *National Geographic,* to which they had sent their proposal, but there was nothing definite. Jinx recalls:

> It was an act of bravura: George had something to prove. Until then Capa, then Chim had always been able to find him assignments. But now he was completely on his own, and for the first time he felt stuck, like a turtle on its back, without perspectives. That's why we went. When we started, driving from Paris to Morocco then camping in the desert, it was pure joy. We were singing though there was no one to hear. There had been such a buildup—George's disabling headaches had lasted from 1953 to 1956. Now the fog lifted—it was such a release.[6]

They set off on the four-thousand-mile, ninety-day trip with a half-ton of equipment. The typed list of contents for customs went on for four pages. From Paris to Morocco, they lived out of their Land Rover. Again, thanks to Rodger's planning, they would never be stuck without food, drink, or gas.

With the Algerian War raging, they had to argue relentlessly for visas. Because all traffic leaving Algiers for the south was being attacked by armed bands, the Rodgers decided to avoid the usual route and enter the Sahara through Morocco. In Colomb-Béchar they reported to the police, who were surprised they had not been shot by the *fellaghah*. Rodger's diary reads: "The Algerian customs man, when he heard we intended to go by Tamanrasset, said: 'It is the best way to die.' "[7]

Rodger was ecstatic. The tougher the conditions, the better he felt. It took him back to his World War II Sahara trips. They journeyed on rough, stony roads covered with fine dust and got stuck in soft sand dunes, where Rodger could show off his talent for negotiating sand tracks. The road markers could be stone cairns, a pile of bleached camel bones, or an empty whisky bottle.

The "western camel," as the Tuareg called their Land Rover, vanquished the Tanezrfout desert—known as "the land of fear and thirst"—surviving both sandstorms and flash floods. On the way to Colomb-Béchar, a landmine was set off by the truck immediately behind them, but they escaped the explosion. They saw the monument that had been erected to General Leclerc where he had been killed in a plane crash in 1947. They departed from Colomb-Béchar with a military convoy of one ambulance, eight armored cars, fifty young French soldiers,

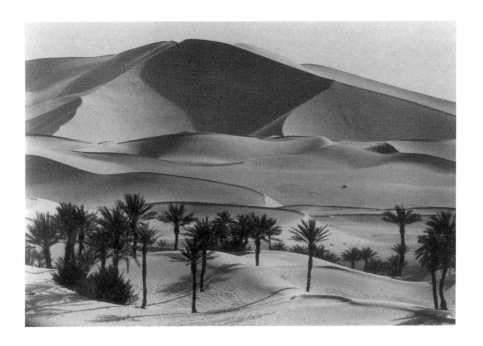

The dunes of Kirzaz, Algerian Sahara, 1957. © *George Rodger/Magnum Photos.*

and seventy trans-Sahara transport trucks bound for the south. Soon after, left to their own devices again, they continued their trip to the Hoggar Piste, observing scrub grasses, tamarisk trees, and Sodom apples. The towns they passed were colored orange, ochre, or red mud. The scenery changed every day, from rough and stony plateaus, to dunes and soft sand, then oases, then the jagged peaks and fantastic boulders of the Hoggar.

The best part of the trip was camping out under the desert stars. South of Tamanrasset, through a local schoolmaster, they encountered the Tuareg. They traveled from camp to camp, each time welcomed by an extended family. Under the shade of a large reed hut, Rodger made striking black-and-white portraits of a Tuareg matriarch with beautiful, expressive hands and large, dark eyes, her face framed by a black veil. Later she invited them to attend a feast in honor of her granddaughter.

During that trip Rodger recovered his spirit. He worked nonstop, both in color and in black and white, covering their Schlumberger assignment and also producing beautiful photographs of the deserts, the fortress of Timimoun, the Tuareg people, and flash floods at Ghardaïa. They all found their way into his first important publication in several years, "Sand in My Eyes," published by *National Geographic* in May 1958: thirty-three photographs with a long text by Jinx.

Most of 1957 was spent working, uneventfully, on an industrial assignment for *The Lamp* in Ethiopia: "Took first pictures in Ethiopia—the Stanvac terminal," Rodger wrote in his diary. "It was neat, tidy, very dull and exactly like all other terminals all over the world."[8] Then on November 13 a cable from John Morris reached them in Djibouti, confirming that *National Geographic* would pay their expenses to go to East Africa and photograph large game. They arrived in Kenya by boat and worked in Nairobi National Park and Amboseli National Reserve photographing elephants, lions, baboons, and oryxes, with snow-capped Kilimanjaro in the background. In Uganda their route cut through the "Impenetrable Forest" where Rodger had first encountered the Pygmies. Some of them came out to greet the Rodgers at their campsite near the Hihizo River. They continued on to Queen Elizabeth National Park in Uganda near the Congo border.

Rodger had wanted to photograph wildlife because of ecologists' reports that much of Africa's wild game was endangered. By the end of the 1950s, half the original wild areas of Africa had already been eliminated, and 75 percent of the animals in the remaining areas had died as a result of poaching, habitat destruction, and government-sponsored schemes to control cattle disease.

The Rodgers continued traveling through the spring of 1958 in various reserves of Kenya, Uganda, and Congo—among them the Garamba National Park, the Murchison Falls Park, and the Tsavo Royal National Park. Rodger

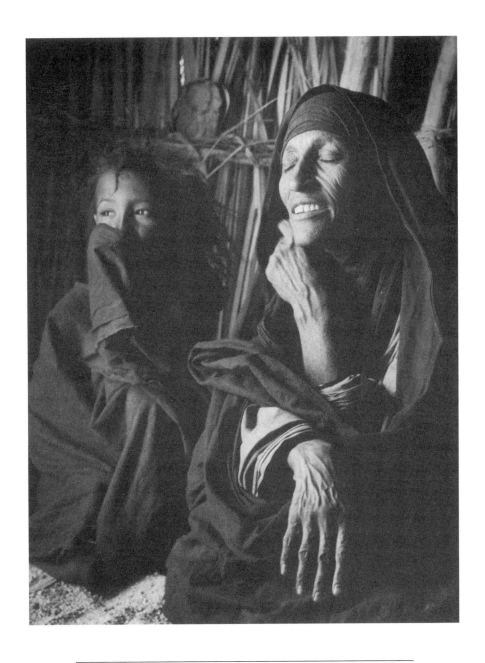

A Tuareg matriarch in Tamanrasset, Algerian Sahara, 1957. © *George Rodger/Magnum Photos.*

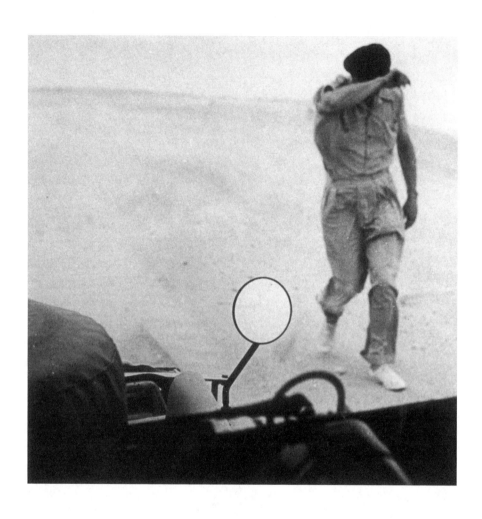

George Rodger looks for tracks during a sandstorm in the Algerian Sahara, 1957. © *Jinx Rodger.*

added to his photographic collection white and black hippos, kongonis and giraffes, and an amazing collection of wild birds. They escaped animal stampedes. They were awakened on a full-moon night when an elephant pushed his head through their hut window. (The elephant took his time circling all around their hut before sauntering off at dawn.)

Near Moyo they witnessed a ritual dance by the Madi people, who performed music on traditional instruments. In northeastern Uganda they encountered Napore herdsmen, and attended their blessing of the spears, a ceremony performed before every hunt. The Jie and Dodoth of Karamoja were also among Rodger's subjects. As always, traditional life brought out Rodger's best—some of the pictures he took were black and white, and personal; others were in color, for magazines to print.

Their *National Geographic* piece, "Elephants Have Right of Way," published in the fall of 1960, included pictures of both wildlife and indigenous life; George and Jinx wrote the text together. The piece ended on a hopeful note: "Though tribal land may disappear and new roads open the country wide, with African cooperation there will always be places where elephants have right of way." [9]

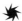

Though the Rodgers had enjoyed their African trip and their rough conditions on the road, camping out or sleeping in the Land Rover's bunks, they felt very much in need of a home to come back to. In the fall of 1958, on returning to England, they purchased for £2,250 a group of four small Tudor cottages in an old Kentish village called Smarden. Waterside House had a pond and a garden and was just across the street from the Norman church of St. Michael and its cemetery.

Only one of the cottages was habitable—and just barely at that. Even so, Jinx and Rodger were excited about owning their own home, and in a pouring rain at the end of October 1958, they moved in.

By then, Jinx was pregnant with Jennifer, the first of their three children. After the baby was born the following spring, Jinx looked after her while Rodger spent all his free time restoring the cottages. He carried out this task fastidiously; it would take him a good part of the next seven years to complete. One has the sense that manual work was his therapy, that he enjoyed it so much he never wanted it to end. The first task was to dig out twenty tons of clay to drop the floors (the original ceilings were not high enough to stand under for anyone taller than five feet six). Then he had to renovate the cottages from top to bottom, drawing plans, tearing walls down—there were sixteen bedrooms and four

Jinx Rodger making friends with women of the Dodoth Tribe in
Kaabong, Karamoja, northern Uganda, 1958. © *George Rodger*

staircases in all—and joining the cottages into one larger house. Finally, there was the garden to landscape.

Always a perfectionist, Rodger took all the work very seriously. He studied Kentish architecture and history and gathered information from books and through conversations with locals. "In order to restore a period house it is necessary to use materials of the same type and date," he wrote, "and my search for old hand-made bricks and tiles and centuries-old timbers, took me all over the county." [10]

Finally, the adventurer and his wife had what Rodger referred to as "a den of our own."

19

Public Successes, Private Ordeals

This book has focused on George Rodger's adventures in photography. In the latter part of his life, his enthusiasm for daring exploits left him. He no longer saw photography as his vehicle to adventure; it became, mostly, just a job.

Now that he was no longer constantly on the move, Rodger put a lot of energy into Magnum politics, taking an active part in the Paris office and in meetings where decisions were made. Magnum in the 1960s and 1970s was a place of drama, upheaval, and change.[1] Many Americans joined the organization; more staff were hired; members were getting married, buying homes, and having children. Dinner parties replaced bistro nights; the old freewheeling spirit gave way to a more formal approach.

The alliance between magazines and photographers became an uneasy one. Many editors had gone back to treating photographers as mere illustrators. Photojournalists had lost some of the status they had gained over the past decades. Their field was in crisis: the public had seen it all and was more attracted to television than to print. Many magazines, including *Look, Life*, and the *Saturday Evening Post*, were forced to close, and Magnum began scouting for other venues for making a profit, including films, education, annual reports for industry. The generous postwar spirit in which Magnum had been born had been replaced by troubled and uncertain times—the ongoing Cold War, a divided Germany, the Algerian War, the Vietnam War, civil unrest in the United States . . . As Cornell Capa put it: "Magnum was learning that the Family of Man is not one."[2]

The 1960s were full of change for the Rodgers. By the middle of the decade they had three children: Jennifer (born 1959), Jonathan (1962), and Peter (1965). Rodger continued traveling, although not as much as before. He worked mainly

in England, and his assignments were run-of-the-mill magazine reports that followed someone else's agenda—jobs of the sort he had hated so much when he worked for the BBC: "Princess Margaret's Wedding" (1960), "London Restaurants" (1961), "Churchill's Funeral" (1965), and illustrations for a publication called the *World of the Horse*.

In the mid-1960s he was hired by ICI Pharmaceuticals. He was not thrilled about making pictures of seated chairmen of pharmaceutical plants and synthetic-fiber factories, but it paid the bills and fulfilled his constant desire for travel in the Middle East. In 1966 he did a story in color on "Ancient Cities of the Middle East," traveling to Lebanon, Syria, Israel, Jordan, Turkey, and Cyprus for a book that was published two years later.[3] His assignments of 1966–67—some of which he undertook with Jinx—included trips to Baalbek and Byblos in Lebanon; Palmyra in Syria; Old Jerusalem; Petra and Jerash in Jordan; Goreme, Cappadocia, Ephesus, Pergamum, and Bogazkoy in Turkey; and various locations in Greece. All these pieces were in color.

In the 1960s, Rodger's participation with books increased. He contributed regularly to Time-Life books, among them *The Desert: 25 Years of Life* (1961) and *The Arab World* and *Ecology* (both 1962). He supplemented his income with assignments from *Paris-Match*, *Fortune*, and *Scientific American*, and with company reports for Schlumberger and Esso.

One of his most successful stories was a 1962 piece for *Paris-Match* on Charles Dickens's London, for which he photographed places the author had described in his novels. His London, decaying and labyrinthine, suffused in fog and darkness, strongly evokes Dickens's world view. Rodger knew a thing or two about ghosts, so there was no one better qualified to find in the present traces of a disappeared past. Along similar lines, he worked on a literary series for the *London Sunday Times* that linked writers to their home places—Robert Burns and Sir Walter Scott to Scotland, and again Dickens to London.

Rodger's mother died on August 15, 1961. Here was another specter to haunt Rodger and to remind him of his own mortality. At that time he wrote Jinx:

It is a sad time, these last few twilight hours. Last night, as the day was fading, I walked into the garden and the sun was still shining on The Cloud where we used to live, though it was dusk already down here on the plain. And there was a dark sky behind. But against it there was the gold of the corn in the fields where we played as children and the green and the grass of the pastures. And I thought of the *Kamundere*, the song of the Pygmy people of the impenetrable forest that the King of Kigezi translated: "I am old and as dried grass in the sun. But, when

I am gone, Spring will come. Fresh green will come from my roots with the rain and I shall live again in the lives of my children."[4]

Reading this letter, one has the distinct feeling that Rodger was mourning not just his mother, but something of himself that had died as well.

Rodger's series "Venice in Winter," in black and white, has an elegiac quality, conveyed through the strong lines of the magnificent Italian city in the desolation of winter. Rodger's interest in people is nowhere to be seen in these images; here he focuses on the city itself; the streets are empty of all but furtive silhouettes. This reportage appeared in many magazines, and many of the images from it were made into postcards and posters. (Three decades later, in 1995, when Peter Rodger learned of his father's death, he happened to be in a restaurant in Greece, seated next to one of Rodger's "Venice in Winter" posters.)

Rodger was an expert at hiding from his own emotions; now he was striving at all costs to avoid recording discord and suffering in his work. The effect in his photographs is unpleasant. They give out a sense of forced, or false, harmony, not the genuine happiness that radiated from his earlier African photographs. Because he eradicated from his imagery any hint of suffering, his photographs suffered a loss of content; they have a merely superficial beauty that is almost painful to look at.

Rodger was not unaware of his denials. In 1977 he traveled to India with his middle child, Jonathan, then fifteen years old. The trip had not been well organized, and Jonathan was generally miserable, as well as appalled by the poverty he saw. After they returned home, Rodger wrote somewhat defiantly:

> We projected my colour slides and my wife asked why I had no pictures of beggars, especially as they seemed to have affected Jonathan so acutely. It was an interesting point. Certainly I had no pictures of beggars and carrion kites. All my children are smiling or looking pensive. None of them are shouting "Baksheesh mister!" at the top of their horrid little voices and jumping in front of my camera. There are no down-and-outs in my India. No stench. It is all Shangrila. And why not? It IS serene for an hour after sunrise and for an hour before the sun goes down . . . Nobody looking at my pictures would ever suspect that some of them stank to the high heaven.[5]

This sanitized "Shangrila" was bought at a cost. Years later, photographer Peter Marlow, a colleague at Magnum, edited Rodger's 1995 monograph *Humanity and Inhumanity*. He observed that as they were selecting images for the book, Rodger resisted Marlow's editorial choices and consistently went for photographs that were not his strongest. Marlow noted: "We had quite a few argu-

ments about editing: he self-censored . . . he was self-conscious, overly senti-mental, and could not share the dark side of his experience. The kind of pictures he felt strongly about were often pure sentimentality, and he was rejecting some material that to me had so much more emotion."[6] Rodger's editorial self-censorship[7] is a central reason why his work did not gain more recognition. He was his own worst enemy.

Rodger's son Peter also noted that his father was "a man whose inner self is like a locked cabinet."[8] As a result, when Rodger's repressed emotions did sur-face in his life, they were distorted. Through denial, sentiment became twisted into sentimentality. Jonathan Rodger remembers that "he was very emotional about animals or any little bird or cat dying . . . He wrapped my cat up in his fa-vorite sweater when it died when I was in India in 1987—a cat that he never wanted in the house in the first place."[9]

The inspiration and poetry that had been so potent in Rodger's earlier pho-tographs were now rarely found in his work. He recognized this and admitted it freely, if indirectly. Speaking with Tom Hopkinson about a story he did in the late 1970s on the Masai, he said: "My Masai story is the first I've felt really happy with since I left Kordofan in 1949."[10]

By the mid-1970s, Rodger's work had become better known in Britain and Europe. He was included in two major British historical exhibitions that traveled widely: "Personal Views: 1850–1970" (1970) and "The Real Thing: An Anthol-ogy of British Photographs 1840–1950" (1975). The prestigious Bibliothèque Nationale in Paris requested a set of fifty prints for its collection, and historian Helmut Gernsheim included Rodger in his classic *History of Photography* (1965).

Photography was beginning to be considered an art; even so, Rodger never saw himself as an artist. He continued doing assignments for magazines, film companies, and industries, and photographing for company reports. Beginning in 1968, his often meager income was supplemented by a monthly pension from Magnum.

In 1974 Rodger had his first one-man show at London's Photographers' Gallery, organized by a long-time supporter, Sue Davies. This was followed by many more shows[11] and by an invitation to the annual Rencontres d'Arles pho-tography festival in 1976, where one of that year's major exhibitions was "British Photographers," at which Rodger was a guest of honor. His appearance at Arles led to a number of interviews and profiles in European magazines, and Rodger emerged as a public figure. Requests for exhibition prints became more numer-ous. Rodger, whose eyesight was beginning to fail him, trained his son Jonathan as a black-and-white printer.

In the 1980s both *Life* and Magnum looked back at their beginnings; as one

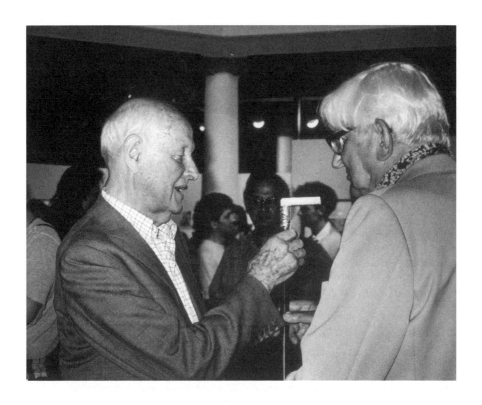

George Rodger *(right)* and Henri Cartier-Bresson at the opening of Rodger's exhibition at the Royal Photographic Society, Bath, England, 1994. © *Joan Wakelin.*

result, a large number of anniversary exhibitions and publications featured Rodger's work. Among them were *This Is Magnum* (1979), *Paris-Magnum: Photographs 1935–1981* (1981), *Terre de Guerre* (1982), *Magnum Photographs 1932–1967* (1985), and *Magnum en Chine* (1988). Also, 1989 saw the publication of a huge retrospective book commemorating the agency's fortieth anniversary, *In Our Time: The World Seen by Magnum Photographers. In Our Time* was intended as a major historical study; but when it came out, Rodger was sorely disappointed to find that his biography in the book, by Stuart Alexander, was sketchy, and that French historian Jean Lacouture had completely ignored his role as one of the agency's four founders and as a major presence in Magnum's affairs. In Rodger's letter to Lacouture, his usual elaborate politeness barely conceals his sadness and bitterness at being overlooked:

> I am constantly asked by people who know my record why a text piece on the Founders of Magnum should be written about three when they all know there were four. This is very embarrassing. Magnum's Paris office sent me the English translation of a revised paragraph. That is perfectly okay as a paragraph but it still leaves me basking in the reflected glory of "The original trio" when, in reality, I was one of the originals myself. Far from "remaining in the wings" and "refusing all responsibility," I played a very active part. For instance, when Capa resigned the Presidency on April 26, 1952, he handed it over to me and it was I who pulled Magnum out of the financial mess it was in and established financial order in the organization. I outlined a constitution which was ratified at the December A.G.M. I was on the Board of Directors for the next twenty years, handing my proxy to Henri when assignments prevented me from attending meetings in person. [Not living in Paris] did not deter my concern over Magnum, my closeness and my upholding of the "spirit" . . . After our 1953 meeting in the Hotel Lancaster establishing percentages, I was able, a year later, to veto New York's expensive endeavour to appoint an American director for the Paris office.
>
> But this is beginning to sound like a vindication which surely isn't necessary. As the text reads at the moment I am written off as an outsider, very early on, with no mention of what I meant to Magnum. It is all in the historical memos, in the minds of the early members, but it is not in the FOUNDERS text of IN OUR TIME.[12]

Indeed, Rodger had always been extremely involved in all of Magnum's decisions, and his business advice was always sound, as is obvious in his correspondence with Chim and later with the members of Magnum's board—especially with Marc Riboud and Cartier-Bresson.[13]

Fortunately, Fred Ritchin's text "What Is Magnum?" in the same volume gives a major role to Rodger. In the opening paragraphs of his piece, Ritchin uses

Rodger's presence at Bergen-Belsen and his subsequent decision to work in Africa—"to get away where the world was clean"—as a metaphor for the meaning of photojournalism as a profession; and later in the text he acknowledges at length Rodger's role at Magnum.[14]

Is it impossible to be an adventurer if one has a family to support? Should Rodger's circumstances bear the blame for the poorer quality of his photographs in the later years of his life? Perhaps—but only partially. After all, Rodger had wanted a family, and Jinx was doing most if not all of the family work.

The probable cause of Rodger's diminished inspiration was that he was still plagued by severe depressions, which struck him every year on the anniversary of Cicely's death. "Each October he would clam up and sink in guilt and sorrow over Cicely," remembers Jinx.[15] Later on he also suffered panic attacks when he traveled alone; this restricted his career considerably, as Jinx was now tied up with home and children and could not travel with him. When Peter Marlow was editing Rodger's contact sheets for the 1995 monograph, he noticed "huge gaps in his work due to his breakdowns."[16] Rodger's yearly depressions and the constant fight he put up to repress painful and traumatic memories sapped the energy from his work.

In the 1980s, Rodger's health began to fail: he had leg ulcers, a hip replacement, then cataract troubles that prevented him from photographing. Worst of all, he lost most of his hearing; even hearing aids did not help. "Those were difficult years for us," remembers Jinx. "George's loss of hearing was a great drawback. Magnum meetings were agonizing for him as he could not hear what anyone said even though they were *shouting*. He felt very isolated because of his deafness . . . Gradually he had to opt out and took to writing messages on his old typewriter. It was a big help when the FAX machines appeared."[17] And Rodger's loss of hearing of course intensified his sense of isolation.

Late in life Rodger's fear of loneliness became extreme: he needed to feel Jinx's presence in the house even if he was not talking to her and was working in a different part of their home. Her presence was a buffer that protected him from his demons. He must have detested his dependency—as well as the fact that Jinx was so aware of his frailty. As ever, he wanted to present a strong façade to the world. He had become like a crab, rigid outside and soft inside, his flesh devoured by sadness, guilt, and regrets. Cicely's ghost had appropriated his sub-

stance, and in some ways he had become a ghost himself—a syndrome that his African friends might well have understood.

Many men and women—journalists, curators, and above all young photographers—saw Rodger as a father figure. They were taken in by his front and seduced by his charm, his sense of humor, his quizzical, unassuming manner, and his willingness to listen. He would make well-chosen remarks with his deep, vibrant voice, and they would listen as if to an oracle.

Those who remember Rodger tend to fall into two camps: staunch, unfailing admirers, and those who knew first-hand his darker side. English photographer David Hurn is one of the former: "George was one of my heroes . . . never let my hero worship down, he was one of the great human beings." [18] But those closest to Rodger often were more ambivalent. Rodger's youngest child Peter was caught between two sides of his father that he could not reconcile any more than Rodger could. Three years after his father's death, Peter described him as "bitter, angry, self-possessed . . . passive-aggressive, manipulative." But at the same time, "he was also the wisest, most intuitive and succinct human being I ever met. He taught me character, how to see, gave me a key to doing things he could not do. And when it came to sitting down at contact sheets he gave me all the time in the world." [19]

His son sensed of course that with Rodger the giving could rarely be direct; it often had to be mediated through an object—letters, contact sheets. But children crave from their parents a love that is more open and more immediate; they need to be seen, appreciated, and encouraged. These were things that Rodger was unwilling or possibly unable to give.

Rodger in his seventies was still handsome, his face tanned not from the desert sun but now (more prosaically) from working his vegetable and rose garden, which he kept with pride and thrift, just as his mother had tended hers.

He was instrumental in the opening of Magnum's London branch in 1986. In his last years, Rodger was in his best form either there or with younger British photographers and editors who came to visit him: Chris Steele-Perkins, Neil Burgess, David Hurn, Peter Marlow, and others. Burgess recalls Rodger's enthusiasm at the notion of setting up the London office: "George was excited . . . about the possibilities. His warmth and encouragement was of huge importance to us in light of indifference and even hostility from elsewhere . . . I was surprised at how youthful his attitude was; he was fully engaged and his quiet enthusiasm was infectious." [20]

As always, the rift separating his public and private lives was deep. In his years roaming the world, Rodger had often claimed that he needed a home, a place to come back to between trips; he had not known himself enough to realize that when he settled down, he would sink. Only perpetual movement had spared him from himself. Even with the busy work he attended to at home—keeping his garden and his house—staying in one place was extremely difficult for him. Whenever he saw his children relaxing, he would invent a chore for them to do—they were being "lazy." Television and films were banned, and the children were never allowed to sleep late in the mornings. "The house was oppressive," Peter remembers. "There was a sense of doom, a cloud around his head . . . We were not allowed to be happy. Happiness was not allowed."[21]

Rodger showed a clear preference for Peter's older brother Jonathan, which was of course painful for the younger son. As for his daughter Jennifer, girls held little interest for Rodger—unless they were young journalists and part of his fan club. "It was very much a patriarchal family," Jinx recalls. "In this patriarchal lineage it was very hard for a woman to find her place. Jenni felt that he expected too much, thought that she could never live up to his expectations."[22] Jennifer, who was his first born, was a problem to Rodger from the start. In 1958, Jinx's pregnancy stirred renewed feelings of guilt, sorrow, and fear over the tragic death of his first daughter, Mary Ann. Records show that Rodger did very little work in that period, and letters from Jinx to John Morris, her close friend and surrogate father, indicate that Rodger was terrified and depressed while she was pregnant.

Later on, when Jenni was a young woman, Rodger clashed constantly with her over the way she managed her private and professional life. When he drew up a will, he called Jonathan "My son and heir"[23] and did not include Jenni in the will, in spite of protests from both Jinx and the lawyer. (Jinx later altered these provisions to make them fairer.) Jennifer resolved the situation by moving away. This allowed her to keep a close relationship with her mother while retaining a kinder image of her father, about whom she never said anything negative.

Rodger was rarely a model husband to Jinx, the brave, funny, intelligent woman he had married. Resenting his own growing dependency on her, he treated her as a combination nurse-researcher-secretary-cook. In his worst moments, he made it plain that Jinx had been his second choice: throughout his life, he kept alive his treasured, idealized myth of Cicely and the life they could have had.

Dorothy Parmalee, Cicely's favorite sister and a close friend to Rodger, recalls that shortly after Cicely's death he came to ask for some family portraits of Cicely. His intention was to erect a shrine to her in his own house; he would be

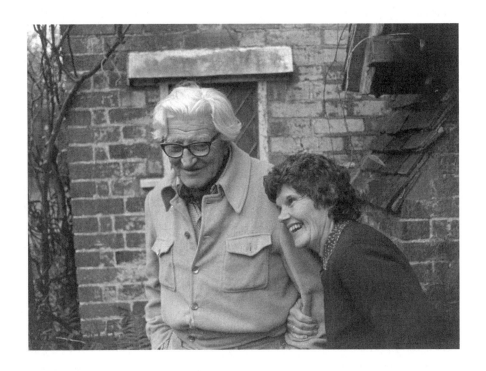

One of the last pictures of George and Jinx Rodger together,
Waterside House, Kent, England, 1994. © *Peter Johns.*

the only one with the key. Dorothy had the good sense to refuse him. She observed that he was "overly emotional"[24]—a summation that might have astounded many of Rodger's friends and colleagues, but was in fact true.

In response to Rodger, Jinx developed a tough, brisk manner and kept herself very busy. She took a teaching job at a private school and in this way paid for their children's studies and kept the family afloat in financial circumstances that were often dire. Rodger, ever obsessive about money, scraped pennies, demanded that Jinx bake their bread, bought a deep freezer, and then would drag home half a cow or half a pig, which she was to butcher and freeze. ("One of the worst experiences of my married life," Jinx recalls, "was to bag those pieces of cow, label them, and blow the air out. It put me off meat forever."[25]) Through the concession at the school where she taught, Jinx bought supplies in bulk: "Nescafé in seven-pound jars, baked beans and jam in six-pound jars . . . They were stale long before the end of the tin."[26] She spent the summer months freezing fresh vegetables for the winter.

Yet Jinx remained utterly loyal to Rodger, and concealed to the outside world whatever despair she might have felt. She once stated that when she married him, Rodger was "a wreck"; when asked why she had married him, she simply answered: "He was my hero. I went into it with my eyes wide open—I knew what I was in for."[27] Jinx and Rodger did share a mordant and wicked sense of humor, which may have been part of what held them together, and what saved Jinx in the darkest hours of her life with her husband.

Unable to control his inner life, Rodger wanted to exert absolute control over his family and home. He was parsimonious to an extreme, never allowed Jinx to have a checkbook, and made her justify the weekly household expenses to the penny. He was forever turning lights off and heat down. His children had to pay for their own phone calls. He did not want to pay for their studies, and if Jinx had not had her teaching job, they would not have had good schooling. Peter recalls: "He was very tyrannical, holding himself and everybody up to impossible standards. With his family he was a biblical father and did not succeed with his own children. Isn't it strange that he became a surrogate father to so many people?"[28]

The three children had different fates. Jonathan, to whom Rodger was always partial, suffered the bane of the favored child: it was difficult for him to move beyond his father's shadow. He stayed on at Waterside House, where he had grown up and part of which he inherited. A gifted black-and-white printer, married with four children, he has not yet fulfilled his personal ambition of becoming a photographer in his own right.

Peter still harbored resentment against his father several years after Rodger's death. Some of what Peter has become stems from his reaction to

The Rodger family at Waterside House, Smarden, Kent 1990. From left to right: Jonathan, George, Jinx, Peter, and Jenni. © *George Rodger.*

Rodger. He is now a photographer based in California; he works almost exclusively in color, using complex equipment, choosing glamorous subjects, taking on well-paid commercial jobs, making portraits of celebrities . . . all things his father had looked down upon. And in sharp contrast to Rodger's perennial reticence, Peter is openly expressive—almost to a fault. His children Georgia and Eliott are much loved in the "American way."

Jennifer, Rodger's oldest child, may have suffered a different kind of response from her father: he may have felt a certain resentment—why was Jenni alive when Cicely's daughter had died? Yet Jennifer seems to hold no grudge against Rodger. She has found love and fulfillment in her personal life and in her career as an etcher. She lives in the south of France with her longtime boyfriend. Jenni does not have children of her own, and like her father shows little interest in financial success.

For the many visitors that flocked to Waterside House in the 1970s and 1980s, Rodger's failings were unknown. He was someone else entirely: a spiritual father, a guide, a kindly gentleman with a sense of humor, who remained unreadable but always adored other people's confidences. He was an attentive guide to many younger photographers, including Sebastião Salgado, who shared Rodger's passion for Africa. "We met at Magnum in 1979 or 1980," Salgado recalls. "We became friends right away. And it is through his photographs of Africa that we communicated. He was like family—the same age as my father. He recounted big pieces of his life to me. Then when I traveled to Africa he gave me tips about the seasons, droughts, rains. He projected himself in my trip. To him photography was not an art, it was a way of life.[29]

In the mid-1970s a measure of recognition came to Rodger in the form of retrospective shows and many books, among them Inge Bondi's excellent 1974 monograph, and *George Rodger: Magnum Opus* by Colin Osman and Martin Caiger-Smith (1987), as well as my own *George Rodger en Afrique* (1984). He received several honorary doctorates, and finally, in May 1995, was given a retrospective at the Barbican Galleries in London, which was accompanied by Marlow's monograph *Humanity and Inhumanity: The Photographs of George Rodger.*

Though very ill by this time, Rodger was able to attend the opening of his retrospective at the Barbican. Spanning an entire floor of the museum, it was a comprehensive survey of his career, from his images of the London Blitz to those of the Masai circumcision ceremony. There were several display cabinets filled with memorabilia: *Life* clippings, cameras, passports, and medals, and an entire

room dedicated to Bergen-Belsen (which Rodger approved only after a great deal of persuasion by Marlow and the curators). Some of his short black-and-white films shot in Africa were screened for the first time in public. By then, Africa had been for so many years the site of conflict and devastation that Rodger's images seemed to show a lost Eden.

After the opening, Rodger returned to Smarden. He would never again leave his house. His prostate cancer had spread, and he died eight weeks later, on July 25. The evening before his death, he had found the strength to water his rose garden for the last time.

20

Back to Africa

1977–1980

Before Rodger's death, Africa had given him one last gift.

In 1977 big news came to Waterside House: the Arts Council of Great Britain had awarded Rodger a grant to return to East Africa. At seventy, the photographer was still in excellent physical condition. He was thrilled; furthermore, he knew exactly what he wanted to do.

One project had been on Rodger's mind for years, since his journey in 1942—he wanted to photograph the Masai. But they were fiercely independent, distrustful of foreigners, and notoriously difficult to approach.

Rodger had tried three times to enter their territory in Kenya, but East Africa was in the throes of civil wars, drought, and famine. He knew the Masai had barely survived a recent cholera epidemic. On his first two attempts he had had to turn back without even making contact with them, and by 1979 he was despairing of his chances.

Then came a miracle of sorts: while Rodger was in a Brussels hospital having his vaccinations for his third trip to Kenya, he ran into an African acquaintance named Yusuf, whom he had not seen in many years. Yusuf's presence in the hospital was itself an amazing coincidence.

Yusuf was in the bed just next to his, and when he recognized Rodger he did not seem surprised. It was as if no time had passed, as if he had expected to see Rodger just then and there. Yusuf smiled his deep smile, turned to Rodger, and said: "Would you like to photograph the Masai? Some ceremony perhaps? They are my people, you know."

"Do I hear you?" Rodger asked, his heart pounding.

"You hear me, M'zee."

In his text "Masai Moran," Rodger recalled: "I could not believe it. On fifteen different visits to Africa I had tried to photograph the Masai and got no further than the polite offer of a long-bladed spear between the ribs."[1]

A few days later, Rodger was on a plane to Nairobi, where Yusuf was waiting for him. His Masai friend had been most mysterious and had not identified either the name of the ceremony or its location. He had arranged for a guide to meet them in Nairobi and take them to a village about which Rodger only knew that it was "south of Mara."

As promised, the Land Rover was ready when they arrived. They started out at dawn, driving south all day across a dry savana of grass, thorn bushes, and acacia. Rodger later recalled: "Yusuf attacked the African bush with his Land Rover like a hungry man biting at a sandwich."[2]

At the last stop before the village, they piled in barrels of oil, bags of flour and sugar, and bundles of fabric for their hosts. That night they slept only two hours. At four in the morning Yusuf woke Rodger and said: "Let's go. The village is still an hour away. The ceremony must start early. We believe that before sunrise there is less bleeding."

What ceremony? Rodger still did not know.

Silently, as if emerging from nowhere, a Masai warrior met their Land Rover. He was to guide them to the *enkang*, or village. There was no more road, and the warrior ran faster than the car could move. Rodger wrote: "A tall Masai ran ahead of the Land Rover to show the way. With his coat flapping winglike as he leapt over thorn bushes, revealing bare thighs, and his spear flashing in our headlights, he looked like some mad spectre dancing."[3]

The village consisted of four mud huts surrounded by a high thorn enclosure to keep out the lions. When they arrived, the women and young girls were already up, milking cows into leather gourds. An old man approached Rodger, and Yusuf introduced him as the senior elder who had invited Rodger to the ceremony. They touched fingertips—the Masai greeting.

Then a small group of adolescent boys, the *moran*, appeared on the dusty path. Their faces were elaborately decorated with white paint around their eyes and down their cheeks. They wore tunics of dark cloth and large headdresses of ostrich feathers. Rows of bracelets adorned their slim wrists. "The young *moran* were like hooded crows in their black cloaks and their dark *olemasari* headdresses," Rodger wrote.[4]

The *moran* formed a circle, but as the photographer approached they broke it to let him in. To his surprise he discovered at the center a dazed young man stand-

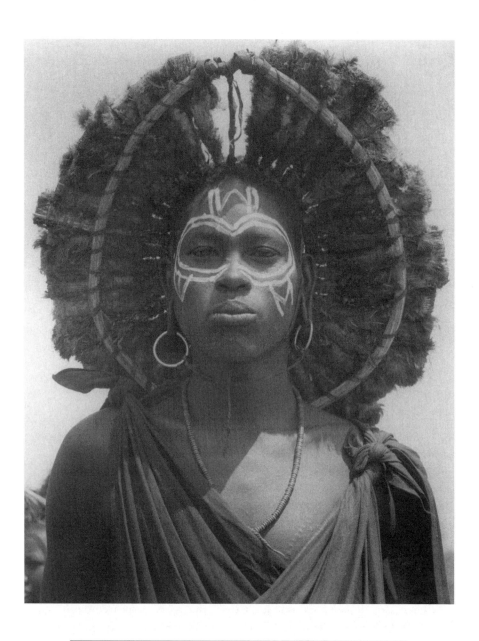

Before a circumcision ceremony, a junior *moran* (warrior) of the
Masai poses with a headdress of sundried bird skins, Kenya, 1979.
© *George Rodger/Magnum Photos.*

ing, his head shaved, entirely naked. He was looking down. It was only then that Rodger realized that the ceremony he was about to witness was a circumcision.

The *moran* crowded around the initiate, taunting him, prodding him with sticks, and mocking him, saying (Rodger later learned): "It will hurt like hell!" . . . "I bet you can't stand it!" . . . "You will cry out!" The young man remained impassive.

Rodger crouched on the ground as a young boy poured water over the initiate, who then threw himself onto a cowhide, leaning back against his "uncle," one of his father's peers, who held him tightly in his arms.

Rodger was concerned that the light was gray and poor. The sun was just rising, a few bleak orange rays trailing east, low over the brush. He was crouching low, unable to move. And a man who had decided to lean on his back made it difficult for him to steady his Leica for a quarter-second exposure. But he knew he had to do it somehow—he would never, ever have another chance like this.

The young man opened his legs.

The *alamoratani* (doctor), an elderly man, entered the circle and approached the boy carrying a small clasp knife, which he splashed with some white sap. The adolescents, who until then had been laughing and joking and jostling one another, suddenly fell silent.

Rodger quickly moved in with the doctor and knelt on the ground by his side, leaving the doctor's assistant enough elbow room.

> Then, he took the first cut. The young initiate's expression never changed. Neither did he flinch. A second cut was made and then a third. The loosened outer skin was pulled to incredible length, stretched so taut that I thought it must surely twang like a bowstring and then, with yet another cut, it was finally severed. The whole operation took more than a quarter hour and it seemed to me it was prolonged intentionally to test the initiate's fortitude. The pain must have been excruciating—no less than an appendectomy without anaesthetic—but, throughout, the young man showed complete indifference. His expression never changed.[5]

Although the boy's features had never moved during the operation, he was only half-conscious when he was wrapped in the black cloth cloak that signified his entrance into the group of warriors. He was raised up by his "uncle" and brought to his mother's hut. Once he was inside, women of his mother's age planted a sapling by the low doorway to show that a newly circumcised son was in residence.

Then the new *moran* had to be revived with fresh blood. One of his friends

tightened a rawhide thong around the neck of a young bullock, then shot an arrow into his vein from a miniature bow. The quick rush of blood was caught in a gourd by a little boy, who hurried to the hut with it.

Rodger followed him, crawling on his hands and knees, and stole a look inside. A fire was burning, filling the hut with thick, acrid smoke. Dimly, Rodger was able to see a woman lift the gourd to the lips of the young man, urging him to drink. But the heavy smoke made it impossible to photograph.

When Rodger got back to the clearing he saw that a large crowd was assembling: women and children were arriving out of the bush in groups to take part in the celebrations. Rodger's friend Yusuf told him that some had walked all night from distant settlements. The *nditos*, or young girls, were decked in all their finery: beaded headdresses, large necklaces of beads, buttons, and cowrie shells around their necks. Shyly, they approached the young *moran*'s hut; they had come as playmates for him and would stay with him as soon as the healing period was over.

A group of warriors began dancing. They towered over six feet, their skin as black as skin can be, their limbs and torsos long and slim. Their dance was without any music or drums, just a vocal rhythm provided by the women. They jumped in rhythm, repetitively, arms to the flanks, their heavy necklaces clicking. They pushed off the ground from their ankles, jumping higher and higher, raising clouds of dust.

Stunned at his luck, amazed that he had been allowed there at all—and afraid that the Masai would suddenly change their minds and take back the privilege—Rodger had been photographing steadily for more than four hours. He had not wanted to use a flash, which would have been too disruptive, and he had been using his Leica without being able to measure his exposures. But when he arrived back in England a few days later, Rodger saw that he had done his best work since his time with the Nuba. The intensity and beauty of the images is deeply moving; the Masai have an indescribable presence. They are self-contained yet highly aware of the witness they have allowed into their life. "See us," they seem to be saying. These were people living in conditions that most Westerners would find unbearably limited, yet their faces exuded a profound fulfillment. The Masai would be photographed again, but no one would ever capture their spirit as Rodger had.

He may have sensed as he was making these images that these would be his last pictures of the place he loved most: this was Rodger's farewell to Africa.

Epilogue

My last conversation with George Rodger was on April 21, 1995, five weeks before the opening of his retrospective at the Barbican Galleries in London. His monograph, edited by his friend Peter Marlow, had just come out, and I was writing a review of it for an American magazine.

I called him: Did he remember the exact date when he had entered Bergen-Belsen with his driver, Dick Stratford? Rodger looked at his war notebooks. It had been fifty years to the day—April 21, 1945.

On July 25, Rodger died. His obituary appeared in the *New York Times* four days later. It was titled "Death of an Adventurer" and was written by Alan Riding, who mentioned that Rodger had been "long overshadowed by two other cofounders of Magnum, Robert Capa and Henri Cartier-Bresson," but acknowledged his work at Bergen-Belsen and among the Nuba. He also quoted Cartier-Bresson as saying that Rodger "belongs to the great tradition of explorers and adventurers."

It was somehow impossible to believe he had died, that that inscrutable Cheshire cat smile and warm voice had vanished for good. I was in tears when I called Jinx, but on the phone she took her usual brisk tone: "Don't be sad. He had a great life. And he has been so sick: better to see him go now. Do not send flowers! We have so much, from George's garden. Love to Fred and the boys." It was *she* who was consoling *us*.

I did not bring flowers. In England, it was George's favorite weather: sweltering heat. On the train from London I changed into shorts and a T-shirt; the funeral was not going to be formal.

From the train station at Headcorn, Kent—the town closest to Smarden—I called Waterside House so that one of Rodger's children could come and pick me

up. But the line was busy, though I tried several times. Some things never change, I thought. Must be Marc Riboud on the phone.

Riboud, a frequent visitor to the Rodgers and a close friend to Jinx and George, was always calling Magnum's Paris office from their house—to Rodger's chagrin (he was never sure whether Riboud had remembered to reverse the charges). Whenever Marc was on the phone, Rodger would pace nervously just outside the door; Riboud, oblivious or perhaps secretly provocative, would carry right on chatting.

When my taxi pulled onto the curb near the fig tree I saw—slightly blurred and bent out of shape by the house's hand-blown windowpane—sure enough, Riboud's head of white hair, nodding up and down as he held the phone receiver in the crook of his neck. I rang and rang before he heard the doorbell.

The house, despite Jinx's advice, was full of flowers. More bouquets were on the tables outside. Guests were flowing in, neighbors bringing trays of food, homemade pies, more flowers.

The service was strangely devoid of emotion. Rodger was absent, not only in person but from the eulogies. St. Michael's was full: the family up front, then a mix of Magnum colleagues from Paris and London, and the entire village of Smarden. In the back, tall and silent, two Nuba representatives stood holding a bouquet of irises.

It felt as if Rodger had bowed out once more, as if he was brooding in his studio upstairs, lost in his private world, battling with his ghosts, away from his family and his friends. That would have been characteristic of Rodger, but those spells usually happened in the autumn, not in the height of summer's heat.

It was only later that night, as I lay down to sleep under the sloped eaves of his studio—where Rodger had worked every day—that I felt some inkling of his presence.

Something woke me just before dawn. I looked at the aligned spines of his journals, seventy years of diaries. Perhaps it was the red moon rising outside the window. The lonely hour was struck by the bell of St. Michael's across the street, where George's ashes had been placed under a simple stone with his name and his dates. That was when I really said my farewell. That was when I felt Rodger's presence, coming through the window like a gust of wind from far away, hovering about the room to see that everything was in its place.

And everything was: all the family photographs; his diaries and Jinx's journals; his and Cicely's war letters in the beat-up case that Jinx, out of respect, had never opened; all of his and Jinx's letters to their friends since the mid-1950s.

In Waterside House, too, all was in order. The lights were out so the electricity bill would not go up—he would have liked that. The food remaining from

the party had been put away in the refrigerator, the tables wiped clean, the lawns watered by Jon and his wife Jane. The grandchildren were asleep.

In the end, I thought, I did not know anything, anything at all about George. The only way to know a little would be to write this book. I would tell Jinx in the morning, as we made the bed together.

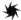

But biographies are hard on biographers. Facts always get in the way of fiction, and it takes so much and so long to understand a little.

My hero has died in the process. He rises again and smiles his wistful smile; he enjoys the unexpected attention.

Tears? Never. As his aunties had told him, "Big boys don't cry."

It was hot even in the Rodgers' garden. Suddenly George's death hit me hard. He may have been difficult, but after all I had loved the work and the man, and had been somehow convinced that he would never die.

No, although everyone was playing light and sunny and wore bright clothes and ate and drank, this was no garden party. Rodger was not here. He would have been by the back door, on his favorite bench, surveying the scene and making quips. The young photographers from the London office would have been lining up, vying for his attention.

M'zee Rodger was gone for good. Not a Blitz bomb, not a tempest, not a Japanese bomber, not a sandstorm or a tsetse fly, not a headhunter, not even what horror he had witnessed, had killed him. Cancer had seemed an especially unfair and painful way for Rodger to go.

Now, of the four-man club that had founded Magnum Photos forty-eight years earlier, the only remaining member was Cartier-Bresson—whom Rodger called "my little one," as he was some six months Rodger's junior.

Exhausted and jetlagged, I sat in a garden corner near George's favorite rose bush. It struck me that Rodger had been present at his own funeral, but only very briefly, in the song that his daughter Jenni, barefoot and in a long flowing dress, sung for him with his guitar. To an outsider who had known Jenni as a teenager, her song, which she had written herself, was heartbreaking in its sweetness and purity: it was as if a young girl was singing, not a woman almost forty years old, and as if she was covertly singing about herself as well as about her father:

> But I say, hold on to your vision
> Sing your sacred song

Hold on to your vision
Let the river take you where you belong.[1]

So I was left the way I often had been left with Rodger: obliquely disap-
pointed, disconnected—perhaps angry that he would not let himself be known.
Why had I crossed an ocean to come here? Who *was* this person I was mourning?
What had he been afraid of, this man who was never afraid?

I breathed in the delicate perfume of the pink and apricot tea roses. But
there was another smell—faint but distinct—that drifted in the summer air.

Cigar? It was peculiar, because no one I could see was smoking. *As I have told
you many times, Old Goat,* Robert Capa must have been saying behind my back, *it's
the end of the game that counts, and what counts is how many chips you've got in your
pocket. That is, if you are still playing.*

I turned around, but did not see Capa. Instead, in the far corner of the gar-
den, I saw a man wearing the time-honored uniform of the photojournalist:
khaki shirt and pants, a Leica M6 dangling from the right shoulder. I recalled
that a few years back an advertisement for khakis had used one of Rodger's
wartime pictures of the Flying Tigers in Burma. The man was short, with raven-
black hair and olive skin. It was Chris Steele-Perkins, a good friend of George's
from the London office and a frequent visitor to Smarden.

Before I could say hello, my friend Abbas, a Paris-based Iranian photogra-
pher, came and sat next to me. In a familiar gesture he was stroking his goatee
and frowning mysteriously; it impressed some people.

"Tu veux ton portrait près de l'étang?"

No, I did not want my portrait by the pond. George had already made that
picture when we met eighteen summers before.

Susan Meiselas, in from New York, asked me pointedly what I was doing
here. She had not known I was a friend of Rodger.

The two iris-bearing Nuba representatives had vanished after accompany-
ing Jinx to the crematorium. High up in the pale-blue summer sky a retinue of
swallows veered and plunged, as if drawn by an invisible target. Their sharp calls
cut the sky into shapes.

Chris Boot, who had overseen the publication of Rodger's Phaidon mono-
graph, and his friend Tony lifted their heads in unison to look at the birds.

"This is surreal," Tony said.

Once again, Marc Riboud had disappeared toward the phone. In another
corner of the garden, closer to the pond, I spotted—I thought I spotted—an
owlish, squat, balding little man who was rubbing his glasses clean. In the entire
gathering, he was the only one wearing a black suit.

"David!" someone called to him, "What's the best place to have lunch near the Paris office these days?" I made for his corner, but Chim was already heading for the kitchen to refill his glass. Oddly, he had left a tiny mahogany and ivory chessboard on the bench. He had checkmated himself.

Sebastião Salgado's recently shaved head gleamed in the sun. He and his wife Lélia looked bereft. I placed my hand on Lélia's arm. Under her close-cropped black hair, her eyes were brimming with tears: "He was a father to me," she said softly.

I needed a drink rather badly and headed for the kitchen, going against a flow of village ladies in floral dresses who proudly carried in more watercress sandwiches, salads, quiches, cakes, and fruit than one could possibly eat. Jimmy Fox, one of Rodger's closest friends and supporters for thirty years—in 1966 they had been the only British members on Magnum's New York staff—was standing nearby, a glass in his hand. His voice broke as he read me a few lines from the tribute he had just written for the Spanish newspaper *El Pais*. "For many years Rodger had spent a good part of the year in his house near Valencia with his family. George would finish his notes to me as 'Bwana M'Kubwa,' " said Jimmy. "Now his time has arrived to become a great Bwana . . ."

Peter Rodger wanted to make a call, but Riboud was still on the line. Peter shook his head, with its long ponytail, in disbelief. His blue eyes resembled his father's, but Peter's smile did not have the same self-deprecating quality as Rodger's. Peter pulled his mobile out of his attaché case and called Hollywood.

His brother Jonathan soon came in for a beer. As usual, he wasn't talking but smiled a lot, a smile that contradicted his deep-set brown eyes and did not reveal much. Jonathan had inherited his mother's warm smile and high cheekbones, I saw it clearly now. He had been close to his father, the one Rodger taught and in whom he occasionally confided, knowing that the confidences would not be betrayed. Jonathan must be devastated, I thought, but his face showed nothing.

"Right," said Jonathan, receiving a friend's condolences.

Jon was the son after his father's heart: handy and silent, a wonderful black-and-white printer. It came as no surprise that he was the main beneficiary of Rodger's will.

As I later learned, Rodger had divided Waterside House between Jon and Jinx, leaving to Jon also the family summer house near Valencia, where he and his father had spent many a summer installing drywall, doing plumbing and carpentry.

Not too far off, Jon's wife Jane was sitting serenely on a bench near her favorite flowerbed. Their daughter Lucy, still a baby, was on her lap. Rodger's old-

est child Jenni was entertaining her California niece and nephew Georgia and Eliott and her Smarden nephews Thomas and George. She was wearing a summer dress and was laughing and telling stories to the transfixed children.

Jenni had a miraculous capacity for love. Her father's slights had apparently slid off her like water off a mallard duck. She held no grudge against him, although he could not have been easy for her to contend with. He had tolerated Jenni when she was a small child, but when she became an adolescent the air between them became electric. He had resented her boyfriends, looked down on her, yelled at her, treated her as an irresponsible person who could not fend for herself.

But if Jenni looked like a blond elf, she was tougher than her looks let on. She had survived it all; a gifted artist and cook, she was now living with her boyfriend Marc a few hours from Smarden.

Jinx looked in turn exhausted, sad, happy, animated, silent, relieved. She kept comforting the guests. "It's better this way, dear. He was very sick. It was time for him to go." "Good girl, but now I had said no flowers; the house is full already."

Henri Cartier-Bresson and Martine Franck had not made the trip from Paris with other members of the agency, such as James Fox, a close friend of Rodger's and longtime editor of the Paris bureau. It was too much for Henri, Martine had explained, too emotional.

Marc Riboud told me that when Cartier-Bresson learned of Rodger's death, he wept. But a few months later, when I talked with Henri about Rodger, he told me: "I can't say anything about George. I knew Chim and Capa so much better! He was a gentleman, and we weren't—that was the difference. *Vraiment, je l'aimais beaucoup mais je le connaissais mal.*"

Je le connaissais mal . . . I did not know him well. It had been a recurring phrase with most of my interviewees, and I had learned precious little from most of Rodger's acquaintances. It was discouraging.

True, Rodger had rarely let himself be known. True, there was almost nothing personal in the cordial letters he and Cartier-Bresson had exchanged from the 1950s to the 1990s: news from Magnum *au jour le jour*, tips for foreign travels, hellos to the wives. They had traded anecdotes, little presents and souvenirs, and had had drinks together each time George was in Paris or Henri in London. Rodger may have felt some envy at his friend's international fame, but true to his own gentleman's code, he did not show it.

Perhaps it *was* true that Rodger had remained unknowable to Cartier-Bresson, as he had to most people. "Death?" said Henri. "I am not afraid of death.

I am only afraid of sickness. Death? . . . *Tu sais* . . . in our circle, *les copains* were always out and about. *Toujours en vadrouille.* Sometimes they died at war, like Capa, like Chim, in an accident like Werner. *Il fallait s'y attendre.* It was part of the job. But in any case we saw each other only sporadically. *La mort, ce n'est qu'une absence prolongée.* Death was only a too-long absence."

Notes

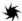

Index

Notes

Much of the source material for this account is from unpublished papers such as letters and diaries, written by George Rodger as he traveled, often under primitive conditions. It is a rare thing in the modern history of photography for a photojournalist to keep written track at all beyond telegrams to press agencies. It was my good luck that Rodger, who originally wanted to be a writer, was a stellar and gifted exception.

However, when I explored his archive eighteen months after his death, many documents had never been accessed, let alone organized. While I have tried to cite sources as fully as possible, the nature of the material and its sheer abundance (close to one hundred thousand pages of text) have inevitably left some gaps in the record, and efforts to fill these gaps have in some cases been stymied by inconsistent accounts or imperfect recollections by witnesses of earlier events. For example, although Rodger kept extensive diaries, he often compressed several days in a single entry, or dated entries later on.

In the 1980s, when Rodger decided to write his autobiography, he started a new "retrospective" agenda, attempting to find out where he was on each day of his life since he started photographing. While some of these dates coincided with those supplied by my other sources, some did not. Likewise, Rodger's unpublished autobiography *20,000 Days* exists in several incomplete and sometimes overlapping drafts, making pagination impossible. Therefore I can only apologize for the information which despite my best efforts I have been unable to supply.

Prologue

1. Homer, *The Iliad*, trans. Stanley Lombardo (New York: Hackett, 1997), 18.22–29.

2. Homer, *Iliad*, 18.111–13.

3. Some of the ideas in this passage were inspired by psychoanalyst Françoise Davoine, who has studied at length psychological trauma in World War I soldiers, and who advised me to read *The Best of the Achaeans: Concepts of the Hero in Archaic Greek Poetry* by Gregory Nagy (Baltimore: Johns Hopkins University Press, 1979).

1. Big Boys Don't Cry

1. Augustus Eck to Carlotta Eck, March 22, 1908. In 1940, families were urged to burn papers that could increase fire hazards in a time of war. Walter Mason rescued the protocols from the attic of the Bridgelands.

2. The crest is found in two heraldic sources: Arm. Gachet, 1799, and Monnier, 1857.

3. Communal Archives, Vevey, Switzerland.

4. George Rodger, *20,000 Days* (unpublished autobiography), Smarden Archive. The same phrase was used by Peggy Rodger and Jinx Rodger.

5. Peggy Rodger, interview by author, Congleton, Cheshire, May 1997.

6. Ibid.

7. "Drummers Knob" was the lower-right point of the triangle formed by the chapel and the Bridestones.

8. Sue Dale, interview by author, Congleton, Cheshire, May 1997.

9. Rodger, *20,000 Days.*

10. Peggy Rodger, interview by author, Congleton, Cheshire, May 1997.

11. Rodger, *20,000 Days.*

12. Inscription on the monument, Selkirk, Selkirkshire, Scotland.

13. Peggy Rodger, interview by author, Congleton, Cheshire, May 1997.

14. Rodger, *20,000 Days.*

15. Ibid.

16. Ibid.

17. George Rodger to Hilda and George Rodger, Sr., July 15, 1915.

18. George Rodger to Hilda and George Rodger, Sr., August 15, 1915.

19. George Rodger to Hilda and George Rodger, Sr., July 11, 1915.

20. George Rodger to Hilda and George Rodger, Sr.,

21. Jinx Rodger, interview by author, Smarden, Kent, May 1997.

22. *20,000 Days*, unpublished autobiography, Smarden Archive.

2. The End of Paradise: 1921–26

1. George Rodger to Arthur Chapman, February 10, 1990.

2. Rodger, *20,000 Days.*

3. Arthur Chapman, letter to the author, January 3, 1998.

4. Rodger to Chapman, February 10, 1990.

5. Ibid.

6. Rodger, *20,000 Days.*

7. Ibid.

8. Ibid.

9. Ibid.

3. Wanderings: 1926–35

1. George Rodger, SS *Matra* diary, 1926, Smarden Archive.

2. Rodger, *20,000 Days.*

3. George Rodger, letter to Cicely Hussey-Freke, November 3, 1939.

4. Rodger, *Matra* diary, 1926.

5. Ibid.

6. George Rodger, letter to Hilda Rodger, December 14, 1926.

7. Rodger, *Matra* diary, 1926.

8. Rodger, *20,000 Days.*

9. Rodger, *Matra* diary, 1926.

10. George Rodger, letter to George Rodger, Sr., December 1926.

11. Rodger, *Matra* diary, 1926.

12. Ibid.

13. Ibid.

14. Ibid.

15. Ibid.

16. Ibid.

17. Rodger *20,000 Days.*

18. George Rodger, interview by Patricia Wheatley, *The Magnum Story* (television documentary), BBC, 1985.

19. Rodger, *20,000 Days.*

20. Prints of these black-and-white photographs were discovered in a shoebox at the Smarden Archive.

21. Peggy Rodger, interview by author, Congleton, Cheshire, May 1997.

22. George Rodger, letter to Hilda Rodger, March 6, 1928.

23. George Rodger, SS *Matra* diary, 1928, Smarden Archive.

24. Rodger, *Matra* diary, 1928.

25. Ibid.

26. Charles Baudelaire, *Flowers of Evil*, trans. Richard Wilbur (New York: New Directions, 1963), 51.

27. Rodger, *Matra* diary, 1928.

28. Ibid.

29. Ibid.

30. George Rodger, interview by author, May 1979.

31. Rodger, *Matra* diary, 1928.

32. Rodger, *20,000 Days.*

33. George Rodger, unpublished notes for a career summary, Smarden Archive.

34. George Rodger, *U.S.* diary, 1933, Smarden Archive.

35. Rodger, *U.S.* diary, 1933.

36. Ibid.

37. Ibid.

38. Rodger, *20,000 Days.*

39. Ibid.

40. Ibid.

41. Tom Hopkinson, draft of "George Rodger and How He Operates," for *Phototechnique* (1986), Smarden Archive.

4. From Studio to Street: The Making of a Professional, 1936–40

1. George Rodger, interview by Wheatley, *The Magnum Story.*

2. Hopkinson, draft of "George Rodger and How He Operates."

3. George Rodger, interview (December 1977) by Paul Hill and Thomas Cooper, in *Dialogue With Photography,* by Paul Hill and Thomas Cooper (New York: Farrar Straus Giroux, 1979).

4. Rodger, *20,000 Days.*

5. Ibid.

6. Rodger, in *Magnum.*

7. Rodger, *20,000 Days.*

8. Tom Hopkinson, *The Blitz: The Photography of George Rodger* (London: Penguin [U.S. edition]), 1991.

9. Rodger, *20,000 Days.*

10. Ibid.

11. Ibid.

12. Ibid.

13. Ibid.

14. Linda Morgan, interview by author, New York, October 1999.

15. Obituary of Frederick Hussey-Freke, *Shanghai Times,* March 31, 1936.

16. Rodger, *20,000 Days.*

17. Ibid.

18. George Rodger, letter to Cicely Hussey-Freke, Smarden Archive.

19. Ibid.

20. Rodger, *20,000 Days.*

21. Miller, *Magnum.*

22. Anita Summer, interview by author, March 13, 1998.

23. Ibid., March 24, 1998.

24. Rodger, *20,000 Days.*

25. George Rodger, letter to Cicely Hussey-Freke, Smarden Archive.

26. Rodger, *20,000 Days.*

27. Ibid.

28. Allan Michie, 1936 diary illustrated with photographs, Michie Archive, Mugar Library, Special Collections, Boston University.

29. Barbara Michie, interview by author, March 24, 1998.

30. George Rodger, letter to Cicely Hussey-Freke, Smarden Archive.

31. Tom Hopkinson, *Picture Post: 1938–1950* (London: Penguin, 1970).

32. George Rodger, letter to Cicely Hussey-Freke, Smarden Archive.

33. Ibid.

34. Ibid.

35. *The Leader,* December 2, 1939.

36. *The Leader,* November 25, 1939.

37. Musée de l'Elysée, Lausanne, Switzerland, 1990.

38. Pierre Gassmann, interview by author, Paris, France, May 4, 1997. See also "Picto: 40 ans, La fête," in *Photomagazine,* Paris, June 1990.

39. George Rodger, letter to Cicely Hussey-Freke, Smarden Archive.

40. Ibid.

41. Ibid.

42. Hilda Rodger, letter to George Rodger, March 5, 1940, Smarden Archive.

43. George Rodger, letter to Cicely Hussey-Freke, Smarden Archive.

44. Rodger, in *Dialogue With Photography*.

45. Rodger, *20,000 Days*.

46. "The East End at War," *Picture Post*, September 28, 1940.

47. George Rodger, letter to Cicely Hussey-Freke, Smarden Archive.

48. Rodger, *20,000 Days*.

49. George Rodger, letter to Cicely Hussey-Freke, Smarden Archive.

50. Rodger, *20,000 Days*.

51. George Rodger's 1940 photo-essays in *Picture Post* include: "Ervin Andrews, VC" (August 24), "MTBS" (September 14), "US War Correspondents" (September 2), "East End at War" (September 28), "Submarine Base" (October 5), and "Rescue Squads" (November 9). Those appearing in the *Illustrated* in 1940 include: "River Holiday" (August 17), "The Balloon Goes Up" (August 31; later republished in *Life*), and "The Yanks Have Arrived" (November 9).

52. Lee Stowe, "In the Wake of the Storm," 1953, Michie Archive, Mugar Library, Special Collections, Boston University.

53. Rodger, *20,000 Days*.

54. Barbara Michie, interview by author, March 1998.

55. "Bomber Command of the RAF," BBC script by Allan Michie (one of a series of thirteen), from "Britain to America—A Dramatized Story of the Exploits of B.C.," Michie Archive, Mugar Library, Special Collections, Boston University.

56. Hopkinson, *The Blitz*.

57. Eve Arnold, interview by author, London, January 9, 1998.

58. Peter Marlow, interview by author, London, January 10, 1998.

59. Allan Michie, unpublished diary, entry from 1936, Michie Archive, Mugar Library, Special Collections, Boston University.

60. Rodger, *20,000 Days*.

5. The Desert Campaign: 1940–41

1. Despite its name, the Lend-Lease Act was actually a gift, and Britain did not expect to have to pay it back.

2. Phillip Knightley, *The First Casualty* (New York: Harvest Books, 1976), 304.

3. George Rodger, *Desert Journey* (London: Cresset Press, 1944).

4. Paul Fussell, *Wartime* (London: Oxford University Press, 1989), 96.

5. A subsidiary of Time-Life, which produced a number of newsreels during the war.

6. Rodger, *Desert Journey*.

7. Ibid.

8. Ibid.

9. Rodger, *20,000 Days*.

10. Rodger, *Desert Journey*.

11. Ibid.

12. Rodger, in *Dialogue With Photography*.

13. George Rodger, "The Vanishing Africa: Safari Through Kenya, Uganda, and the Southern Sudan."

14. Alan Moorehead, *A Late Education* (London: Hamish Hamilton, 1970).

15. Rodger, *20,000 Days*.

16. Rodger, *Desert Journey*.

17. Rodger, *20,000 Days*.

18. Rodger, *Desert Journey*.

19. Ibid.

20. George Rodger, quoted in Bruce Bernard's introduction to *Humanity and Inhumanity: The Photographic Journey of George Rodger* by George Rodger, Peter Marlow, and Bruce Bernard (London: Phaidon, 1995).

21. In the 1996 film *The English Patient*, these episodes of the mad guide thumping a drum-roll on the Chevrolet's roof, and of the rear axle breaking in the sand, can be viewed with dialogues lifted almost verbatim from Rodger's *Desert Journey*. No such adventures appear in Michael Ondaatje's beautiful novel, from which the film was adapted. It seems that researchers appropriated excellent material from a publication whose copyright had, unfortunately, not been renewed.

22. Rodger, *Desert Journey*.

23. Ibid.

24. Captain Ingram (later Colonel Ingram) was also a cinematographer for the Indian army, and took the photograph that appears on the cover of this book, of Rodger in a Lawrence of Arabia getup—probably a publicity still for a 1941 newsreel.

25. Rodger, *Desert Journey*.

26. Chris Boot, then photography editor at Phaidon Press in London.

27. Colin Osman, "The Foundation of *Parade*," in *Creative Camera*, special issue, "Information and Propaganda," July-August 1985, 10.

28. Rodger, from *Desert Journey*, as cited in *Creative Camera*, special issue, "Information and Propaganda," July-August 1985, 40.

29. George Rodger, quoted in the encyclopedia *Contemporary Photographers* (London: MacMillan, 1982).

30. Rodger, in *The Magnum Story*.

31. Ibid.

32. Rodger, *Desert Journey*.

33. Allan Michie, unpublished diary, Michie Archive, Mugar Library, Special Collections, Boston University.

34. Rodger, *Desert Journey*.

35. Michie, unpublished diary.

36. Ibid.

37. In the bright desert sun, kohl is used as protection from glare and eye infections.

38. Rodger, *Desert Journey*.

39. George Rodger, "The Heart of the Middle East," in *Picture Post*, September 27, 1941, and a *Life* portfolio on Emir Abdullah in December of that year.

40. T. E. Lawrence, from *The Seven Pillars of Wisdom* as quoted in Michie, unpublished diary.

41. Rodger, *Desert Journey*.

42. Allan Michie, *Retreat to Victory: A Mighty Answer to a Faltering Confidence* (Chicago: Alliance, 1942).

6. Taxi to Tehran, A Hammock in the Himalayas: August-December 1941

1. Rodger, *Desert Journey*, 117.

2. Ibid., 120

3. Allan Michie, unpublished diary, entry from August-September 1941, Michie Archive, Mugar Library, Special Collections, Boston University.

4. Ibid.

5. Rodger, *Desert Journey*, 128.

6. George Rodger, "War in Iran: British Join Soviet Allies," *Life*, January 26, 1942.

7. Rodger *Desert Journey*, 133.

8. Ibid., 134.

9. Michie, unpublished diary, 167.

10. Allan Michie, letter to his agent, Nannine Joseph, February 2, 1942.

11. Michie, unpublished diary.

12. Rodger, *Desert Journey*, 141.

7. Burma Fever: January-June 1942

1. Carl Mydans, who teamed up with his wife, Shelly Smith-Mydans, was one of *Life*'s best photojournalists. In an interview on March 10, 1988, he told the author: "I knew Rodger and have the utmost respect for him. He was always in one part of the world when I was in another. He covered Europe and I covered Asia. In Burma we did not meet, which I regret." Mydans, who had been with General McArthur when Manila fell, was taken prisoner and repatriated; he then returned to the Philippines in December 1943, in time to shoot McArthur's victorious return at Luzon (Mydans's portrait of him appeared on the cover of *Life*.) McArthur was by then a national hero who had both a camellia and a dance named for him. While Rodger was in Europe, Mydans published one of his best and most humane essays on the Japanese-American prisoners ("enemy aliens") at Tule Lake Segregation Center in Newell, California.

2. David E. Scherman, *Life Goes to War: A Picture History of World War II* (New York: Simon & Schuster, 1977), 116.

3. George Rodger, *Red Moon Rising* (London: Cresset Press, 1943), 5.

4. British Universities Newsreel Project Database, Tozer Biography, BU Film and Video Council; biography courtesy of Luke McKernan of the BU Archives.

5. The sixteen were two squadron leaders (John Newkirk and James Howard), three flight leaders (David Lee Hill, Noel Richard Bacon, and Edward Rector), eight pilots (Robert Layher, Frank Lindsay, William Bartling, Tom Cole, Matthew Kuykendall, John Bright, Frank Shiel, and Henry Gesselbracht), two armorers (Pat Hanley and Jim Musick), and a radio mechanic (Michie Mihaldo).

6. Rodger, *Red Moon Rising*, 15.

7. The squadron's exploits inspired a John Wayne movie, *Flying Tigers* (1942), directed by Nicholas Ray. See Michael J. Lyons, *World War II: A Short History* (Paramus, N.J.: Prentice-Hall, 1994), 296. In August 1999 the Flying Tigers alumni held a reunion in San Antonio, Texas, where

Rodger's pictures were exhibited. More than one former Tiger requested a print of his own 1942 portrait, as a memento of an exceptional time in his life.

8. One of Tozer's newsreels, *Yunnan-Burma Railway*, shows shots of Tseng and the American engineering adviser, the riverbanks being sprayed with arsenic dust against mosquitoes, and quinine being distributed to children.

9. George Rodger, letter to Cicely Hussey-Freke, Khyukok, Burma, February 17, 1942.

10. Rodger, *Red Moon Rising*, 36.

11. Ibid., 59.

12. George Rodger, *Life* dispatch, n.d. (probably March 1942), Smarden Archive.

13. Rodger, *Red Moon Rising*, 79.

14. Ibid., 98.

15. David Halberstam, *The Powers That Be* (New York: Knopf, 1979), 19. Halberstam refers to this campaign as "The Great China Hoax."

16. Rodger, *Red Moon Rising*, 99.

17. See "Burma Mission," in *Life*, June 15, 1942; cover, frontispiece, and five pages, with text by Clare Boothe-Luce.

18. George Rodger, *Life* report, "Escape from Burma," sent from Calcutta, May 1, 1942, Time-Life Archive, New York.

19. Rodger, *Red Moon Rising*, 110.

20. Ibid., 119.

21. George Rodger, letter to Cicely Hussey-Freke, Calcutta, April 28, 1942.

22. Ibid.

23. Ibid.

24. Ibid.

25. George Rodger, telegram to Cicely Hussey-Freke, May 5, 1942. Some of the many other wartime telegrams that Rodger sent to Cicely read: "Stuck in Gold Coast Love," "Arrived Khartoum," "Arrived Brazil," "Arrived Rangoon," "Arrived Lahore," and finally, "Arrive New York tomorrow."

8. A Reluctant Hero: March 1942-July 1943

1. George Rodger, letter to Cicely Hussey-Freke, June 27, 1942.

2. Allan Michie, *Retreat to Victory* (Chicago and New York: Alliance, 1942), Foreword.

3. George Rodger, letter to Cicely Hussey-Freke, July 18, 1942.

4. Barbara Michie, interview by author, New York, March 29, 1998.

5. George Rodger, letter to Cicely Hussey-Freke, n.d. (probably July 24 or 25, 1942).

6. George Rodger, letter to Cicely Hussey-Freke, July 27, 1942.

7. Ibid.

8. Ibid.

9. *Life* 13, no. 6 (August 10, 1942).

10. Rodger, in *The Magnum Story*.

11. George Rodger, letter to Cicely Hussey-Freke, August 6, 1942.

12. Ibid.

13. Linda Morgan, interview by author, New York, January 7, 1999.

14. Bruce Bernard, quoted in *Humanity and Inhumanity* by Rodger, Marlow, and Bernard, 47.

15. George Rodger, letter to Cicely Hussey-Freke, August 19, 1942.

16. George Rodger, letter to Cicely Hussey-Freke, August 23, 1942.

17. Ibid.

18. George Orwell, in the *New Statesman*, August 14, 1943.

19. Elizabeth Bowen, in the *Tatler*, September 22, 1943.

9. Where George Rodger Meets Robert Capa: August 1943-May 1944

1. Robert Capa's words as remembered by George Rodger, in *The Magnum Story*.

2. See Richard Whelan, *Robert Capa* (New York: Knopf, 1985), 199.

3. Rodger, *20,000 Days*.

4. George Rodger, letter to Cicely Rodger, September 20, 1943.

5. Robert Capa, *Slightly Out of Focus*, as quoted in *Magnum* by Russell Miller.

6. Robert Capa, as quoted in *Robert Capa: Photographs*, by Richard Whelan (New York: Aperture, 1996), 81.

7. George Rodger, letter to Cicely Rodger, March 9, 1943.

8. Ibid.

9. George Rodger, letter to Cicely Rodger, March 4, 1943.

10. George Rodger, letter to Cicely Rodger, March 9, 1943.

11. George Rodger, letter to Cicely Rodger, March 11, 1943.

12. George Rodger, letter to Cicely Rodger, October 17, 1943.

13. Rodger, in *The Magnum Story*.

14. Ibid.

15. Cicely Rodger, letter to George Rodger, October 25, 1943.

16. George Rodger, letter to Cicely Rodger, October 28, 1943.

17. George Rodger, letter to Cicely Rodger, December 25, 1943.

18. Ibid.

19. George Rodger, letter to Cicely Rodger, February 15, 1944.

20. Cicely Rodger, letter to George Rodger, February 23, 1944.

21. Ibid.

22. George Rodger's dispatch to *Life*, April 10, 1944.

23. See "The Case of Montgomery's Hat," Colin Osman's humorous piece in *Creative Camera*, special issue, "Information and Propaganda," no. 247–48, July-August 1985, recalling Monty's efforts to appear at his best in photographs despite his diminutive stature. His fashion counselor was a colleague of Rodger, Edward Keating. Rodger's "composite uniform," tailored in London, also included a beret. Capa soon also affected a foulard to imitate his well-traveled friend.

24. Rodger, *20,000 Days*.

25. John Morris, *Get The Picture* (New York: Random House, 1998), 210.

10. The Dire Sink of Iniquity: June 1944-May 1945

1. Morris, *Get The Picture*, 210. But Richard Whelan has it differently in his biography of Capa, *Robert Capa: Photographs* (p. 210), where he writes that there were only four *Life* photographers assigned to cover the landing: Bert Brandt of Acme and Robert Capa with the American amphibious troops, George Rodger with the British, and Robert Landry with the paratroopers.

2. Patton's Third Army had not originally been expected to land on D-Day.

3. See Robert Capa's memoir, *Slightly Out of Focus* (New York: Henry Holt, 1947).

4. Quoted in *The First Casualty* by Phillip Knightley (New York and London: Harcourt Brace Jovanovich, 1976), 323.

5. *The Best of Ernie Pyle's Dispatches* (New York: Random House, 1986), 277.

6. Rodger, *20,000 Days.*

7. Quoted in Martin Gilbert, *The Second World War* (New York: Henry Holt, 1989).

8. Morris, *Get The Picture*, 80.

9. George Rodger, interview by Brigitte Ollier, in *Libération*.

10. Walter Rosenblum, interview by Studs Terkel in *The Good War: An Oral History*, by Studs Terkel (New York: Pantheon, 1984).

11. Rodger, in *The Magnum Story*.

12. See Carole Naggar, "Magnum raconte Paris, Rodger raconte Magnum" (Magnum tells about Paris, Rodger tells about Magnum) in *Photomagazine*, Paris, November 1981: 36–45.

13. Cicely Rodger, letter to George Rodger, August 25, 1944.

14. Ibid.

15. George Rodger, letter to Cicely Rodger, September 6, 1944.

16. George Rodger, *War Diary*, 1945, Smarden Archive.

17. Ibid.

18. Rodger, *War Diary*, 1945.

19. George Rodger, letter to Cicely Rodger, January 23, 1945.

20. Rodger, *War Diary*, 1945.

21. Raul Hillberg, *The Destruction of the European Jews* (London and New York: Homers & Myers, 1985), 256.

22. Dick Stratford, interview by author, Penrith, Cumbria, England, May 1998.

23. Rodger, *War Diary*, 1945.

24. George Rodger's dispatch to *Life*, filed April 30.

25. Rodger, in *The Magnum Story*.

26. Ronald Munson was interviewed by Phillip Knightley in *The First Casualty*. Munson had entered Bergen-Belsen on the same day as Rodger.

27. Rodger, *War Diary*, 1945.

28. *The Guardian*, London, February 1995.

29. Dr. Jacques Hassoun, interview by author, Paris, September 1996.

30. Studs Terkel, *The Good War: An Oral History* (New York: Pantheon, 1984).

31. Mavis Tate, quoted in *Remembering To Forget*, by Barbie Zelizer (New Haven: Yale University Press, 1999), 87.

32. Margaret Bourke-White, quoted in *Remembering To Forget*, by Zelizer.

33. Chaim Potok, *In The Beginning* (New York: Knopf, 1975), 377.

34. Rodger's Bergen-Belsen pictures were published countless times, in particular along with those of John Florea in the 1950 volume *Life's Picture History of World War II* (with Rodger's copyright). Earlier on, Rodger's photographs had been attributed to the Signal Corps, because Time-Life had pooled pictures with other press organizations. Rodger's photographs can also be found, with Margaret Bourke-White's, in the 1979 *Life: The First Decade* and in the "Holocaust" section of the 1989 Time-Life book *History of the Second World War*.

35. *Life*, May 4, 1945.

36. Jinx Rodger, interview by author, Smarden, May 11, 1997.

37. Rodger, Marlow, and Bernard, *Humanity and Inhumanity*.

38. George Rodger, letter to Cicely Rodger, April 22, 1945.

39. Linda Morgan, interview by author, New York, January 1999.

40. Cicely Rodger, letter to George Rodger, April 24, 1945.

41. Rodger, *War Diary*, 1945.

42. Rodger, *20,000 Days*.

43. Ibid.

44. Rodger, *War Diary*, 1945.

11. Welcome to the Time, Inc., Stink Club: Summer 1945-June 1947

1. George Rodger, *Memory Book*, n.d., Smarden Archive.

2. Wilfred Owen, "Mental Cases," in *The Collected Poems of Wilfred Owen* (London: Chatto & Windus, 1966).

3. Rodger, *20,000 Days*.

4. Ibid.

5. George Rodger, letter to Cicely Rodger, October 6, 1945.

6. Rodger, *20,000 Days*.

7. Ibid.

8. Linda Morgan, interview by author, New York, January 3, 2000.

9. Barbara Michie, interview by author, New York, March 24, 1998.

10. George Rodger, letter to Rita Vandivert, June 6, 1947.

11. Rodger, *20,000 Days*.

12. Ibid.

13. Ibid.

14. Rodger, diary entry, April 19, 1947.

15. Rodger, diary entry, April 24, 1947.

16. Rodger's stories on "Ancient Cities of the Middle East" were shot in 1966–67 and appeared in a score of publications, from the *London Observer* to Rio de Janeiro's *Manchete*, as well as in Time-Life books.

17. See Pierre Assouline's biography, *Henri Cartier-Bresson: L'Oeil du Siècle* (Paris: Plon, 1999), 208.

18. Henri Cartier-Bresson, interview by author, Paris, January 14, 1998.

19. See Inge Bondi, *Chim: The Photographs of David Seymour* (Boston: Bulfinch, 1996).

20. Henri Cartier-Bresson, interview by author, Paris, January 14, 1998.

21. Ibid.

22. Rita Vandivert, letter to George and Cicely Rodger, New York, May 19, 1947.

23. Ibid.

24. George Rodger, letter to Rita Vandivert, June 6, 1947.

25. Ibid.

26. Morris, *Get The Picture*.

27. John Morris, memo to the Goulds, spring 1947, John G. Morris Archive, Paris.

28. Among certain circles, however, the "Family of Man" project was reviled as a saccharine venture that ultimately damaged the medium's efforts to be taken seriously. Later, in the atmosphere

of structuralism and postmodernism of the 1960s and 1970s, the show became a target for critics as the epitome of a certain brand of forced "humanistic" photography. Roland Barthes, Susan Sontag, and many others questioned its sentimentality and broad generalizations, which emphasized pat cultural resemblances instead of trying to convey a more profound understanding of non-Western cultures.

29. Rodger, *20,000 Days*.

12. Into Africa: February 1948-February 1949

1. Peter Hamilton, "George Rodger and the Nubas," in *Village of the Nubas* (London: Phaidon, 1999).

2. "Road Expedition through Africa: Plan for a Year's Journey," Johannesburg, February 1948. Unidentified newspaper clipping, Smarden Archive.

3. George Rodger, "Transkei, Land of the Red People," story 15, 1948, Smarden Archive.

4. Ibid.

5. George Rodger, "Tshudwana," story 3, 1948, Smarden Archive.

6. George Rodger, letter to Jinx Witherspoon, April 11, 1948, Smarden Archive.

7. Jinx Rodger, interview by author, Smarden, May 8, 1997.

8. George Rodger, letter to Jinx Witherspoon from the banks of the Sabi River, May 18, 1948, Smarden Archive.

9. Ibid.

10. George Rodger, *African Diary*, June 23, 14, Smarden Archive.

11. Ibid.

12. George Rodger, interview by author, Smarden, April 1982.

13. Ibid.

14. Rodger, *African Diary*, 41.

15. Ibid., 57.

16. George Rodger, "The Snake Dance," story 14, 1948, Smarden Archive.

17. Rodger, *African Diary*, 70.

18. Ibid., 75.

19. Ibid., 77.

20. George Rodger, letter to Jinx Witherspoon, Yei, Sudan, January 23, 1949.

21. Peter Beard, *The End of the Game* (New York: Doubleday, 1977), 112.

22. George Rodger, stories 20–23, captions 1–27, Smarden Archive.

23. Rodger, *African Diary*, 91.

24. Ibid., 92.

25. Ibid., 120.

13. Village of the Nuba: February-March 1949

1. Siegfried F. Nadel was one of the few who had studied the Nuba. In 1947, his book *The Nuba* was published by Oxford University Press. It is likely that Rodger knew of his work, as well as of a 1932 book by C. G. and Brenda Seligman, *Pagan Tribes of the Nilotic Sudan*.

2. George Rodger, *Kordofan Diary*, 1949, 126, Smarden Archive.

3. The image has appeared in many publications, including Suleiman Rahhal's recent *The Right*

to Be Nuba, which was instrumental (along with Arthur Howes's and Peter Moyzinzki's films on the Nuba) in bringing about the cease-fire agreement in the Nuba mountains (signed January 24, 2002, at Burgenstock, Switzerland) between the government of the Republic of Sudan and the Sudanese Peoples Liberation Movement (SPLM/Nuba). This was achieved at the initiative of the United States and under the joint mediation of Switzerland and the United States. Colonel Dennis Giddens and Swiss Ambassador Josef Burcher are in charge of seeking negotiated solutions.

4. George Rodger, "Where Brutality Does Not Exclude Emotion," in *Village of the Nubas* by George Rodger (London: Phaidon, 1999), 63–64.

5. Rodger, *Kordofan Diary*, 1949, 126.

6. Ibid., 127 and 128.

7. Ibid., 131.

8. Ibid., 132.

9. Ibid., 134.

10. Ibid., 135.

11. Ibid., 136.

12. Rodger, *Kordofan Diary*, 1949, 136.

13. George Rodger, letter to Jinx Witherspoon, El Obeid, March 14, 1949.

14. Rodger, *Kordofan Diary*, 1949, n.p.

15. George Rodger, *Le Village des Noubas*, collection "Huit," (Paris: Robert Delpire Editeur, 1955); republished in English as *Village of the Nubas* (New York: Phaidon, 1999).

16. See Carole Naggar, "André Kertész: Frère Voyant," exhibition catalog, Fondation Nationale de la Photographie, Lyon, 1981.

17. George Rodger, letter to Leni Riefenstahl, n.d. (spring, 1951), Smarden Archive.

18. Leni Riefenstahl. James Fox, a close British friend of Rodger and long-time editor-in-chief at Magnum Paris's office, wrote about his encounter with Rodger's Nuba pictures: "The first time I ever saw a photo by George Rodger or even the mention of his name, must have been in 1958 when I was working at the Photo department of the NATO Press and information service. . . . Many months later, I plucked up my courage to phone the Magnum office in Paris, and asked if I could see the work of Gerge Rodger. . . . Mr Noah Ringart greeted me; he was the archivist and was an old friend of Bob Capa's whom he had known at the Dephot agency in prewar Berlin. He allowed me to look at the prints and a pocketbook of the Nuba tribes in Sudan illustrated with George's magnificent work. It was sixteen years later that I was in Munich, and that again Nuba tribesmen surfaced. This time I was talking with the German photographer Leni Riefensthal about her colour book on the Nubas, and she told me that she too was overwhelmed by the Rodger photo of the tribesmen fighting, that it had haunted her for years. She went to the Sudan herself and did two books on the Sudanese tribes. . . . How strange that it was the same Leni Riefenstahl that had made the various enhancing films for the Nazi regime, and that her and George Rodger's lives crossed because of this one image." "George Rodger, in the shadow of limelight," *El Pais*, July 1995.

19. Among the titles in Rodger's extensive Africa library were memoirs such as *Out of Africa* by Karen Blixen (aka Isak Dinesen), Elspeth Huxley's *Four Guineas*, Geoffrey Dutton's *Africa in Black and White*, Gerald Durrell's *The Overloaded Ark*, and Alan Moorehead's *The White Nile*. The picture books included Paul Strand's *Ghana*, William Thesiger's *Desert*, and Riefenstahl's volumes.

20. George Rodger, interview by Robert Block, in "Then and Now," *Independent*, London, March 28, 1993.

21. Riefenstahl had purchased one of Rodger's Nuba pictures, which she kept on her desk,

where it is prominently featured in Ray Mueller's documentary *The Wonderful, Terrible Life of Leni Riefenstahl*, 1993.

22. As Arthur Howes points out, the Nuba tradition of wrestling persists in the heart of the mountains and can be observed by trekking on foot for many days to the remotest areas, where the rituals are still performed.

23. Ian Fisher, "Can International Relief Do More Good Than Harm?" in the *New York Times Magazine*, February 11, 2001.

14. Speak to Me: February-November 1949

1. George Rodger, letter to Cicely Rodger, London, June 4, 1949.

2. George Rodger, letter to Cicely Rodger, London, June 14, 1949.

3. Jinx Witherspoon, interview by author, Smarden, June 10, 1998.

4. Jinx Witherspoon, diary entry, July 1949.

5. Jinx Witherspoon, letter to her parents, Limassol, August 15, 1949.

6. George Rodger, letter to Cicely Rodger, July 10, 1949.

7. Jinx Witherspoon, diary entry, July 1949.

8. George Rodger, letter to Jinx Witherspoon, Kyrenia, August 21, 1949.

9. Cicely Rodger, postcard to Jinx Witherspoon, August 28, 1949.

10. George Rodger, letter to Dorothy Bye, Limassol, October 20, 1949.

11. George Rodger, letter to Jinx Witherspoon, October 7, 1949.

12. Rodger, letter to Bye, October 20, 1949.

13. Eclampsia was more often fatal in the 1940s than it is today, especially if it went undiagnosed.

14. Rodger, *Memory Book*.

15. Dorothy Bye, interview by author, July 2000.

16. Kip Ross, letter to George Rodger, October 20, 1949. The letter, on *National Geographic* letterhead, is signed "Kip Ross, Illustrations Division."

17. John Morris, letter to George Rodger, October 12, 1949.

18. George Rodger, "To Cicely, Troodos Mountains, Cyprus," October, 1949, Smarden Archive.

19. Peter Rodger, interview by author, New York, winter 1999.

15. New Beginnings: Fall 1949-August 1951

1. Inge Morath, interview by author, New York, May 7, 1998.

2. Ibid.

3. Ibid.

4. Ibid.

5. Barbara Michie, interview by author, March 29, 1998.

6. Joan Bush, letter to George Rodger, December 1, 1949.

7. The two stories were published in the *Weekly Illustrated*, London, on March 5 and May 27, 1950.

8. Jinx Rodger, interview by author, Smarden, June 10, 1998.

9. George Rodger, letter to Maria Eisner, Pétionville, Haiti, March 1950.

10. Jinx Rodger, interview by author, Smarden, June 10, 1998.

11. John Morris, letter to Jinx Witherspoon, March 1950.

12. Jinx Rodger, interview by author, Smarden, June 10, 1998.

13. George Rodger, letter to Jinx Witherspoon, April 24, 1950.

14. George Rodger, letter to Jinx Witherspoon, June 9, 1950.

15. George Rodger, letter to Jinx Witherspoon, n.d. (probably late June 1950).

16. Ibid.

17. Jinx Rodger, interview by author, Smarden, June 10, 1998.

18. George Rodger, letter to Jinx Witherspoon, June 27, 1950.

19. George Rodger, letter to Jinx Witherspoon, August 17, 1950.

20. Jinx Witherspoon, letter to Dele and John Morris, Drenthe, Holland, October 16, 1950.

21. Ibid.

22. George Rodger, letter to Maria Eisner, November 23, 1950.

23. Fred Ritchin, "What is Magnum?" in *In Our Time: The World Seen by Magnum Photographers* (New York: Norton, 1989).

24. George Rodger, letter to Norman Wood, Libreville, Gabon, January 1, 1951.

25. George Rodger, letter to John and Dele Morris, December 25, 1950.

26. Rodger, letter to Norman Wood, January 1, 1951.

27. Jinx Witherspoon, letter to her parents, January 9, 1951.

28. "Welcome, the non-working Plan!"—a play on "Marshall Plan."

29. Rodger's story on Schweitzer was without question an inspiration for W. Eugene Smith's 1954 photo-essay on the doctor, "A Man of Virtue," shot after Schweitzer was awarded the Nobel Peace Prize. Smith's photo-essay was published in *Life* on November 15, 1954. The magazine published only a small selection—twenty-two images—from Smith's monumental essay, which ultimately led to his resignation from *Life*.

30. Jinx Witherspoon, letter to her parents, January 28, 1951.

31. Jinx Witherspoon, letter to John Morris, June 1951.

32. Jinx Witherspoon, diary entry, July 28, 1951.

33. Jinx Witherspoon, letter to her parents, July 1951.

34. "Schweitzer: A Doctor with a Mission," in the *Weekly Illustrated*, July 28, 1951.

35. Jinx Witherspoon, diary entry, July 20, 1951.

16. Dire Straits: September 1951-December 1954

1. Jinx Witherspoon, letter to John Morris, August 19, 1951.

2. George Rodger, letter to John Morris, December 5, 1951.

3. Ibid.

4. Jinx Witherspoon, letter to John and Dele Morris, November 18, 1951.

5. Jinx Witherspoon, letter to John and Dele Morris, December 16, 1951.

6. Jinx Witherspoon, letter to her parents, n.d. (ca. December 17, 1951).

7. Robert Capa, letter to George Rodger, January 16, 1952.

8. Beginning in the 1970s, the notion of the "objectivity" of the photographer-as-witness was challenged by the European concept of subjective journalism and the American concept of "con-

cerned photography"—a term coined by Robert Capa's brother, Cornell Capa. Magnum photographers such as Gilles Peress, Eugene Richards, and Raymond Depardon (among others) began exploring the possibilities of a kind of photojournalism that did indeed "take sides."

9. Robert Capa, letter to George Rodger, January 16, 1952.

10. Ibid.

11. George Rodger, letter to Jinx Witherspoon, August 22, 1952.

12. Jinx Rodger, interview by author, Smarden, June 11, 1998.

13. Jinx Witherspoon, letter to George Rodger, July 14, 1952.

14. Jinx Rodger, interview by author, Smarden, June 11, 1998.

15. Inge Bondi, though an important witness, declined to be interviewed or to have her letters quoted in this bibliography.

16. George Rodger, letter to Jinx Witherspoon, June 26, 1952.

17. Ibid.

18. George Rodger, letter to Jinx Witherspoon, July 1, 1952.

19. Ibid.

20. The title "The Decisive Moment" was chosen by the book's American translator. See Pierre Assouline's biography *Cartier-Bresson: L'Oeil du Siècle* (Paris: Plona, 1999).

21. Henri Cartier-Bresson, letter to Jinx Witherspoon, October 20, 1952.

22. George Rodger, letter to Henri Cartier-Bresson, November 16, 1952.

23. Ibid.

17. The End of an Era: 1954

1. $1,000 in advance and $1,000 in expenses from *Life*, with other possible sales.

2. George Rodger, diary entry, February 15, 1954, Smarden Archive.

3. Jinx Rodger, interview by author, Smarden June 10, 1998.

4. George Rodger, *Africa On a Shoestring*, Beirut, February 1955.

5. Ibid.

6. Jinx Rodger, interview by author, Smarden, June 10, 1998.

7. "What is Mau-Mau?" in *Picture Post*, March 27, 1954.

8. Rodger's publications include two stories for the *Picture Post*: "The Trial of General China" (March 6, 1954) and "What is Mau-Mau?" (March 27, 1954). The *Life* story was "Spikes for Mau-Mau" (n.d.f.).

9. Rodger, *Africa on a Shoestring*.

10. In "What is Mau-Mau?" *Picture Post*, March 27, 1954.

11. Rodger's images of the Mau-Mau massacres anticipate those by later photographers of the genocide of the Tutsi by the Hutu. See, for example, work from the 1990s by Gilles Peress, Sebastião Salgado, and James Nachtwey.

12. George Rodger, diary entry, Yei, March 26, 1954.

13. George Rodger, interview by author, Smarden, May 1982.

14. "King of Bunyoro," in *Natural History*, April 1955.

15. Ibid.

16. George Rodger, letter to Margot Shore, April 30, 1954.

17. George Rodger, diary entry, April 25, 1954.

18. George Rodger, letter to John Morris, June 3, 1954.

19. Rodger, *Africa on a Shoestring*.

20. Rodger, *20,000 Days*.

21. Capa's final days are reconstructed by Richard Whelan in *Robert Capa* (New York: Knopf, 1985), 297–99.

22. John Steinbeck, "Death With a Camera," in *Picture Post*, June 12, 1954.

23. Margot Shore, letter to George and Jinx Rodger, n.d. (early June 1954).

24. Ibid.

25. Hopkinson, *Picture Post: 1938–1950*.

26. Rodger, *Le Village des Noubas*, collection "Huit."

27. Ibid.

28. George Rodger, letter to Chim, Cornell Capa, and John Morris, London, September 25, 1954.

29. George Rodger, letter to Marc Riboud, n.d. (early June 1954).

30. George Rodger, letter to Henri Cartier-Bresson, January 14, 1955.

31. Marc Riboud, telephone interview by author, Paris, January 1997.

18. Desert and Africa: 1955–1958

1. George Rodger, diary entry, February 17, 1955, Smarden Archive.

2. George Rodger, letter to John Morris, September 5, 1955.

3. George Rodger, diary entry, November 3, 1956.

4. Jinx Rodger, diary entry, November 12, 1956, Smarden Archive.

5. See Miller, *Magnum*, 128 29.

6. Jinx Rodger, interview by author, Smarden, January 3, 1998.

7. George Rodger, diary entry, February 17, 1957, Smarden Archive.

8. George Rodger, diary entry, November 5, 1957, Smarden Archive.

9. Jinx Rodger and George Rodger, "Elephants Have Right of Way," *National Geographic*, September 1960.

10. George Rodger, "Kent: A Den Of Our Own," unpublished and undated manuscript, Smarden Archive.

19. Public Successes, Private Ordeals

1. For a more detailed history of Magnum in this era, see Fred Ritchin's text "What is Magnum?" in *In Our Time: The World as Seen by Magnum* (New York: Norton, 1989); George Rodger, "Random Thoughts of a Founder Member," *Phototechnique*, November 1977; and Miller, *Magnum*; as well as John Morris's and Inge Bondi's detailed Magnum memos, which relate to current events and photographers' travel itineraries and exhibitions and also provide snippets concerning members' social, professional, and personal lives. For information about internal politics, agendas, and board resolutions, see also Magnum's reports to shareholders from Cornell Capa and other directors, 1957-present, Magnum Photos archives, Paris, London, and New York offices.

2. Cornell Capa, quoted in "The Last Happy Band of Brothers," by James Baker Hall, *Esquire*, April 1962.

3. George Rodger's "Ancient Cities of the Middle East" series was shot in 1966–67 and published widely in a variety of magazines as well as in Time-Life books.

4. George Rodger, letter to Jinx Rodger, July 29, 1961.

5. George Rodger, "Focus on India," unpublished text, 1976, 25–26, Smarden Archive.

6. Peter Marlow, interview by author, London, January 5, 1998.

7. George Rodger's weakness as an editor of his own photographs was noted by others as well. Inge Morath noted that although Rodger's "sequences in pictures were very good . . . George was not a good editor of his own pictures." (Interview by author, New York, May 7, 1998).

8. Peter Rodger, in "Relative Values," *Times* of London, 1995.

9. Jonathan Rodger, interview by author, Smarden, August 2, 2000.

10. Tom Hopkinson, draft of "George Rodger and How He Operates," 4.

11. Other important group shows after 1974 were "Life: The First Decade" (1980); "La Déportation" (1982, Musée du Trocadéro, Paris); "South Africa" (1987, FNAC Montparnasse, Paris); and "In Our Time: The World as Seen by Magnum" (1989, International Center of Photography, New York, and on international tour). Rodger had many solo exhibitions as well, including "Tribal Africa" (1978, University of South Africa); "Masai Moran" (1982, Photographers Gallery, London; FNAC Montparnasse, Paris, and elsewhere); "Festival Africain" (1982, Grenoble); and many others. These were presented in Angoulême, Cyprus, London, Folkstone, Aberdeen, and other cities. Rodger's retrospective at the Musée de 'Élysée in Lausanne, curated by Charles Favrod, was the first to include his images of Bergen-Belsen.

12. George Rodger, letter to Jean Lacouture, December 18, 1989.

13. On a less serious note, Rodger composed a short, droll poem during one of Magnum's general meetings. It ended: "God Save the King," the members roared / In wild, tumultuous accord / "A gallant pair!" cried HCB / and clicked his Leica crazily. / (The squire smiled, indifferently. / The agent . . . photogenically.) / That selfsame eve, though gaunt and ill / And somewhat water-logged, but still / Intact, they packed their bags and went / To England, Porchester and Kent / (which, having little choice, alack, / were duly forced to take them back)." The photogenic agent in question was John Hillelson.

14. Fred Ritchin, "What Is Magnum?" in *In Our Time: The World as Seen by Magnum Photographers*, 417–20.

15. Jinx Rodger, interview by author, Smarden, January 3, 1998.

16. Peter Marlow, interview by author, London, Janaury 5, 1998.

17. Jinx Rodger letter to the author, August 5, 2001.

18. David Hurn, letter to the Rodger family, n.d. (August 1995).

19. Peter Rodger, interview by author, New York, October 19, 1998.

20. Neil Burgess, letter to the author, August 10, 2001.

21. Peter Rodger, interview by author, New York, October 19, 1998.

22. Jinx Rodger, interview by author, May 7, 1997.

23. Jinx Rodger, interview by author, May 4, 1997.

24. Dorothy Bye Parmalee, telephone interview by author, March 15, 2001.

25. Jinx Rodger, interview by author, Smarden, May 11, 1997.

26. Ibid.

27. Jinx Rodger, interview by author, Smarden, May 7, 1997.

28. Peter Marlow, interview by author, London, January 5, 1998.

29. Sebastião Salgado, interview by author, Paris, May 6, 1998.

20. Back to Africa: 1977–1980

1. George Rodger, "Masai Moran," unpublished text, n.d. (1981, written upon his return from England), Smarden Archive. This chapter's narrative is also based on Carole Naggar, *George Rodger en Afrique* (Paris: Herscher, 1984).

2. Ibid.

3. Ibid.

4. Ibid.

5. Ibid.

Epilogue

1. "The River," sung by Jenni Rodger, dedicated to her father. Jenni sang this song during the funeral service for George William Adam Rodger, 1908–1995, held at Smarden Parish Church on Thursday, August 3, 1995. The Rev. Brian Melbourne gave the sermon and Richard Dray played the organ. Other parts of the service included an opening prayer (Psalm 23), a Scripture reading (Matthew 13.1–7); the hymn "Dear Lord and Father of Mankind," prayers, and the commendation.

Index

Mosley, Leonard, 75

Mountbatten-Brabour marriage, 149

movie camera, 165, 182

movie companies' offer, 110

m'pango, 237

"Mr. Congressman Goes to Washington" (Michie, Rodger), 207–8

Munson, Ronald, 294n. 26

Murrow, Edward R., 142

Museum of Modern Art (New York), 154, 158, 189

musical milking, 23

Musick, John, 91

Mussolini, Benito, 144

Mwadui diamond mine, 169–70, 217

Mydans, Carl, 88, 291n. 1

Nachtwey, James, 192, 300n. 11

Nadel, Siegfried F., 296n. 1

Naga tribesmen, 98, *99*

Naggar, Carole, 1–6, 136, 268, 275–81

Nairobi, 232

Nalam ceremony, 177–78

Napore people, 238–39, 253

Nash, Mary, 232

Nasser, Gamal Abdel, 232

National Geographic: "Elephants Have the Right of Way," 253; Kuwait story for, 222; Nuba assignment, 179–90; Sahara proposal and, 248; "Sand in My Eyes," 250

Native Americans, 35–36

Navarro, Robert, 63–67

Netherlands, 211, 217

Newhall, Beaumont, 154, 189

Newhall, Nancy, 154

Newkirk, John, 91

new year ceremony, 177–78

New York, 35–38, 103–7, 207–8, 224

Ngurah, Anak Agung, 230

nightmares: after Burma, 96, 103, 105; after Capa's death, 245; of Bergen-Belsen, 146

nkusiri (growing old dance), 174

Normandy invasion, 112–15, 123–45, 293n. 1, 294n. 2

Nuba Conversations (Howes), 193–94

Nuba people: banning of customs of, 190, 193; cease-fire agreement, 296–97n. 3; fate of, 193–94; first encounter with, 70–71; Fox on photographs of, 297n. 18; photographs in Museum of Modern Art, 187, 246; publications on, 241–42, 296n. 1; Riefenstahl among, 191–92; Rodgers' stay with, 180–90; Rodger's understanding of, 192–93; Rodger's viewing of photographs of, 196

Nuru (sheikh of Kau), 186, 188

Ohrdruf, 134

Orwell, George, 111

Osman, Colin, 73–74, 268

Owen, Wilfred, 146

package stories: Capa's work with, 212; on ECA project, 214; first attempts at, 35; Nuba story as, 189; Rodger as inventor of, 4, 160–61

Pafuri, 167

Pahlevi, Reza Khan, 83

Palestinian refugees, 218–20, 221, 222

Panama Canal, 29

Paris: with Cicely after the war, 132–33; Jinx editorial work in, 217–18; liberation of, 128, 129, *130*; meeting of remaining Magnum stockholders, 241; return to after Haiti trip, 209; return to from Cyprus, 206; return to from ECA assignment, 216

Paris-Magnum: Photographs 1935–1981, 261

Paris-Match, 257

Parmalee, Dorothy née Hussey-Freke, 46, 109, 201, 264

Pearl Harbor, 86, 88

Peress, Gilles, 192, 300n. 8, 11

"Personal Views:1850–1970," 259

Philippines, 230